PASSION AND ORDER

A volume in the series
Conjunctions of Religion and Power in the Medieval Past
Edited by Barbara H. Rosenwein

A list of titles in the series is available at
www.cornellpress.cornell.edu.

PASSION AND ORDER

RESTRAINT OF GRIEF IN THE
MEDIEVAL ITALIAN COMMUNES

CAROL LANSING

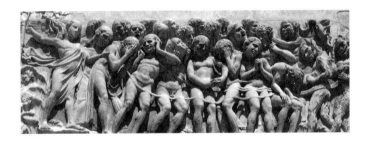

Cornell University Press
Ithaca and London

First published 2008 by Cornell University Press

Printed in the United States of America

Library of Congress Cataloging-in-Publication Data
Lansing, Carol.
 Passion and order : restraint of grief in the medieval Italian communes / Carol Lansing.
 p. cm. — (Conjunctions of religion and power in the medieval past)
 Includes bibliographical references and index.
 ISBN 978-0-8014-4062-5 (cloth : alk. paper)
 1. Mourning customs—Italy, Northern—History—To 1500. 2. Grief—Political aspects—Italy, Northern—History—To 1500. 3. Emotions—Political aspects—Italy, Northern—History—To 1500. 4. Burial laws—Italy, Northern—History—To 1500. 5. Italy—Social life and customs—To 1500. 6. Italy—History—1268–1492. I. Title. II. Series: Conjunctions of religion & power in the medieval past.
 GT3390.5.I8L36 2007
 393'.909450902—dc22

 2007029238

Cornell University Press strives to use environmentally responsible suppliers and materials to the fullest extent possible in the publishing of its books. Such materials include vegetable-based, low-VOC inks and acid-free papers that are recycled, totally chlorine-free, or partly composed of nonwood fibers. For further information, visit our website at www.cornellpress.cornell.edu.

Cloth printing 10 9 8 7 6 5 4 3 2 1

CONTENTS

ILLUSTRATIONS

ACKNOWLEDGMENTS

It is a pleasure to thank John Ackerman, the infinitely patient editor at Cornell University Press, and his superb editorial staff. I have been privileged to have time available for research supported by fellowships from the National Endowment for the Humanities and the Harvard University Center for Italian Renaissance Studies at Villa I Tatti as well as funding from the University of California, Santa Barbara. I have relied on the generosity of many Italian archivists, especially Marilena Rossi Caponeri, now director of the Archivio di Stato di Terni, which includes the archive of the Orvietan Commune, and her staff, and also Diana Tura and the staff at the Archivio di Stato di Bologna. The librarians and staff at I Tatti have been a great help in many ways as well.

My intellectual debt to my doctoral committee at Michigan in the 1980s is evident: Marvin Becker for his stimulating analysis of the intersection of politics and religious culture; Diane Owen Hughes for her brilliant, pathbreaking work on mourning, sumptuary laws, and gender; Thomas Tentler for his humane and compelling understanding of late medieval anxieties about sin; and Charles Trinkaus for his sensitive readings of the influence of philosophical ideas and social and political life on inner experience. It would have amused Charles to hear that decades after he dragooned me to work on Petrarch in his graduate seminar, I have actually written a chapter on the letters.

I received invaluable comments on the manuscript from Barbara Rosenwein, the series editor, as well as an anonymous, particularly exciting reader. Colleagues who painstakingly read versions of the entire manuscript include Edward English, Sharon Farmer, Steve Lansing, Stephan Miescher, Mau-

reen Miller, Ann Plane, and Thomas Tentler. I have also profited from suggestions at many talks I've given on the project, most memorably at Il Pentafillo in Florence, organized by Sara Matthews Grieco.

Other people who helped me in a variety of ways that I suspect they have long forgotten include Laura Andreani, Armando Antonelli, Nicole Archambeau, Mario Ascheri, James Banker, Judith Bennett, Sarah Blanshei, Daniel Bornstein, William Bowsky, Elena Brizio, Joan Cadden, Sam Cohn, George Dameron, Sabine Eiche, Konrad Eisenbichler, Valeria Finucci, Karen Frank, Margery Ganz, Phillip Gavitt, Patrick Geary, Massimo Giansante, Emmie Hileman, Steve Humphreys, Kate Jansen, Susan Kent, Christiane Klapisch, Lezlie Knox, Benjamin Kohl, Thomas Kuehn, John Easton Law, John Lee, Lester Little, Thomas Luongo, Stephen Milner, Edward Muir, John Najemy, Lucio Riccetti, Nick Terpstra, Stefania Tutino, Chris Wickham, and Corinne Wieben. People who are especially relieved to see the project finished include Nick Gould, Phil Gould, John Lansing, Phil Lansing, and Steve Lansing.

This book is dedicated to Edward English, who sometimes can even be persuaded to help with a tough document.

ABBREVIATIONS

AASS *Acta sanctorum quotquot toto orbe coluntur* . . . , ed. Joannes Bollandus et al. Paris: V. Palmé, 1863–1919; electronic rpt., Cambridge: Chadwyck-Healey, 1999–2002.

AGOP Archivum Generale Ordinis Praedicatorum

ASB Archivio di Stato di Bologna

ASF Archivio di Stato di Firenze

ASO Archivio di Stato, Comune di Orvieto

ASP Archivio di Stato di Perugia

ASS Archivio di Stato di Siena

BNF Biblioteca Nazionale di Firenze

BNR Biblioteca Nazionale di Roma

CD *Codice diplomatico della città d'Orvieto*, ed. Luigi Fumi, Documenti di storia italiana, 8. Florence: Vieusseux, 1884.

PG *Patrologiae cursus completus. Series Graeca*, ed. Jacques-Paul Migne. Paris, 1857–66; electronic rpt., Cambridge: Chadwyck-Healey, 1996–2005.

PL *Patrologia cursus completus. Series Latina*, ed. Jacques-Paul Migne. Paris, 1844–65; electronic rpt., Cambridge: Chadwyck-Healey, 1996–2005.

RIS *Rerum Italicarum scriptores*, ed. L. A. Muratori. Città di Castello: Tipi dell'editore S. Lapi, 1900–.

PASSION AND ORDER

INTRODUCTION

Not that I'd grudge a tear for any man gone down to meet his fate.
What other tribute can we pay to wretched men than to cut a lock,
let tears roll down our cheeks? —Homer, *The Odyssey*

The Italian communes in the thirteenth century were directly confronted with what modern scholars term the problem of civil society. The communes were self-governing associations of citizens, and for much of the thirteenth century no outside power could effectively rule over them for long. How, then, would they govern themselves? Given sharp socioeconomic and political divisions, could a town restrain conflicts that could lead to civil war? What were the potential sources of disorder, and could they be kept in check, enabling people to live together in a peaceful community? Thirteenth-century lawmakers articulated these questions in terms of the need to maintain "the good and peaceful state of the commune," a *vita comunale*. The problem was acute because of the effects of rapid growth. Towns doubled and tripled in size as immigrants poured in to take advantage of the opportunities offered by thriving commercial economies and also the pleasures of urban life. Some urban nobles made quick fortunes, built increasingly hierarchical alliances, and competed to dominate their towns. Popular associations based in neighborhoods and guild corporations challenged noble power and privilege. Townsmen sought to develop governing institutions that could maintain political balance among these contending powers and contain their conflicts.

State formation in the communal age was a matter of improvised solutions that were often copied from neighboring towns or from ancient precedents. Townsfolk experimented with institutional and social forms: guilds, arms societies, parish associations, political and judicial offices, systems of taxation, religious associations. People discussed the problem of a vita comunale in a

rich variety of forms, including political theory, sermons, council debates over electoral process, manuals of advice, even political frescoes. What are the real sources of disorder, and what can foster the good and peaceful state of the commune? Town councils responded by developing elaborate legislative programs that envisioned peaceful order. Some laws addressed obvious sources of violence, banning weapons, imposing curfews, penalizing violent crime. Other placed curbs on how men were to speak and act in council meetings. Further laws addressed perceived threats to order that ranged from luxury expenditure and lavish weddings and funerals to sexual actions and religious deviance. One common thread was a worry about gender: many laws distinguished at length between behaviors acceptable for men and for women.

This book examines one aspect of these legislative programs, laws that addressed shows of grief and laments at funerals. I began the study because I chanced upon a surprising set of legal sentences for violations of mourning laws in the town of Orvieto. Not only did Orvieto, like many towns, legislate to ban histrionic displays of grief and public laments for the dead, but the town's consuls also went to some effort to enforce the laws, sending spies to funerals and then fining people who wept and cried out, tore their hair, or joined in a public lament. Further, although the laws stated that women mourned in this way, all but two of the sentences penalized men who had wept and lamented in the streets and churches. More than two hundred men were fined, many of them elites and civic officeholders. It was effectively the same men who wrote the laws, then broke them at funerals, and then fined themselves. The laws were a contradictory intrusion into their own mourning practices.

I found these sentences both puzzling and revealing. They raised questions about how late thirteenth-century Italian townspeople understood their communes. First, why did the town consuls think it the business of government to restrain public laments for the dead? Grief at a funeral posed no obvious threat to civic order. What was it about the display of grief that provoked serious political concerns at this historic moment? And since the consuls evidently considered public grief to be a threat, why then did they break their own laws and weep and lament in the streets? Second, what of the gender discrepancy? Why if the laws emphasized women's grief were they enforced almost exclusively against men? Why term their own ritual actions something that women do? What were the sources of these ideas and who urged them in the thirteenth century? The mourning sentences thus offered a way to explore a complex of ideas about emotionality and gender that shaped late medieval understandings of civil society during this period of rapid formation of civic institutions.

Initially, I approached the funeral laws as an effort to alter ritual practice in order to control deviant religious belief. That is, I assumed the lawmak-

ers thought histrionic laments implied understandings of death that were not particularly Christian, so that efforts to restrain laments were best understood as an attempt to suppress those dangerous ideas. There is probably some truth to this view: certainly Petrarch, for one, thought that histrionic funeral grief stirred up terrifying doubts about the Christian afterlife. However, I have come to think that the laws and sentences were more directly concerned with the power of grief itself. One influence was a 1986 article in which the anthropologist Renato Rosaldo pointed out that scholars tend to focus on the obligatory routine of burial rituals rather than the emotions associated with loss.[1] Rosaldo wrote very movingly of the ways in which his own bereavement—his grief and rage at the death of his wife in an accidental fall—changed his thinking about research on death rituals. His article demonstrated to me the limits of analysis of death ritual in terms of social process. Studies often collapse the process of mourning with the ceremonial rites performed at funerals. The two are interrelated but distinct, and some funeral rituals surely engage the emotions associated with grief and the internal process of mourning more than others. Rosaldo urged the importance of considering not only power relations and the social and political functions of death ritual but the emotions of bereavement, "the need to grasp the cultural force of rage and other powerful emotional states."[2] This spoke directly to my own experience of the shock and pain of bereavement at the deaths of my parents. From this perspective, to study funerals in terms of the ritual expression of belief and ignore the force of grief seems deracinated.

I turned, then, to analysis of changing understandings of the power of grief. The evidence is rich: Italian society at the end of the thirteenth century and beginning of the fourteenth was preoccupied with grief for the dead. The great writers of this age explored the psychology of sorrow. Dante in the *Vita Nuova*, Petrarch in his *Canzoniere* and his many letters wrote of passionate love for idealized dead women. The power of grief was central to contemporary painting. Conventions changed: before 1250, gestures of sorrow were

[1] Renato Rosaldo, "Grief and a Headhunter's Rage: On the Cultural Force of the Emotions," in *Text, Play, and Story: The Construction and Reconstruction of Self and Society*, ed. E. Bruner (Washington, D.C.: American Ethnological Society, 1986), pp. 178–95. Studies of late medieval and early modern death that consider grief include Margaret King, *The Death of the Child Valerio Marcello* (Chicago: University of Chicago Press, 1994), and George McClure, *Sorrow and Consolation in Italian Humanism* (Princeton, N.J.: Princeton University Press, 1991). See the articles collected in *Savoir mourir*, ed. Christiane Montandon-Binet and Alain Montandon (Paris: L'Harmattan, 1993).

[2] Rosaldo, "Grief," p. 189. See for its bibliography Sarah Tarlow, *Bereavement and Commemoration: An Archaeology of Mortality* (Oxford: Blackwell, 1999), chap. 2.

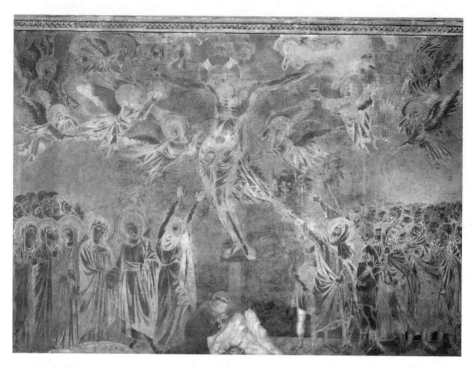

Cimabue. *Crucifixion*. c. 1280. Upper Church, S. Francesco, Assisi. Photo credit: Scala/Art Resource, NY.

restrained. In Crucifixion scenes, Mary and John delicately tilt their heads, raising a hand to the eye or cheek. From the second half of the century, Italian painters drew on stylized Byzantine imagery to make fresco and then panel paintings intensely emotional. In Cimabue's magnificent ruined fresco of the Crucifixion in the upper church at Assisi, swirling angels weep and throw back their heads in sorrow as a woman, probably the Magdalene, violently extends her arms upward, straining toward the body of Christ dead on the Cross. Gestures of self-mutilation became common and were almost always given to women. The horrific scene of the Massacre of the Innocents became a popular subject. In these scenes, the cruel deaths suffered by the infants are mirrored by the pain on the faces of their mothers. In the massacre fresco in the lower church of Saint Francis at Assisi, women holding murdered babies lacerate their cheeks, tear at their hair and clothing, or throw up their arms in lamentation for their sons.[3] Why this preoccupation with grief, and why the shift to dramatic images of grieving women?

[3] See Moshe Barasch, *Gestures of Despair in Medieval and Early Renaissance Art* (New York: New York University Press, 1976), chap. 5.

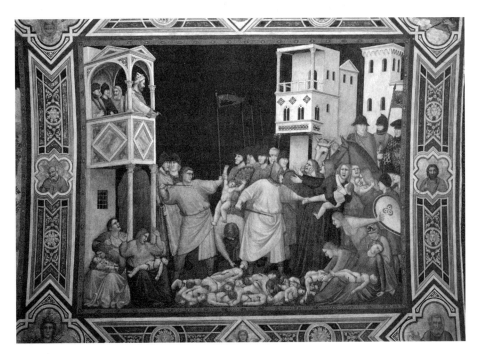

Extreme gestures of grief ascribed to women. School of Giotto di Bondone. *Massacre of the Innocents*. c. 1310. Lower Church, S. Francesco, Assisi. Photo credit: Scala/Art Resource, NY.

I have come to think that the funeral sentences reveal a turning point in ideas about how grief and passionate emotion relate to political order. Conventions about emotions do change, as the rich scholarship on the history of emotion has shown. Grief is particularly revealing: the way people think about grief is linked to how they understand themselves, their sexuality and reproduction, as well as their families and the social and political order.[4] Responses to death can both define and reconstruct social roles: when more than a hundred Orvietan men gathered together to weep and lament with a nobleman who had lost his son, they were demonstrating ties that were both social and affective. Friends, neighbors, clients, political allies all shared in his grief. The gathering also reconstituted their community after the loss of

[4] See Barbara Rosenwein, "Worrying about Emotions in History," *American Historical Review* 107 (June 2002): 821–45; S. C. Humphreys, "Introduction: Comparative Perspectives on Death," in *Mortality and Immortality: The Anthropology and Archaeology of Death*, ed. Humphreys and Helen King (London: Academic Press, 1981), pp. 9–10; for a comparative study of grief and understandings of identity in Confucianism and in western European philosophy, see Amy Olberding, "Mourning, Memory, and Identity: A Comparative Study of the Constitution of the Self in Grief," *International Philosophical Quarterly* 37 (March 1997): 29–44.

the young man. Their noisy grief and laments were an obligatory show of honor, loyalty, and affection among men. Why, then, did they fine themselves for their lament? The answer, I think, is that understandings of grief and strong emotion more generally were changing. Lay intellectuals concerned to maintain a *vita civile* drew on Stoic and Augustinian ideas to represent emotionality as irrational passion and a threat to civic order.

In effect, the Orvietan lawmakers had become uncertain about their customary forms of mourning. This is not in itself surprising. There is a long tradition in the Christian West of ambivalence about the display of strong emotions, particularly the wrenching feelings provoked by death. Grief, the most painful of human emotions, can involve an overwhelming combination of feelings, including guilt, horror, pity for suffering, fear for oneself, rage, and despair as well as sorrow for the dead. When someone very close dies, these emotions do not easily fade—a year after the death, survivors can still be overwhelmed by depression and by anger.[5] This was true in the Middle Ages as it is today: for Petrarch, the frightening power of grief was epitomized by the sudden death of a friend: when the man saw the corpse of his son, killed and mutilated in battle, he literally dropped dead of sorrow. But again, although the intense feelings associated with grief are on some level surely universal, how people perceive and express them is conditioned by culture. Petrarch viewed his friend's fatal grief not as the tragic expression of a father's love but as a reprehensible moral failure. The man should have consoled himself with Hellenistic philosophy, not died of shock and grief.

Many cultures, like Petrarch, read mourning rituals as rhetoric, statements about the character of the mourner as well as the dead. What different cultures think the actions truly indicate, however, can vary sharply.[6] At some historic moments, the loud display of grief was a measure of status and honor. Medieval epic offers a familiar example: when Charlemagne comes upon the corpse of Roland in the eleventh-century *Song of Roland*, he faints, tears at his hair and beard, and wails at the loss to himself and to his kingdom. With his beloved Roland gone, he laments, the subject peoples will rise up and his kingdom will be devastated. In the political culture evoked in the poem, it would have been an unthinkable dishonor for Charlemagne to react to his follower's heroic death with calm acceptance. At other times, to show grief and anger instead meant weakness, and the control of emotion became a measure of character and of religious faith.

[5] Beverley Raphael, *The Anatomy of Bereavement* (New York: Basic Books, 1983), is a classic study of the psychology of grief.

[6] For a recent argument for the political manipulation of grief in the modern world, see Gail Holst-Warhaft, *The Cue for Passion: Grief and its Political Uses* (Cambridge, Mass.: Harvard University Press, 2000).

A display of mourning was a loss of self-control, giving way not only to doubt but to passions that could be sexual and even murderous. Stoic and Christian authors used this measure to judge their contemporaries. For some Christians, to grieve at a death was to doubt the Christian teaching of a joyous afterlife: John Chrysostom preached in fourth-century Antioch that Christian women who lamented the dead in the forum were shamefully displaying their bodies to men and behaving like the Bacchae, the female followers of Dionysius who in a wild sexual frenzy tore apart living creatures.

I argue, then, that the funeral sentences reveal a moment of change in how people understood and expressed the powerful feelings associated with death. The display of intense emotions—despair, grief, rage—was coming to be considered disruptive. Violent passions, including lust as well as grief, meant a loss of rational control and challenged rather than reinforced order, within the self as in the community. This shift in the conventions for acceptable emotional display was tied both to politics and to gender expectations. Men, especially ruling elites, were to act with decorum and quiet dignity at funerals and give emotional grief over to women. Loud laments were something done by women, not honorable knights, and should be curbed. Strong emotion was coded as irrational feminine passion. This was a return to the rich complex of gendered understandings of emotion inherited from the ancient world. Chrysostom's sermon is an example: Christian women who lamented the dead in the forum were putting on a shameful, sexual display. The most evident influence on thirteenth-century writers was the Stoic association of the passions with female nature. When the Stoic philosopher Seneca wrote an instructive play about the destructive force of the passions, he embodied them in the figure of Medea. In a sexual rage because Jason betrayed her by taking a young wife, Medea murders the children she had borne him and hurls their severed limbs at him. Ovid sketched a similar picture in the *Metamorphoses* and the *Heroides*, and Medea became a figure of murderous female passion in the Middle Ages.[7] The thirteenth-century mourning laws have often been read as an effort to restrict the public roles of women by banning them from funerals. I suggest instead that the lawmakers were more concerned with their own emotionality, and in Claude Lévi-Strauss's evocative phrase used women to think with, analyzing interior, emotional order and external, political order in gendered terms.

This book is about medieval Italian understandings of grief and of its display in mourning. The difference between them is important, although it

[7] See Ruth Morse, *The Medieval Medea* (Cambridge: Cambridge University Press, 1996).

can be overstated: grief is interior, an emotion, whereas mourning is a behavior, the action of expressing sorrow in funeral ritual.[8] The book is not intended to be a reconstruction of the behavior—the rituals surrounding death—already the subject of a number of excellent studies. Instead, it concerns how people understood the emotion and its display. I have chosen to begin with a close look at Orvieto, the distinctive, well-documented town where the mourning sentences survive. These records make it possible to look at both norms and practice. Scholars sometimes blur the difference between representation or discourse and actual practice, that is, between the ways people talked about grief and how people actually mourned. The sentences offer a rare medieval opportunity to approach both, attempting an understanding of sumptuary laws that is based not only on normative texts but on actual enforcement and a glimpse of social practice. I also compare the enforcement of mourning laws in two other towns in the papal states where thirteenth-century court records survive, Perugia and Bologna.

Further, the Orvietan records allow a broader look at context: social and political forces are revealed in a rare set of sources for a medieval commune, including not only the thirteenth-century judicial archive and an extensive *catasto*, or tax survey, of 1292, but also detailed minutes of the debates in the town councils, starting in 1297. The statutes that resulted from those discussions survive in various versions beginning in 1307. These records allow glimpses of the struggles over maintaining order in a medieval commune. Further, as I have argued elsewhere, though Orvieto is an exquisite backwater today, in the thirteenth century it was an influential cultural crossroads. A self-governing commune within the papal states, it became a popular residence for the popes, cardinals, and curia.[9] Like any thirteenth-century ruler, the pope traveled with his court, circulating among the towns of the papal states. The curia—huge by medieval standards—stopped in Orvieto often, spending a total of almost eight years in the course of the century. The town was also home to a Dominican convent that was a major provincial center, with a studium in theology planned

[8] See Karen Stears, "Death Becomes Her: Gender and Athenian Death Ritual," in *The Sacred and the Feminine in Ancient Greece*, ed. Sue Blundell and Margaret Williamson (London: Routledge, 1998), p. 121.

[9] Daniel Waley, *Mediaeval Orvieto: The Political History of an Italian City-State, 1157–1334* (Cambridge: Cambridge University Press, 1952), pp. 2–3. Agostino Paravicini Bagliani, "La mobilità della curia romana nel secolo XIII: Riflessi locali," in *Società e istituzioni dell'Italia comunale: L'esempio di Perugia (secoli XII–XIII)* (Perugia, 1989), pp. 155–278. There is a revised version: "La mobilità della corte papale nel secolo XIII," in *Itineranza pontificia: La mobilità della curia papale nel Lazio (secoli XII–XIII)*, ed. Sandro Carocci, Nuovi Studi Storici, 61, pp. 3–78 (Rome, 2003).

from 1269 and in natural philosophy from 1288.[10] Medieval Orvieto was a sophisticated and influential place, an important site for thirteenth-century struggles over political, religious, and gender identities. At the same time, the town's modest size and struggle for autonomy makes its politics somewhat more typical of the Italian communes than the heavily studied Renaissance cities, such as Florence and Venice.

The book has an untraditional format: it is not a straightforward social, political, or intellectual history. Instead, its structure retraces the paths I followed as I sought to make sense of the mourning sentences. Chapter 1 begins in Orvieto and sets the effort to restrain laments against the background of the growth of government and the workings of a thirteenth-century communal regime, its courts and laws. The mourning laws were part of broader legislative efforts to control disorderly behavior: laws on adultery, sodomy, and blasphemy as well as efforts to restrict women's activities, including a law banning them from entering the town hall. The second chapter first turns to the funeral laws and their enforcement in three towns in the papal states. Then I examine the statutes and actual sentences to unpack what they reveal about late thirteenth-century north Italian funerals in practice. I found that the Orvietan funerals included a disproportionate number of male elites, particularly nobles and men who held high civic office. This finding opened up questions about context: were Orvietan—or even north Italian—funerals simply anomalies? I move in chapter 3 beyond Orvieto's walls to take a more general look at medieval funeral practice. Representations of male lamentation in thirteenth-century literary and historical accounts suggest that mourning was not always a female role. More typically, whole families and communities were pictured as lamenting the dead. Male nobles in particular were expected to display their grief for lost comrades or sons.

Why, then, was the lament ascribed to women in late thirteenth-century Italy? Where did these ideas come from? The long tradition associating women with disorderly lamentation which derived from the ancient world influenced medieval lawmakers. Chapter 4 explores a number of these ancient sources, including Greek funeral laws and philosophic and literary texts that linked women with laments for the dead, with sexual passion and rage, and with religious doubt. These ideas were important to some Christian writers, as well as to Stoic philosophers concerned to restrain the passions, and were passed on to the medieval world in a variety of texts, often indirectly. The recognition that these ideas were available in the thirteenth century raised a new set of questions. Who actually urged the restraint of

 [10] M. Michèle Mulcahey, *"First the Bow Is Bent in Study": Dominican Education before 1350* (Toronto: PIMS, 1998), pp. 264, 306.

grief and which ideas were most influential? My expectation was that the funeral laws were the result of clerical efforts to Christianize mourning. Chapter 5 explores this possibility, turning first to canon law on lay lamentation and then to sermons in thirteenth-century Italy to explore the influence of contemporary preachers. Ultimately, I came to recognize that the funeral laws were not a late effort at Christianization. Thirteenth-century preachers were far more concerned with sorrow for sin: there was a new emphasis on interior emotion, the contrition that was crucial to penance and salvation. So, for example, when Eudes of Châteauroux preached on grief, probably in Orvieto, he used female sorrow as a positive model, urging his listeners to grieve for Christ as a mother grieves for a lost child. Late thirteenth-century confraternities sang vernacular hymns that modeled sorrow for sin, often in the form of the lament of the Virgin at the Passion.

The impetus for the restraint of grief came instead from lay intellectuals. Chapter 6 turns to discussions of unseemly lamentation in manuals of rhetoric, advice, and consolation, notably Boncompagno's 1215 *Rhetorica antiqua*. The civic judge and moral philosopher Albertano of Brescia, in his 1246 *Book of Consolation and Counsel*, used an account of a male lament to connect the restraint of grief and anger with the avoidance of factional violence. His most evident influence was Seneca. Albertano's treatise is the closest I have come to a "smoking gun," a text in which a medieval author directly stated that civic peace requires that men restrain their emotional distress and depicted this idea in terms of passionate female lamentation. The latter half of the thirteenth century saw the development of political theories—influenced by Ciceronian and Aristotelian thought—that justified state authority. I suggest in Chapter 7 that understandings of female nature and original sin that derived ultimately from Augustine became an important thread in these late thirteenth-century political teachings. Townspeople knew these ideas: they were urged by contemporary preachers such as Fra Remigio de'Girolami, who connected disorder within the self with disorder in society. The association of political disorder with irrational female passion also was portrayed in political frescoes, including an astonishing painting from Massa Marittima that directly equates imperial rule with sexual disorder.

Chapter 8 turns to the difficult problem of subjective emotion. The decades in which towns sought to control the display of grief for the dead also fostered a new humanistic sensibility, a fascination with subjective emotion. The traditional father of Italian humanism, Petrarch, was entirely preoccupied with grief and mourning and represented his feelings endlessly in his letters. I had attempted to concentrate on the late communal period—roughly, the second half of the thirteenth century—and this entailed a leap forward to the mid-fourteenth. However, I found Petrarch to be an extraor-

dinarily revealing source for understandings of what he termed the seductive dangers and morbid pleasures of the lament. Petrarch wrote about his own psychology and the need to find a way to come to terms with intense sorrow. Like the authors of the Orvietan statutes, he thought in terms of gender, suggesting that to give way to grief is unmanly, womanish behavior. And he reacted to this interior conflict by projecting it outward, suggesting that women should be restricted from public laments for the dead.

Chapter 9 returns to Orvieto. The town's wealth and influence faded with the papal curia's 1303 move to Avignon, and the delicate political balance of the turn of the century failed. After 1313, Orvieto was decimated by decades of civil war as local nobles contended for lordship of the town. When a popular regime was briefly restored, it responded with an elaborated funeral statute. A contemporary chronicler vividly described these decades in ways that reveal the Orvietans' thinking: why they responded to factional war with yet more rules on whether men could wear black and gather at a grave to weep and cry out or women could unbind their hair and count the honors of the dead. The anonymous chronicler closely linked funeral grief and anger with lust for power and civil war. This connection underscores both the rhetorical power of the display of grief and how the meaning of a lament can shift. The evidence for thirteenth-century funerals in Orvieto suggests a show of community solidarity, as political opponents attended each other's funerals. After 1313, noble funerals became instead a show of division.

Funeral decorum did change. I know of no way to date this shift with precision, but scholars have demonstrated that by the mid-fourteenth century there was a general turn to pomp and ostentation, with lamentation given to hired mourners. As Sharon Strocchia has shown for Florence, lavish funeral pomp for male elites often included chivalric trappings: horses, banners, shields, and helmets. The men themselves grieved with what was now considered dignified restraint. This was true even for the professional military: when at the end of the century the Florentines put on an ostentatious state funeral for the great mercenary commander John Hawkwood, it was not his men but women—who were apparently hired—who wept and wailed at his bier.

In sum, the book is not intended as a definitive history of understandings of grief. My objective instead is a speculative essay on a constellation of ideas about the restraint of emotion, gender, and state formation in late thirteenth- and early fourteenth-century Italy: in essence, the association of emotional and political disorder. To suggest affinities and raise questions, I have read a series of representations of laments.

CHAPTER ONE
GRIEF AND STATE FORMATION

In medieval Italy, the death of a grown son was thought the worst loss that one could suffer. Funerals for young men drew crowds of mourners. In 1295, a nobleman, Lord Muntanari, stood in a cluster of men in the street outside his house and wailed at the death of his son Pietro. We do not know whether Pietro died of illness, accident, or war. Pietro's brother, Vanne, grieved along with his father, as did four young nobles, perhaps Pietro's friends. Four older nobles were present, powerful and important men, several of them from the Monaldeschi, the rising Guelf lineage that within a few decades took over the town as *signori*, despots, and then tore it apart with their internecine rivalries. There were also two brothers, both of them merchants, a notary, and a man termed "Fredo who stays outside Lord Muntanari's house." Some of these men were surely clients and had a different kind of social obligation to share in the father's grief. At least seventeen men were present, and the gathering was noisy: they stood in the street, "wept and cried out in loud voices" and "made a *corrotto*," which meant they sang or chanted a lament, praising Pietro and grieving his loss.[1]

January 1288 saw a formidable gathering for another young man, Lotto Morichelli. At least 129 men took part in the lament in the street. Again, we do not know what killed Lotto Morichelli, but the men who grieved for him included distinguished noblemen, civic officials, and former ambassa-

[1] Archivio di Stato, Comune di Orvieto (hereafter ASO), Giudiziario, Busta 2, fasc. 8, 75 recto. These seventeen were the men fined for their actions at the funeral; more people probably were present. This text has not been published, to my knowledge.

dors to the papal court, as well as artisans, a tavern keeper, and a butcher. A distinguished old nobleman who had been fined for heresy twenty years earlier named Ugolino Lupicini took part, as did Lotto's nephew, the young knight Janne.[2] This was an impressive show. At least sixteen men not only wept loudly but pulled off their headgear or tore at their hair in a display of grief.[3]

We have these vignettes of grief because an anonymous spy working for the city's court watched the funerals and kept track of who wailed, chanted, or ripped at his hair or clothing. Over the next few days, all these men were fined for violations of the town's funeral statute. Spies also targeted more modest funerals, including those of women. For example, in 1287, a spy observed the funeral of a woman called Allebrandina, at the Franciscan convent. The spy reported back that three men, a furrier, a mason, and a meat vendor, had "remained after the sermon in the church of Saint Francis to mourn for domina Allebrandina."[4] The men were convicted of breaking the town's mourning law and paid modest fines of 20 soldi. In October 1295, a group of six men wept publicly and tore their hair, not in a church but outside the home of the recently dead Celle Bramandi. They too were reported to the court and fined 20 soldi.[5] In another case, three men were found to be weeping without hats on in the church of Saint Francis, and two men were weeping hatless in front of the house. Baring one's head was expensive: the fine was 100 soldi, except for one fellow who also ripped at his hair, which cost him an additional 40. In all, the fragmentary records from the courts of late thirteenth-century Orvieto contain 25 sentences for mourning violations. Two hundred twenty people were fined for lamenting the dead. All but two of them were men, and many were prominent citizens; a number held high civic office.

Sentences for public displays of grief are startling to historians, for several reasons. First, because mourning was often represented as a female practice,

<hr />

[2] ASO, Giudiziario, Registro 1, 556 verso and 557 recto. Janne was one of the men put in charge of martial games when the pope visited in 1295: see ASO, Riformagioni 70, 50 recto. Most of the Orvietan sentences and statutes have been edited: "Orvieto," ed. T. Petrocelli, L. Riccetti, and M. Rossi Caponeri, in *La legislazione suntuaria, secoli XIII–XVI: Umbria*, ed. M. Grazia Nico Ottaviani, Pubblicazioni degli Archivi di Stato, 43 (Rome: Ministero per i beni e le attività culturali, 2005); this text is n. 6, pp. 991–93.

[3] ASO, Giudiziario, Registro 1, 550 verso–551 recto; "Orvieto," ed. Petrocelli et al., *La legislazione suntuaria*, n. 6, pp. 992–93.

[4] "remanserunt post predicationem factam ad ecclesiam Sancti Francisci ad luctum domine Allebrandine delate." ASO, Giudiziario, Registro 1, 58 verso (1287); "Orvieto," ed. Petrocelli et al., *La legislazione suntuaria*, n. 5, p. 991. All translations are my own unless otherwise noted.

[5] ASO, Giudiziario, Busta 2, fasc. 8, 105 verso; to my knowledge, this text has not been published.

scholars have thought of lamentation as a traditional role of women, particularly in Mediterranean lands.[6] The laws of the thirteenth century, then, are viewed as efforts to restrict this female role.[7] For example, Augustine Thompson has recently argued that in Italy, women were "the great mourners of the age," with "a special role in mobilizing sentiment at funerals" through their laments. His evidence is a fourteenth-century devotional Lament of the Virgin, Niccolò dell'Arca's great fifteenth-century sculptured *Compianto*, and legal norms, since, he suggests, "knowledge of the pianto [lament] comes mostly from sumptuary legislation to control it."[8] As the court sentences demonstrate, two risky assumptions underlie Thompson's argument. The first is the assumption that art and legal norms accurately depict practice; I hope to show that far more complex relationships existed among them. The second is that lay funeral ritual remained unchanged over these centuries, so that an image carved in 1463 depicts laments as they were practiced two centuries earlier. I hope to show that these mourning rituals were not static but had a history, a history that was driven by political and cultural change.

Second, some historians have treated mourning laws, like sumptuary legislation more generally, as efforts to control—or at least tax—luxury expenditures such as funeral candles, or as mainly symbolic gestures that were left unenforced.[9] We expect the state to pursue tangible threats, not gestures of sorrow. Again, the Orvietan records and a few scattered cases from Perugia indicate serious if sporadic enforcement of the law on lamentation at the

[6] The classic study of the role of women in laments is Ernesto da Martino, *Morte e pianto rituale* (Turin: Einaudi, 1958).

[7] To give a recent example, Allison Levy in a fine article on humanist mourning terms the thirteenth-century laws an "attempt on the part of the new humanist elite to territorialize public space by suppressing women's mourning . . . the desired result of this strategic revision of female lamentation was a masculinization of the death ritual and the spaces of that ritual." Levy, "Augustine's Concessions and Other Failures: Mourning and Masculinity in Fifteenth-Century Tuscany," in *Grief and Gender, 700–1700*, ed. Jennifer C. Vaught with Lynne Dickson Bruckner (New York: Palgrave Macmillan, 2003), pp. 81–94.

[8] Augustine Thompson, *Cities of God: The Religion of the Italian Communes, 1125–1325* (University Park: Pennsylvania State University Press, 2005), p. 401.

[9] Catherine Kovesi Killerby in an ambitious general study argues that sumptuary laws were supposed to be enforced; her research is largely based on published collections of statutes, not records that reveal enforcement in practice. Killerby, *Sumptuary Law in Italy, 1200–1500* (Oxford: Clarendon Press, 2002). She debates the path-breaking 1983 article by Diane Hughes, "Sumptuary Legislation and Social Relations in Renaissance Italy," in *Disputes and Settlements: Law and Human Relations in the West*, ed. John Bossy (New York: Cambridge University Press, 1983). See also Killerby, "Practical Problems in the Enforcement of Italian Sumptuary Law," in *Crime, Society, and the Law in Renaissance Italy*, ed. Trevor Dean and K. J. P. Lowe (Cambridge: Cambridge University Press, 1994), pp. 99–120.

end of the thirteenth century. Why did lawmakers trouble to put a mechanism in place to enforce laws on public laments by sending spies to funerals? One simple answer might be that this was a way to repress deviant behavior or people considered marginal: perhaps the lawmakers and courts used mourning fines as a pretext to harass people or to attack actions they considered undesirable for other reasons. However, the evidence does not fit this explanation since the men fined were hardly marginal and, as I hope to show, laments were a normal response of men as well as women confronted with loss. Most significant, the lawmakers themselves were deeply implicated. It was effectively the same men who first wrote the statutes, then broke them by wailing at funerals, and then paid the fines.

This book is a study of the contradictory intrusion of elite men into their own expressions of grief. The central argument is that the funeral laws were part of their effort to create an orderly urban community. The laws were imposed during a period of rapid state formation, the dramatic growth of civic government. To term frail, ramshackle medieval Italian communes "states" seems anachronistic.[10] And yet the thirteenth century saw real change, driven ultimately by the commercial revolution and the expansion of urban economies. Towns doubled and even tripled in size as people emigrated to take advantage of new opportunities. During this richly creative, improvisational period, townspeople reshaped the structure of power, forming corporate economic and professional associations.[11] In many communes, popular institutions representing urban neighborhoods and guilds gained a voice in government by about 1250, dislodging a narrow oligarchy of knights. The late thirteenth century was thus a pivotal moment in Italian urban politics. In some towns, a strongman, or *signore*, took over. But by the 1280s and 1290s, many of the communes established popular regimes, broad-based oligarchies that drew in leaders from the artisanal guilds as well as older elites, so that shoemakers and barbers served in office alongside knights, judges, and bankers. It was these late thirteenth-century regimes that struggled to find new ways to establish a stable community. Laws controlling grief were part of their effort to imagine a peaceful, orderly urban society.

American scholars have long tended to look to the city republics for the origins of modern democracy. To give a recent example, Robert Putnam in

[10] On the applicability of definitions of the state to medieval institutions, James Given, *State and Society in Medieval Europe* (Ithaca: Cornell University Press, 1990), introduction.

[11] The significance of this change, especially outside the major commercial centers, has been the most debated problem in medieval Italian urban history. For a survey of the scholarship on smaller towns to the south of the heavily studied Veneto and Tuscany, see Jean-Claude Maire Vigueur, *Comuni e signorie in Umbria, Marche e Lazio* (Turin: UTET, 1987).

1993 saw the medieval Italian communes as a major turning point in the creation of the sense of civic community that fostered civil society in Italy.[12] This fascination with the origins of the modern has in many ways been an obstacle to understanding the culture and complex political fluctuations of the towns on their own terms. Regardless of whether they were antecedents of modern democracies or even of modern north Italian civic traditions, it is certainly true that communes at the end of the thirteenth century directly confronted the problem of how to create a *vita civile*, an orderly life in an urban community. One part of their solution was legislative programs, with ever more elaborate rules about behavior, including the mourning statutes. The laws created what the legal historian Robert W. Gordon has called "pictures of order and disorder, virtue and vice, reasonableness and craziness." As Gordon argued, "the power exerted by a legal regime consists less in the force that it can bring to bear against violators of its rules than in its capacity to persuade people that the world described in its images and categories is the only attainable world in which a sane person would want to live."[13] Perhaps lawmakers hoped for social control, but whatever their intentions, the effect of the statutes was largely rhetorical. They portrayed an orderly urban community in terms of the restraint not only of unruly grief but of things like angry speech, blasphemy, prostitution, sodomy, and adultery, as well as women's dress and excessive displays of wealth at weddings and funerals. These actions were disorderly, even dishonorable, and some were morally reprehensible. They had no place in the peaceful Christian town lawmakers envisaged.

THE ORVIETAN COMMUNE

The laws on grief thus were initially produced at a distinctive social and political moment. This chapter examines that historical moment more closely, looking at the communes, their courts, and their legislative programs. Funeral laws were written in many towns, and one approach would be to write a general narrative tracing their development. I have not chosen this approach, for several reasons. The earliest mention of a particular law is usually not evidence for its original date: in Orvieto, for example, where the evidence is particularly good, I can show that a funeral law existed and was

[12] Robert D. Putnam, *Making Democracy Work: Civic Traditions in Modern Italy* (Princeton, N.J.: Princeton University Press, 1993), chap. 5. See the discussion by Edward Muir, "The Sources of Civil Society in Italy," *Journal of Interdisciplinary History* 29 (Winter 1999): 374–406.

[13] Robert W. Gordon, "Critical Legal Histories," *Stanford Law Review* 36 (January 1984): 57–125; the quotation is p. 109.

enforced thirty years before its first mention in the council minutes. Judicial records do not survive for most of the thirteenth-century towns, so we can track only the first extant mention of a law, usually in a collection of statutes.[14] A general narrative thus would tell us more about when the statutes were compiled than when they were written. Further, the history of norms is only a narrow part of the story, without an understanding of how they related to social practice. My interest is not in the history of these laws so much as what they can reveal about power relations and culture in the society that enacted them. For these reasons, I have chosen to locate the study first in Orvieto— where considerable evidence survives—and then move outward.

A spectacular hill town, Orvieto sits on a stub of volcanic rock six hundred feet above the valley of the Paglia River. The town commands a ford on the main road north from Rome through Arezzo to Florence, and Orvietan prosperity was due in part to this strategic position. The region is one of the driest areas in Umbria, reliant on hydrology. Orvieto's district includes both arid, mountainous areas that could support only a sylvan and pastoral economy and rich alluvial lands that allowed intensive cereal production. The light and fertile volcanic soils in the southwestern portion of the district were used for viticulture, then as now.

One defining characteristic was Orvieto's close and often conflictual relations with the papacy. In 1157, the Orvietans acknowledged a theoretical papal sovereignty that dated back to the Carolingian era. In practice, the town's expansion of its sphere of influence collided repeatedly with papal territorial ambitions. Orvieto competed with the curia, the Sienese, and at times the German emperors to control strategic lands, including the vast Aldobrandeschi lands stretching from Orvieto to the sea.[15] The most important, however, was Aquapendente, a small town to the west that commanded the bridge where the great north-south road, the via Francigena, crossed the Paglia, and the adjoining Val di Lago di Bolsena, a valuable grain-producing region. Control of Aquapendente along with its own valley would enable Orvieto to dominate the traffic of goods and people to and from Rome. The town changed hands repeatedly. The Aquapendentans periodically rose in revolt against outside rule and were crushed. Orvieto suffered numerous papal interdicts in the conflict, beginning with an 1198 interdict from Innocent III. The dispute was temporarily settled with Boniface VIII in 1297. The papal presence gave the

[14] Killerby has given us a useful discussion of these methodological questions and a table of the distribution and chronology of Italian sumptuary laws. *Sumptuary Law in Italy*, pp. 27–30.

[15] On the Aldobrandeschi lands, see Jean-Claude Maire Vigueur, *Cavaliers et citoyens: Guerre, conflits et société dans l'Italie communale, XIIe–XIIIe siècles* (Paris: EHESS, 2003), p. 43.

region a measure of stability. In the fourteenth century, after the curia's move to Avignon, warring local factions battled over the same lands, with disastrous consequences, burning crops and raiding villages.

A rare, detailed portrait of a medieval town's social structure and economy is contained in the 1292 catasto, a household-by-household survey of holdings in rural land that is one of the masterworks of the medieval commune. One defining characteristic that emerges from the tax record is the allure of Orvieto's urban culture. Although the economic interests of town and country were intertwined, virtually everyone who was able to do so lived up on the plateau, in town. In 1292, the rural population of the contado, which meant the bishop's diocese, together with the district, which was the town's larger zone of influence, numbered somewhere between 19,000 and 32,000.[16] These figures include estimates of the laborers who owned no land and therefore are not mentioned in the catasto. Small peasant proprietors do appear: their tiny holdings averaged a hectare and a half. Setting aside the residents of rural monasteries, virtually all other Orvietans, including the heirs of the feudal nobility, lived in houses crowded into the town and were assessed as townsfolk. Orvieto's plateau is only about 86 hectares, roughly 212 acres. The urban population in 1292 was between 14,000 and 17,000. This was probably the peak of growth until the nineteenth century.

The 1292 catasto lists a few great landowners and then a striking majority of modest proprietors, who were city dwellers with a few plots of land near the town. The mixed character of the urban population resulted from a series of changes in the structure of power, as the old feudal nobility faded. Roughly speaking, two new waves of elites rose to power, first urban knights and then guildsmen and professionals. The first wave becomes apparent in the Orvietan sources when it multiplies around 1200. It was an elite of about thirty families that held titles and defined identity in terms of knighthood. Reliant on landed wealth and perhaps the profits of war, some also came to engage in commerce and modest manufacture. As Jean-Claude Maire Vigueur has pointed out, the knightly elite comprised the upper 10–15 percent of the urban population in most towns.[17] In the first half of the century, they ran the place: 91 of 110 Orvietan magistrates were drawn from the same thirty families.[18] In larger towns, competition within alliances of the knightly elite

[16] Estimates from Elisabeth Carpentier, *Orvieto à la fin du XIIIe siècle: Ville et campagne dans le cadastre de 1292* (Paris: CNRS, 1986), chap. 3.

[17] See Jean-Claude Maire Vigueur, "L'ufficiale forestiero," in *Ceti, modelli, comportamenti nella società medievale (secoli XIII–metà XIV) (Pistoia, 14–17 maggio 1999)* (Pistoia: Centro italiano di studi di storia e d'arte, 2001), pp. 75–97.

[18] Lucio Riccetti, "Monaldeschi, Filippeschi, comune ad Orvieto nel Medioevo," in *I Monaldeschi nella storia della Tuscia*, ed. Antonio Quattrani (Bolsena, 1995), pp. 5–17.

sparked internal wars. Orvieto was relatively stable, due probably to its small size and to the prosperity of the second, overlapping wave of elites: urban professionals and a well-to-do artisanate, with its masters represented in the guilds. These men drove the popular movement and by the last decades of the century held civic office. I have termed them waves; as Igor Mineo has noted for Sicily, lines between social groups were indistinct, so that the elite resembled a *zuppa inglese* rather than a layer cake.[19] In major centers such as Florence and Siena, this picture was complicated, both by the rise of knightly families that made quick fortunes in international banking and textile manufacture and by a sharp division between greater and lesser guilds. In Orvieto, economic and social divisions within the elite were less sharp.

The social transformations of the thirteenth century are apparent in the rural landholding patterns described in the catasto. A handful of old feudal comital families appeared in 1292, although their sources of power had faded: the counts of Montemarte, who were a branch of the Aldobrandeschi, and a local house, the Bulgarelli. They tended to hold large tracts of low value, including woods and scrub. The five heirs of the old Count Andrea of the Aldobrandeschi, dead in 1288, came from a very old family, mentioned as great landowners in records from the early eleventh century. They still held the largest fortune in land recorded in the catasto, based on its estimated value. Much of their holdings were to the southeast, along the Tiber, with their best lands near Lake Corbara. Often the Aldobrandeschi lands were adjacent to church properties, reflecting the close association between noble lineages and ecclesiastical patronage in past centuries. However, Aldobrandeschi power had been checked, at least for a time. Count Andrea's heirs had lost the richest of their lands, properties along the right bank of the Paglia River and the villas of Porano and Rocca Sberna. Their castle, Montemarte, in the contado of Todi, long perceived as a military threat by Orvieto and Todi, had been sold to Todi and was demolished by 1301.[20] They retained some rich lands near Corbara, but overall a full 40 percent of their holdings was considered woods and waste.[21] They had little political influence. The lineage submitted to Orvietan authority in 1171, and special laws restricting them were put in place in 1221. After that time they played little role in Orvietan politics until the move of the curia to Avignon and the

[19] E. Igor Mineo, *Nobiltà di stato: Famiglie e identità aristocratiche nel tardo Medioevo; La Sicilia* (Rome: Donizelli, 2001), p. x. Mineo cites Susan Reynolds, *Fiefs and Vassals* (Oxford: Oxford University Press, 1994), p. 40.

[20] *Codice diplomatico della città d'Orvieto*, ed. Luigi Fumi, Documenti di storia italiana, 8 (Florence: Vieusseux, 1884), nos. 587, 588, pp. 374–6. (Hereafter *CD*.)

[21] See Carpentier, *Orvieto*, pp. 198–200.

wars of the mid-fourteenth century opened up new opportunities.[22] The Bulgarelli were in a similar situation, with vast tracts of wood and scrub, in their case concentrated in the north, and again linked to church lands.

With the containment of these older feudal houses, the first wave of elites was a cluster of families of more recent and in part urban social origins. They were marked by titles: in the 1292 catasto, eighty households were headed by men termed *domini*, lords. This group included petty nobles such as the Monaldeschi, who were episcopal vassals in the twelfth century and by 1292 also included merchants and jurists. One of the richest men in Orvieto was a Monaldeschi, Corrado di Ermanno. He held less acreage than the older feudal houses, but his lands were richer, located in two distinct regions, with a total value of 14,195 libra (silver pounds).[23] Corrado enjoyed an impressive public career, an example of the *cursus honorum* characteristic of the knightly elite, with appointments to high civic and military offices: among others, he served as Capitano del Popolo in Florence in 1299 and was chosen by Boniface VIII to oversee both the construction of Orvieto's new cathedral and the defense of the long-contested Val di Lago and Aquapendente. These men were real knights: Corrado died on the battlefield at Radicofani in 1300. It was his son Ermanno who took over as Orvieto's signore in 1334; the bitter power struggle among his grandsons wrought havoc in the town and contado, as I discuss in Chapter 9.

Elite wealth and status was largely based in land. Only two men identified themselves as merchants in the tax records, though men from families such as the Monaldeschi and the Miscinelli demonstrably owned shops and engaged in merchant ventures but called themselves lords. By 1292, the eighty men identified as lords included not only dubbed knights from the old military elite but jurists and guildsmen whose titles derived from their service in civic office. The average assessed value of the rural holdings of lords was close to 4,000 libra. People termed the children of lords, with average holdings at 2,350 libra, headed another 173 hearths. Overall, the 9 percent of the population with titles owned 55 percent of the acreage that belonged to townsmen. The large funerals in the court records were all the burials of men from this petty urban knightly elite: the Muntanari, Lupicini, Morichelli.

The second wave of elites is apparent in the tax record as well: 101 hearths were headed by men termed *magistri*, masters, a group that included twelve notaries and five doctors, as well as master artisans. They held smaller parcels

[22] *CD*, nos. 133–7, pp. 90–92.
[23] On Corrado di Ermanno, see Giuseppe Pardi, *Comune e signoria a Orvieto* (Città di Castello, 1916; reprint, Rome: Multigrafica, 1974), p. 58, and Carpentier, *Orvieto*, p. 202.

of high-value land, typically vineyards and plots near the town, their produce probably used for the family table. In all, 246 identifiable artisans appear. A few groups were particularly well-to-do, including textile and leather tradesmen and potters, who made the jugs for Orvietan wine. Their prosperity was probably linked to the repeated visits of the papal and Angevin courts in the century. Wine sales surely skyrocketed. In effect, by 1292, the tiny feudal nobility had faded and the Orvietan elite included older knightly families and a rising group of guildsmen, among them professionals and also the prosperous artisanate. All had close ties to the countryside. By 1292, this mix of knightly and guild elites ruled the town, a broad-based oligarchy that achieved a precarious political stability.

COMMUNAL RULE

What we know of the town's internal history in the ill-documented twelfth century is essentially a long struggle between the landed nobility and the bishop, and then the gradual replacement of episcopal rule with independent civic institutions. Orvieto achieved a gradual conquest of its contado, as rural nobles submitted to rule by the bishop and then from 1168 by the town. This was very successful: the town's subject territory tripled in size between 1198 and 1216. Crucially, in the late twelfth and thirteenth centuries, these campaigns were waged by the town's militia. The city-states characteristically required their adult male citizens to serve in war. The exact form of obligatory service and equipment came to be decided based on wealth, as determined by fiscal surveys. The richest men were expected to keep arms, armor, and war horses, though they could pay substitutes to serve for them. The rest fought as infantry with shields, pikes, bows or crossbows, helmet and hauberk. Civic militias were typically funded by a direct tax, in Orvieto termed a *data*. The data was explicitly tied to financial support for knights serving in the militia. Wary of taxation then as now, the Orvietans literally had the tax law twice carved on a rock, in 1209 and 1220. It restricted the circumstances in which the commune could impose a direct levy to four. One of them was war. Those who provided the service of a horse worth over 20 libra and either fought themselves or provided a substitute were to receive 5 libra, a figure reduced to 4 in 1220.[24] Citizens were recompensed for war losses, notably knights who were paid for lost horses.

[24] See the description in the 1883 inventory of T. Piccolomini-Adams, *Guida storico-artistica della città di Orvieto e suoi contorni* (Siena, 1883), pp. 179–80.

Men who failed to show up to serve in the army suffered fines.[25] In 1295, 459 men were fined a modest 20 soldi for failing to show up for an expedition to Bolsena.[26] In general, they did take part: in the thirteenth century, a strikingly high proportion of male citizens fought on behalf of their communes. The best evidence comes from the records of the army of the Florentine Primo Popolo, which were captured in its 1260 defeat by the Sienese at Montaperto and preserved as a war trophy: 16,100 men fought, only 100 of them mercenaries, from a town of roughly 70,000.[27] The records for the Orvietan militia suggest that a high number of knights could be raised in proportion to the town's size: 800 to 1,000 knights, though the normal operational force was 400 to 500.[28]

In the early thirteenth century, energetic bishops, notably Ranerio (1228–48), developed systematic forms of administration and record keeping, enabling them to rebuild dispersed episcopal resources. In many ways, civic administration followed the bishops' lead.[29] Most civic offices were held by an oligarchy of men from the knightly elite. In these decades, townsmen gradually forged independent, popular institutions. The early popolo, or popular movement, in Orvieto as elsewhere had a double organization, based in neighborhood parish associations and also in the urban professional and corporate organizations. Historians measure this process by tracking when popular institutions are first mentioned in such records as treaties. In Orvieto, guilds had formed and chosen consuls by 1214. Neighborhood associations played a political role by 1229. A *Carta del popolo*, or popular constitution, and executives called rectors of the popolo existed by October 1244. Popular policy expressed the interests of guildsmen—master artisans and merchants—as well as urban knights. Their initial concerns are revealing. First, they sought to extend the town's power and independence in the region and actively campaigned to force the long series of rural nobles such as the Aldobrandeschi and adjoining communities to submit to Orvieto's authority. Second, the popular regimes worked energetically to protect collective resources in the countryside. These were the *beni comunali*, woods and pastures held by the

[25] See the discussion in Philip Jones, *The Italian City-State: From Commune to Signoria* (Oxford: Clarendon Press, 1997), pp. 383–87.

[26] ASO, Giudiziario, Busta 2, fasc. 8, 26 recto–30 recto.

[27] See Daniel Waley, "The Army of the Florentine Republic from the Twelfth to the Fourteenth Century," in *Florentine Studies*, ed. Nicolai Rubinstein (Evanston, Ill.: Northwestern University Press, 1968), pp. 76–79.

[28] See Maire Vigueur, *Cavaliers et citoyens*, p. 98.

[29] See David Foote, *Lordship, Reform, and the Development of Civil Society in Medieval Italy: The Bishopric of Orvieto, 1100–1250* (Notre Dame, Ind.: University of Notre Dame Press, 2004).

commune, including vast summer pastures at Monte Rufino; one reason the town sought the Aldobrandeschi lands was their value as winter pasture.[30] One of the major early triumphs of the popolo was a bureaucratic one, a 1244 inventory of these collective lands that facilitated their protection.[31]

Popular regimes worked not only to extend their control in the region but to construct the communes. The most visible efforts were building campaigns, staggering investments in urban infrastructure. These public works gave Orvieto the distinctive physical structure and elegant character it still enjoys, and which today lures hordes of tourists.[32] As Lucio Riccetti has pointed out, in the second half of the century the entire town was a construction yard. Projects included the 1247 repair of the city gates and, crucially, the building of a major aqueduct in 1273–76.[33] Palaces to house the town government went up in a series of campaigns, beginning in 1216–19. One of them burned in 1255 and was rebuilt by 1276. In the 1280s, major streets were paved and the Palazzo del Popolo constructed, its broad piazza built in part over the demolished houses of noble families condemned for heresy. The two papal palaces date from these decades as well, as do the mendicant convents. The building yard for the magnificent Gothic cathedral that now defines Orvieto opened between 1285 and 1290, and the old cathedral was demolished in 1297. The impetus for the building came from the bishop, the financing from the communal government.[34] This ambitious building campaign is typical of the communes in this period—Florence, Siena, Perugia, Bologna, Pisa—though towns without Orvieto's high plateau also built massive walls and sometimes bridges as well. The point should be underscored: the most significant feature of these regimes was their investment in infrastructure. The popular regimes literally built the towns, an investment that has endured.

[30] See Maire Vigueur, *Cavaliers et citoyens*, p. 81.

[31] This document is extant and includes the first mention of the Carta del Popolo. See Sandro Carocci, "Le comunalie di Orvieto fra la fine del XII e la metà del XV secolo," *Mélanges de l'École Française de Rome* 99, 2 (1987): 701–28.

[32] On Orvieto and the relationship between public works and the idea of the medieval city, see Lucio Riccetti, *La città costruita: Lavori pubblici e immagine in Orvieto medievale* (Florence: Le Lettere, 1992).

[33] Lucio Riccetti, "*Per havere dell'acqua buona per bevere*: Orvieto; Città e cantiere del Duomo, secoli XIV–XV," *Nuova rivista storica* 78 (1994): 243–92.

[34] *Il Duomo di Orvieto*, ed. Lucio Riccetti (Rome: Laterza, 1988), esp. Marilena Caponeri Rossi, "Il Duomo di Orvieto e l'attività edilizia dei Signori Sette (1295–1313)," pp. 29–80. See for a general discussion Patrick Boucheron, "À qui appartient la cathédrale? La fabrique et la cité dans l'Italie médiévale," in *Religion et société urbaine au Moyen Age*, ed. Boucheron and Jacques Chiffoleau (Paris: Publications de la Sorbonne, 2000), pp. 95–117.

A parallel effort was the construction of stable and effective fiscal and governing institutions, a project that—to judge from the results—was far harder than building palaces, cathedrals, and aqueducts. This was a period of rich political invention. No clear theory of communal government existed until late in the Duecento. Towns improvised and very often copied institutions from their neighbors. Popular governments, despite their relative autonomy and as we'll see their innovations in judicial apparatus, were after all fatally weak. They perceived the worst threats to be internal violence and strife among factions backed by outside powers: the armies of the papacy, the emperor, and then the Angevins, neighboring towns. Any analysis of the threats to stable communal government is complicated by the heated popular rhetoric that termed the nobles rapacious wolves and so forth. Still, the popular regimes were based in corporate associations, guilds, and neighborhoods. They were at risk of the establishment of *signoria*, boss rule: elite families might gain control of civic offices, use them to reward their *amici*, clients and allies, and punish enemies. Judicial offices were particularly open to partisan manipulation. This does not mean that all elite families sought to rule their towns; rather, they tended to have mixed and conflicting allegiances, owing loyalty to the commune, to their extended kin group and its allies, and to a political faction. Economic interests of course played a role: papal bankers were hardly likely to support the Ghibelline alliance. Loyalty to the commune tended to suffer. Most communes ultimately gave up popular rule and succumbed to a signore, trading autonomy for the hope of stability.[35]

This strategy failed in Orvieto as well: the Monaldeschi signoria in the 1330s sparked wars among elites that devastated the countryside as well as urban neighborhoods for decades. Factional struggles linked to the larger wars in the Italian peninsula shaped Orvietan politics only after about 1250. During the first half of the century, factional conflict seems muted. In larger towns, notably Florence, popular associations were quick to bring in an outsider Capitano del Popolo to lead them, an officer whose role paralleled and at times competed with the town's executives; the Orvietans did so only by 1250. Local alliances coalesced into factions that came to be headed by the Monaldeschi and Filippeschi lineages. As elsewhere, they looked to the rival international factions, the Monaldeschi to the pro-papal Guelf party and the Filippeschi to their Ghibelline opponents, linked to the imperial fortunes. The death of the Holy Roman Emperor Frederick II was a decisive turning point throughout Italy, as his heirs were defeated by the Guelf, papal, and Angevin alliance. After the 1266 death in the Battle of Benevento

[35] See the discussion in Jones, *Italian City-State*, esp. pp. 540–44.

of Frederick's son Manfred, Orvieto became loosely aligned with the victorious Guelf and Angevin cause. These international power struggles closely affected Orvieto, initially because it became a papal refuge. When Urban IV was threatened by imperial forces in 1262–64, he holed up there, and after Benevento the papal curia and the victorious Charles of Anjou often visited.[36] One body of evidence for the importance of the curia to Orvieto is the town's investment in papal palaces. In the 1260s, the town constructed a palace for Pope Urban IV; it was expanded in 1281 by Martin IV. In 1297, the town built a second elegant palace to house Pope Boniface VIII and his staff.[37]

Orvieto did not meekly become a papal client state. In 1280, it established an independent, bipartisan regime led by Raneri della Greca, who served as Capitano del Popolo in 1280–81 and 1284 and revived the power of the Council of the Popolo. Gradually, Orvieto built a broad-based guild regime. Termed the Seven, or Signori Sette, it was led by seven guild executives, chosen by lot to serve two-month terms. It lasted until factional antagonisms were rekindled in the second decade of the fourteenth century, with the arrival in Italy of Emperor Henry VII. In August 1313, in the course of the struggle, first Guelfs and then Ghibellines were driven from the city. A brief Guelf period gave way to a revived popular regime, which struggled against noble domination with varying success until Ermanno Monaldeschi's coup d'état of 1334 established a signoria that sparked endless factional wars until the town's submission to indirect papal rule in 1354.

PODESTÀ: HIRED OUTSIDERS

A central problem for the communes was the well-founded fear that whoever governed would use their offices for family gain and partisan political ends. The creative solution most towns adopted was to hand over the actual business of governance, particularly the courts, to outsiders, in hopes of a measure of impartiality. In Orvieto, the earliest outsider officials were rectors sent by the papal curia. Pietro Parenzo was the first, a member of a Roman Senatorial family imposed on the town as rector by Innocent III. The pope justified sending Parenzo as a response to the perceived threat that Cathar heretics were about to take over. Parenzo's 1199 assassination, as we

[36] Daniel Waley, *Mediaeval Orvieto: The Political History of an Italian City-State, 1157–1334* (Cambridge: Cambridge University Press, 1952), p. 48, lists Clement IV in 1266; Charles of Anjou in 1268; Gregory X in 1272 and 1273, accompanied by Charles; Martin IV, most of spring 1281–summer 1284; the Angevins in 1289; and Nicholas IV in 1290 and 1291.

[37] See Lucio Riccetti, *La città costruita*, pp. 113–15.

will see, sparked a great lament. He was followed by a series of his kinsmen. Orvieto then imitated other communes by hiring an executive, or *podestà*. The podestà was usually an outsider, generally a nobleman, invited to serve a fixed term and bring with him professional judges, notaries, soldiers, and policemen as well as household staff. The size of the entourage varied. Such figures are better documented in the late thirteenth century, when the Bolognese Alberto Asinelli served as podestà in Pistoia with three judges, two knights, three notaries, three attendants, a factor, and twenty police-men.[38] Bologna required more, including four judges and about ten notaries. These hired officials ran the courts.

Maire Vigueur has shown that podestà came almost exclusively from the knightly elite, families that based their identities on the military profession and a courtly, chivalric culture.[39] Podestà themselves generally were not professionals; they served in this role intermittently and might or might not have university training. Like Corrado di Ermanno of the Monaldeschi, the Orvietan repeatedly hired by allied towns to serve as their podestà, long ha-bituation to the military and knightly customs served them well. Podestà were supposed to be expert in three areas, "guerra, diritto e parola" (war, law, and oratory). Often, like Corrado, they were better versed in war than in the law. And as Maire Vigueur has pointed out, their culture and values were in some ways ill-suited to the job of podestà. Political theorists and di-dactic treatises of the period urged podestà to live like monks while in office: no women, banquets, or festivals, and no mingling with local elites. They were to renounce all reunions with family and allies and avoid chivalric games. Chronicle evidence shows that they often did not comply with this stringent ideal, taking part in local festivities and even organizing them. Further, they did at times have recourse to the vendetta, which surely means they valued the obligations of kin and alliance over a temporary political role, however honorable. Ironically, as Maire Vigueur argues, when podestà practiced the rites and habits of knighthood in violation of local statutes or normative treatises, it probably reinforced rather than damaged their pres-tige. I suggest in Chapter 2 that it was this contradictory male elite culture that the laws on funeral laments most directly sought to curb.

We have an early glimpse of this culture from 1229, when a Florentine from an old noble family, the Adimari, who was serving as Orvietan podestà, died of wounds suffered fighting for Orvieto against the Sienese. The Orvietan com-mune was obligated to compensate his heirs not only for his lost salary but for

[38] See Armando Antonelli and Riccardo Pedrini, "Appunti sulla formazione socio-culturale del ceto funzionariale del tempo di Dante: Sondaggi su documenti e tracce," *Il Carobbio* 27 (2001): 15–37.
[39] Maire Vigueur, "L'ufficiale forestiero."

his goods, captured by the Sienese. The list of his belongings offers a window into noble military culture. He went to war with two warhorses and a packhorse worth a very substantial 300 libra, gear for these horses along with another four packhorses and a saddle horse. His armor was extensive and quite valuable, including four swords and shields and a silver helmet. He enjoyed rich clothing in abundance, including three cloaks, one of them purple and one silk, and two silver belts. He traveled in some style, with a carpet, table linens and bed linens, plates and dishes, a chest of candles, and 2 nappe of silver.[40]

Towns chose these officials based on their networks of political influence and alliances.[41] The sources of these men thus varied with the town's political ties. Orvietan podestà were often Roman: from 1200 to 1247, fourteen Roman podestà served in Orvieto, seven of them from Pietro Parenzo's family. This does not mean the papal curia simply ran Orvieto. Often, these men—like the Parenzi—came from Senatorial families and were by no means papal allies. A snapshot of the selection process survives in the Orvietan council minutes from September 1295, when the Seven needed to choose a new Capitano and podestà. First, they settled on twenty-nine citizens drawn from all quarters of the city to take part in the process. Then they agreed that the new podestà should come from Lombardy, Bologna, or the Trevigian Marches. They would choose several men, and those who accepted would serve for six months, in sequence, and would come from different cities, starting with Padua. The podestà would be paid a salary of two thousand libra. He would be required to bring "three good, knowledgeable, and experienced judges, four notaries and two associates, ten horses, eight attendants, and fourteen armed policemen." He was to run the prison and guard the prisoners, to have the *campana* rung, and to provide his own paper, parchment, pens, wax, and other supplies.[42] Then the current Capitano suggested a list of eighteen names, from Padua, Bergamo, and Treviso. The council voted unanimously to invite them in sequence: if the first turned them down, they would go to the second, and so forth. On October 8 they sent off a syndic, with a notary, to travel to those towns and carry out the plan.

In theory, one crucial role for the podestà was to make the courts impartial, including a complete turnover of judges and notaries, once a year or

[40] ASO, Titolario A, 63 recto. *CD* no. 195, pp. 125–26. See the discussion in Maire Vigueur, *Cavaliers et citoyens*, pp. 67, 147.

[41] See *I podestà dell'Italia comunale*, ed. Jean-Claude Maire Vigueur (Rome: École Française de Rome, Istituto storico italiano per il Medio Evo, 2000). For Orvieto, see G. Pardi, "Serie dei supremi magistrati e reggitori di Orvieto," *Bollettino della R. Deputazione di Storia Patria per l'Umbria* 1 (1895): 337–415.

[42] ASO, Riformagioni 69, 45 verso, 47 recto.

even every six months, as in Bologna. In practice, the precise nature and limits of the judicial authority of the podestà was ambiguous.[43] It was complicated by the addition of the Capitano del Popolo, an office created by guildsmen in many towns because they felt that elites were overly powerful. The Capitano in theory served to protect the interests of the town's popular associations, including the guilds and neighborhood associations. However, in practice the office typically duplicated aspects of the podestà. Communal regimes tended to add new offices as safeguards without subtracting others, so that overlapping positions proliferated. In Orvieto, the relative power of the podestà and the Capitano varied with the political breeze, particularly the extent of popular influence. In some years the podestà issued judicial sentences on his own, in some years with the formal agreement of the Capitano, and in some years the same person held both offices. At times, the town invited the pope to be podestà, serving through his appointed vicar.

Yet another strategy to promote fairness that to my knowledge only a few Umbrian towns adopted for a brief period was an official called the Exgravator, literally the "Unburdener." His job was to remedy the inequities of the previous regime, most of them the court sentences of the podestà. In Orvieto in 1269, people appealed the decisions of the former podestà to the Exgravator, and he often overturned them. One irresistible example is an appeal from two men from the Lupicini family who had been recently convicted of heresy by a Franciscan Inquisition. They appealed their assessment for the civic militia to the Exgravator, on the grounds that the inquisitors had confiscated much of their property, so their old assessment was now unfairly high and they were unable to provide a horse for the militia. This was a tragic admission for an old knightly family. The sympathetic Exgravator— ignoring the fact that as convicted heretics the men were entirely deprived of legal privileges and had no business appealing to the court—found the request reasonable and reduced their obligation.[44]

After 1266, these outsider officials and Orvietan politics more generally were closely influenced by the papal court and the Guelf alliance. Agostino Paravicini Bagliani has calculated that the curia spent a total of seven years nine and a half months in Orvieto during the century; most visits were quite short.[45]

[43] Massimo Vallerani, "Il potere inquisitorio del podestà: Limiti e definizioni nella prassi bolognese di fine Duecento," in *Studi sul Medioevo per Girolamo Arnoldi*, ed. Giulia Barone, Lidia Capo, and Stefano Gasparri (Rome: Viella, 2000), pp. 379–415.

[44] ASO, Giudiziario, Busta 1, 1 bis, 24 recto–verso. See my discussion in *Power and Purity: Cathar Heresy in Medieval Italy* (New York: Oxford University Press, 1998), p. 147.

[45] See Agostino Paravicini Bagliani, "La mobilità della corte papale nel secolo XIII," in *Itineranza pontificia: La mobilità della curia papale nel Lazio (secoli XII–XIII)*, ed. Sandro Carocci, Nuovi Studi Storici, 61, pp. 3–78 (Rome, 2003).

The two papal palaces were a measure of the town's reliance on the curia as a source of wealth and prestige. More generally, as Sandro Carocci has shown, from the 1250s the job of podestà in the papal states became a perquisite tied to papal politics: when a Roman family was able to dominate the papal curia, its clients or family members often served as podestà in towns in the papal states. These were men from the Roman *baroni*, families that rose during the thirteenth century because of their close ties to the papacy. They were distinct from the older Roman Senatorial houses like the Parenti, who had served as rectors in Orvieto in the early part of the century and resembled on a larger scale the knightly families of Orvieto. The Orsini are the best example of powerful Roman baroni, with 56 podestà derived from the family by 1350.[46]

This pattern held in Orvieto, and officials often came from the curia. Twenty-five Roman officials served in Orvieto in the second half of the century.[47] The most important was Bertoldo, an Orsini who was named Orvietan podestà during the pontificate of his kinsman Nicholas III. After the submission of the Romagna to the papacy, Bertoldo went on to serve there both as papal rector and simultaneously as podestà of the major towns: Bologna, Faenza, Ravenna, Imola, and Rimini. During that period, he issued judicial sentences in Orvieto through four judges acting as his vicars. Bertoldo served as Orvietan podestà in 1287 and was usually in residence that year, a striking measure of Orvieto's political importance. We have records of judicial sentences read on twenty-six days spread over the course of 1287, and Bertoldo issued them in person on all but three.[48] In 1288, his kinsman Gentile Orsini took over as podestà and similarly tended to be present to issue sentences in person over the course of the year. The legal programs of Orvieto and the communes more generally were thus a collaboration among local lawmakers, the salaried nobles serving as podestà and Capitano, and their professional clerks and judges. Chapter 2 examines how this collaboration worked out in practice, in the enforcement of the funeral laws.

[46] Sandro Carocci, "Barone e podestà: L'aristocrazia romana e gli uffici comunali nel Due-Trecento," in *I podestà dell'Italia comunale*, ed. Maire Vigueur, pp. 847–75.

[47] Jean-Claude Maire Vigueur, "Nello stato della chiesa: Da una pluralità di circuiti al trionfo del guelfismo," in *I podestà dell'Italia comunale*, ed. Maire Vigueur, pp. 741–814. See also in the same volume Thérèse Boespflug, "Amministrazione pontificia et magistrature comunali: Gli scambi di personale nel Duecento," pp. 877–96.

[48] ASO, Giudiziario, Registro 1, pp. 1–193 verso, 295–98. No sentences survive from April, July, or September 1287. The fact that the podestà did not issue a particular sentence does not prove that he was out of town.

The urban communes pursued long campaigns to expand the sphere of action of their courts. As Chris Wickham has suggested for the twelfth century, "the development of regular law courts is the best guide available to the slow crystallization of city communes everywhere." Many communes established consular courts by the 1150s.[49] They struggled to take over much of the diverse judicial apparatus of earlier periods, including ecclesiastical and seigneurial courts.[50] A century later, civic courts still competed with alternative courts, notably church courts. People maneuvered among competing courts, although records are scarce. There is a glimpse from Orvieto, a copy of a 1282 appeal on behalf of a group of nobles from Castel Piero. The case had been initiated in the podestà's court, but the rector of the papal patrimony had remanded it to his court, which imposed a ban and fines. Now the nobles appealed to the papal judge presiding over criminal appeals to allow them to have their case return to the court of the Orvietan podestà, where, they argued, criminal cases had been handled by custom immemorial.[51]

Still, as Massimo Vallerani has argued, once civic courts obtained full jurisdiction over the city and contado, available to all citizens, they functioned as an instrument of power.[52] The formal process of accusation mediated by a professional jurist meant that the court could not so much coerce as regulate disputes, providing a formal process and set of categories through which a controversy could be resolved, often ultimately with a private peace. One measure of the success of this process is how quick people were to use the courts to settle disputes and attack enemies. In small towns such as Todi and Orvieto, townsfolk went to court with enthusiasm: men and women endlessly litigated over petty insults and minor threats. Often these were exchanges. When a master mason brandished a knife and told another man that he "lied through his beak and his teeth and was a mercenary son of

[49] See Chris Wickham, *Legge, pratiche e conflitti: Tribunali e risoluzione delle dispute nella Toscana del XII secolo* (Rome: Viella, 2000), translated as *Courts and Conflict in Twelfth-Century Tuscany* (Oxford: Oxford University Press, 2003), p. 301.

[50] See Jean-Claude Maire Vigueur, "Giudici e testimoni a confronto," in *La parola all'accusato*, ed. Maire Vigueur and Agostino Paravicini Bagliani (Palermo: Sellerio, 1991), pp. 105–23.

[51] "ex longa et longissima consuetudine, cuius non extat memoria." *CD* no. 526, pp. 325–26.

[52] Massimo Vallerani, "Modelli processuali e riti sociali nelle città comunali," in *Riti e rituali nelle società medievali*, ed. Jacques Chiffoleau, Lauro Martines, and Agostino Paravicini Bagliani (Spoleto: Centro italiano di studi sull'alto Medioevo, 1994), pp. 115–40.

a whore," it was worth a fine of 20 soldi, several days' wages for a skilled artisan.[53]

In the second half of the thirteenth century, civic courts investigated offenses ex officio as well as responded to accusations. An individual could denounce a crime to a judge and ask him to proceed ex officio; the courts also were obliged to investigate certain crimes. Not surprisingly, inquests in practice could operate very much like cases sparked by accusations.[54] Court cases were more often ways to settle disputes than any significant imposition of the authority of the state. Nevertheless, the turn in the thirteenth century to active investigation of crime—including funeral violations—was a real change in the role of the court. As Vallerani has argued on the basis of a contemporary treatise by the jurist Albertus Gandinus, the core justification for the inquest was not juridical but rather political and ideological: the discovery of truth and punishment of the guilty served the interests of the state and the judge.[55] Inquests represented a reinforced state authority, even if they tended in practice to be hijacked by local interests.

Court procedure was a sophisticated mix of cases sparked by accusations, denunciations that led to ex officio inquests, and inquests initiated by the court. In Orvieto, this mix of functions can be seen in practice in the judicial registers. In 1277, the year of the first extant register of sentences, the town's podestà, Raynaldo Leonis, charged his officers with uncovering violations. Members of his household, or *familia*, were supposed to denounce curfew violators, gamblers, and those found carrying concealed weapons. Men were picked to be *custodes*, a term that means guardians or spies, assigned to the markets in the main piazza and to the city's woodlands. In many cases, guardians were required by statute.[56] The guards of property outside the

[53] ASO, Giudiziario, Busta 2, fasc. 4, 15 recto, dated at 21 recto on 26 October 1291. On insults, see Trevor Dean, "Gender and Insult in an Italian City: Bologna in the Later Middle Ages," *Social History* 29 (May 2004): 217–31; Daniel Lesnick, "Insults and Threats in Medieval Todi," *Journal of Medieval History* 17 (1991): 71–89.

[54] See Massimo Vallerani, "L'amministrazione della giustizia a Bologna in età podestarile," *Atti e memorie delle Deputazione di storia patria per le provincie di Romagna*, n.s. 43 (1993): 291–316, and "I processi accusatori a Bologna fra Due e Trecento," *Società e storia* 78 (1997): 741–88; Sarah Blanshei, "Criminal Law and Politics in Medieval Bologna," *Criminal Justice History* 2 (1981): 1–30. On judicial procedure in Perugia, see Clara Cutini, "Giudici e giustizia a Perugia nel secolo XIII," *Bollettino della Deputazione di storia patria per l'Umbria* 83 (1987): 67–110, and Massimo Vallerani, *Il sistema giudiziario del comune di Perugia: Conflitti, reati e processi nella seconda metà del XIII secolo* (Perugia: Deputazione di storia patria per l'Umbria, 1991).

[55] "reipublice interest et etiam iudicis invenire hoc crimen et prevenire." Vallerani, "Il potere inquisitorio."

[56] This was true in Bolognese statute as well. See Lodovico Frati, *La vita privata di Bologna dal secolo XIII al XVII* (1900; reprint, Rome: Sala Bolognese, 1986), part 4, pp. 269–70.

town (*custodes bonorum exteriorum*) investigated agricultural infractions. The grape guards (*custodes uvarum*) caught men carrying wine grapes who owned no vineyards; other guards investigated those who sold illegally measured wine.

The 1277 register includes 459 sentences.[57] They are a mix of cases. Some penalize a single person, some a long list. A count of the sentences is probably not a good measure of patterns of criminality, since we do not know about crimes that did not lead to sentences or how many sentences were for fictional offenses. It is, however, an excellent measure of the real function of the court. Many reveal the unsurprising business of most medieval civic courts: 31 sentences for assault, 49 detentions for debt, a few homicides. Most striking is the extent to which the Orvietan court served to protect the interests of landowners in the countryside. In all, 260 sentences—over half the register—concerned rural infractions. Of these, 171 concerned damage to a planted field, such as allowing one's pigs to feed on someone else's crops. Twenty-nine were for illegal woodcutting. The rest were a mix: damage to gardens and vineyards, theft of livestock or such crops as grapes and spelt. Since we have seen that most owners of rural land lived in town, this is not surprising: one of the primary functions of the court was to protect the economic interests of city-dwelling elites against poor locals in the country.

The urban offenses penalized in the register also reflect the court's concern to protect economic interests: 37 sentences in some way penalize illegal sales, including wood, wine, and the resale of eels, probably the famously delicious eels of nearby Lake Bolsena. A scattering of cases concerned families: disputes over seduction, marriage, guardianships. There are infractions that reflect the court's interest in civic order: blasphemy, curfew violations, 9 gambling sentences, 12 sentences for illegal weapons. A couple of people were caught dirtying the fountains. There also were sentences for actions that threatened the commune: treason in the form of support for a rebellious *castrum* (fortified village), a jailbreak, efforts to bribe court officials, a man who tried to choke a policeman, a fellow who dropped a rock rather than a bean in the bags used for voting and spoiled a council vote. And there were two sentences for public grief, in violations of the statute on mourning.

How effective were the civic courts in curbing violence? Recent debates over the real nature and scale of violence in medieval society have clarified the problem.[58] A certain level of everyday violence existed in a town like Orvieto,

[57] ASO, Giudiziario, Busta 1, fasc. 6.

[58] See the discussion by Trevor Dean and K. J. P. Lowe, "Writing the History of Crime in the Italian Renaissance," in *Crime, Society, and the Law in Renaissance Italy*, ed. Dean and Lowe (Cambridge: Cambridge University Press, 1994), pp. 1–15, esp. 5–6, a critique of the idea that spontaneous, impulsive violence defines the difference between

as it does in modern towns: judicial records endlessly chronicle after-hours drinking, gambling, and brawls, as well as serious offenses such as theft, assault, rape, kidnapping, and homicide. Beyond this, recourse to violent remedies was very much a part of the culture of thirteenth-century elites, particularly the knightly oligarchy. What does this mean? Legal scholars, notably Steven White, have urged reading violent actions not simply as random brutality but rather as an element in customary patterns of conflict resolution. Andrea Zorzi has developed this point for communal Florence, arguing that recourse to the vendetta was normal practice at all social levels, was even considered a virtue, and was tolerated by the law because it contained violence, so long as reprisals were proportional.[59] He is clearly right that vendetta was seen as normal practice. However, it is worth pointing out that some mechanisms of conflict resolution are more provocative and bloody than others and that nobles had the motivation and resources to pursue vendettas. Elite reprisals against enemies could and did escalate into conflicts in which men butchered their enemies and torched their palaces. Bystanders might well draw conclusions about the real effectiveness of state authority.

Communal governments certainly perceived a need to punish elite violence and assert the authority of their courts but were not always able to do so. The Pandolfini homicides, a notorious case from Orvieto in this period, illustrates the podestà's weakness. In 1272, a group of Filippeschi nobles butchered three rivals from the Pandolfini lineage in a tavern, along with the unlucky tavern keeper. The attack was part of their longstanding conflict with these Guelf allies of the Monaldeschi: the family thought them responsible for the death of a kinsmen, Raniero di Bartolomeo Filippeschi. The family was powerful. When the court summoned twenty-two men as witnesses—many of them villagers from nearby Fabro—the men simply failed to appear, surely calculating that it was more dangerous to risk reprisals from the Filippeschi than fines from the civic court. The podestà slapped twenty Filippeschi and associates considered implicated in the killings with huge fines (7,000 libra) and condemned them to be banned, their rights lost and houses destroyed. Two Filippeschi were ordered to travel to Jerusalem and then spend another five years in exile. This sentence

medieval and modern. Stephen D. White, in a comment on Thomas Bisson's view of the "feudal revolution," offers a thoughtful discussion of the problem of analyzing medieval violence: "Comment," *Past and Present* 152 (August 1996): 205–23.

[59] See Andrea Zorzi, "Politica e giustizia a Firenze al tempo degli ordinamenti anti-magnatizi," in *Ordinamenti di giustizia fiorentini*, ed. Vanna Arrighi (Florence: Archivio di Stato, 1995), pp. 105–47, and "La cultura della vendetta nel conflitto politico in età comunale," in *Le storie e la memoria: In onore di Arnold Esch*, ed. Roberto Delle Donne and Andrea Zorzi (Florence, 2002; http://www.storia.unifi.it/_rm/e-book), pp. 135–70.

was largely unenforced, and in 1273 another podestà, Giovanni Colonna, in what was perhaps intended as a face-saving gesture, reduced the penalties to modest fines. Even this lessened sentence was not enforced, however. The commune arranged a public reconciliation of the warring lineages, leaving the homicides unpunished.[60] Perhaps as Riccetti suggests the regime let them off to maintain some counterweight to the rising power of the Monaldeschi. If so, it was at a great loss of face.

Despite their institutional advances, the communes were ill-equipped to handle violence. Their police power was minimal. Wickham argues for late twelfth-century Tuscany that the power of the courts depended on consent.[61] This was surprisingly true even a century later. When an individual chose not to comply, if he or she was not actually captured, judges had little ability to enforce their orders. Most people summoned to the criminal court were simply contumacious and sentenced in absentia. Presumably, then, if they knew of the sentence, they calculated the advantages and disadvantages of paying the fine, leaving the area, or gambling that if they stayed they would not be caught. Their parish neighbors might act, perhaps to protect them, perhaps to hand them over to the court. Civic authorities sometimes achieved dramatic exemplary punishments but did not have the police power required to carry out heavy sanctions with consistency.[62] Florence at the end of the thirteenth century numbered roughly 100,000 people and probably had forty or fifty policeman. For Orvieto, the 1325 Carta del Popolo required the Seven to have twenty retainers, a group that was to include a cook, a porter, and two assistants to the notary as well as policemen.

Certainly, the popular regimes insisted that strengthened courts and laws were needed to protect the weak from the strong. From the 1280s, these

[60] Giudiziario, Busta 1, fasc. 3, 2 recto–verso, lists the men fined for not attending court, including twenty Filippeschi kinsmen and then twenty-two men from Fabro. There is no indication that they paid. Fasc. 5, 1 recto, is the public reconciliation. See *CD*, no. 504. The podestà managed to confiscate some Pandolfini property but did not collect the fines or enforce the exiles. Lucio Riccetti has found that Guidarello di Alessandro was in Orvieto during the period in which he was supposed to be exiled to Jerusalem: *Dizionario biografico degli italiani* (Rome: Società Grafica Romana, 1997), 47:677–83 on the Filippeschi and 47:682–83 on Guidarello.

[61] See Chris Wickham, *Legge, pratiche e conflitti: Tribunali e risoluzione delle dispute nella Toscana del XII secolo* (Rome: Viella, 2000). The formation of popular associations in many towns was in part an effort to solve this problem: neighborhood militias composed of guildsmen were to respond to noble violence. See the Orvietan Carta del Popolo of 1325, 121: *CD*, p. 810. On the problems of police power and social control, see Andrea Zorzi, "Controle social, ordre public et répression judiciare à Florence à l'époque communale: Éléments et problèmes," *Annales: ESC* 45 (1990): 1169–88, and the pathbreaking article by William Bowsky, "The Medieval Commune and Internal Violence: Police Power and Public Safety in Siena, 1287–1355," *American Historical Review* 73 (1967): 1–17.

[62] On Florence, see Zorzi, "Judicial System," p. 49; Carta del Popolo, 5: *CD*, p. 742.

regimes wrote laws designed to restrain the local nobles—termed magnates—and keep them out of most public offices. The magnates were rapacious wolves, and special laws were needed to protect *popolani* from their violence. These laws served to legitimate the new rulers' authority and sometimes were even enforced.[63] In Orvieto, laws restraining the magnates were late, perhaps because the strength of the alliances represented by the popolo made them less necessary. The laws derived largely from the period after 1303, when the Seven struggled to maintain Orvieto's fragile political balance. The extant list of magnates dates from 1322, almost a decade after the onset of serious factional warfare.[64]

After the creation of the Seven in 1292, the court system was expanded. By 1295, custodes were explicitly appointed by the Capitano del Popolo and the Seven.[65] There were active guards of the butcher shops and guards of the fountains. A pig guard denounced people who let their animals run loose in the streets. This investigative effort cast the city government in the role of protector of the local economy, public order, and safety; people caught doing laundry in a public fountain were fined, as was a man who tossed the carcass of a dog into the street.

In Bologna, a larger town that was a major center for legal studies and also torn by civil war, active investigation of crime went much further. A petition read to the town's executives and the Consiglio del Popolo in 1288 conveys the tone of popular political rhetoric that drove these inquiries:

> Since many crimes are committed daily in the city of Bologna against the honor of the Lord Podestà and against the good state of the commune and people of Bologna, and furthermore, even more gravely, assassins and infamous persons continue to live in the city of Bologna without fear of any regime or of the office of the podestà . . . [and go unpunished because they are protected by specific statutes, council decisions, and privileges, the petitioner requested the Capitano del Popolo, his advisers, and the general council to act] for the good state and prosperity of the commune and people of Bologna and so that evil deeds cease and infamous persons and assassins fear to remain.[66]

[63] See *Ordinamenti di giustizia fiorentini*, ed. Vanna Arrighi (Florence: Archivio di Stato, 1995); George Dameron, "Revisiting the Italian Magnates: Church Property, Social Conflict, and Political Legitimization in the Thirteenth Century Commune," *Viator* 23 (1992): 167–87.

[64] See Waley, *Mediaeval Orvieto*, pp. 84–85, 108–9.

[65] ASO, Giudiziario, Busta 2, fasc. 8.

[66] See Archivio di Stato di Bologna (hereafter ASB), Riformagioni del Consiglio del Popolo, vol. 1, 32 verso.

The petitioner called for more action by the state: immediate inquests into crimes and punishment of malefactors, effectively summary justice.

In practice, investigations were carried out by the podestà's judges and notaries. The podestà was obligated to have a court notary read the statutes on certain offenses to the *ministrales*, representatives of the parishes, and then ask them individually whether they knew of any offenders. The most important was the statute on people considered infamous, a legal category derived from Roman law that in the thirteenth century meant people considered morally reprehensible.[67] The statute included a list, which was often revised. In 1286, it included all thieves, highwaymen, those already banned for crime, counterfeiters, assassins, prostitutes, pimps, heretics, sodomites, fortune-tellers, and poisoners, both male and female. They were required to leave the city.[68] Judging from the records of the notary charged with holding these inquiries, the ministrales at least in the thirteenth century rarely responded by naming anyone, except perhaps prostitutes or the priest's concubine, people who could do them little harm.

People convicted of serious crimes had their pictures painted as *infames* on a wall in the town hall. This at times served as a punishment in absentia, apparently an effective one.[69] One consequence was that town halls were covered with pictures of people banned for infamous crimes. The pictures are lost, but records of artists hired to paint them survive in Bolognese archives from 1301. Three painters—Gherardo, his son Magistro Bartolomeo, and a man named Johannes—were repeatedly commissioned. In October 1301, the judge Andreas, acting as *vicarius* for the podestà, arranged to pay Bartolomeo to spend the entire next day painting eight titled nobles in the *palatio veteris*, the old civic palace. He must have worked quickly. The going rate varied: 20 soldi for pictures of four men, 12 for four men, 12 for three men and a horse, to be painted "in facia muri anterioris isti palatii," on the face of the anterior wall of the palace. The people represented included banned nobles, men banned for debt, and four men banned for producing false instruments.[70] Townsfolk must have been acutely aware of at least these forms of infamy, and must also have considered the pictures

[67] On infamy, see Giovanna Casagrande, "Fama e diffamazione nella letteratura teologica e pastorale del sec. XIII," *Ricerche storiche* 26 (1996): 7–24, and Francesco Migliorino, *Fama e infamia: Problemi della società medievale nel pensiero giuridico nei secoli XII e XIII* (Catania: Gianotta, 1985).

[68] ASB, Libri Inquisitionum et testium 7, fasc. 4, 1 recto.

[69] See Samuel Edgerton, *Pictures and Punishment: Art and Criminal Prosecution during the Florentine Renaissance* (Ithaca: Cornell University Press, 1984).

[70] ASB, Giudiziario, Corone ed armi, 12, fasc. 2, 37 recto, 40 recto, 41 verso, 43 verso, 44 recto, 45 verso, 55 recto, 69 verso; fasc. 13, 132 verso–133 recto. See Gherardo Ortalli, *La pittura infamante nei secoli XIII–XVI* (Rome: Jouvence, 1979).

dishonoring. In 1291, a man who worked as a *nuncio* for the Bolognese court was convicted of going on an official mission under false pretenses. As a part of his sentence his picture was painted just over the door of the town hall. It was soon mysteriously scratched off the wall. The criminal court held an inquest: ultimately, the man's son confessed under torture that he had conspired with a former guard to sneak into the palace at night and destroy the shameful image of his father.[71]

Legal scholars are fond of pointing out that official actions by the courts were usually part of a larger process of conflict resolution. As Wickham has recently said of twelfth-century Tuscan courts, "the settlement of disputes cannot simply be generated by the application of social norms (or rules, or customs, or laws), but is rather a framework for bargaining, transaction and compromise."[72] By the late thirteenth century, at least in the orbit of sophisticated civic courts, this can be pictured as the intersection of two processes, one of them primarily a way to settle disputes and enable a community to come to agreement and resolve conflicts, the other a way for the state to assert its authority. The two were intertwined in practice, uneasily.

PICTURES OF ORDER: CIVIC STATUTES

Civic courts adjudicated most cases on the basis of the *ius commune*, Roman and canon law common to Europe and familiar to the university-trained judges who came to town with podestà. Townsfolk also wrote and endlessly revised local statutes, with an emphasis on mechanisms of governance and taxation. Local norms existed in unsettled dialogue with the ius commune.[73] From about the 1270s, lawmakers in Orvieto as elsewhere became fascinated with laws that attempted restraints on such things as luxury dress, nonprocreative sex, ritual feasts, and weddings as well as funerals. The laws can and should be read as a return to the ancient Roman sumptuary laws, familiar to the expert jurists who advised the towns.[74] But why turn to those legal

[71] ASB, Libri Inquisitionum et testium 21, fasc. 1, 70 verso–72 recto.

[72] Wickham, *Courts and Conflict*, p. 303.

[73] For a summary of and bibliography on this complex topic, see Elena Maffei, *Dal reato alla sentenza: Il processo criminale in età comunale* (Rome: Edizioni di storia e letteratura, 2005), chap. 1.

[74] This included not only Republican sumptuary laws and the *Lex Julia Sumptuaria* but late imperial hierarchical rules on dress, as for example *Codex* 11, 9 and 11, 12. See Franco Sachetti's comparison of Florentine sumptuary law with the account in Livy's *History of Rome* of the repeal of the Lex Oppia in 195 B.C.E., book 34, 1–8; Sachetti, *Il Trecentonovelle*, ed. Vincenzo Pernicone (Florence: Sansoni, 1946), novella 98.

strategies at the end of the thirteenth century? Why were things like women's pearls, sodomy, and funeral grief felt as a problem the state needed to address? Susan Stuard has recently argued that the laws were efforts to restrain a new fashion for exotic luxury consumption because it underscored the ambiguity of social hierarchy in a society in which wealth could buy status: "Consumption patterns were swiftly transforming society's assumptions . . . men could become what they appeared to be and visual signs of wealth and status mattered."[75]

As Mario Ascheri has pointed out, sumptuary laws were linked to the ideology of "buon governo," good government of a Christian city, as well as ideas of civic honor and social discipline. Why so much local legislation, since general sumptuary legislation already existed in the ius commune? Ascheri argues that the ius commune offered a model of intervention, understood in terms of adherence to the *consuetudo patriae*, the custom of the land. Given the effective independence of the communes, this meant civic custom. Further, from the second half of the century, local legislation was influenced by the idea from learned legal culture that "the *civitas* is *res publica* and has the full power and obligation to intervene to assure good civic government," using legislation in all aspects of social and even religious life for the public good. The commune had the legislative power to reform social custom.[76]

I find it helpful to think of the statutes as pictures of good order. Lawmakers in Orvieto as elsewhere used the law to envision the community in what they repeatedly characterized as its good and peaceful state, "il buono et pacifico stato della città."[77] At times, they termed this picture "civic honor." Stephen Milner has addressed one aspect of this effort, a preoccupation in Florence with decorum and circumspect speech, particularly within the town council. Milner analyzed Florentine statutes to find that they were crafted to regulate not only defamation but "shouting or persuading others to shout during council meetings, parlamenti, or any other formal civic gatherings; making insulting remarks concerning officials of the republic either publicly or in private."[78] There was a special concern with

[75] Susan Stuard, *Gilding the Market: Luxury and Fashion in Fourteenth-Century Italy* (Philadelphia: University of Pennsylvania Press, 2006), p. 83.

[76] Mario Ascheri, "Tra storia giuridica e storia 'costituzionale': Funzioni della legislazione suntuaria," in *Disciplinare il lusso: La legislazione suntuaria in Italia e in Europa tra Medioevo ed Età moderna*, ed. Maria Giuseppina Muzzarelli and Antonella Campanini (Rome: Carocci, 2003), pp. 199–211.

[77] For a recent collection of statutes of the Umbrian communes, see *Gli statuti comunali Umbri*, ed. Ernesto Menestò (Spoleto: Centro italiano di studi sull'alto Medioevo, 1997).

[78] Stephen J. Milner, "The Government of Faction in the Florentine State, 1380–1512" (Ph.D. diss., Warburg Institute, University of London, 1996), chap. 2.

strictly regulating men's behavior within the council chambers: "it was illegal to speak on matters which had not been proposed at the start of the meeting; to rise to speak whilst another person was already speaking; to stand during the meetings; to disturb the meetings in any manner; and to speak against provisions already confirmed by the Consiglio."[79] The laws clearly envisioned good government in terms of male decorum.

For Orvieto, council minutes reveal that lawmakers by the early fourteenth century perceived a growing danger from cultural changes that threatened order and "dishonored the commune." This was how the Seven stated the need for stricter enforcement of mourning laws in 1307. Legislators then as now became fascinated with the idea that they could tinker with the laws to control disorder. They evidently thought about this in terms of gender, defining the proper roles for men and women. To understand the laws and council debates, we must have a sense of the men who took part. From 1292 to 1313, the Seven were genuinely guildsmen, professionals, and prosperous artisans. The men who discussed the need to strengthen enforcement of the mourning law in 1311 were drawn from the guilds of the notaries, merchants, shoemakers, mercers, and butchers, as well as a master smith and a dyer from the wool guild.[80] They expressed the concerns and interests of the landed urban working population. Again, they were not laborers but propertied men, artisans who tended to own small, high-value parcels of rural lands. It is typical that they worried about the threat of corrupt expenditure of civic funds and voted to bring in an outside legal specialist from Bologna to advise their council.[81] They were also nervous about the risk of robbery on the roads and the use of kidnap as a form of economic reprisal against foreign merchants, voting a statute on those issues the same day.[82]

At the same time, the Seven fussed about less tangible threats. There was a new anxiety about sodomy. Any sexual relations that were not intended to produce children were defined as sodomy in canon law, but in practice the term generally meant sex between men. Clerics from at least the eleventh

[79] Milner, "Government of Faction," cites Caggese, *Statuti*, 1, Book V, rubric 98, and 2, Book III, rubric 114, "De puniendo facientes verbo vel opere contra pacem," and Book IV, rubrics 21–29: "Quod consiliarii vadant ad consilia," "Quod consiliarii veniant ad consilia," "De aringatione in consilio," "De aringatoribus," "Quod nullus stet in pedibus in consilio," "Quod nullus turbet arengantem," "Quod nullus vadat ad stangam," "Quod nullus dicat aliqua verba iniuriosa contra aliquem in aliquo consilio," "Quod consiliarii non dicant contra prohibita."

[80] The Signori Sette included a judge or notary, a merchant, a wool dyer, a shoemaker, a mercer, a butcher, and a smith, in office November and December 1311.

[81] See ASO, Riformagioni 77, 174 verso–175 verso; "Orvieto," ed. Petrocelli et al., *La legislazione suntuaria*, n. 8, pp. 994–97.

[82] See ASO, Riformagioni 77, 174 verso–175 verso.

century sometimes used harsh rhetoric to condemn sodomy, but there is little evidence that townsfolk paid much attention until the late thirteenth century. In Orvieto as late as 1295, sodomy was not considered an important threat, judging from the case of a former policeman accused of an attempt to kidnap, imprison, and rape the young son of a master barber. The man was contumacious and sentenced in absentia to a fine of 50 libra for the kidnap, 200 for being a known highway robber and a "vachabundus," and 100 for attempted sodomy. By comparison, the fine for heterosexual rape was 200 libra. If captured and unable to pay, he was to be hanged until dead or blinded, penalties not for sodomy but for repeated theft.[83] The victim's father served as a guild consul the same year, and it was perhaps due to his influence that a new sodomy statute was passed. It does not survive.[84] By 1308, the mood had changed. The Seven considered that "the vice of sodomy is increasing in the city of Orvieto, an insult to God and man." They left the exact practice undefined and simply called it a sin against nature. However, the punishment they devised indicates that they viewed sodomy not in terms of the canonical definition, any nonprocreative intercourse, but rather as a sin committed by two men. The Seven responded to what they perceived to be this increasing vice with a cruel and humiliating punishment for men convicted of sodomy and unable to pay the judicial fine. A convicted sodomite was to be paraded around the city with trumpets sounding before him, holding a cord tied to his male member "in such a way that the member was publicly visible." Men guilty of sodomy were banned from public honors or offices.[85] The threat of sodomy was so serious that normal rules restricting torture were to be waived.[86] Pimps for sodomites were discovered to exist and treated accordingly. The penalty for an unpaid fine shifted from public humiliation and loss of citizenship to a permanent branding. Men found guilty of sodomy were literally to be branded on their throats with the eagle, symbol of the Orvietan commune, to mark them permanently.

Worried that these cruel laws might not be enforced, the Seven charged the podestà with investigating and punishing sodomy, with a fine of 500 libra if he failed to do so. They had good reason to be concerned about enforcement. In these decades, elaborate punishments for sodomy were

[83] ASO, Giudiziario, Busta 2, fasc. 9, 7 verso.

[84] The sentence was read on 16 February 1295. The victim's father, a master barber, was named as a guild consul on 24 August 1295. On 27 August, the council passed a statute "super vitio soddomie et contra culpabiles in ipso vitio." ASO, Riformagioni, vol. 69, 28 recto and 30 verso; he is identified more clearly as a barber on 91 verso.

[85] ASO, Statuti 27, 38 verso.

[86] ASO, Statuti 26a, 21 recto–verso.

probably usually honored in the breach.[87] It is doubtful that many people were accused of sodomy, and if so they were probably contumacious. And a well-to-do person could pay the fine, which remained a relatively modest 100 libra, still half the size of the fine for heterosexual rape. When in 1303 the town actually held two men in its prison who had been convicted of sodomy and were too poor to pay, the Seven humanely reduced the fine and let them go.[88] The sodomy law punished men who did not control a sensual appetite that was considered a vice against nature. The punishment devised by the Seven dramatized the loss of male political privilege consequent upon a sodomy conviction: an elaborate public humiliation, a parade that parodied the formal processions of civic officials, with trumpeters playing, the man's penis displayed to view while he lost the privilege of access to civic office and honors.

Prostitution laws were passed during these same decades. Prostitution flourished in Orvieto, surely in part due to the repeated sojourns of large courts, including the papal curia and the Angevins, with all their household staff and garrisons. The intent as in other towns in this period was not to eliminate prostitution but to limit it and to ban pimps. The extant cases in the thirteenth-century Orvietan judicial records are the sentences of pimps but not the women who themselves sold sex.[89] The Seven sought to ban prostitution from certain areas, particularly near churches. By 1313–15, prostitution was to be excluded from the city and the landlords of properties used for the sex trade to be fined. Enforcement of these laws on prostitution reshaped a casual part-time enterprise into a narrowly defined and more cruel profession, in which women came to be forced by debt peonage to live and work in brothels.

[87] The classic study of changing views of homosexuality is John Boswell, *Christianity, Social Tolerance, and Homosexuality* (Chicago: Chicago University Press, 1980). Boswell dated "the rise of intolerance" to the thirteenth century; see chap. 10. On the ubiquity of same-sex relations among male youths in fifteenth-century Florence, see Michael Rocke, *Forbidden Friendships: Homosexuality and Male Culture in Renaissance Florence* (Oxford: Oxford University Press, 1996), and " 'Sodomites' in Fifteenth-Century Tuscany: The Views of Bernardino of Siena," in *The Pursuit of Sodomy: Male Homosexuality in Renaissance and Enlightenment Europe*, ed. Kent Gerard and Gert Hekma (New York: Harrington Park Press, 1989). For Venice, see Guido Ruggiero, *The Boundaries of Eros* (Oxford: Oxford University Press, 1985).

[88] ASO, Riformagioni 73, 29 verso–30 recto.

[89] See for a prostitution case the 1291 banning of seven men and one woman as pimps: ASO, Giudiziario, Busta 2, fasc. 3, 16 recto, and fasc. 4, 17 recto. On prostitution in Florence, see Maria Serena Mazzi, *Prostitute e lenoni nella Firenze del Quattrocento* (Milan: Il Saggiatore, 1991). For Bologna, see Rosella Rinaldi, "*Mulieres publicae*: Testimonianze e note sulla prostituzione tra pieno e tardo Medioevo," in *Donna e lavoro nell'Italia medievale*, ed. Maria Giuseppina Muzzarelli, Paola Galetti, and Bruno Andreolli (Turin:

The laws emphasized not the punishment of prostitutes but controls on where the trade took place and on recruitment. There was a special anxiety that women prostituted their daughters, and the statute provided that women were not to hold their own daughters or other women in brothels; any woman who did so was to be whipped through the entire city and then banned.[90] Did this reflect the actual recruitment of prostitutes? The court records include the sentences of several men selling the sexual services of their wives. In a number of other cases, men were charged with enticing or abducting women and forcing them into prostitution; in one episode, a woman was seduced and then dumped in a brothel in a neighboring town, presumably for money.[91] A few pimps were women. The overall shift from prostitution as an occasional way to make money to an exclusive social identity surely meant that some women were forced to recruit their own children, if they had not long since abandoned them. An aging prostitute and her illegitimate daughter had few social and economic options. The idea preoccupied people: the charge that a woman was a prostitute and mistreated or killed her children was a common insult in the judicial records: "You whore! You prostituted your own daughter," or "You whore! You drowned your babies in the well." In effect, the law is best read not as an accurate picture of how prostitutes were recruited but as a glimpse of what was thought most dangerous about the trade. This was the greed and depravity of pimps, of mothers corrupting and victimizing their children. The Seven debated these social problems together, suggesting that they perceived a link between such crimes as prostitution, sodomy, blasphemy, and even heresy.[92] Another effort was the pursuit and even court-initiated investigation of cases of sexual impropriety, notably adultery, making conflicts between husband and wife the province of the state.

Some laws linked disorder with the presence of women or qualities considered female. On December 20, 1311, the Seven brought together a set of concerns about feminine disorder, including mourning, weddings, and female dress. As we will see, the Seven were troubled about funeral laments and hair-tearing, as well as wedding and funeral banquets and gifts of food.

Rosenberg & Sellier, 1991), p. 109. See Carol Lansing, "Concubines, Lovers, Prostitutes: Infamy and Female Identity in Medieval Bologna," in *Beyond Florence: The Contours of Medieval and Early Modern Italy*, ed. Paula Findlen, Michelle Fontaine, and Duane Osheim (Palo Alto, Calif.: Stanford University Press, 2003), pp. 85–100.

[90] See ASO, Statuti 27, 33 recto.

[91] See, for example, ASO, Giudiziario, Registro 1, 6 recto–verso, 192 verso; Busta 2, fasc. 4, 4 recto, 6 recto; fasc. 9, 60 verso. The case in which the woman ended up in a brothel is ASO, Giudiziario, Registro 1, 521 recto.

[92] ASO, Statuti 27, 38 verso, dated 1313–15, treats prostitutes, sodomites, blasphemers, pimps for sodomites, and then heretics.

They also worried about a threat from women's dress. Their explanation is revealing. The law banned gold, silver, and pearl detailing, as well as tiaras, "lest for the foolish things of women men kindled by excessive love be confounded and destroyed."[93] Control of female dress was a way for men to restrain their self-destructive desire. The exact scenario the Seven envisaged is not clear. Perhaps men's passion for their wives would lead them to buy too many rich trinkets and suffer financial destruction; perhaps men fired by love at the sight of women decked out in tiaras and pearls could then be destroyed by the consequences of lust. Regardless, bans on female ornament were needed to avoid kindling destructive male passion.

The Seven also became concerned to create separate spaces for men and women. In 1315, they made provision to separate the portion of the prison in which women were incarcerated and to make sure that no woman was placed in with the men. "No woman could or should be mixed into the prison where men are detained." Access was controlled. The new women's prison was to be locked with two keys, one to be held by the Capitano del Popolo or the podestà and the other by the Seven.[94] Were they enforcing the laws more stringently and locking up more women? Regardless, the intent must have been to keep imprisoned women inaccessible to men, who might be fired by lust. It is striking that the Capitano and the podestà did not trust themselves: better to provide a check on everyone by locking the door with two keys.

Another statute sought to remove women from public life by excluding them from the public building where justice was administered. Again, in this period the towns went to great lengths to create monumental public spaces, giving the political community a spatial and architectural identity.[95] The Palazzo del Popolo was the physical expression of the popular commune and its authority, built elegantly in stone. This was a spectacularly successful effort: the magnificent town halls that still shape the identity of many Italian towns are the result. On September 13, 1310, the Seven defined their town hall as an exclusively male province. Women were denied access to the palazzo and its broad exterior stairs, where legal business often was conducted: "no woman may ascend to the Palazzo del Popolo or the Orvietan commune, nor to its stairs for any cause or reason." Florence enacted a similar law, banning women from the civic palace and from going to the courts

[93] "ne pro fatuitatibus mulierum ex nimio amore accensi homines destruantur et confunduntur."

[94] ASO, Statuti 26c, 14 verso. It probably dates from 1315.

[95] See Riccetti, *La città costruita*; for Florence, see Marvin Trachtenberg, *Dominion of the Eye: Urbanism, Art, and Power in Early Modern Florence* (Cambridge: Cambridge University Press, 1997).

of the commune, the podestà, or the Capitano del Popolo, or their judges, notaries, or knights. Women also were not to approach the commune's other judges and tribunals. There were exceptions, notably women summoned because of an accusation or in order to give testimony: the notary was to administer the oath and question them outside the doors of the palace. If a woman was to be tortured, she could enter the palace for that purpose with impunity.[96]

In Orvieto, the law provided that when it was necessary for women to be questioned concerning accusations, inquests, testimony, and the like, such interrogations would take place at the foot of the stairs, next to the piazza of the Palazzo del Popolo. Officials who ignored the law were to be fined 25 libra, and disobedient women were to be fined 10, the same fine imposed by the Florentines.[97] The statute made no effort to alter the legal rights and obligations of women, based in Roman law: they still could lodge accusations, serve as witnesses, suffer convictions, enjoy town citizenship, and so forth. It simply defined the place where public administration took place as masculine. The immediate pretext for the statute is not explained. It may have been prompted by the idea that the Palazzo del Popolo was a violent or risky spot for women, though how moving them off the steps into the busy piazza next to the butcher shops under the stairs protected them is unclear.[98] The law did provide that women could be questioned in the nearby and perhaps more respectable church of San Andreas.

This cannot have been an easily enforceable law, and by the time it was copied in the statutes, between 1313 and 1315, the emphasis had shifted from straightforward exclusion to the division of women into two categories, those of *bone fame*, good public reputation, and those considered infamous. The statute applied to women of bone fame. They were not to be compelled to go to the Palazzo del Popolo but instead could be safely questioned at home and represented in public by procurators.[99] The women's prison is another example. It was expressly created "for the utility and honor of the commune." The law on prostitution also stated that prostitutes dishonored the commune, again associating the commune with patrilineal honor.

These laws were enforced with a revealing ambivalence. Enforcement of laws on dress could be particularly difficult and unpopular. Like the laws on grief, they clashed with social practice. It is striking that no evidence survives from Orvieto for the enforcement of any sumptuary law other than

[96] Caggese, *Statuti*, vol. 2, Book 4, rubric 71, p. 358.

[97] ASO, Riformagioni 77, 113 recto.

[98] See, for example, ASO, Giudiziario, Registro 1, 557 recto, for a complaint by the custodem macelli comunis, dated 1288.

[99] ASO, Statuti 27, 33 recto.

those on funerals. There is some evidence from Bologna, where the late thirteenth-century popular regime, heavily influenced by its powerful notaries, required an extraordinary level of documentation. Roughly fifty large files of registers of judicial inquests and inquest testimony survive for the thirteenth century. They contain evidence of a brief effort to enforce the laws on female dress. On January 11, 1286, the podestà's notaries reported that three women, all wives of nobles, wore illegal tiaras or pearls at the Franciscan church on Epiphany.[100] The notaries were new to the job: they had just come in at the beginning of the year with the new podestà, a Salimbene from Siena. The women's husbands each put up a defense, and it is that record which survives. Witnesses testified to lists of points, which are lost but can be inferred from the depositions. The gist of the defenses was two points: first, that the husbands were not responsible because they were not present and had tried their best to restrain their wives, and second, that the law was never enforced.

A servant woman testified that one of the husbands had sent her to tell his wife, Andrucchia, who was staying with her father, not to wear her pearls to church. Two men, presumably his friends, corroborated: after the husband heard the *precone* read the law, he sent a servant to instruct his wife. Andrucchia's sister Bellina was spotted wearing a tiara. She too was reported to be staying with their father, a noble named Tomaso who is termed a *frater*, implying that he had entered some form of the religious life and thus was not legally liable for his daughters' actions. Johanetto, a tailor whose shop was under Tomaso's house, testified that the women were staying there and also that he had heard Bellina's husband say that he was grieved by his wife's propensity for wearing a tiara in violation of the law. Further, Johanetto the tailor testified, he had never heard that any man or woman had ever been condemned for wearing crowns.[101] Another witness, Vandino Bernardini, similarly said that Bellina to his knowledge had been wearing a crown for two years. He had for a long time seen the women of Bologna wearing crowns.[102] Rodulfo Benvenuti stated that he had never known women wearing crowns to be condemned for it. A fifth witness agreed. The third case concerned Bartolomea, who was married to Bellina and Andrucchia's

[100] ASB, Inquisitionum et testium 7, 8, 24 recto.

[101] "audivit dictum dominum Jacobum quando die cuius non recordatur quod ipse dolebat quia ipsa uxor sua portabat coronam. Interrogatus super sexto dicit se nichil scire. Interrogatus super septimo dicit quod numquam audivit dicere quod aliqua domina vel aliquis homo fuerunt condempnati propter portationem coronarum." ASB, Inquisitionum et testium 7, 11, 4 recto–6 recto; this text is 5 recto.

[102] "vidit dominas civitatis Bononie bene portare coronas iam sunt magnum tempus." ASB, Inquisitionum et testium 7, 11, 5 verso.

brother, Jacobo. Jacobo's three witnesses, again including Johanetto the tailor, stated that Jacobo had been out of town tending to some rural property for a long period. These witnesses also reported they had heard him say that he was grieved because his wife wore a tiara; one of them claimed to have been present when Jacobo told her not to do so.

I do not know whether any of this convinced the court to drop the charges against the husbands, since the cases themselves to my knowledge do not survive.[103] It is telling that one of the formal points in the defenses is the claim that the law had until then been left unenforced. Women had been wearing tiaras and pearls, and the witnesses could not remember any instance of a condemnation. This claim must have at least been credible or the advocates would not have made it to the court. The implication is that the podestà and his judges and notaries were not really expected to carry out the laws on female dress, or at least in the case of tiaras and pearls.[104] After all, the notaries who reported Andrucchia, Bellina, and Bartolomea were newcomers, who presumably had not yet worked out which laws actually to enforce.

The office responsible for reading and enforcing these laws has come to be termed the Corone ed armi, Crowns and Arms. Although the absence of evidence cannot constitute proof, it is significant that in the eleven large files of registers that survive from the Crowns and Arms notary for the thirteenth century there are only a few scattered cases on women's dress, compared with hundreds of reports of other offenses. In one episode, in July 1290, the notary spotted a woman with an illegally long train on her dress. She outran him and hid in her father's house. Her husband was summoned and insisted that the dress was legal. When he brought it in to be measured, it was found to be in compliance, presumably because it had been hemmed in the interval.[105] Another inquest took place in August 1286 because the notary spotted a woman with an illegal train at the festival honoring Saint Dominic, at the Dominican church. The notary and his nuncios were unable to measure the dress because of the press of the crowd.[106] Enforcement of

[103] On the laws on female dress, see Maria Giuseppina Muzzarelli, *Gli inganni delle apparenze: Disciplina di vesti e ornamenti alla fine del Medioevo* (Turin: Scriptorium, 1996), and Stuard, *Gilding the Market*, chap. 4.

[104] Sarah Blanshei, who is writing a major study of politics and the courts in medieval Bologna, reports that the councils occasionally passed measures instructing the podestà not to enforce certain laws.

[105] ASB, Corone ed armi, 3, Liber denuntiationum notificationum accusationum inquisitionum of July–December 1290, 2 recto.

[106] This inquest is edited in "Bologna," ed. Maria Giuseppina Muzzarelli, *La legislazione suntuaria, secoli XIII–XIV: Emilia-Romagna*, ed. Maria Giuseppina Muzzarelli, Pubblicazioni degli Archivi di stato, 41 (Rome: Ministero per i beni e le attività culturali, 2002), p. 49.

some of these laws was unpopular, difficult, and potentially embarrassing for the notary. It cannot have been easy to charge nobles with allowing their wives luxury dress. Witnesses also tended to stonewall. A 1300 Crowns and Arms inquest into violations of the laws on female dress and weddings lists parish representatives questioned 112 times over the course of five months. None reported any violations.[107] Not surprisingly, the Crowns and Arms officials spent their time on illegal weapons, gambling, curfew violations, and occasionally prostitution inquests, not trains, pearls, and tiaras.

In sum, during the decades around the turn of the thirteenth century, lawmakers in Orvieto and elsewhere wrote and endlessly revised laws that in various ways described a need to restrain passions, not only grief but forms of lust: lust for power and wealth, ambition and greed, as well as sexual passions. And passion was often coded as feminine: an orderly community meant moderating or eliminating feminine influence. Again, Gordon's formulation captures this effort well: these were "pictures of order and disorder, virtue and vice"; a rhetorical attempt "to persuade people that the world described in its images and categories is the only attainable world in which a sane person would want to live."[108] The world the lawmakers pictured was a peaceful, honorable city, passionate emotions kept firmly checked.

The people the lawmakers sought to convince with this picture evidently included themselves. Certainly, the Seven imposed these laws with ambivalence. They made ever more elaborate provisions to ensure that the laws were carried out, at times threatening the podestà with huge fines if he failed to do so. Then, when officials actually caught offenders who were unable to pay their fines, the Seven tended to step in and exercise summary justice in order to mitigate their sentences. In Orvieto, even convicted sodomites and adulterers were let off with much-reduced fines. Similarly, they wrote sumptuary laws but—as the bits of evidence from Bologna suggest—were not in practice enthusiastic about enforcement. This was true of the funeral laws as well. Like elaborate punishments for sodomy or the effort to keep women out of the town hall, the funeral laws are best read as a picture of order, part of a rhetorical effort to show the dangers of unrestrained emotions.

[107] "Bologna," ed. Muzzarelli, *La legislazione suntuaria*, pp. 60–69.
[108] Gordon, "Critical Legal Histories," p. 109.

CHAPTER TWO
FUNERALS AND FUNERAL LAWS

In late medieval Italy, town councils concerned to preserve what they termed the good and peaceful state and the honor of their commune wrote and endlessly revised statutes that sought to restrain passionate behaviors, including sodomy, prostitution, luxurious dress, ritual feasts, even loud speech. I have suggested that the laws can be read as pictures of civic order, part of a rhetorical effort to envision a peaceful commune. I turn in this chapter to one odd aspect of this project, controls on funeral laments. Why did lawmakers target mourning in particular? What prompted the Orvietan town council to send spies to intrude on a family's display of grief? An answer requires first a look at contemporary death rituals, to understand what actions were targeted and penalized. Then an analysis of the lists of people actually fined for their show of grief at a funeral offers a way to test some possible explanations. Was this effort ultimately driven by political faction fights, men in power using funeral laws to pursue their enemies? Or was it perhaps an effort to end rituals that were seen as un-Christian? Was it, as scholars have argued, an attempt to restrict the public roles of women? I suggest that although the lawmakers and their contemporaries thought about funeral grief in gendered terms, their main concern was not to restrict women but rather to change male decorum. The people most evidently targeted were male elites, especially knights.

Any discussion of medieval death ritual draws on a rich tradition of scholarship. Death was an aspect of the early Annalistes' interest in mentalities, Lucien Febvre's famous call for histories of love, of death, of pity, of cruelty, of joy. As Michelle Vovelle has pointed out, it took a long time

for scholars to respond, but "the discourse that a society carries on about death is without a doubt one of the most significant and also surely one of the most enveloping."[1] By 1980, as Jacques Le Goff remarked, in medieval and Renaissance studies, "la mort est à la mode."[2] Death has remained in style, and there is a vast historical and sociological literature. Much of this research explores ways in which death rituals serve social purposes, allowing people to reconcile themselves to loss and adjusting the community to the change.[3] The approach derives from Emile Durkheim and from the classic 1907 essay on death by Robert Hertz. Hertz argued that some societies understand death and the departure of the spirit not as a single event but as a gradual process, associated with the period of the decomposition of the corpse.[4] Carlo Ginzburg put this well: Hertz showed how ritual transformed the biological event of death into a social process.[5] Many studies of burial ritual have illuminated these complex social processes. Recent medieval research includes histories of funeral liturgy, representations of death, and an extended study of death ritual and funerals in one region.[6] For Italy, rich scholarship derives from the work of the anthropologist Ernesto da Martino. It includes Strocchia's major study of funerals in fifteenth-century Florence, as well as many works on death

[1] Michelle Vovelle, *Mourir autrefois: Attitudes collectives devant la mort aux XVIIe et XVIIIe siècles* (Paris: Éditions Gallimard/Julliard, 1974), p. 9.

[2] See Le Goff's introduction to the major study of testaments and funerary practice in fourteenth-century Avignon by Jacques Chiffoleau, *La comptabilité de l'au-delà: Les hommes, la mort et la religion dans la région d'Avignon à la fin du Moyen Age (vers 1320–vers 1480)* (Rome: École Française de Rome, 1980). Michelle Vovelle replied by calling for further study, in "Encore la mort: Un peu plus qu'une mode?" *Annales ESC* (1982): 276–87. For a recent survey on death in the Middle Ages, see Danièle Alexandre-Bidon, *La mort au Moyen Age, XIIIe–XIVe siècle* (Paris: Hachette, 1998).

[3] See Richard Huntington and Peter Metcalf, *Celebrations of Death: The Anthropology of Mourning Ritual* (Cambridge: Cambridge University Press, 1979), chap. 2. Most analysis derives from Emile Durkheim, *The Elementary Forms of Religious Life*, trans. Joseph Swain (1915; London: Allen & Unwin, 1964).

[4] Chiffoleau, *La comptabilité*, makes this point, p. 117. Robert Hertz, "Contribution à une étude sur la représentation collective de la mort," *Année sociologique* 10 (1907): 48–137; reprinted in *Death and the Right Hand*, trans. Rodney and Claudia Needham (Glencoe, Ill.: Free Press, 1960), pp. 27–86. Another classic account is Arnold Van Gennep, *Rites of Passage* (Paris, 1909).

[5] Carlo Ginzburg, "Représentation: Le mot, l'idée, la chose," *Annales ESC* 46 (November–December 1991): 1222.

[6] For the liturgy, see Frederick Paxton, *Christianizing Death: The Creation of a Ritual Process in Early Medieval Europe* (Ithaca: Cornell University Press, 1990); for representations, see Paul Binski, *Medieval Death: Ritual and Representation* (Ithaca: Cornell University Press, 1996). The regional study is Michel Lauwers, *Le mémoire des ancêtres, le souci des morts: Morts, rites et société au Moyen Age (Diocèse de Liège, XIe–XIIIe siècle)* (Paris: Beauchesne, 1997).

confraternities.[7] Current debate centers on testamentary bequests and whether quantitative analysis can show change over time.[8] I do not break with this rich literature so much as draw on it to ask a different question: how and why did ideas about the display of grief change?

FUNERALS

Death rituals were quick in medieval Italy. The body was washed and dressed, men shaved by a barber. The heir was obliged to inform kin and neighbors; at least in Siena, this meant paying the town's *gridatori dei morti*, literally "criers of death," to announce the death twice, in the morning and evening. As contemporary paintings of resurrection miracles show, family and household members, both men and women, grieved and prayed while clustered around a corpse laid out on a bed. The *Resurrection of the Boy*, from the miracles of Saint Nicholas painted by Ambrogio Lorenzetti in the 1330s and now in the Uffizi, shows men and women, father and mother, mourning at the bedside of the dead child when Saint Nicholas deployed a ray of light and restored the boy to life.[9] Kinsfolk and neighbors gathered at the house of the dead. It may be that men usually met to grieve outside and women inside, though this distinction is difficult to document. One horrible piece of evidence for this social division comes from a tragedy at a Florentine funeral in 1239: the floor gave way under the room containing the body of Masetto Orciolini, and twenty-six women fell with the collapsing floor to their deaths.[10] This scene suggests that women and not men were crowded inside the house.

[7] Sharon Strocchia, *Death and Ritual in Renaissance Florence* (Baltimore: Johns Hopkins University Press, 1992); James Banker, *Death in the Community: Memorialization and Confraternities in an Italian Commune in the Late Middle Ages* (Athens: University of Georgia Press, 1988); Diane Hughes, "Mourning Rites, Memory, and Civilization in Premodern Italy," in *Riti e rituali nelle società medievali*, ed. Jacques Chiffoleau, Lauro Martines, and Agostino Paravicini Bagliani (Spoleto: Centro italiano di studi sull'alto Medioevo, 1994), pp. 23–39.

[8] See Samuel Kline Cohn, *Death and Property in Siena, 1205–1800: Strategies for the Afterlife* (Baltimore: Johns Hopkins University Press, 1988), and *The Cult of Remembrance and the Black Death: Six Renaissance Cities in Central Italy* (Baltimore: Johns Hopkins University Press, 1992). See the discussion in Michele Pellegrini, "Negotia mortis: Pratiche funerarie, economia del suffragio e comunità religiose nella società senese tra Due e Trecento," *Bullettino senese di storia patria* 110 (2003; published 2004): 19–52.

[9] See Chiara Frugoni, *Pietro and Ambrogio Lorenzetti*, trans. Lisa Pelletti (Florence: Scala, 1988), pp. 50–51. On representations of funerals in Sienese painting, see Maria Corsi, "La rappresentazione del rito funebre e della sepoltura nella pittura senese del Medioevo," *Bullettino senese di storia patria* 110 (2003; published 2004): 341–70.

[10] Robert Davidsohn, *Firenze ai tempi di Dante*, trans. Eugenio Duprè Theseider (Florence: R. Bemporad & Figlio, 1929), p. 659.

A family gathered to mourn a child. Ambrogio Lorenzetti. *Stories of Saint Nicholas: Resurrection of the Boy*. c. 1330. Uffizi, Florence. Photo credit: Scala/Art Resource, NY.

At the time of the funeral, the corpse was carried in procession to the burial church, usually the parish church or one of the mendicant convents. Women as well as men took part, though after 1250 laws often sought to restrict women to funerals of their own sex. Legislation also repeatedly insisted that the corpse be completely concealed by a drape, attacking a continuing tendency to expose the face of the dead. Gifts, including furs, jewelry, and weapons, might be placed on the bier. The procession could be quite a display, including candles and crucifixes as well as a large number of mourners. A knight's funeral procession in Perugia in 1277 included a horse with a coat of arms and banner.

After the funeral service, presumably a requiem mass, burial followed quickly. This was at either the church or a cemetery. Probably, a lament followed. The Florentine chronicler Dino Compagni mentions the 1296 funeral of a woman from a noble lineage, the Frescobaldi, because a factional scuffle broke out. Many citizens gathered at the Frescobaldi piazza, he reports, and following Florentine custom, ordinary citizens were seated on the ground on mats, and knights and doctors were seated on benches. Presumably, they were gathered for a lament.[11] Mourners then took part in a funeral banquet at the house of the dead.[12] Further rituals marked the stages of the soul's gradual separation from the body, at two days, seven days, nine days, and a year.[13]

Death could be expensive. A rare account book from a middling-level Sienese household in the 1230s and 1240s lists its funeral costs, including a ritual gift of shoes to a newly widowed sister-in-law. Expenditure varied by age and status. In 1240, both an adult brother named Spinello and a female child died. The family expended 14½ soldi for the child's burial, for her clothing. They spent ten times that amount, over 7 lire, to bury Spinello. Further, his death was commemorated annually with gifts of grain or money for the love of God. These gifts were distinct from payment of Spinello's own charitable bequests, on behalf of his soul, which amounted to 25 lire in 1241 and 17 the following year.[14] The cost of a death did not end with the burial.

After about 1240, many towns wrote mourning laws, seeking not to overhaul this ritual structure but rather to control specific actions and expendi-

[11] Dino Compagni, *Cronica delle cose occorrenti ne' tempi suoi*, ed. Fabio Pittorru (Milan: Rizzoli, 1965), book 1, chap. 20.
[12] Robert Davidsohn reconstructed thirteenth- and fourteenth-century Florentine funerals, *Storia di Firenze*, 8 vols., trans. G. B. Klein (Florence: Sansoni, 1965), 7:6–18. Sharon Strocchia, "Death Rites and the Ritual Family in Renaissance Florence," in *Life and Death in Fifteenth-Century Florence*, ed. M. Tetel, R. G. Witt, and R. Goffen (Durham, N.C.: Duke University Press, 1989), esp. p. 124.
[13] Patrizia Turrini, "Le cerimonie funebri a Siena nel basso medio evo: Norme e rituale," *Bullettino senese di storia patria* 110 (2003; published 2004): 62.
[14] "Ricordi di una famiglia senese del secolo decimoterzo," *Archivio storico italiano* s. I, V (1847): appendix. See the discussion in Pellegrini, "Negotia mortis."

tures within it. Siena recorded funeral laws in the *Charta bannorum* of January 1250. Thirteenth-century funeral laws were also written in Brescia, Reggio, and Bassano, as well as Perugia, Todi, Orvieto, Florence, and Bologna.[15] Tracing the history of the diffusion of mourning laws is a complex problem because so many do not survive. The statutes often are hard to date, since in many cases we have only later copies of earlier laws that are lost. Still, virtually all the medieval funeral statutes in some way describe mourning in terms of gender roles. Chieri's statutes of 1313, for example, include a law providing that no man may weep while beating his palms together or calling out at the death of a kinsman; men were allowed to give forth tears, but without clapping.[16]

Perugia wrote a statute before August 1277, when a visiting judge enforced it. The 1279 version of the law stressed knightly funeral display. It was forbidden to dress a corpse in a knight's belt or to bring a horse to the church. There was a limit on the weight of the candles, a clause that became standard in most funeral laws. The Perugian law also addressed the show of grief: no one could grow a beard beyond his usual custom. People could not rip hair from their heads, claw at their faces or clothing, or remove their hats or clothes, regardless of any kinship with the deceased. These possible ties were spelled out: the prohibition held whether the dead was consanguineous or an affine, linked through either line of parentage, ascending or collateral. The only exception to the rule was that wives could wear mourning clothing in grief for their husbands. The law set the fine for any violation at a heavy 10 libra.[17] Women were not allowed to go to the house of the dead after the friar's sermon unless

[15] Catherine Kovesi Killerby gives a synthetic account of thirteenth- and fourteenth-century funeral laws from Italian towns, *Sumptuary Law in Italy, 1200–1500* (Oxford: Clarendon Press, 2002), pp. 71–77. There is an excellent recent survey: *Disciplinare il lusso: La legislazione suntuaria in Italia e in Europa tra Medioevo ed Età moderna*, ed. Maria Giuseppina Muzzarelli and Antonella Campanini (Rome: Carocci, 2003). For the early Florentine laws, see Ronald E. Rainey, "Sumptuary Legislation in Renaissance Florence" (Ph.D. diss., Columbia University, 1985). For mourning restrictions in thirteenth-century Siena, see Turrini, "Le ceremonie funebri"; Donatella Ciampoli, "La legislazione sui funerali secondo gli statuti delle comunità dello 'stato' di Siena," *Bullettino senese di storia patria* 110 (2003; published 2004): 103–119; and Maria A. Ceppari Ridolfi and Patrizia Turrini, *Il mulino delle vanità* (Siena: Il Leccio, 1993), pp. 9–13, 55–58. For Padua, see A. Bonardi, "Il lusso di altri tempi in Padova: Studio storico con documenti inediti," *Miscellanea di storia veneta*, ser. 3, vol. 2 (1910): chap. 2. For Spain, see Ariel Guiance, "Douleur, deuil et sociabilité dans l'Espagne médiévale (XIVe–XVe siècles)," in *Savoir mourir*, ed. Christiane Montandon-Binet and Alain Montandon (Paris: L'Harmattan, 1993), pp. 15–28.

[16] "Nemo de Cherio masculus teneatur nec debeat aliquem parentum suum vel consanguineum cum mortuus fuerit flere percutiendo palmas vel etiam clamando nec etiam alio modo nisi forte lacrimas emittere sine palmarum percussione nisi esset minor XIII annis." *Statuti civili del comune di Chieri*, ed. Francesco Cognasso (Pinerolo: C. Rossetti, 1913), statute 189, p. 59.

[17] The extant statute dates from 1279 but evidently was promulgated earlier: *Statuto del comune di Perugia del 1279*, 2 vols., ed. Severino Caprioli, Fonti per la storia dell'Umbria,

they were within the third degree of kinship; women were to be buried by women. And a mechanism for enforcement was included: the podestà and Capitano del Popolo were obligated to send one of their notaries to what must have been the usual funeral churches, the church of San Lorenzo and the monastery of San Pietro, whenever a corpse was taken there for burial, to watch and record violators.[18]

That is exactly what happened on August 8, 1277, when Jacomino Guardoli, a judge serving as vicar during the temporary absence of the podestà, Gerardino de Boschettis of Modena, complied with the statute and sent his notary, Alexandrino, to the church of San Pietro to observe the funeral of Lord Blanzardo.[19] Alexandrino found precisely the kind of knightly display the law addressed. A horse carrying a coat of arms and a banner had been brought to the church, though it was quickly led away. There were four candles. The widow, Clara, was disheveled and tearing at herself, crying out and weeping. Alexandrino reported this back to the judge. After the widow was summoned twice and remained contumacious, she was provisionally banned in 10 libra, meaning that she had three days to pay or suffer a conviction.[20] At some point she hired a legal procurator, Tebalduccio Ufreduci, who appeared and ultimately, on September 11, agreed on her behalf to pay this very heavy fine.

A second Perugian case was similar. On August 31, Alexandrino was sent by the podestà to the funeral of Ugolini Abadenghi in San Lorenzo, where he found the widow, Richa, "descapiliata," tearing at her hair, in violation of

21–22 (Perugia: Deputazione di storia patria per l'Umbria, 1996), 1:379. It begins with a prohibition on dressing a corpse with a knight's belt or having a horse at the church: "nemo deinceps aliquem mortuum audeat accingere seu accingi facere cingulo militari; vel aliquem equem apud aliquam ecclesiam dimittere." Then it limits wax candle weight and next turns to mourning: "Nullus insuper pilos in barba pro mortuo aliquo ultra quam solitus est portare presumat, vel capillos de capite sibi extrahere, vel faciem seu vestem dilaniare, guililmetum vel insulam vel caputium de capite sibi extrahere, nec vestes muttare, non obstante quod fuisset mortuus consanguineus vel affinis, coniunx vel coniunctus aliqua linea parentele, ascendente vel collaterali. Et si aliquis contra predicta vel aliquod predictorum venire presumpserit, soluat pro vice qualibet decem libras denariorum, saluo quod uxoribus pro maritis liceat habere vestes lugubres et portare" (lines 17–25).

[18] "Item potestas et capiteneus unum de suis notariis mittere teneantur ad ecclesiam Sancti Laurentii et ad monasterium Sancti Petri cotidie, quando ad ipsa loca cadavera deportantur ad sepeliendum, ad videndum et scribendum illum qui fecit contra predicta vel aliquod predictorum" (lines 37–41).

[19] Archivio di Stato di Perugia (hereafter ASP), Podestà 1277 (10b), filza 5, 27 recto, 28 verso. This text has not been edited, to my knowledge.

[20] The condemnations are recorded at ASP, Podestà 1277 (10b), fasc. 6, 99 recto–verso. This text, along with the statutes, is edited in "Perugia," ed. Paola Monacchia and Maria Grazia Nico Ottaviani, in *La legislazione suntuaria, secoli XIII–XVI: Umbria*, ed. M. Grazia Nico Ottaviani, Pubblicazioni degli Archivi di stato, 43 (Rome: Ministero per i beni e le attività culturali, 2005), pp. 45–46.

the statute. Again, he reported back; the widow was summoned twice and then banned in 10 libra. She also hired Tebalducio Ufreduci. In the same month, a third woman was banned for her actions at her husband's funeral: Clara, the widow of Lord Galucio, son of Lord Baspuli, though I have located only the sentence, not the record of the court process. The court notary confused the two women, substituting Clara for Richa.

How should these episodes be read? My guess is that people were simply incredulous that the court would fine a new widow the large sum of 10 libra for her show of sorrow at her husband's funeral, though I cannot prove the point. These women were the widows of noblemen: surely honor as well as marital affection required that they demonstrate their grief. At least two of them ignored the court summons and responded only when they were actually banned. There is a revealing note in Richa's case: when the procurator, Tebalducio, finally came before the judge on her behalf, and presumably protested the fine, the judge responded that he was prepared to proceed because it was the law and she had already been banned. Again, the court officials were outsiders: both the podestà and his diligent notary, Alexandrino, came from Modena, and the judge who insisted on enforcing the law came from Imola.[21] It was their duty to carry out the law despite community sentiment.

And yet, then as now, the feelings of a community influence enforcement. To my knowledge, the next extant revision of the Perugian funeral laws is a complaint in the *volgare* (vernacular) statutes of 1342 that the law was not being carried out. People were lamenting the dead in violation of the law, and Perugian officials were negligent in enforcement. The 1342 statute directly prohibited men at a burial from making what is termed a *lucto*, or rather *pianto*, with a *lamento*, or rather *grido*. These terms, as I will show, indicated a noisy lament. They also were not to bare their heads, pull at their hair, or claw at their faces.[22]

[21] Vittorio Giorgetti, *Podestà, Capitani del Popolo e loro ufficiali a Perugia (1195–1500)* (Spoleto: Centro italiano di studi sull'alto Medioevo, 1993), p. 93.

[22] "Anco conciòsiacosa ké 'n la città de Peroscia, al tempo ke muoiono gli uomene e sepelisconse, se fa grande grido e pianto per gli uomene e femmene contra la forma deglie statute e ordenamente del comuno e del popolo de Peroscia, e gli offitiaglie del comuno del Peroscia en la oservantia deglie dicte statute siano negligente, statuimo et ordenamo ke niuno huomo ardisca overo presuma al tempo ke alcuno morerà overo se sepelirà overo ennante la sepultura overo puoie fare lucto overo pianto con lamento overo grido, né ardisca alcuno a sé el capo scoprire, né capeglie trare, né faccia scortecare, a pena de cento libre de denare per ciascuna fiada, cusì aglie predicte contrafacente co' etiando a l'erede del morto, glie quaglie el corocto recevessero overo tenessero overo da mane overo da sera overo al tempo del al sepultura overo de la morte overo ennante overo puoie." *Statuto del comune e del popolo di Perugia del 1342 in volgare*, ed. Mahmoud Salem Elsheikh, Fonti per la storia dell'Umbria, 26 (Perugia: Deputazione di storia patria per l'Umbria, 2000), rubric 230, no. 2, vol. II, p. 305.

In Orvieto, like Perugia, the statute was in place by 1277 but does not survive; it is known only because of court sentences and later laws.[23] The first law we have appears in an August 1307 collection of a number of the city's statutes. The law first limits funeral banquets and gifts of food to close kin, with provisions for enforcement, and then turns to lamentation. "No woman or any other person may go outside the house wailing and crying out [*plorando*], nor may they wail outside the house; those breaking the law must pay a ten-libra fine for each occasion. A woman who breaks the law must pay the fine from her dowry and not from her husband's goods. . . . Wailing and crying out inside the house of the dead are allowed, and not outside. Anyone can enter the church without penalty so long as they do not wail and cry out. If they do, they incur the fine."[24] The concern was with public displays of grief, not sorrow inside the house. Again, 10 libra was a heavy fine, and I have seen no evidence that anyone in Orvieto actually was made to pay it, though the records are incomplete. The court was more apt to enforce modest fines of 20 or 100 soldi.

What actions did the statute target? An answer entails understanding what specific terms for expressions of grief meant in the thirteenth century. The famed Florentine Dominican preacher Fra Remigio de'Girolami defined mourning verbs in a contemporary sermon, making a fascinating shift from a catalog of grief to an Augustinian discussion of the relationship between emotional and political disorder, a shift I discuss in Chapter 7. For now, the text is a useful contemporary effort to define the verbs that distinguish forms of mourning. Fra Remigio discussed six words: *maerere, gemere, flere, plorare, plangere,* and *lugere. Maerere,* he explained, means to show sorrow through a distressed face, not by the voice or any action. It means to grieve in silence. And so a person is said to *maerere* who *mente carere,* lacks

[23] The statute may be one of the new laws created in 1276, mentioned in the "Cronica potestatum," in *Ephemerides Urbevetane,* ed. Luigi Fumi, *RIS* XV/V (Città di Castello, 1920), p. 147. The first extant sentences date from late April or May and July 1277: ASO, Giudiziario, Busta 1, fasc. 6, 14 verso and 23 recto; "Orvieto," ed. T. Petrocelli, L. Riccetti, and M. Rossi Caponeri, in *La legislazione suntuaria, secoli XIII–XVI: Umbria,* ed. Ottaviani, 1 and 2, p. 989. An extensive register from 1278 contains no mourning convictions. For a survey of the medieval judicial records, see Marilena Caponeri Rossi, "Nota sulle fonti giudiziarie medioevali conservate presso la sezione di Archivio di Stato di Orvieto," *Bollettino dell'istituto storico-artistico orvietano* 38 (1982): 3–7, and the introduction to "Orvieto," ed. Petrocelli et al., *La legislazione suntuaria,* pp. 953–66.

[24] ASO, Statuti 26a, 10 recto–verso, dated 25 August 1307 at 13 recto.

[25] Biblioteca Nazionale di Firenze (hereafter BNF), Conventi Soppressi D.1.937 (Schneyer #927), 341 verso–343 recto. "Maerens proprie ostendit tristitiam per turbulentiam faciei non pro rumpendo in vocem vel alium actum. Unde proprie maerere, sic dicit Hugus, est cum silentio dolere. Unde dicitur maerere qui mente carere ut scilicet nesciat loquere vel aliquem actum exercere."

presence of mind and does not know what to say or do.[25] If people also sigh and have moist eyes, they are said to *maerere gemens*.[26] Those who add an abundance of tears are said to weep, *flere*.[27] To *plorare* is to add the voice, interrupting tears with cries and sobs.[28] To *plangere* is also to strike the chest or face or beat the hands together.[29] Finally, *lugere* means one who mourns and also *luce egere*, lacks light, has lost all joy, and is altogether in darkness; Remigio gave the example of widows at the deaths of their husbands.[30]

The Orvietan statute used the verb *plorare*. That meant, at least according to Fra Remigio, to weep effusively and interrupt tears with vocal cries. Many of the court sentences used this verb as well: if a man *plorasse ad mortuum alta voce*, he wept at a death and cried out in a loud voice. The legal distinction, then, was between *flere* and *plorare*. If people simply wept, that was licit. If they interrupted their tears with vocal cries, they broke the law. And if a person—for example, a hired female mourner—was said to *plangere*, she was also beating her breast, clapping, or clawing at her face. In effect, it was the noise and histrionics that were objectionable, not the tears. Later in 1307, the Seven discussed concerns that men and women of the city were flouting the mourning law. Their primary worry concerned rituals of lamentation, termed the *luctus*, or lament, and *capillationes*, hair-tearing; they also discussed funerary banquets and gifts of food. The consuls decided that the current statutes were adequate but needed enforcement. They also tinkered with the statute limiting displays at weddings.[31]

[26] "Qui extra mentem exens dum gemere addit suspiria et aliquam madescionem oculorum vero sic dicitur quod gemens maerere."
[27] "Sed flere ad turbulentiam ulterius dictam addit fluxum seu habundantiam lacrimarum. Unde dicetur flerere qui fluere."
[28] "Plorare vero supra flere addit vocem. Ut dicatur plorare plus quam rorare, id est lacrimari vel qui pluviam scilicet lacrimarum rarum facere scilicet interuptione clamose vocis et singultuum."
[29] "Sed plangere ad plorare addit tursionem pectoris aut faciei vel repercussionem manuum. Unde dicitur plangere qui plagis seu plagas augere, videlicet qui plaudendo id est manus repercutiendo angere id est angustiare."
[30] "Sed ulterius lugere addit ad plangere vel plorare dicta miserabilia et habitus mutationem. Unde dicitur lugere qui luce egere, qui scilicet omni gaudio careat omniquaque obtenebratus, scilicet sic faciunt vidue in morte maritorum."
[31] "Quoniam cum in civitate predicta fiant capillationes et lucti hominum et mulierum dicte terre in mortuis seppelliendis et pro mortuis contra bonam consuetudinem et bonos mores quasi omnium maiorum civitatis Ytalie at etiam mictentur ensenia ad domos mortuorum et fiant convitionem in ipsis domibus." ASO, Statuti 26A, 30 verso, continuing on 11 verso–12 recto. This odd notebook is apparently a 1307 copy of a number of statutes made preparatory to the writing of another text. Laura Andreani very generously showed me the document. The statutes also appear in ASO, Riformagioni 77, 173 recto–verso. See the edition in "Orvieto," ed. Petrocelli et al., *La legislazione suntuaria*, 8, pp. 994–97.

Funeral statutes, like sumptuary laws more generally, are puzzling without information about patterns of enforcement. It could be that the laws were ignored in practice, or were used to target certain individuals or groups, or perhaps were uniformly applied. Unfortunately, thirteenth- and early fourteenth-century court records survive for very few towns, and sentences for mourning infractions are even more rare. One funeral sentence apparently survives in Todi.[32] To my knowledge, the Orvietan funeral sentences are by far the most detailed. Registers of court sentences were often a target for popular violence in the fourteenth century, and perhaps the fact that few sentences exist now is due to later destruction of the records rather than to a general lack of enforcement of mourning laws. In effect, we do not know how common it was to enforce these laws in most towns in the thirteenth century.

The exception is Bologna, where quantities of court records survive. As I have suggested, the town was home to a sophisticated university and legal faculty and enforced its sumptuary laws with selective energy. The podestà was required to charge a special notary with the tough job of enforcing sumptuary, curfew, weapons, and gambling laws. Crowns and Arms registers survive in some detail from 1285 on. Are there mourning violations? Bologna's funeral statute prohibited loud wailing, hair tearing, and so forth as well as forms of display.[33] Notaries charged with enforcing the statute demonstrably read it out to the *ministrales*, or parish representatives, along with other laws. However, the registers surviving from this office contain few mentions of actions concerning funeral violations. The beleaguered Crowns and Arms notaries were quicker to enforce laws on weapons, the curfew, and gambling.

In 1286, during Stricca Salimbene of Siena's six-month term as Bolognese podestà, four funerals sparked inquests. On February 18, two ministrales were questioned about possible violations at the funerals of a nobleman's son and another noble's wife. Were there were any illegal candles and did anyone wail or clap in the funeral procession? They denied it. On March 1, an inquest was held because someone lodged a denunciation with the court, charging violations at the funeral of the wife of Lord Ubaldino, at the Franciscan church. Two ministrales were questioned. One denied any wrongdoing. The other denied any illegal laments or banqueting but admitted to the

[32] Daniel Lesnick, "Insults and Threats in Medieval Todi," *Journal of Medieval History* 17 (1991): 71–89, mentions a single sentence.

[33] ASB, Giudiziario, Inquisitionum et testium, Busta 4, filza 7, records a public reading of the funeral laws from 1286. The published statutes date from 1288: *Statuti di Bologna dell'anno 1288*, ed. Gina Fasoli and Pietro Sella (Rome: Edizione Anastatica, 1973).

presence of two crosses. There is also a full funeral inquest, dated February 11–12, against Andreolo, a butcher. Someone had informed the court that there were two crosses at his wife's funeral. Eight people were questioned, three of them fellow butchers. Antonio, a scriptor from Modena, testified that there were two crosses because someone brought the cross from the parish church of San Columbano, but men quickly told him to take it away because it was illegal to have two crosses.[34] On April 24, two ministrales were charged with failing to denounce violations at a funeral.[35]

I found no further inquests into funerals until 1292, when a man was accused of ringing a church bell with a hammer at his son's funeral.[36] Six years later, in 1298, two funerals were investigated despite the apparent inattention or stonewalling of the ministrali. An inquest was held on November 22 because "it came to the ears" of the Crowns and Arms notary that there were two candles at a nobleman's funeral in the church of San Domenico. Witnesses testified that the man's dwelling was to be enjoyed by his sister's son during his lifetime and then the Dominican friars would inherit everything. The nephew was charged. He testified that the extra candle was the Dominican sacristan's idea. A friar testified as part of the nephew's defense that he himself, not the nephew, had placed the two candles because the uncle had left the convent over half his goods and was greatly devoted to the friars. Apparently, a generous donation was rewarded with a fancy funeral. The notary also questioned the ministrales for the parish: why had they not reported the funeral violation?[37] The same energetic notary held a second inquiry on December 11: he had happened upon a funeral and spotted two candles, so he charged both the heir and the ministrales.[38] No further record of the case survives, to my knowledge. In 1300, an inquest was held because the bells of Santa Maria Maggiore and San Pier Maggiore were rung with a hammer for the funeral of domina Jacopa, the widow of a nobleman.[39] Her apparent heir testified that his natural brother Pace was a canon at Santa Maria Maggiore; perhaps Pace had rung the bell. Nevertheless, the heir was charged. In his defense, he proved that his mother had been not Jacopa but another woman, who had been married to his father for more than thirty years. He was absolved.

These scattered inquests are more typical of the enforcement of sumptuary laws, which tended to function as a tax on luxury goods such as funeral

[34] ASB, Ufficio Corone ed armi, Busta 1, 1286. The first inquest fragments are at 2 verso–3 recto. The full inquest is 9 recto–10 recto.

[35] ASB, Ufficio Corone ed armi, Busta 1, 1286, 15 verso.

[36] ASB, Ufficio Corone de armi, Busta 4, 1292 I, 50 recto.

[37] ASB, Ufficio Corone ed armi, Busta 9, inquests of November–December 1298, 2 recto–4 recto.

[38] ASB, Ufficio Corone ed armi, Busta 9, inquests of November–December 1298, 4 verso.

[39] ASB, Ufficio Corone ed armi, Busta 11, Atti, April–October, 20 verso–21 verso.

candles. The notaries were the same energetic officials who attempted to enforce the laws prohibiting women from wearing tiaras.[40] Apparently, they ignored the laws on lamentation. Incidental evidence shows that Bolognese men gathered in large numbers for funeral laments: one text of 1285 mentions fifty men at a lament for a political exile.[41] Further, the Bolognese popular council worried about large funerals. In October 1297, it passed a long funeral statute. The stated rationale was to eradicate a disreputable custom, since it is reprehensible to hold feasts and debauches at a time of mourning, as well as a useless expenditure.[42] The council then imposed limits on the people who could attend banquets and on mourning dress. It also provided that men could not gather because of a death, except for those needed to carry the corpse to the church. After the burial, everyone was to return home except for those permitted to attend the banquet, kin and ten neighbors. They also required the podestà to enforce the statute on lamentation. These provisions reveal a serious concern to limit laments. However, no extant case from thirteenth-century Bologna to my knowledge shows enforcement of the rules on lamentation. For the most part, the Crowns and Arms notaries endlessly pursued more tangible threats to order: gamblers and curfew and weapons offenders. In effect, it was not the existence of male laments but the fact that the law was enforced that made Orvieto anomalous.

Enforcement in Orvieto relied on anonymous spies. The podestà was required by statute to appoint at least one custos, guardian or spy, per region of the city; the custos received a 50-libra endowment to attend all funerals and swear to denounce anyone he or she detected breaking the law. The spy would then receive half the fines, which provided an incentive to report infractions. The podestà by contrast had a punitive incentive, since he was liable for a fine of 100 libra if he neglected to appoint mourning spies.[43] The identities of the spies were concealed: some of the judicial sentences refer directly to the denunciations of the "spy of laments whom we must keep

[40] ASB, Ufficio Corone ed armi, Busta 1, 1286, 39 recto.

[41] ASB, Capitano del Popolo, Giudici 70, 89 recto. Thanks to Armando Antonelli for suggesting this source.

[42] "Cum inhonestum sit luctus tempore crapulari et convivia facere et inutilles ex hoc expense sequantur et inhoneste consuetudines inutilesque expense sint radice extirpande." ASB, Riformagioni, IV/4, n. 146, 189 recto–90 verso. Thanks to Sarah Blanshei for pointing this text out to me; it is now edited in "Bologna," ed. Maria Guiseppina Muzzarelli, *La legislazione suntuaria, secoli XIII–XVI: Emilia-Romagna*, ed. Maria Giuseppina Muzzarelli, Pubblicazioni degli Archivi di stato, 41 (Rome: Ministero per i beni e le attività culturali, 2002), pp. 59–60.

[43] These details are spelled out in the version of the statute contained in the 1324 Carta del Popolo. They probably date from the 1276 statutes noted in the *Cronica potestatum*, since spies are mentioned in sentences from the 1280s. Capitula Carte Populi, no. 117, *CD*, pp. 804–5.

secret" (custode luctuum quem in secreto retinere debemus). One spy was named, perhaps inadvertently, "Fucçepto Risii custode luctus."[44] The idea that the spies could remain anonymous in a small town is surprising, though everyone went to neighborhood funerals. The spies were in practice assigned by neighborhood: one sentence was based on a denunciation from the "spy of those who mourn the dead of the neighborhood of San Salvatore."[45] This system worked, perhaps because of the profit incentive: the spies actually attended funerals in order to uncover lawbreakers, note their illegal actions, report them, and (although this is not mentioned in the sentences) presumably if the mourners were convicted pocket half the fines.

Who were these anonymous spies? The Orvietan court notaries scrupulously kept their names secret. One tantalizing bit of evidence survives from San Gimignano, the small town between Florence and Siena that was an independent commune in the thirteenth century. In 1269, during the tenure of a Florentine podestà, Arnolfo de'Buondelmonti, the treasurer, Arrigo Benintendi, recorded in the vernacular his payments to *spie*, spies sent out by the commune. Forty-five payments totaling 5 libra, 4 soldi, and 6 denari are noted. Twenty-eight of those payments were made to eleven people who are securely identified as women.[46] Five were simply listed by their Christian names, four as the wives of so-and-so, and two as the mothers of so-and-so. Most of these women spied repeatedly: donna Buona, for example, was paid eight times. These women were not looking for violations of sumptuary laws. Most were spying on military actions: donna Buona repeatedly went to nearby Poggibonsi to watch for news of a military force assembled there. I have seen no further evidence to show whether the employment of women as spies was common. Still, this record suggests the possibility that some of the anonymous funeral spies in Orvieto were female.

THE FUNERALS

The Orvietan sentences are thus almost certainly the most extensive evidence we have for Italian funeral violations in the thirteenth century.

[44] See "Orvieto," ed. Petrocelli et al., *La legislazione suntuaria*, 4, p. 990.

[45] "Custodis illorum qui plorant ad mortuum de regione Sancti Salvatoris." These derive from ASO, Giudiziario, Busta 1, fasc. 6; the mourning text is at 14 verso. See "Orvieto," ed. Petrocelli et al., *La legislazione suntuaria*, 1, p. 989.

[46] They are donna Buona, la mogle Michegli Ugolini, la mogle Manetti, donna Lieta, la mamma di Bono, donna Bonaventura, la mamma di Giannino, donna Benvenuta, la mogle di Giano, la mogle Ugolini Giannini, and donna Richa. The text is edited in *La prosa italiana delle origini, I Testi toscani di carattere pratico*, vol. 1, *Trascrizioni*, ed. Arrigo Castellani (Bologna: Pàtron, 1982), pp. 421–25.

Unfortunately, the texts are quite terse. They appear in registers used to record not the details of ritual practice but how a court case was resolved and whether a fine was paid: condemnations, sentences, bans, payment or nonpayment of fines, absolutions, and, rarely, corporal punishment. The actual offense is usually noted in a single phrase. No inquest records survive.

The mourning sentences vary from individual convictions to Lotto Morichelli's large funeral, for which 129 men were fined in eight separate cases. Most funerals were modest: in twelve episodes, six men or fewer were mentioned. Enforcement targeted the two problems that bothered the Seven in 1307: wailing and crying out, and gesticulations of grief, especially tearing of hair. In most of the sentences, men were fined for wailing and crying out and perhaps baring their heads and tearing their hair, either in the street or in church. For example, in the earliest extant sentence, from late April or early May 1277, a man was fined because he "wept and cried out in a loud voice" for a death (plorasse ad mortuum alta voce) outside someone's house.[47] This does not mean that he was alone, only that he was the only person fined. Soon after, a man and his son were fined: they too had wept loudly just outside a man's house to grieve for his brother's death.

Several sentences mention a *luctus*, a word derived from *lugere*, to mourn. In these cases, it was evidently a lament held in the funeral church after the service for the dead. In June 1287, the notary Pietro Redilossu was fined because he remained in the church to lament a woman, madonna Amata of Perugia.[48] Pietro was a well-known notary, an important man who at times worked for the civic government. His connection to madonna Amata is unknown and could even have been friendship. Four more men, three of them the sons of titled nobles, were fined the same day: they also stayed after the service at the Dominican church to grieve for madonna Amata.[49] When the three artisans mentioned earlier remained after the service at the Franciscan church, they were there *ad luctum* madonna Allbrandine. This evidently was a moment of lay lamentation inside the church. Contemporary statutes from Bordeaux suggest that at least in France, lay laments might even take place during the service. The laws required

[47] ASO, Giudiziario, Busta 1, filza 6, 14 verso; "Orvieto," ed. Petrocelli et al., *La legislazione suntuaria*, 1, p. 989.

[48] ASO, Giudiziario, Registro 1, 58 verso; "Orvieto," ed. Petrocelli et al., *La legislazione suntuaria*, 5, p. 991. See, for example, a council record written by Pietro in 1295: ASO, Riformagioni 69, 126 recto.

[49] The funeral of Allebrandine, mentioned above, was on the same day. All three cases appear in ASO, Giudiziario, Registro 1, 58 verso; "Orvieto," ed. Petrocelli et al., *La legislazione suntuaria*, 5, p. 991. The sentences were announced in June 1287.

priests to forbid the laity from lacerating their faces, tearing at their hair, or crying out in a way that disturbed the celebration of office of the dead. If they persisted, priests and clerics were to desist from prayers until they stopped.[50]

In other Orvietan cases, men were fined for making a "corrotto" in the street. At a funeral in the Muntanari family, the men stood in the street outside the house of the dead man's father, "made a corrotto and wailed in loud voices." At a Bramandi funeral, they "made a corrotto and wailed in the street outside the house of the dead person." What was a corrotto? The statute included in the 1324 Carta del Popolo depicted it as a kind of ritual counting, done by women: "No person may count or make a corrotto at the burial of the body and any such *computatrix* [literally, "counting woman"] or person breaking the law is to be fined 100 soldi from her dowry and if she has no dowry is to be beaten; the same fine is to be paid by the household in which she counted."[51] This again was a heavy penalty, and I have seen no evidence that it was imposed on anyone.

The term *corrotto* appears in contemporary *laude*, hymns: the lament of the Virgin after the death of her son is termed her corrotto.[52] It seems, then, to have meant a vocal lament. We also have a detailed account of a corrotto that dates from just over a century before the Orvietan statute was written. Boncompagno da Signa, in his chatty manual on rhetoric, used the term in a long digression on comparative funeral customs that I discuss in detail in Chapter 6. Boncompagno described Roman computatrices:

Certain women are brought to Rome in order to wail over the bodies of the dead for a price in money. They are called computatrices, because they count rhythmically in series the nobility, wealth, beauty, good fortune, and all the praiseworthy deeds of the dead. For a computatrix remains on her knees or sometimes seated near the corpse, at times upright or at times bent over, with loosened hair, and begins to narrate the elegy of praise in a fluctuating voice. And always at the end of a sentence she brings out *ho* or *hy* in the way of a person lamenting, and then everyone standing around

50 Statuts de Bordeaux, can. 80, *Les statuts synodaux français du XIIIe siècle*, vol. 1, *Les statuts de Paris et le synodal de l'Ouest*, ed. and trans. O. Pontal (Paris, 1971), cited by Joseph Avril, "Mort et sépulture dans les statuts synodaux du Midi de la France," *La mort et l'au-delà en France méridionale (XIIe–XVe siècle)*, Cahiers de Fanjeaux, 33 (Toulouse: Privat, 1998), p. 348.

51 "Et quod nulla persone computet vel corruptum corpore sepulto faciat, et talis computatrix seu contrafaciens in C. sol. den. de dote sua puniatur, et si dotem non habuerit fustigetur: eamdem penam solvat dominus domus in qua computabitur."

52 See, for example, *Poeti del Duecento*, vol. 2, ed. Gianfranco Contini (Milan: Ricciardi, 1960), pp. 119–24, and the discussion in Chapter 5 of this book.

gives out dolorous sounds with her. But a computatrix produces tears for money not for grief. [53]

A computatrix here is a professional, hired to lead funeral chants. This image recalls the ancient Roman tradition of hired female mourners.[54] For Boncompagno, a corrotto was a formal lament, not spontaneous wails of grief but a professional recounting of an elegy of praise with the mourners joining in at the end of each sentence. He adds that Sicilians, Apulians, and Campanians follow the same custom and that those men or women who cannot have computatrices themselves proclaim the songs of their grief as they know them. The implication is that a repertoire of dirges existed that people more or less knew but that it was preferable to bring in a paid specialist to lead them. There is another mention, from Paris: Peter the Chanter, a master at the cathedral school of Paris who died in 1197, referred in an aside to men and women in Lombardy who wept and cried out at funerals for pay.[55] I know of no other evidence that hired mourners were employed in medieval Orvieto, but there is considerable evidence that in practice men performed these laments.

A corrotto in late thirteenth-century Orvieto evidently meant a defined ritual moment in which mourners brought forth laments that expressed their grief and praised the dead. In Siena, the practice, banned by 1250, was termed a *bociarierum*, a voicing.[56] The word appears repeatedly as a noun. It was not simply a way of grieving but something that one made, a lament. The important point is that mourners not only wept and cried out but sang or chanted elegies. At the Muntanari funeral, the men stood in the street outside the house of the dead man's father, "made a corrotto and wailed and cried out in loud voices." At the Bramandi funeral, they "made a corrotto,

[53] "Ducuntur etiam Rome quedam femine precio numario ad plangendum super corpora defunctorum, que conputatrices vocantur, ex eo quod sub specie rithmica nobilitates divicias formas fortunas et omnes laudabiles mortuorum actus conputant seriatim. Sedet namque conputatrix aut interdum recta, vel interdum proclivis stat, super genua crinibus dissolutis, et incipit praeconia laudum voce variabili juxta corpus defuncti narrare, et semper in fine clausule ho vel hy promit more plangentis, et tunc omnes astantes cum ipsa flebiles voces emittunt. Set conputatrix producit lacrimas pretii, non doloris." Boncompagno, *Rhetorica antiqua*, in *Briefsteller und Formelbucher des elften biz vierzehnten Jahrhunderts*, 2 vols., ed. Ludwig Rockinger (Munich: Auf Kosten der K. Akademie druck von J. G. Weiss, 1861), 1:141–43.

[54] See John Bodel, "Death on Display: Looking at Roman Funerals," in *The Art of Ancient Spectacle*, ed. Bettina Bergmann and Christine Kondolen (New Haven, Conn.: Yale University Press, 1999), pp. 259–81.

[55] "Item: Exemplum ploratorum et ploratricum Longobardorum, in exsequiis mortuorum ad flendum et plangendum solo pretio conductorum." Peter the Chanter, *Verbum abbreviatum*, PL 205: 98C.

[56] See Turrini, "Le cerimonie funebri," esp. p. 56.

wailed, and cried out in the street outside the house of the dead person." There is an incidental reference in testimony from Bologna in 1285 that suggests a similar understanding. A man called Fra Alberto sought to prove to the judges of the Capitano del Popolo that his brother, exiled as a part of the Lambertazzi faction, was dead and thus unable to comply with the law. Fra Alberto produced a witness who testified that Ugolino had been dead about a month and a half. He knew it because he had been at the *coruptum*, the funeral lament, and had seen him buried, and because it was *pubblica fama*. How did he define *pubblica fama*, public knowledge? Fifty men were present, he responded.[57] Again, this implies that large male laments were normal practice in Bologna but left unpenalized by the courts.

The absence of women from the Orvietan funeral sentences is puzzling. The bit of evidence from San Gimignano listing payments to female spies raises the possibility that the funeral spies tended to be women, so one imaginable explanation is that the spies were female and tended to report not other women but men. To my knowledge, no other shred of evidence supports this idea. Alternatively, could it be that the reason virtually everyone fined for mourning was male is that women and their families were daunted because the statute imposed heavier fines or even beatings on them? Perhaps, but the only extant sentence imposed on female mourners does not support this explanation, since the two women paid the same modest fine as the six men.[58] My view instead is that male laments in the streets and the church were customary practice, as the long lists of men fined for mourning suggest.

The fines actually varied not by sex but by gesture. Gheczo di Pietro di Barthone was fined for two actions at the funeral of a woman termed his father's wife, presumably his stepmother. He wailed outside the house and then walked to the church "cum manibus acchiavicchiatis," a notary's attempt to render vernacular dialect into a Latin court register. Probably Gheczo was clapping. This was an action common in funeral rituals across many cultures and directly banned in some medieval Italian funeral statutes.[59] Among the 129 men fined for Lotto Morichelli's funeral, men who simply wailed were fined 20 soldi. Those who tore their hair or took off their headgear were fined 100 soldi, though after they balked at the fine, the commune settled for 40.

The practices that were attacked by the Orvietan court were lay forms of commemoration of the dead. No explicitly Christian aspect of burial ritual

[57] ASB, Capitano del Popolo, Giudici 70, 89 recto.

[58] ASO, Giudiziario, Registro 1, 160 recto; "Orvieto," ed. Petrocelli et al., *La legislazione suntuaria*, 4, p. 990.

[59] For a cross-cultural look at percussion at funerals, see Huntington and Metcalf, *Celebrations of Death*, chap. 2.

attracted concern. The laws in part addressed forms of expensive display that are usually considered the target of sumptuary legislation, notably lavish funeral meals and candles. But enforcement targeted noise and the disruptive public show not of wealth but of grief. People were fined for lamentation: weeping and crying out, or clapping. It is quite striking that the heaviest fines in the sentences were imposed on men who displayed their sorrow by tearing at their hair and beards. This gesture had long been associated with heroic grief.[60] In the late thirteenth century, it was instead becoming a disreputable expression of rage: in fourteenth-century painting, virtually the only men who tear at their beards are men, often Muslims and heretics, who rage because they have been condemned to Hell.[61] Huge frescoes of the Last Judgment and the Triumph of Death survive from the early to mid-fourteenth century. Francesco Traini's *Last Judgment* in the Camposanto, Pisa, like Nardo di Cioni's *Last Judgment* in Santa Maria Novella in Florence, depicts men with turbans in Hell, tugging at their beards in helpless anger at their eternal damnation. There is an exquisite representation of exaggerated gestures of grief from Orvieto just in this period in the *Last Judgment* relief on the facade of the cathedral, carved by Lorenzo Maitani in the first decade of the fourteenth century. The faces of naked sinners condemned to Hell are contorted with fear, rage, and grief; some claw their cheeks, others tug at their hair or hide their faces. These were extreme gestures, the despair of the damned.

The Orvietan laments seem far from the calm processions replicating social hierarchy that characterized funerals a century later, at least in Florence.[62] Whether Orvietan processions were carefully structured, like the aristocratic funerals of republican Rome or late Trecento Florence, is unclear. They certainly featured the noisy display of grief, put on by men. The most dramatic example is the large lament for the young nobleman Lotto di messer Morichelli. Again, 129 men were fined, many of them nobles and prominent citizens, and there were surely more participants who escaped the court's attention. Orvieto was a small place, and the lament must have been a formidable show: a large mass of men, including knights, notaries, town consuls, artisans, and guildsmen as well as family retainers, crowded in the narrow streets, crying out and wailing in grief over the young man's death.

[60] See, for example, Carine Bouillot, "La chevelure: La tirer ou arracher, étude d'un motif pathétique dans l'épique médiévale," in *La chevelure dans la littérature et l'art du Moyen Age (Actes du 28e colloque du CUERMA, 20, 21, 22 février 2003)*, ed. Chantal Connoche-Bourgne (Aix-en-Provence: CUERMA, 2004), pp. 35–45.

[61] Moshe Barasch, *Gestures of Despair in Medieval and Early Renaissance Art* (New York: New York University Press, 1976), p. 19, points out that the gesture was used in illustrations of the plays of Terence.

[62] See Strocchia, *Death and Ritual*, pp. 7–11.

Grief and rage ascribed to Muslims, Mongols, pagans, and Jews condemned to hell. Nardo di Cione. Group of sinners. Detail from the *Last Judgment*. c. 1350. S. Maria Novella, Florence. Photo credit: Scala/Art Resource, NY.

WHY TARGET GRIEF?

One immediate reason for the court's pursuit of lamentation was surely that the fines raised money for the town and the spies. But why choose to fine mourning rather than something else? When the Seven themselves commented on the statute, they intimated that funeral laments dishonored the town: they were "counter to the custom of all the greater Italian cities."[63] What did this mean? Mourning fines have been seen as a direct effort to stop ritual behaviors that promoted disruptive vendettas. Following Jacques Heers, Diane Hughes suggested in 1983 that the thirteenth-century laws restricting noble gatherings both at weddings and at funerals were directed against the corporate solidarity of extended kin groups. Large funerals and violent public displays of grief could whip up the anger and outraged honor of the kinsmen of the dead. The scuffle at the Frescobaldi funeral in Florence in 1296 is a famed example. The laws thus limited the size of funerals and

[63] ASO, Statuti 26A, 30 verso, 11 verso–12 recto.

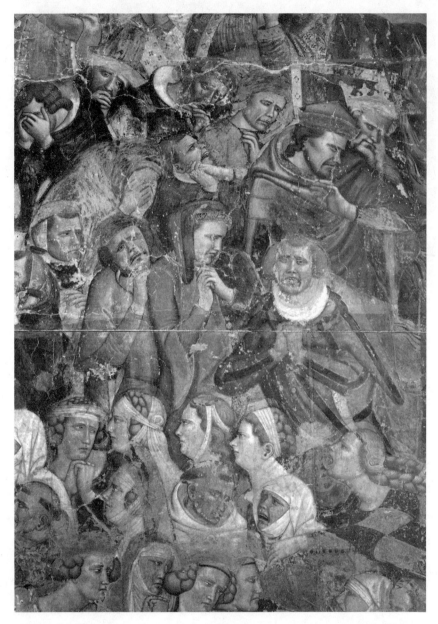

Detail of the damned. Francesco Traini. *Triumph of Death*. c. 1350. Camposanto, Pisa. Photo credit: Scala/Art Resource, NY.

The grief of the damned. Lorenzo Maitani, attrib. Detail from the *Last Judgment* relief. c. 1310. Facade, Cathedral of the Assunta, Orvieto. Photo credit: Edward English.

restrained public displays of grief in order to forestall the vendetta and up-hold public order.[64] Similar arguments have been advanced to explain the funeral laws of the ancient Greek city-states as well.[65]

One way to explore this problem is to examine the lists of people actually fined for their participation in funerals to see whether they were nobles or linked to particular factions. Social and political analysis of the lists of mourn-ers is a delicate problem, however. It is not certain which process of selection is being revealed: the men who chose to mourn, the men the spies chose to fine, or the cases that are extant because the registers happen to survive. Neverthe-less, the lists of men fined in Orvieto are revealing: they suggest that knights and elite men were prominent at funerals but that these late thirteenth-century funerals were not a display of factional division. Orvietans in these de-cades despite their differences joined together to grieve for the dead.

Knights were present in disproportionate numbers: 43 of the 220 men fined, or 20 percent, were identified with titles. In the 1292 catasto, 9 percent of the population was titled. I have come to think that the high proportion of titled men fined was not just because the wealthy were obvious targets but because dramatic funeral laments were expected of the knightly elite, as the 1277 funeral in Perugia that included the dead knight's horse and banner suggests. As I show in Chapter 3, this practice reflected the epic tradition that was very much alive in late thirteenth-century Italy: male warriors had an obligation to display their grief. However, laments were not confined to

[64] Jacques Heers, *Le clan familial au Moyen Age* (Paris: Presses Universitaires de France, 1974). See Diane Hughes, "Sumptuary Legislation and Social Relations in Re-naissance Italy," in *Disputes and Settlements: Law and Human Relations in the West*, ed. John Bossy (Cambridge: Cambridge University Press, 1983).

[65] See S. C. Humphreys, *The Family, Women, and Death: Comparative Studies* (London: Routledge & Kegan Paul, 1983).

nobles: everyone took part. Many of the men fined for mourning were arti-
sans. For example, when 17 men were fined for weeping outside the house of
the recently dead Missino di Guido, they included a barber, a meat vendor,
two tavern keepers, a tailor, and a merchant as well as several nobles and
knights. The group was both a social and a geographical mix: though 11 men
came from one neighborhood, Santa Pace, five other parishes were also rep-
resented. Funerals of titled nobles also included probable clients, like the
"Fredo who lives by the house of Lord Muntanari" at the Muntanari fu-
neral.[66] The 129 Morichelli mourners included titled nobles and a long list of
artisans. [67] Overall, alongside the 43 noble mourners were 41 men identified
as guildsmen: notaries, merchants, doctors, woodworkers, tailors, shoemak-
ers. Some of the remaining 136 were probably guildsmen or artisans as well,
since nobles were rarely mentioned without their titles, but identification by
profession was erratic. In sum, loud funeral grief was characteristic of the
knightly elite, titled men from lineages such as the Morichelli, Miscinelli,
and Monaldeschi, and their clients. Guildsmen and artisans took part as well.

Was the regime in power penalizing its enemies by slapping them with
fines for public grief? An analysis that always has resonance in Italian his-
tory is factional politics: the podestà and the Seven could have used restric-
tions on mourning to harass opponents or perhaps to forestall factional
conflicts. Many of the mourners came from houses associated with the
Ghibelline faction and even houses linked to Cathar heresy.[68] Families with
long Cathar traditions included the Lupicini lineage, publicly identified
with Catharism from 1238, and the Miscinelli. In fact, three men fined for
mourning had been among the people penalized by an Inquisition for
Catharism decades earlier.[69] The best case is the 1295 funeral of Celle de
Miscinellis, a well-known and contentious character. Twelve men were

[66] "Fredum qui stat prope domum domini Muntanarii." ASO, Giudiziario, Busta 2,
fasc. 8, 75 recto.

[67] Elisabeth Carpentier refers to the Morichelli as a new noble family, but cites no di-
rect evidence, in *Orvieto à la fin du XIIIe siècle: Ville et campagne dans le cadastre de 1292*
(Paris: CNRS, 1986), pp. 16, 227. The 1292 catasto entry for "Vannes Locti domini
Morichelli" appeared on a page that has been lost. It is indicated on p. CI (medieval pag-
ination) as appearing at the top of the next page but is followed by a four-page gap.

[68] Probable Ghibellines included the Lupicini and Miscinelli lineages as well as the
Morichelli. Identification of Orvietan Ghibellines is tricky because of the late medieval
and modern tendency to read these factional loyalties back into the past. Two fragments
from contemporary chronicles list members of these families killed fighting in a Ghi-
belline force in 1289: see "Annales Urbevetani," in *Ephemerides Urbevetane*, ed. Luigi
Fumi, *RIS* XV, V, vol. 1 (Città di Castello, 1920), pp. 162, 186.

[69] Jacopo Barthi, Raneri Monaldi, and the notary Pietro Redilossu were all men fined
for mourning who had been convicted of the heresy in 1268. See Carol Lansing, *Power and
Purity: Cathar Heresy in Medieval Italy* (Oxford: Oxford University Press, 1998), chap. 7.

convicted for wailing and making a corrotto outside his house.[70] Celle had been a wealthy man with a long family history of open dissent from Catholic and Guelf orthodoxy. His lineage, the Miscinelli, were bankers and money-lenders and were publicly labeled Ghibellines in a time when Guelfs were in power.[71] Miscinelli also were heavily involved in Cathar heresy. The Cathar movement espoused a dualist Christianity and attacked the wealth and political involvement of the Roman Church. Catharism was particularly successful in Orvieto, a town with complex and often fractious relations with the papal curia. The Cathar faith drew many Orvietan sympathizers and converts until the movement was crushed by a Franciscan Inquisition in 1268–69. In the late thirteenth century, Catharism became linked to the Ghibellines, at least in the minds of their opponents: both expressed hostility to the church in Rome. In Florence, Ghibelline leaders, notably Farinata degli Uberti, were condemned after death for Cathar heresy. The Miscinelli were heavily involved in Catharism, with four family members convicted and fined for heresy in 1268, probably including Celle himself.[72]

Celle lacked respect for civic authority, but he had some political clout. In 1288, when a tax official insulted him, Celle attacked the man. Celle was fined a whopping 25 libra for the assault but managed to get the official fined 100 soldi in turn for verbal defamation. This was four times the usual fine for an insult.[73] I do not know what the man said to provoke Celle's attack and to justify these large fines. This political background means that Celle's funeral could well have been a display of Ghibelline partisanship, even a show of Cathar hostility to the current regime with its ties to the papal curia and Guelf orthodoxy. However, the social composition of Celle's funeral procession does not support this view. Men from Guelf families—including

[70] ASO, Giudiziario, Busta 2, fasc, 8, 74 recto. To my knowledge, the text has not been published. Celle is well-documented. He witnessed an important family transfer of property, dated 1287: ASO, Liber Donationum, 149 recto. His catasto return of 1292, which listed his holdings in rural land, included twenty-one pieces of property, valued at 4,775 l., 13 s. See ASO, Catasto II, 5v. For comparative figures, see Carpentier, *Orvieto à la fin du XIIIe siècle*, pp. 225–27.

[71] A text of 11 October 1287 from the Caleffo Vecchio di Siena sets out a series of loans involving Cambio Ricci Miscinelli and his brothers: Archivio di Stato di Siena (hereafter ASS), Caleffo Vecchio, c. 348; *CD*, no. 344, pp. 217–18. Mary Henderson edited the text in her "Piety and Heresy in Medieval Orvieto" (Ph.D. diss., University of Edinburgh, 1990), pp. 212–13. Celle's property was confiscated for Ghibellinism in 1313, long after his death: ASO, Catasto 401 ("Bona Comunis Olim Rebelium"), 22 verso; 24 verso also lists his son, messer Pietro.

[72] Celle, or Scelle, was probably the Miscinello Ricci Miscinelli convicted in 1268; see ASO, Liber inquisitionis, 11 verso.

[73] The sentences regarding the tax official are ASO, Giudiziario, Registro 1, 328 recto and 426 verso. Celle actually paid the substantial fine of 25 libra. One hundred soldi was four times the normal fine for *verba iniuriosa*.

the very prominent Monaldeschi—took part in his corrotto. A community sense of obligation to honor the dead overrode enthusiasm for a display of partisanship and faction.

It is particularly revealing that numerous civic officeholders were fined for mourning. Twenty-nine of the men fined can be clearly identified as holding public office in 1297, the year of the first extensive council records.[74] Presumably, had earlier council records survived, more men who were fined for shows of grief would have appeared in them. The men fined were notaries, tax officials, consuls of the guilds, and guildsmen who served among the Seven, including a butcher and a mason. Enforcement was not directed against particular social classes or political factions.

In sum, the evidence for the makeup of these funerals suggests that a loud display of grief was part of the culture of the knightly elite. If a man like Lord Muntanari lost a son, he gathered with his kinsmen, allies, clients, and neighbors in the street and lamented his loss. Guildsmen and artisans took part: this ritual was characteristic of urban elites but not exclusive to them. In this period of delicate political balance, funerals were a show of solidarity. Funerals can serve to reconstitute a community. This means that Orvietan lawmakers were not targeting enemies. Instead, they were deeply implicated in the ritual they sought to penalize. It was essentially the same men who wrote the laws and provided for their enforcement, then wailed and cried out in the street, and then paid their fines. They were restraining not their enemies but themselves. They sought to change elite male decorum, moving away from the dramatic, military culture of the urban knightly class. In effect, the Seven cast themselves both in the role of Kreon, who defended the law and a new political order, and in that of Antigone, who defied the law because it meant dishonoring the dead. As I show in Chapter 9, this effort to impose restraint continued after 1313, when the popular regime's delicate political balance broke down and nobles battled to dominate. The town council repeatedly responded with further elaborations of the funeral statute, picturing order and decorum, as if restraining grief could indeed end civil war. Chroniclers' accounts suggest that by this time elite funerals had become a show not of community solidarity but of factional hatred.

[74] The records are ASO, Riformagioni, vols. 69 and 70. From vol. 70: Neri domine Aldrude, Jacobus Grassus, Petrus Scagni, Jacobus Barthi nobilis, Roczius Scangni, Alexander magistri Alberti, dominus Barthus Scangni, dominus Meus domini Guilelmi, dominus Ugolinus Lupicini, Matheus de Balda notarius, Jannes Egidii domini Morichelli, Vannes Donuli. From vol. 69: Ser Oddo Bernardi Rubey, Petrus Rodelossus notarius, Filippus Fidanze, Thebaldutius Guidecti, Cinus Ranutii Provenzani, Neri Mathei Dentis, Nallus domini Viviani, Pepus Albere, Vannes Bonfilii, Bartuzius Beraldi, Ceccarone Ranerii domini Francisci, Petrus macellarius, magister Johannes magistri Uguicionis muratorus, dominus Stefanus Magalocti.

CHAPTER THREE

LAMENTS AND MALE HONOR

In January 1286, just as the judges in Bologna were assembling in a council room in the civic palace to meet with the podestà, a man named Pietro Ravignani stormed up to a judge named Leonetto, took him by the robe, and began to strike him, crying out, "This is the man who has killed me by putting my son to the torment." Asked to repeat his words later, Pietro reported that he had said: "You are the ones who had my son killed."[1] Pietro was charged with verbal defamation. His defense stated his lament. First, his son Martino was put to the torment. Second, at the day and hour his son was tortured, because of his grief and anguish he wept and was as if out of his mind (*insanus*) and demented. Third, when Leonetto asked him what was going on, he responded: "You know well, as do the others who are in the palace. I am dead and my son similarly tortured and destroyed against God and reason. Never has anything happened in the city of Bologna like what was done to me and to my son. My life is grievous and full of sorrow and will remain that way because of what was done to me." Weeping and crying out from the depth of his sorrow, he said, "Would that I were dead rather than see what I have seen. All of the men of this city and of the world should know of my sorrow and be struck by what was done to me."

What had happened to Pietro's son Martino? He evidently suffered judicial torture, though it is not clear that he was actually killed, which would have been against the law. Torture was allowed in an inquest when there

[1] ASB, Comune, Curia del Podestà, Libri Inquisitionum et testium 7, II, 9 recto–12 recto, contains the testimony. The case is Inquisitionum et testium 8, 23 recto.

were strong indications of the truth of a charge and other means were exhausted, since proof required either two eyewitnesses or a confession. Given an incomplete presumptive body of evidence against a defendant, torture could be used to extract a confession, which then had to be repeated without torture to be valid. However, torture could not cause death or permanent injury.[2] In what sense, then, was he killed? Perhaps Martino had confessed under torture to a capital crime and would soon be executed.[3] Perhaps he had confessed to crimes that rendered him infamous, a kind of civil death that meant he could not hold civic office or write a will. Or it may be that the torture had killed or crippled him, despite the law. It may also be that his death was a metaphorical one, the social consequences of suffering judicial torture.

Four witnesses testified on the father's behalf. Pietro came to the court and accosted the judge out of grief for his son. One of them stated that he knew Pietro's son Martino had been tortured because he heard him crying out on the rack and afterward saw him returned from the torture. The judges who were present when Pietro accosted Leonetto and then gave depositions in the initial inquest betrayed considerable sympathy for the bereaved father. One judge, Ugolino, said he saw Pietro enter the palace, place his hands on Leonetto's robes, and speak out of the grief he felt because of his son, tortured by Leonetto, "You are the one who had him killed, you have two daughters at home." Ugolino also testified that he saw that Leonetto suffered from the words Pietro said to him. Asked whether in his view Pietro had said these things in order to do harm (*iniuriose*), which was the charge, Ugolino answered that Pietro spoke rather out of a father's grief for his son than for any other reason, since the two men otherwise had been accustomed to be friends.

Pietro's outburst has all the power of an epic lament. The defense brief is the closest text I know to an actual lament from thirteenth-century Italy, a representation of the intense grief and rage of a man who felt he had lost an adult son in a brutal and dishonoring way. The legal defense was surely that Pietro was out of his mind with grief and anguish at the time of his assault on Leonetto, as evidenced by his statements about his son's death. It is worth noting that it was not Martino's mother but rather his father who protested the death and disrupted the town hall with lamentations. This was a conflict among men. The close identification between father and son is

[2] Edward Peters, *Torture*, 2nd ed. (Philadelphia: University of Pennsylvania Press, 1996), pp. 54–58.
[3] On the death penalty in law and practice, see the discussion of Siena by Mario Ascheri, "La pena di morte a Siena (sec. XIII–XIV): Tra normativa e prassi," *Bullettino senese di storia patria* 110 (2003; published 2004): 489–505.

also striking: what was done to a son was done to his father: "I am dead and my son similarly tortured and destroyed against God and reason. Never has anything happened in the city of Bologna like what was done to me and to my son. My life is grievous and full of sorrow and will remain that way because of what was done to me." Pietro's action was exactly what the statutes sought to prevent: grief and rage challenging state authority, in this case a man driven by overwhelming emotion to walk into the town hall and accost a judge. The case reveals a clash between two sets of rules, legal norms and cultural values. The judge had been doing his job, enforcing the law by using torture in an attempt to meet the requirements for proof of whatever the charge was against the young man. Pietro's harangue—at least as it is depicted in his legal brief—did not challenge the legality of the torture. He spoke instead of cultural and moral values: its cruelty and horror were "against God and reason." Similarly, to charge a man who attacked a judge was simply to carry out the law. And yet the witness Ugolino, himself a judge, implied that this also was not really in keeping with cultural values. Pietro's emotional outburst was not done iniuriose. It was appropriate, the expected grief and anger of a father for a son. Pietro cast himself in the role of Antigone with Leonetto the judge in the role of Kreon. The court nevertheless carried out the law, and Pietro was convicted and fined 25 libra. This was a family of troublemakers: Pietro Ravignani lost another son five years later when the commune banned Martino's brother Francisco for a deadly assault in 1291.[4]

This idea that a man has an obligation to lament his dead is echoed in the funerals of late thirteenth-century Orvieto. As I have suggested, men joined together in the streets and in church to weep and cry out, to chant elegies, clap, and even tear their hair. To explore the implications of their actions requires a look at context, to understand whether this practice was anomalous. How were laments used and understood? In this chapter, I explore medieval representations of laments for the dead. The evidence is scattered, but grieving people appear in a variety of sources, including the visual arts and literary texts, notably epic poetry and the romances. Formal verse laments were common and over time became a highly polished literary form.[5] Laments, particularly the corrotto of the Virgin, became central to liturgical drama.[6] Normative texts in canon law and penitential manuals are another source, since they often list funeral actions considered objectionable. It is

[4] ASB, Comune, Curia del Podestà, Accusationes 9b, filza 37, 2 verso.

[5] On the literary genre, see Claude Thiry, *La plainte funèbre*, Typologie des sources du Moyen Age occidental, vol. 30 (Turnhout, Belgium: Brepols, 1978).

[6] See, for example, Nils Holger Petersen, "A Mutual Lamenting: Mother and Son in *Filius Getronis*," *Roma ETC* 2: 687–701.

not obvious how close any of these representations of laments were to actual practice, since none were written to record ritual actions.

Medieval writers also mentioned laments in sources that purport to be historical, including tales in the lives of the saints and accounts of funerals in family histories. These historic sources are not simple reflections of practice either, since, as I will show, authors tended to deploy mourning rhetorically, as a way to comment on the character of the dead by showing that people loved them, or hated them, or didn't much care. Laments also could show the survivors to be pious, or devoted to the dead, or perhaps insensitive or hypocritical. Nevertheless, these historical descriptions generally cannot be too far from practice since the authors shared a common culture with their audience. They had to write accounts that were credible. There was a tension between funeral grief viewed as a measure of respect and honor and funeral grief seen as histrionic excess. Usually, the emphasis was on respect and honor: medieval accounts both literary and historic often seem close to a Homeric understanding of lamentation as honorable, appropriate, a proper way to define the status and identity of the dead. Men—particularly kings and warriors—as well as women lamented the dead, often in dramatic and noisy ways. I turn first to laments from literary sources and then to accounts that purport to be historical.

EPIC LAMENTS

To read accounts of mourning in epic poetry is to enter a social and political world in which violent lamentation is not a dishonorable loss of self-control but part of the nature of things. A warrior had an obligation to grieve for his fallen comrades. The paradigmatic funeral laments in Western literature are the Homeric ones. The last books of the *Iliad* are dominated by scenes of death in battle, of violent, cruel revenge, of intense love between men and uncontrollable grief. The grief of Achilles for his beloved Patroclus parallels the sorrow of King Priam for the loss of his son, Hector. Both men express their pain in horrible gestures: Achilles pours dirt on his head and lies in Patroclus' dead arms, Priam rolls in the dung in shame at Achilles' mockery of Hector's corpse. The rescue of the corpse from dishonor becomes a paramount concern, even for the gods. When Priam and Achilles meet, they weep together, each for his own loss. Female lamentation in the *Iliad* is different, more controlled and often collective. The laments of wives and mothers are as much social as personal. They grieve even before the death, cruelly aware in advance of the fates they will suffer. And since those fates are decided by men's battles, the women can do little about them. Often

their laments spell out the implications of the hero's death for his family and community. When Andromache finally holds the head of her dead husband, Hector, in her lap, she grieves for the consequences of his killing. The city will be sacked, she and the other women will be carried off as prisoners, and her young son will either be butchered by a vengeful Greek or suffer a life of bondage and drudgery.[7]

Homeric choruses of lamentation are sometimes men and women, more often exclusively female. As Priam grieved for Hector, "the citizens wailed in answer / and noble Hecuba led the wives of Troy in a throbbing chant of sorrow."[8] War captives, often women, were made to grieve for their captors' losses. As with hired mourners, it must have been the action and not the emotion that mattered. When the captured Briseis remembered the kindness of Patroclus and lamented his death, "the women wailed in answer, grief for Patroclus calling forth each woman's private sorrow."[9] These women were war prizes.

The fourth book of the *Odyssey* includes a conversation about the painful obligation to mourn the dead. It is sparked by Telemachus' visit to the old king Menelaus in search of news of his missing father, Odysseus. As Menelaus and his dinner companions reflect on the past and recall their affection for dead comrades, they begin to weep. When Pisistratus is overcome with grief for his fallen brother, he asks Menelaus' indulgence: "Myself, I take no joy in weeping over supper. Not that I'd grudge a tear for any man gone down to meet his fate. What other tribute can we pay to wretched men than to cut a lock, let tears roll down our cheeks?"[10] This is an eloquent statement of the rightness of mourning: what tribute can he pay his fellow warriors other than to display his sorrow? Menelaus commends his wisdom. The passage continues with an acknowledgment that grief can be unbearable. Helen observes the men's tears and then laces their wine with a drug that for a time entirely frees them from grief, even from sorrow for lost parents.[11]

The Homeric epics were not directly known in the early Renaissance, although Dante was able to populate the Inferno with Homeric warriors,

[7] Homer, *The Iliad*, trans. Robert Fagles (New York: Penguin Books, 1991), 24:850–878. When Andromache first hears of Hector's death, she grieves for the consequences for her son: *Iliad*, 22:569–93.

[8] Ibid., 22:505–6.

[9] Ibid., 19:357–58.

[10] Homer, *The Odyssey*, trans. Robert Fagles (New York: Penguin Books, 1996), 4:216–222.

[11] Nicole Loraux argues that Helen's drug is somewhat ambiguous because to be freed from mourning is to be cut off from society: see "Of Amnesty and Its Opposite," in *Mothers in Mourning*, trans. Corinne Pache (1990; Ithaca: Cornell University Press, 1998), pp. 95–97.

Achilles, Ulysses, Hector.[12] The cast of characters and their stories were familiar to educated Italians from Vergil and Ovid as well as Statius, the Silver Age poet whose epics became standard medieval textbooks, used to teach Latin.[13] One example of a lament from Statius is the account of a family's grief for a child, in the sixth book of the *Thebaid*. It directly recalls Homeric imagery: "The father himself sits stripped of the honor of the twined fillet, his unkempt head and neglected beard sprinkled with the dust of mourning. More violent than he and passionate with more than a man's grief, the bereaved mother urges on her handmaidens . . . and yearns to cast herself upon the mangled remains of her child." A group of princes arrive and "smite their breasts though wearied and raise clamor upon clamor, and the doors re-echo with the new-kindled wailing."[14] If a mother's grief is more violent and passionate, the climactic scenes of the twelfth book of the *Thebaid* nevertheless recount the laments of fathers. Oedipus throws himself on the corpses of the sons he had cursed, sons who had killed each other and now lay dead together on the battlefield. The *Thebaid* was known in late medieval Italy, even illustrated by Francesco Traini in a great fresco in the Camposanto in Pisa.[15]

Violent male grief appears in Late Antique depictions of military funerals, barbarian and Roman alike. Jordanes vividly described the manly fashion in which Attila was honored at his funeral: "his people cut off part of their hair and hacked their flesh with deep cuts," so that he was mourned, Jordanes writes, "not with feminine lamentations and tears but with manly blood."[16] Cavalry rode in circles around his body, and warriors chanted a dirge enumerating Attila's deeds and victories. There was a funeral banquet, and war trophies were set up over his grave. Ultimately, all those who had contributed to making the grave were put to death.

Epic male grief was central to the medieval chansons de geste. These popular tales relied on male laments as plot devices. Masculine grief was highly

[12] See Ronald Martinez and Robert Durling, introduction and notes, *The Divine Comedy of Dante Alighieri*, ed. and trans. Durling, vol. 1, *Inferno* (Oxford: Oxford University Press, 1996). For medieval uses of classical legends, see H. David Brumble, *Classical Myths and Legends in the Middle Ages and Renaissance: A Dictionary of Allegorical Meanings* (Westport, Conn.: Greenwood Press, 1998).

[13] Paul M. Clogan, *The Medieval Achilleid of Statius* (Leiden: Brill, 1968), pp. 1–3.

[14] Statius, *Thebaid*, trans. J. H. Mozley (Cambridge, Mass.: Harvard University Press, 1957), vol. 2, book 6, lines 30–44.

[15] See Hayden Maginnis, *Painting in the Age of Giotto: A Historical Reevaluation* (University Park: Pennsylvania State University Press, 1997), fig. 84.

[16] Jordanes, *Gethica*, ed. Mommsen, *MGH, Scriptores auctores antiquissimi*, 5, 1 (Berlin, 1882), no. 49, 254–55, pp. 123–24. For Roman military funerals, see Javier Arce, "Imperial Funerals in the Later Roman Empire: Change and Continuity," in *Rituals of Power from Late Antiquity to the Early Middle Ages*, ed. Frans Theuws and Janet Nelson (Leiden: Brill, 2000), pp. 115–29.

formulaic: men wept, tore their hair and beards, and swooned in sorrow when heroes died. An example familiar to modern readers is Charlemagne's reaction to Roland's death in the *Song of Roland*.[17] When Charlemagne finds the dead Roland, he dismounts, runs to the corpse, and then faints on the body. When he awakens, he praises Roland's knighthood. With the loss of Roland, Charlemagne himself loses honor: " 'My honor has fallen into decline.' Charles faints, he cannot help himself."[18] He reawakens to lament Roland's death and his own loss at great length. He is a *mal seigneur* to have allowed this to happen. The political and military results will be devastating: without Roland, his nephew who had subdued his realms, a long list of subject peoples—Saxons, Hungarians, Bulgars, Romans, Apulians, Africans—all will rise up against his rule, and there will be no military leader able to stop them:

> "I have such anguish that I'd rather be dead!"
> He begins to tear his white beard
> And, with both hands, the hair from his head.
> A hundred thousand Franks fall to the ground in a swoon.[19]

Charlemagne's sorrow is both personal and political: he grieves for his own loss and for the disastrous effect on his kingdom.

In epics, male lamentation not only measured the honor and worth of the individual character but underscored social and political networks of association. Epic laments, including those in Homer and Vergil, as well as the *Song of Roland*, can spell out political and military alliances. A lament may describe a political contract between two social groups and even preserve a record of that contract for posterity.[20] When Charlemagne grieves for Roland, it is the grief of a lord for a loyal vassal, or the grief of a lord who is

[17] Paul Zumthor, "Étude typologique des planctus contenus dans la *Chanson de Roland*," in *La technique littéraire des chansons de geste*, Actes du Colloque de Liège (September 1957) (Paris: Société d'édition "Les Belles Lettres," 1959), pp. 228–29; "Les planctus épiques," *Romania* 84 (1963): 61–69.

[18] *The Song of Roland*, 2 vols., ed. and trans. Gerard J. Brault (University Park: Pennsylvania State University Press, 1978), 2:lines 2890–99; see the commentary by Brault, 1:284.

[19] Si grant doel ai que jo ne vuldreie estre!
Sa barbe blanche cumencet a detraire,
Ad ambes mains les chevels de sa teste.
Cent milie Francs s'en pasment cuntre terre.

Song of Roland, ed. and trans. Brault, 2:line 209.

[20] This is the view of Gabrielle Oberhansli-Widmer, based on her typology of literary laments. See her *La complainte funèbre du haut Moyen Age français et occitan*, Romanica helvetica, 106 (Bern: Editions Francke, 1989).

threatened by powerful nobles for a beloved youth who was a loyal member of his entourage.

The contrast with *Antigone* is striking. Emotional rituals of grief are not a challenge to the state but a means of reinforcing the fragile and purportedly masculine ties on which order and authority depend. Lamentation thus has little to do with women but displays bonds of affection and obligation among male warriors. As in Homeric funerals, women in medieval epics at times provide choruses of grief. However, mourning women are glimpsed only on the margins. Their laments are usually brief, a quick reflection on the hero. The paradigmatic female lament is that of Roland's fiancée, Aude, in the *Song of Roland*. When she learns of his death she wastes little time, gracefully dropping dead.

False death reports and passionate grief appear in medieval romances as well. In Chrétien de Troyes' *Cligès*, written c. 1176, the empress Fenice drinks a potion to appear dead so she can escape to her lover, Cligès. The emperor, court, and city grieve extravagantly, lamenting her loss for pages: "How the emperor wept and lamented, and the mourning that filled the room. People were crying out and weeping all over the city, saying, 'Oh God, what hateful wicked things all-horrible death has done!' . . . The people raged, waving their arms and beating their palms." Three doctors from Salerno recognized that she was alive and brutally tried to revive her, even scourging her and pouring molten lead over her hands. She withstood their efforts. At her funeral procession, "rich and poor, everyone in all of Constantinople followed the body, weeping and hurling curses at Death. Boys and knights alike fainted, as did ladies and girls, beating their breasts. . . . But Cligès' weeping and mourning were the most intense; staggering half distraught behind the body, he came close to dying," even though he knew she was in fact alive. The lament measures the popularity of the empress, but as background to the protagonists' love.[21]

Epic laments were well known in the Italian towns. The epic tradition was very much alive in thirteenth-century Italy, and popular new Franco-Italian epics continued to depict violent masculine sorrow. False death reports were a common plot device, used to point out just how heroic and beloved the hero was. In an early fourteenth-century poem written by an anonymous Paduan, *L'Entrée d'Espagne*, Charlemagne and his men heard a false report of Roland's death and reacted with an exaggerated display. Charlemagne "fell in a swoon and trembled with grief." Lords pulled their hair, beat their fists on their chests, and grieved for Roland; men from France, Anjou, Navarre, and

[21] Chrétien de Troyes, *Cligès*, trans. Burton Raffel (New Haven, Conn.: Yale University Press, 1997), lines 5768–6125, pp. 182–93.

so forth wept. "The king reawakened and looked around, tore his beard and pulled his moustache, then beat his palms and cried in a fierce tone, 'Roland my friend, Roland my companion.' "[22] The stature of a warrior was expressed in the way other men mourned his death.

People loved the epics, even named their children after such epic heroes as Roland and Pallamidesse. The famed preacher Cardinal Eudes of Châteauroux vividly complained about the popularity and emotional impact of epic death scenes in a Good Friday sermon preached in Orvieto or nearby Viterbo around the time of the funeral laws. Eudes urged listeners to grieve over the Crucifixion as a way to foster contrition for sin, and he complained that people were impervious to the Passion but emotionally engaged with epic heroes: "there are many who are more apt to weep if they hear someone speak of the death of Roland than if they hear someone speak of the death of Christ."[23]

LAMENTATION IN HISTORICAL ACCOUNTS

What of lamentation not in literature but in practice? From the Early Middle Ages, Christian funeral liturgy and lay expressions of grief existed

[22]
> Quant Carles voit que cil en aporta
> Son neveu pris, que jameis nel quida,
> En pasmasons chiet et de dol trembla.
> E Dieux! seignors, donc veisez vos la
> Tirer chevoiz e poing q'a piz urta.
> En maint lengaiges Rollant se regreta;
> Par pué ceschuns an fue ne s'en va.
>
> Plorent Francos, Angeins e Berton
> E Navarois, Piteins e Gaschon,
> Frixons, Flamans e tot le Bergognon.
> E li Alemans sor tot grant doel en fon,
> Che perduz ont Rollant lor campion,
> Lor chevetayne e la lor garison . . .
> Le roi revient e se garde anviron,
> Sa barbe sache e tire son grignon,
> Pués bat ses paumes e escrie a fiers ton:
> "Rollant amis, Rollant mon compaignon . . ."

L'Entrée d'Espagne, 2 vols., ed. Antoine Thomas (Paris: Firmin-Didot, 1913), 1:lines 1741–60. For a discussion of the influence of the Italian urban audience on these epics, see Henning Krauss, Epica feudale e pubblico borghese, trans. A. Fassò (Padua: Liviana Editrice, 1980). See also Alberto Limentani, "L'Entrée d'Espagne" e i signori d'Italia, Medioevo e Umanesimo, 80 (Padua: Editrice Antenore, 1992).
[23] Archivum Generale Ordinis Praedicatorum (hereafter AGOP), XIV, 32, #117, pp. 169 verso–171 recto (Schneyer #236). See the discussion in Chap. 5.

side by side. Death rituals were not contained within the family, even in the sense of the Latin *familia*, the extended household. At least for elites, not only household members but clients, allies, and members of the community took part in laments. To give an early example, Gregory of Tours described a great lament "of all the people" at the death of the Merovingian prince Chlodobert, a son of Chilperic I.[24] Men wept, he writes, and women put on mourning clothes like those worn at the death of a spouse. Implicit in this image is the idea that the most intense show of mourning or at least mourning dress is familial, a woman sorrowing for her lost spouse. But everyone grieves.

An extensive discussion of grief in a sermon of Caesarius, the sixth-century bishop of Arles, contrasted lay and clerical mourning. Caesarius depicted dramatic mourning as the expression of family affection. "If wife or child or husband has died," he preached, "men dash themselves on the ground, tearing their hair and striking their chests, continuing for some time in their mourning and fasting and tears."[25] Caesarius asks whether his listeners take the same care for their souls that they take for the flesh of others. We grieve for flesh that we cannot bring back to life but neglect our own souls, which we actually can return to their pristine state. Worse yet, our lamentations suggest that we love the bodies of the dead but not their souls.[26] The distinction between lamentation and prayer for the dead is very clear: the lament addresses the loss of close kin from this life whereas prayer concerns the fate of the soul after death. In effect, the clergy prayed whereas the laity lamented. This fundamental division between lay and clerical responses to death is evident not only in early medieval sermons but in saints' lives.[27]

[24] "Magnus quoque hic planctus omni populus fuit; nam viri lugentes mulieresque lucubribus vestimentis induti, ut solet in coniugium exsequiis fieri, ita hoc funus sunt prosecuti." Gregory of Tours, *Libri Historiarum X*, ed. Bruno Krusch and Wilhelmus Levison (Hanover, 1951), Monumenta Germaniae historica, Scriptorum rerum Merovingicarum vol. 1, part 1, fasc. 3, book 5, chap. 34. See Alain-Erlande Brandenburg, *Le roi est mort: Étude sur les funérailles, les sepultures et les tombeaux des rois jusqu'à la fin du XIIIe siècle* (Geneva: Droz, 1975), chap. 1.

[25] "Si autem uxor aut filius aut maritus mortuus fuerit in terra se collidunt homines capillos trahendo et tundendo pectora. In luctu, in abstinentia, in lacrimis, non paruo tempore perseuerant. Rogo ergo, fratres, exhibeamus nostrae animae quod illi exhibent alienae carni." *Collectio canonum*, no. 317, p. 475. Saint Caesarius of Arles, *Sermons*, 3 vols., trans. Mary Magdaleine Mueller (Washington, D.C.: Catholic University of America Press, 1956), 2:454.

[26] "Carnem quae non potest suscitaru plangimus et animam nostram non plangimus quam possumus ad statum pristinum reuocare. Se quod nobis peius est corpora mortua plangimus quae amamus animam uero mortuam quam non amamus nec dolemus nec plangimus."

[27] See Michel Lauwers, "La mort et le corps des saints: La scène de la mort dans les *Vitae* du haut Moyen Age," *Le Moyen Age* 94 (1988): 21–50. See also Pierre Boglioni, "La scéne de la mort dans les premières hagiographies latines," in *Le sentiment de la mort au*

Early medieval church councils periodically condemned displays of grief, and penitential manuals listed fines for them. As I discuss in chapter 5, the serious effort to restrain lay mourning practices came with the Carolingian reform. Paul Binski, in his general study of the medieval representation of death, suggests that this effort succeeded and that from the Carolingian period the clergy dominated rituals of remembrance. Binski argues that this shift "amounted to an appropriation of rites by a class of specialized technocrats of death, and for the remainder of the Middle Ages this renunciation by society of rituals which formerly belonged within the family itself, to an impersonal group, remained normal."[28] This view seems to me mistaken: families and communities demonstrably continued to lament at funerals.

The Carolingian laws were of course promulgated in Italy. One source is the *Collectio Canonum*, a compilation of canon law put together between 1014 and 1023, probably at the monastery of Farfa, near Rome. It gives some indication of available texts and monastic concerns about mourning in central Italy in the early years of what became the Gregorian reform.[29] Along with the sermon on funerals of Caesarius of Arles, it includes a number of early medieval canons on death ritual which criticize lay forms of lamentation, including the standard prohibition of funeral songs.[30] Canon 306 cites a Roman and an Irish synod on penances for tearing the hair at funerals.[31]

The eleventh-century *Life* of the Florentine bishop San Zanobi written by Archbishop Lorenzo of Amalfi similarly ascribes histrionic grief to a woman, in this case a distraught mother. Her grief, however, is appropriate, a measure of her devotion to her son. Zanobi was a fifth-century bishop, said to have been a friend of Ambrose. When Zanobi was on a visit to Rome, a mother begged him to resuscitate her dead child. She is described as tearing at her hair and ululating. She threw herself at his feet, then "held the cadaver of her son before his face, and in a lamentable voice cried out, saying 'This is my only son whom I commended, living, to your sanctity. I beg you to return him living and not dead to his unhappy mother.'" Lorenzo

Moyen Age, ed. Claude Sutto (Québec: Les Éditions Univers, 1979), pp. 202–4. On the development of the liturgy for illness, death, and burial, see Frederick S. Paxton, *Christianizing Death: The Creation of a Ritual Process in Early Medieval Europe* (Ithaca: Cornell University Press, 1990).

[28] Paul Binski, *Medieval Death: Ritual and Representation* (Ithaca: Cornell University Press, 1996), pp. 32–33.

[29] *Collectio canonum in V libris*, ed. M. Fornasari, vol. 6 of *Corpus Christianorum, continuatio mediaevalis* (Turnhout, Belgium: Brepols, 1970).

[30] *Collectio canonum*, no. 305, pp. 464–65.

[31] *Collectio canonum*, no. 306, p. 465.

explains that she was "weeping and making these kinds of lamentations *muliebriter* [in a womanish fashion] but confiding *viriliter* [in a masculine way] in the Lord." Zanobi, himself weeping, immediately prayed, and the boy was revived. The miracle got Zanobi in trouble back home in Florence: when a youth was found dead by the city gate, a whole group of Florentines prostrated themselves on the ground and with tearful voices implored him to raise the dead boy, blocking the bishop's path. When he objected, they pointed out that he had already resuscitated a foreign boy; how could he not ask God to revive a local, for whose death his whole city suffers? He told them that the miracle was a reward for the woman's maternal devotion and true faith; they replied, what about their faith? Zanobi conceded and asked them to sing the Kyrie Eleison while he prayed. Happily, the Florentine boy was restored as well.[32]

Grief can be manly, even that of a woman. And for Lorenzo, even the womanish aspects of the mother's show of grief were laudable, evidence of the maternal devotion that—together with her virile true faith—was rewarded with the miracle. It is also worth noting that the whole community, men and women, also gave themselves over to dramatic weeping. Zanobi's technique—asking them to sing the Kyrie Eleison—was based in canon law: the mid-ninth-century False Capitularies urged that the laity substitute the Kyrie for ululations.[33] When the saintly Zanobi was near death, he enjoined his people not to grieve excessively: "Do not, beloved children, do not, I beg, afflict yourselves with immoderate grief . . . rather, rejoice that I your father will go to [the Lord], whom I will beg mercy for your excesses insofar as I can."[34] Apparently, he anticipated a popular lament and hoped to forestall it by pointing out that his death would actually work to their benefit by giving them an advocate.

Historical accounts from eleventh- and twelfth-century Italy also mention popular laments as a matter of course. Donizo's *Life of Mathilda* can provide a tidy example. Mathilda was of course the great noblewoman who supported Gregory VII and his successors in the Investiture controversy, waging war against the imperial forces. Donizo was an important monastic client, the abbot of the monastery at Mathilda's family fortress, Sant'Appol-

[32] Laurentius monachus Casinensis Archipiscopus Amalfitanus, "Vita Sancti Zenobii Episcopi," in *Opera*, Monumenta Germaniae Historica, Band 7 (Weimar, 1973), pp. 50–70. These are lectiones 5 and 6. Thanks to Maureen Miller for suggesting this text. On the medieval cult, see Anna Benvenuti Papi, *Pastori del popolo: Storie e leggende di vescovi e di città nell'Italia medievale* (Florence: Arnaud, 1988), chap. 2.

[33] See *Benedicti diaconi capitularium collectio*, book II, c. 197, *PL* 97, 771D, discussed in chap. 5.

[34] "Vita sancti Zenobii Episcopi," lectio 7.

lonio of Canossa. In 1114–15, at the end of her lifetime, the abbot composed an odd poem celebrating her ancestors the Dukes of Canossa and then Mathilda's career, including the meeting at Canossa of Henry IV and Gregory VII.[35] It is the castle of Canossa itself that speaks in the poem, sometimes in dialogue with Mantua. At the end, the poem urges Mathilda to choose burial at the abbey.

How did Donizo represent an honorable funeral in a text coaxing Mathilda to let him conduct her burial? He devoted seventeen lines to the funeral rites Mathilda's ancestor, Duke Boniface, held for his younger brother, Conrad, who died in 1030 of wounds suffered in battle, though as the editor notes, the battle was actually fought nine years before his death. This funeral took place almost a century before Donizo composed the poem, and it is doubtful that he knew much of its details. He began with the duke's grief. Perhaps because the two men had for a time been estranged— due, naturally, to Lombard machinations—Donizo stressed Boniface's sorrow for his younger brother: he wept for years over the death of the "lovely youth." Prolonged tears measure familial affection. The funeral itself included a service, a procession to Canossa and the burial. Upper clergy were very much involved: clerics of every rank were present at the funeral, where "the God who is three and one was asked to forgive Conrad's sins and grant him rest." A host of saints were asked to stand surety so that Conrad could join them. The emphasis thus was on clerical and saintly intercession to obtain forgiveness for sin. However, Donizo also included a popular lament. He placed it discreetly during a funeral procession rather than at the requiem: when Duke Boniface returned his brother's corpse to the sanctuary at Canossa, where their paternal and maternal ancestors were buried, "innumerable people [*gentes*] grieving for his brother went along with him, and gave voice to the loss of so great a *barone*." When a great noble dies, his people voice a lament. Finally, Donizo included a penitential donation: when Conrad was buried, Boniface gave "a productive farm" to the monastery, in hopes that Conrad's soul would be freed from punishment. In effect, an abbot writing in 1115 to celebrate an aging noblewoman and coax her to be buried at his abbey described a good funeral as one that combined clerical intercession in hopes of forgiveness for sin with lay lamentation and concern for ancestral memory. This was only reasonable: an account of a noble funeral without mention of the sorrow of his people would perhaps imply that he was unpopular!

[35] "Vita Mathildis Carmine scripta a Donizone presbytero," *RIS* vol. 5, part I, lines 564–81.

Gestures of mourning were depicted in miniatures in restrained, stylized ways that remained essentially unchanged from Late Antiquity through the Middle Ages.[36] Men and women engage in posed gestures of grief, the head resting on a palm of the hand, or a delicate hand to the eye, the gesture characteristic of Mary and John at scenes of the Crucifixion. Miniatures generally do not show the more violent gestures banned in the penitentials: beating the chest, tearing the hair or beard, clawing the cheeks. One exception is a striking depiction of female grief in a liturgical text from early eleventh-century Italy. It is probably best read in the context of the reform, as a clerical criticism of lay laments. A series of ten miniatures from the Sacramentary of Bishop Warmundus of Ivrea represent in sequence the stages of death: last rites, washing of the corpse, the body lowered into tomb, and so on. They include a female figure making extreme gestures of grief. The men are calm; it is a woman with wildly loosened hair who beats her breast and extends her arms up to the skies or down to the corpse.[37] Should we conclude from the Ivrea miniatures that laywomen behaved this way at eleventh-century north Italian funerals? Perhaps, but the wildly grief-stricken woman is also used rhetorically. The miniatures derive from a bishop's sacramentary, a volume to be used in the liturgy, for the bishop and other cathedral clergy. The miniaturist portrayed expressions of grief that were banned in canon law and embodied them in the figure of a wildly gesticulating woman. The implicit message is that it is women, not men and certainly not clerics, who act in this uncontrolled way. Ivrea from the tenth century had a lay confraternity that included men and women and was associated with the cathedral clergy. Its statutes provided that when there was a death in the parish, all the members were to hasten and "as is the custom of Christians, with prayers to God, Masses, psalms, vigils, and prayers," bury

[36] Danièle Alexandre-Bidon, "Gestes et expressions du deuil," in *A réveiller les morts: La mort au quotidien dans l'Occident médiéval*, ed. Alexandre-Bidon and Cécile Treffort (Lyon: Presses Universitaires de Lyon, 1993), pp. 121–33. She concludes on the basis of this material that the church judged gestures of mourning to be feminine but in reality men and women joined together in laments.

[37] The miniatures have been printed by Jean-Claude Schmitt and Patrick Geary. See Schmitt, *La raison des gestes* (Paris: Gallimard, 1990), pp. 211–24; Geary, *Phantoms of Remembrance: Memory and Oblivion at the End of the First Millennium* (Princeton, N.J.: Princeton University Press, 1994), pp. 55–59. See also the analysis by Diane Hughes, "Mourning Rites, Memory, and Civilization in Premodern Italy," in *Riti e rituali nelle società medievali*, ed. Jacques Chiffoleau, Lauro Martines, and Agostino Paravicini Bagliani (Spoleto, 1994), pp. 28–29.

the dead.[38] This picture of lay comportment at funerals is dramatically different from the miniature in the bishop's sacramentary. Both served the same rhetorical purpose.

Another exception is twelfth-century Iberia: at the 1109 funeral of Alfonso VI, "men tore their hair and ripped their clothes while women scratched their faces and shrieked to the high heavens."[39] Reliefs on sarcophagi featured scenes of mourning. The tomb of Count Egaz Moniz, who died in 1144, depicts weeping women beating their breasts and tearing their hair.[40] The tomb of Doña Blanca of Navarre, the wife of Sancho III king of Castile, is an example. Blanca died in 1156, a few months after giving birth. Her sarcophagus lid includes a representation of her deathbed and the monarch, her young husband, fainting into the arms of his followers. Men of the court tear at their beards and hair.[41]

The epics were often illustrated, particularly the popular Roland stories.[42] Male laments as we have seen were critical to epic portrayal of the military qualities and social and political significance of the hero. However, whereas verbal images were dramatic and exaggerated, pictures tended to be calm. Roland was first depicted as early as 1097–1104 in carved capitals at the abbey church of Sainte-Foy at Conques, and Roland and Charlemagne cycles became common in a variety of media for centuries. In Italy, they include a fresco cycle of the life of Charlemagne at the Roman church of Santa Maria in Cosmedin, commissioned in 1123 by the Burgundian pope Calixtus II and now sadly damaged. One scene pictured the king seated on a rock, holding a hand to his cheek and weeping a pool of tears as Baoduin reports Roland's death to him.[43] The hand gesture was the conventional

[38] Gerard Giles Meersseman, *Ordo Fraternitatis: Confraternite e pietà dei laici nel Medioevo* (Rome: Herder, 1977), p. 97. See Treffort, *L'église carolingienne et la mort: Christianisme, rites funéraires et pratiques commémoratives* (Lyon: Presses universitaires de Lyon, 1996), pp. 114–15.

[39] Elizabeth Valdez de Alamo cites "Chronicón de D. Pelayo," in E. Flórez, *España sagrada*, vol. 14 (Madrid: Pedro Marín, 1786), p. 475. See J. Filgueira Valverde, " 'El planto' en la historia y en la literatura gallega," *Cuadernos de Estudios Gallegos* 4 (1945): 518. See Elizabeth Valdez del Alamo, "Lament for a Lost Queen: The Sarcophagus of Doña Blanca in Nájera," in *Memory and the Medieval Tomb*, ed. Valdez del Alamo with Carol Stamatis Pendergast (Aldershot, U.K.: Ashgate, 2000), pp. 43–79.

[40] See Arthur Kingsley Porter, *Spanish Romanesque Sculpture*, 2 vols. (New York: Hacker Art Books, 1969), 1:94 n. 107, 2:24, 30.

[41] Valdez del Alamo, "Lament for a Lost Queen."

[42] This discussion is based on Rita Lejeune and Jacques Stiennon, *La Légende de Roland dans l'art du Moyen Age* (Brussels: Arcade, 1966), trans. Christine Trollope as *The Legend of Roland in the Middle Ages* (New York: Phaidon, 1971), 2 vols.

[43] See Lejeune and Stiennon, *Légende de Roland*, 1:47–48. The scene was sketched while still visible by G. B. Giovenale, *La Basilica di Santa Maria in Cosmedin* (Rome: P. Sansaini, 1927), fig. 66, p. 231.

depiction of sorrow and directly evokes contemporary images of Mary and John at the Crucifixion. A sketch of another lost work, a mosaic pavement from Brindisi, probably dated 1178, depicts a very different gesture. Roland, leaning heavily forward, elbow on his sword, hand to his face, pauses wearily in the fighting to grieve at the death of Oliver.[44]

LAMENTS IN THIRTEENTH-CENTURY ITALY

There is some modest evidence for laments in thirteenth-century Italian towns, though much of it describes not funeral ritual but purportedly spontaneous laments, reactions to the discovery of a tragic death. There is a lament in a description of the 1199 murder in Orvieto of the papal rector, Pietro Parenzo. Parenzo was a controversial appointment sent by Innocent III to extend papal authority and combat Cathar heresy in the town. The account of his murder by Cathars was written by a member of the cathedral chapter called Master John, in a failed effort to get Parenzo canonized as a martyr. The author underscored the demonstrative sorrow of the whole community. When Parenzo's corpse was found, he wrote, the Orvietans literally howled with grief at the death. "They cut the sleeves off their clothing, rent their garments, and beat their breasts with their fists. Men as well as women tore their hair out by the roots."[45] This portrayal accords with Boncompagno da Signa's contemporary description of lamentation in the region: he commented that Tuscans—a group that included Orvietans—scratch their faces, tear their clothing, and rip out their hair.[46]

The display of grief expressed what the community thought of the dead: the mourning of the Orvietans measured Parenzo's value to them. Master John, campaigning to get Parenzo canonized, emphasized the grief of the innocent, namely virgin girls and babies. All the virgins, he writes, were

[44] See Lejeune and Stiennon, *Légende de Roland*, 1:99; the image, printed in vol. 2, fig. 72, is enlarged and reproduced from a sketch by H. W. Schultz; they cite his *Denkmaler der Kunst des Mittelalters in Unteritalien* (Dresden, 1860), p. 305, plate 45, fig. 2.

[45] "Vestimentorum amputabant manicas, et vestes scindebant, pectora sua pugnis fortiter ferientes. Capillos suos tam viri quam mulieres radicitus evellebant. Omnes virgines squalidae amaritudine sunt oppresse. In cunis jacentes, ululabant infantes, parentum suorum tristitiam intuentes. Viae civitatis Urbevetanae lugebant, eo quod non erat eis festivitas neque gaudia consueta." *San Pietro Parenzo: La Leggenda scritta dal maestro Giovanni canonico di Orvieto*, ed. Vincenzo Natalini (Rome: Facultas Theologica Pontifici Atheniae Seminarii Romani, 1936), 165.

[46] "In Tuscia fit excoriacio vultum, pannorum scissio, et evulsio capillorum." Boncompagno, *Antiqua rhetorica*, in *Briefsteller und Formelbucher des elften biz vierzehnten Jahrhunderts*, 2 vols., ed. Ludwig Rockinger (Munich: Auf Kosten der K. Akademie druck von J. G. Weiss, 1861), 1:141–43.

covered with bitter funerary gloom, and infants lying in their cribs howled, sensing the sorrow of their parents. The streets of the town were filled with grief rather than the customary festivity. The author perhaps intended this florid picture to counter the evidence for Parenzo's unpopularity with many locals, due probably to his imposition of heavy exactions in pursuit of heresy. Master John admits in his account of Parenzo's early miracles that some people, heretical sympathizers, openly rejoiced when he was killed. Master John's stress on the grief of the innocent—virgin girls and babies in their cradles—hints that those who did not grieve were guilty.[47]

A few records offer a glimpse of spontaneous displays of grief at accidental death or homicide: how people reacted when they found someone they knew dead. Such displays are termed *planctus*. They are common in accounts of the miracles of the saints, where they serve to describe the horror and misery that existed before the saint performed the miracle that restored the dead to life. They are not funerary rituals comparable to the corrotto mentioned in the statutes and judicial sentences but nevertheless depict conventional cries and gestures used to react to death.

In 1240, laments were described by Orvietan witnesses to the miracles of the Franciscan healer Ambrose of Massa. Again, the text was part of a campaign to get Ambrose canonized. These brief, rather formulaic accounts derive from the statements of witnesses that were collected shortly after the friar's death. In effect, they are short redactions of what people actually said about moments of intense emotion, when they feared the deaths of their young children. One case is a moment when a child fell from a palace window. His father raced down to the street, picked up his son's lifeless body, and began to wail and to call on the aid of the blessed Ambrose, and "many people came to the planctus."[48] Neighbors gathered and touched the dead child and grieved along with the father. For example, Iemma Ugulini de Castello explained that she knew the child was dead because she saw and touched it, and the father and other people standing around wept for the dead boy.[49] Then, they testified, Ambrose miraculously restored the boy to life. Again, madonna Gratia, a notary's wife, mentioned that when many of her neighbors came to the planctus for her boy, they saw her collapse while she was holding the child in her arms.[50] Other episodes were similar, suggesting that the expected reaction to tragic death was noisy, ritual wailing.

[47] Carol Lansing, *Power and Purity: Cathar Heresy in Medieval Italy* (New York: Oxford University Press, 1998), pp. 29–37.

[48] "Processus canonizationis B. Ambrosii Massani," *AASS* 66 (10 November): 578 D.

[49] "quia vidit et tetigit eum mortuum et tam pater quam et alii de adstantibus puerum mortuum plorabant." "Processus . . . Ambrosii," 579 A.

[50] "Processus . . . Ambrosii," 607 C; see also 604 E.

Neighbors and kin—men and women—gathered together in the street to wail and grieve, to touch the dead child.

Other miracle stories include similar laments. One example is a tale from the life of Dominic written by Theodoric of Appoldia around 1290. It was probably one of the stories told to Theodoric by Sister Cecilia of Rome, a woman Dominic admitted to the order. This means that Theodoric's source for the story was a woman who may well have been present at the event. One day when Dominic was in a chapter house with the abbess and nuns in Rome, "behold a certain man, wailing and tearing out his hair, exclaimed, lamenting in a horrible voice, 'Alas, alas.' "[51] Everyone was terrified and asking what had happened. The man answered that the nephew of Stefano Orsini had fallen from his horse and was dead. The unnamed man's violent display of grief was again a measure of the importance of the dead noble and the tragedy of his accidental death. Luckily, Dominic was at hand and stepped out into the street, consecrated the Host, and brought the young man back to life.[52]

Illustrations of the miracles of the saints often show these spontaneous laments. Simone Martini and his studio painted four of the miracles of the Blessed Agostino Novello in which the saint restored accident victims to life. Three of the four victims in the painting are young children: a baby dumped by a broken cradle, a child mauled by a dog, a child fallen from a balcony.[53] The scenes show the parents first crying out in shock and grief, then praying in gratitude at the miracle. As the child falls from the balcony, a woman with loosened hair looks down, her face contorted as she apparently wails, and a cluster of men gather in the street. They gaze in amazement as the saint swoops down to rescue the boy. The woman's face expresses grief and horror; the onlookers wonder at the power of the miracle. Another scene, the death of the Knight of Celano from the upper church of San Francesco in Assisi, depicts grief at a sudden death. The knight, who had been dining at table, has fallen lifeless to the ground, and a group gathers to mourn: women with unbound hair clasp their hands and claw their cheeks in shock and sorrow.

[51] "Cumque Vir sanctissimus cum illis venerabilibus patribus in medio capituli resideret, domina quoque abbatissa cum monialibus adstaret, ut hoc opus a Domino gestum, secuturum mox miraculum declararet, ecce vir quidam ejulans, & sibi capillos extrahens, voce horribili lamentabiliter exclamavit: Heu! Heu! Exterritis omnibus & requirentibus, quid haberent, respondit: Nepos domini Stephani de equo cecidit, & mortuus est." "Acta Sancti Dominici," by Theodoric of Appoldia, chap. 7, part 89, *AASS* (first August volume): 579 B–D.

[52] The Bollandist editors noted that the story is not mentioned in earlier accounts, implying that it probably derived from the information Sister Cecilia gave Theodoric. In the Prologue, part 4 (563 A), Theodoric mentioned that Sister Cecilia of Rome, whom Dominic had admitted to the order, told him of some of the great deeds of the saint.

[53] See Alessandro Bagnoli, *Simone Martini e "chompagni,"* catalog of a show from Siena, Pinacoteca Nazionale, 27 marzo–31 ottobre 1985 (Florence: Centro Di, 1985), pp. 56–61.

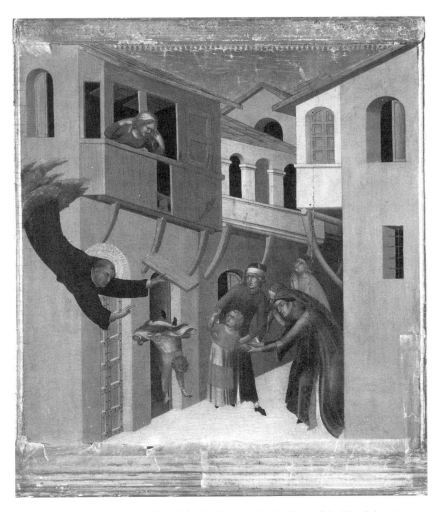

A spontaneous lament at an accidental death. Simone Martini. *Panel of the Blessed Agostino Novello: Miracle of the Baby Falling from the Balcony*. 1324. Pinacoteca Nazionale, Siena. Photo credit: Scala/Art Resource, NY.

Contemporary records from civic courts also mention laments at the discovery of a death. Grief could be a measure of guilt or innocence. Thirteenth-century inquests into deaths survive, not from Orvieto but from Perugia and Bologna. They resemble in some ways inquiries into miracles, although the point was to identify not a saint but rather a murderer. When a suspicious death was reported, court officials went to the place where the death had occurred and held an inquest in which they questioned witnesses and recorded abbreviated versions of their testimony. One obvious focus was the discovery of the body. Judging from the testimony, everyone's first reaction to death was

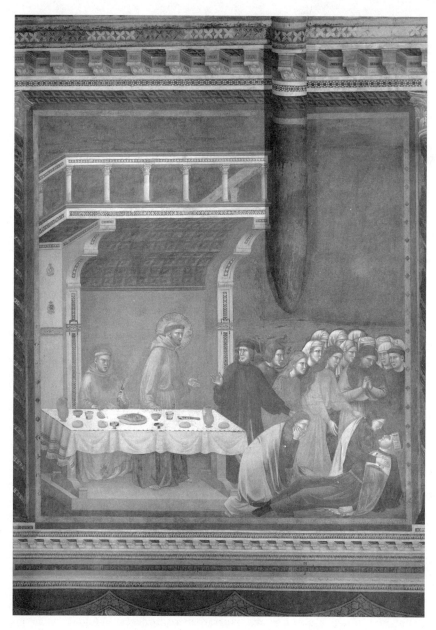

A lament at a sudden death. School of Giotto di Bondone. *The Death of the Knight Celano*.
1299. Upper Church, S. Francesco, Assisi. Photo credit: Erich Lessing/Art Resource, NY.

always loud cries and wailing. So, for example, in 1287 a woman named Maria was questioned about the death of Berta, the wife of her son, Rolandino. Judging from the testimony, Rolandino probably butchered Berta in their bed. Maria reported that she had heard Berta cry out something in the night that the recording notary rendered as "oimichi.vir mi." Maria leapt from her bed, dressed quickly, and went to their bedchamber. She found Berta dead from many wounds and began to clamor, weep, and cry out in a loud voice (incepit clamare et plorare alta voce), calling out to the neighbors to come. When Berta's brother-in-law Guidolino came, he began to weep loudly as well.[54] These laments were again rhetorical. Witnesses surely contrived their depositions to say what they wanted the court notary to record, and one excellent way to demonstrate that you are not the murderer is to make a loud outcry at the discovery of the body. However, depositions also had to be credible and to agree with what other people testified. An invented planctus would be particularly implausible because no one else would have heard it. Even so, the implication is that a loud lament was the expected response to a death. In this case, Maria certainly does not seem to have been reticent: her testimony directly incriminated her son, Rolandino.

A homicide case from the Bolognese countryside includes testimony that assessed grief as a measure of innocence. It is reasonably good evidence that men were expected to react to the death of a kinsman with a vocal show of grief. Defense witnesses were asked to describe the way a group of men reacted to the news of the death of two kinsmen. The issue was whether their grief meant that they were innocent of the deaths. One female witness stated that when Lorenzo, Pietro, and Simone heard about the two deaths, they were overcome with sorrow. How does she know? They wept and lamented when they heard the news, "said to each other how unhappy they were over the deaths and that they themselves were dead, and grieved much."[55] The trope that they shared in the deaths recalls the father's lament that his son's judicial torture had killed him as well. Another witness, a young woman who was a niece, was asked to describe their reaction. She said she saw them weep and grieve strongly (fortiter) and heard them curse those who had committed the homicides. Asked whether they faked this complaint and sorrow, she said she did not believe so, since the dead men were *consanguineos*, of the same blood.[56] A woman named Bona similarly reported that she certainly saw the men weeping, overcome, and grieving, and heard Lorenzo curse and

[54] ASB, Curia del Podestà, Inquisitionum et testium, Busta 10, 92 verso.

[55] ASB, Curia del Podestà, Inquisitionum et testium, Busta 47, I, 4. This testimony is 25–38 recto. I was unable to locate the case for which the testimony was recorded.

[56] "Interrogat si predicti faciebant dictam querimoniam et dolorem predictum fictitie et contra veritatem, respondit 'Ego credo quod non.' "

blaspheme those who had committed the crime, because he was distressed over the two men, since they were his kinsmen. In effect, loud grief at the death of someone of one's own blood was expected and therefore had to be sincere. Whether this circular reasoning actually convinced the court is unknown. Further, men were appropriately moved and distracted by grief. One witness, asked to state whether a particular man was present when his uncle was buried, responded by explaining that he was too moved to notice: "because I was distressed because of my uncle who was dead, I did not look to see who was present."[57] This could of course have been disingenuous, but he must have thought it a credible thing to say.

Another idea that turns up in court testimony is the obligation to attend a funeral. A fragmentary weapons inquest includes testimony in which a man mentioned his participation in a funeral, in the course of explaining to the court how it was that he saw a friend in public with an illegal knife. During the feast of the Assumption of the Virgin in August 1287, he was "called to go with the neighbors accompanying a corpse which was to be buried at San Martino" when he got in conversation with Benvenuto, the man who was accidentally caught with a knife.[58] He spoke also of going "to see the corpse buried." People had an obligation to join in a parish funeral procession, to see a neighbor buried.

There are a few incidental references from Bologna to male shows of grief in proofs that political exiles were dead and thus no longer able to comply with the law, recorded in 1285. These exiles were probably military men. As I mentioned in chapter 2, when a Fra Alberto sought to prove that his exiled brother, Ugolino, had been dead over a month, he produced a witness who stated that he had been at the corrotto and at the burial, and that more than fifty men had been present as well.[59] A witness to another death spoke of men weeping and then assuaging their sorrow. Summoned by a man named Passerino who needed to prove that his brother Petrizolo had died in Apulia over a year before, a witness named Bonaccorso stated that

> when he was traveling from Foggia toward Manfredonia, in the entrance to the city of Manfredonia he found two men from Bologna whose names he does not know. He found them weeping and crying out [plorantes], and then they said to him, "It is well you have come, Bonaccorso, we want you to take the news to Passerino that his brother Petrizolo is dead." And he said, "I do not want to carry that kind of news," and so they all went together to

[57] "Quia ego eram mestus de illa Nicola meo patruo qui erat mortuus quod non respiciebam quis esse illic."

[58] ASB, Curia del Podestà, Libri Inquisitionum et testium, Busta 11, 3, 13 recto.

[59] ASB, Capitano del Popolo, Giudici, 70, 89 recto–verso.

drink in a tavern. The lord priest of the church where he was buried came to them and said that Petrizolo had died well-disposed and had confessed his sins.[60]

This testimony reads more like the start of a novella than an account of actual events. Why would the two men have been weeping at the city gate just as he arrived? Why would they immediately ask Bonaccorso to carry the news home? And why would the priest come reassure them about the death in a tavern? Regardless of these improbable details, the testimony relies on the convention that men wept loudly at death.

Funeral display itself could of course have a rhetorical and political purpose. One irresistible example is the impressive funerals of Bolognese notaries, men who were themselves masters of rhetoric. The guild, which by the 1280s numbered over a thousand members, was governed by consuls and a council of two hundred, drawn from the four quarters of the town. All were at least thirty years of age. There was a formal expectation that they would attend each other's funerals. In July 1285, the council members were summoned at their houses to accompany the corpse of Stefano Storlitti to the funeral in the Dominican convent and then the burial. A guild official kept track of attendance, and the 83 no-shows were required to produce defenses or pay a 2-soldi fine.[61] All but 16 had credible excuses. This means that at least 117 men took part, a formidable show. We do not have records of earlier practice, and the first extant statutes date from a few years later. They require the nuncios to take part in funerals along with the preconsul, the consuls, and the society. Presumably, it was assumed that they would go. It is striking that the funeral took place in the political climate of the Ordinamenti Sacratissimi, when the Bolognese popolo, led by Rolandino Passageri, attempted to restrict the magnates from civic office. Huge guild funerals were a show of their power.

What have we seen? First, laments had social and political uses in medieval Italy, as elsewhere. Laments made statements about the living as well as the dead. Authors of saints' lives, like family historians, deployed laments rhetorically: they became a community comment, in Parenzo's case on the value of the dead saint, in the Orsini case on the value of Dominic's miracle. And in depositions in homicide inquests, they underscore the tragedy of the

[60] ASB, Capitano del Popolo, Giudici, 70, 35 verso.

[61] ASB, Società dei Notai, 25, 70 recto–74 recto. See Giorgio Tamba, *La società dei notai di Bologna*, Ministero per i beni culturali e ambientali, Pubblicazioni degli Archivi di stato, Strumenti 103 (Rome: Libreria dello Stato, 1988), esp. pp. 29–33 and 38–39. For the statutes, see Tamba, "L'archivio della società dei notai," in *Notariato medievale bolognese*, II, Atti di un convegno, Studi storici sul notariato italiano, 3 (Rome: Consiglio Nazionale del notariato, 1977), pp. 191–283.

death, the shock, and especially the innocence of the witness. Funeral liturgy and prayers did not replace laments: lay and clerical forms of remembrance of the dead existed, forms that were separate but parallel or perhaps intertwined. The laments of laypeople demonstrably could include not only women and family members but the household and larger community. There were moments in which women were supposed to play a special role in mourning, but it was more common, at least in the sources examined here, to portray the whole community as grieving. Mourning could be a statement both about the value of the dead and about the mourner: how you honor the dead can measure your character.

Second, men were supposed to show their emotions, weep and lament loudly, perhaps even tear at themselves. Epic poetry well known to thirteenth-century Italians depicted noble male laments as honorable and even politically necessary. One would hardly argue that the men in Orvieto were consciously imitating the heroes of the Roland stories. But it is significant that they knew these pictures of manly histrionic grief. Historical sources also suggest that noisy grief for lost kinsmen, comrades, and followers was important to male honor. When the Bolognese father lamented his son's torture and at least metaphorical death, no one suggested that he was acting in a dishonorable way. Rather, emotionality was an aspect of male identity. Although I have confined this study to medieval Italy, northern sources for monarchs at times contain this idea. The rebellious young king Henry, son of Henry II of England and Eleanor of Aquitaine, died suddenly of dysentery in 1183. The author of the *History of William Marshal* emphasized the extreme grief of the young king's male entourage, at some length. No greater lament is possible, the poet commented.

> Great was the lament and the sorrow
> surrounding the young king that day
> they flailed with their fists and cried out
> cursing death, and said
> Ha! Caitiff death
> traitorous thing
> what have you done?[62]

The poet's account is close to heroic male laments in contemporary epic.

[62]
> Grant fu la pleinte e la dolor
> Entor le giemble rei le jor
> Lor poinz detordent e si crient

Did the obligation to show grief differ by class? Given the fragmentary evidence, I cannot prove the point, but it was evidently a part of noble culture, linked to military identity. Urban elites were knights who showed their affection for fellow soldiers. If it was characteristic of nobles, why did artisans and others take part in the corrotto as well? And why pass laws banning the practice? The categories of gender theory offer one way to think about this question: the laws addressed the contradictions of what R. W. Connell would term "hegemonic masculinity."[63] That is, "the configuration of gender practice which embodies the currently accepted answer to the legitimacy of patriarchy": the behavior expected of men who claimed authority and cultural dominance. In thirteenth-century Italy, this meant gender norms for male nobles. Men in these families had practiced military behavior for generations and thought of their identity in terms of knighthood. They fought on horseback, and many were capable of military command. Corrado di Ermanno Monaldeschi, with his distinguished service as podestà and Capitano del Popolo, and his battlefield death, is a good example; Celle Miscinelli is another. They defined status and identity in terms of a courtly culture of military games, banqueting, and festivals. Judging from the Orvietan evidence, they were expected to engage in the corrotto, loud laments for their dead, especially adult sons. The closest record I have to an actual, spontaneous thirteenth-century lament is Pietro Ravignani's rage and sorrow for his son tortured on the rack by the Bolognese court. He described a close identification: to kill and dishonor his son was to do the same to him. To grieve loudly with him was more than a customary show of respect, something closer to participation in his sorrow. Knights like Corrado di Ermanno shared in each other's grief at the loss of a son, kinsman, or close ally. The practice underscored close ties among elites, a show of emotional solidarity that reinforced their status. It also could be a show of political solidarity.

These gender norms defined nobles and also were followed by men at lower social levels. Connell would say these men were "subordinated but complicit." Again, the Morichelli funeral included not only 43 noble mourners but 41 guildsmen—notaries, merchants, physicians, woodworkers, tailors, shoemakers—and another 35 men not identified by profession.

E blastengent la mort, e dient
"Ha! mort chaitive, chose glote Que faiz tu?"

L'histoire de Guillaume le Maréchal, 3 vols., ed. Paul Meyer (Paris: Librairie Renouard, 1891), 1: lines 6927–32.

[63] R. W. Connell, *Masculinities* (Berkeley: University of California Press, 1995), pp. 76–86. Thanks to Stephan Miescher for suggesting this approach.

Their choice to take part in the corrotto for a noble was a show of respect and a different kind of participation in the father's grief; some were probably clients. They followed knightly culture in other ways as well. In the thirteenth century, townsmen who earned their livings as butchers or furriers also fought for their communes, not always very effectively. Many of the men who grieved at the Morichelli funeral in the streets in Orvieto also personally served on horse or on foot in the civic militia. The mourning sentences date from just before the period when these roles diverged: nobles and hired professionals fought battles, and most citizens gave up the military. They might well enjoy chivalric titles and trappings, but they did not risk their lives in the civic militias. Their actions supported and honored, and to some extent shared, in a noble culture of emotionality.

Finally, masculinity and femininity are constructed together, and the tendency in the statutes to treat displays of mourning as female practice was part of a larger redefinition of gender expectations. I turn in the next chapter to historical antecedents for the idea that funeral grief is a display not of men's honor and solidarity but of the irrational passions of their wives and daughters.

CHAPTER FOUR

ANCIENT LAMENTS: SEXUALITY, RAGE, AND DOUBT

Along tradition in Western culture associates death and lamentation with women and female nature, a tradition evident in the medieval laws that sparked this book. Perhaps the oddest point about the Orvietan court cases was the discrepancy between what was said about mourning—statutes that termed lamentation something done by women—and what apparently took place, more than two hundred men fined for crying out and tearing their hair in the streets of the city. As I have suggested, one implication is that it is a mistake simply to assume that normative texts like the statutes give an accurate picture of practice: that is, that women rather than men lamented the dead, and that the thirteenth-century laws in Orvieto as in other towns restricted a public role played by women. Some medieval traditions did not assign mourning to women; often, in literature and in practice, a display of grief defined male honor. In late thirteenth-century Orvieto, demonstrative lamentation was expected of men from the knightly elite. There also are many accounts of households and communities, men and women, rich and poor, joining in noisy laments for the dead. But at certain historic moments, emotional displays of grief were associated with women and female nature. The miniatures in the Sacramentary from Ivrea are an example. The clerical artist portrayed a show of histrionic grief—forms of mourning banned in canon law—as something done not by a man but by a gesticulating woman.

What were the sources of the ideas about lamentation and gender at play in the thirteenth-century statutes? Many ancient authors associated women with lamentation for the dead in a variety of ways. The purpose of this chapter is to explore some of those texts, with an emphasis on ideas

that were available in the thirteenth century. The object is not to reconstruct ancient practice and find out when women did or did not play special roles in mourning the dead, a project well beyond the scope of this book. Nor does the chapter trace the history of the ancient association of women and grief, again a project that would be very ambitious. Instead, it is a look at moments when ancient writers and then Christian Fathers associated displays of grief with gender and problems of order. In what political circumstances did authors think about grief in this way? And how were these ancient views represented to people in the thirteenth century?

I have chosen to answer these questions with a series of historical and literary vignettes. I begin with a look at a powerful sermon from John Chrysostom, a sermon that encapsulates many influential ideas about the lament. Then I pursue a number of threads evident in the sermon, including grief and political order in representations of Solon's Athens and female sexuality, lamentation, and rage in Greek tragedy. I turn then to Rome to examine ideas about gender in the rational consolation urged by the late Stoic writer, Seneca, and Saint Jerome, who associated women's laments with religious doubt. Finally, I turn to the intriguing question of the early Islamic laws on funeral laments. My purpose is not to reconstruct aspects of these cultures on their own terms, a project best left to specialists. Rather, it is to look at ancient ideas about women and grief and the texts in which they became available to the thirteenth century.

JOHN CHRYSOSTOM: GENDER AND RELIGIOUS DOUBT

John Chrysostom, the great Christian rhetorician of late fourth-century Antioch, preached diatribes against mourning. In one extraordinary sermon, he took as his text the story of the raising of Lazarus. As the story is told in the Book of John, when Jesus returned to his friends Martha and Mary in Bethany after the death of their brother, Lazarus, he comforted Mary with the promise of resurrection: "I am the resurrection and the life: he that believes in me, though he were dead, yet shall he live" (John 11:25). Then, troubled by the grief of Mary and the community, Jesus first wept and then went to the tomb and brought Lazarus back from the dead. John Chrysostom rather incongruously chose this story of sympathy and shared grief for a sermon attacking immoderate female mourning. He preached,

> Truly, here along with other evils the disease of women is revealed. For in the lament and in mourning they display themselves: they bare their arms,

tear their hair, lacerate their cheeks. Some women do this from grief, others to show off, yet others with a shameless spirit bare their arms while men are watching. What do you do, o woman? You strip yourself disgustingly in the middle of the forum, you who are a member of the body of Christ, and this in the forum in the presence of men? You pluck out your hairs, you tear your clothing, you give forth loud ululations, you dance around in a ring in the very image of the maenads, do you not think you offend God? What is this insanity?[1]

Dramatic mourning is insane, an offense to God. The disorderly gestures and passionate cries of public grief are an aberration. Mourning is also a "disease of women." The motives for these actions are suspect: females may seize the opportunity of a funeral and gestures of grief for ostentation and even sexual display. Chrysostom linked public mourners with the maenads, female followers of Dionysius who in a wild, sexual frenzy not only danced in a ring but tore living creatures limb from limb.

Chrysostom went on to describe the religious implications of these mourning practices, expressed in terms of the derisive reaction of unbelievers:

Do the gentiles not laugh? Do they not think that our beliefs are mere stories? For they say, "There is no resurrection, rather, Christian teachings are ridiculous frauds and fallacies. These women grieve before them as if nothing was to be after this life. They take no heed of their own Scriptures. All these things are fictions, as the women attest. If they believed that he who has died is not truly dead but translated to a better life, they would not grieve for him as if he had not already crossed over, they would not tear at themselves, they would not utter cries filled with disbelief: 'I will see you no more; I will not regain you.'" All these teachings are mere stories, according to them. If they do not believe in that which is the source of all good, so much the less will they believe the rest.

Gentiles laugh because these feminine actions directly deny the resurrection, the Christian promise of eternal life.

The appropriate Christian response to death, Chrysostom preached, even for women, is masculine and philosophic: "The gentiles are not so effeminate; many among them are philosophic. A gentile mother, hearing of

[1] John Chrysostom, *Patrologiae cursus completus. Series Graeca*, ed. Jacques-Paul Migne (Paris, 1857–66; electronic reprint, Cambridge: Chadwyck-Healey, 1996–2005) (hereafter *PG*), vol. 59, sermon 62a, cols. 346–47. My readings and translations are based on the Latin translations in the *PG*.

the death of her son in battle, immediately asks how things went for her country. . . . Spartan women exhort their sons to return from battle with their shields, or carried dead upon them." Chrysostom thus set up an opposition between the measured calm of the philosopher and effeminate, disorderly grief. And even women, or at least gentile women, are capable of the masculine, tempered response. The examples he mentioned are mothers who value the needs of the state over their affection for their sons. Wealthier Christian women also temper their grief, he says, but do so not from piety but from shame. He is ashamed, he says, that pagans can be philosophic while Christians act in such a dishonorable manner.

Why the intensity of this attack on mourning? Chrysostom preached in a rhetorical tradition that relied on exaggeration and invective. His fierce tone reflected his fears for a religious community he considered embattled, besieged by Arian heretics, by the ubiquity of pagan culture, by the popularity of Jewish practices. As Robert Wilken has shown, these were real threats. The ultimate triumph of Nicene Christianity was by no means evident in the late fourth century.[2] A powerful Arian movement persisted in Antioch. Pagan ceremonial still structured everyday life. The memory of the emperor Julian was fresh. In 362, as part of his effort to revive paganism and defeat Christianity, which he considered atheism, Julian multiplied animal sacrifice in Antioch. In Antioch, elite education, civic ceremonial, the very calendar, even the decorative mosaics in peoples' homes, all showed the continuing vitality of paganism. Antioch also included wealthy Jewish families; firmly and distinctively Jewish, they were, as Wilken shows, educated, influential, and very much at home in Hellenic culture.[3] Some Christians were drawn to Jewish festivals and adopted Jewish customs: as Wilken writes, they "forsook the cheerless moralizing of Christian preachers to go to the synagogue or the homes of the Jews to celebrate Rosh Hashanah or Passover."[4]

Chrysostom thus feared the loss of Nicene Christians to Arianism, Judaism, and paganism. His attacks on excessive mourning stressed defense of the faith from these threats. He returned to the topic again and again in his sermons: "When I see the lamentations which they make in the forum over those who have died, the ululations, the other indecorousness, then, I am ashamed before the Greeks, Jews, and heretics watching and laughing at us because of it." The lament was a public denial of immortality: "The

[2] Robert Wilken, *John Chrysostom and the Jews: Rhetoric and Reality in the Late Fourth Century* (Berkeley: University of California Press, 1983), pp. 10–16.

[3] Ibid., chap. 2.

[4] Ibid., p. 67. As Wilken points out, Chrysostom's attacks were directed not against the Jews but against Judaizing Christians.

Gentiles attend not to what I say but to what you do."[5] Unbelievers concluded from these funerals that Christians do not believe their own teachings. Chrysostom voiced this Gentile reaction to his listeners: "If [Christians] believed that he who has died is not truly dead, but translated to a better life, they would not grieve for him as if he were not already crossed to the other side, they would not tear at themselves, they would not utter cries filled with disbelief: 'I will see you no more; I will not regain you.' "[6] Chrysostom's attacks on mourning ultimately addressed not Jewish or pagan laughter but Christian weakness and doubt. The underlying concern was not only whether Christians acted in ways consonant with their faith in the presence of pagans and Jews, but whether they themselves truly believed that faith, or whether they doubted life after death.

Chrysostom urged instead of lamentation an ecstatic vision of death as transformation. In a powerful sermon on death, he constructed a dialogue of consolation with a father grieving for the loss of an only son: "But the dead, you say, rot and become dust and ashes. From this only the greatest joy should result . . . just as when an old house is demolished and a more splendid one rebuilt. . . . God acts in the same way; when our body is to be destroyed, he leads forth the soul inhabiting it as if from a house, so that he can construct another more magnificent work and place the soul there with greater glory."[7] Chrysostom was acutely sensitive to the importance of funerals for status and honor. He urged not an end to funerals but a new emphasis, replacing grief with lavish displays of compassionate charity for the poor.[8]

By feminizing mourning, Chrysostom equated Christianity with the measured calm of the philosopher: it was a rational, moderate faith appropriate for the curial class. Chrysostom's misogyny was painful and at times cruel: he honored a father's sorrow but belittled the grief of an impoverished widow for the loss of her only son.[9] His attack on female grief served a crucial purpose: it made doubt shameful, and Christian practice honorable and philosophic. The equation of mourning display with women shamelessly showing their flesh to men in the marketplace made laments deeply dishonoring. Grieving wives and daughters were not honoring the dead but behaving like prostitutes. The man who allowed a wife to act in this way exposed

[5] *PG* 63, sermon 4, col. 43.

[6] *PG* 59, sermon 62a, cols. 346–47.

[7] *PG* 63, sermon 31, col. 803.

[8] On Chrysostom's compassion for the poor, see Peter Brown, *The Body and Society* (New York: Columbia University Press, 1988), pp. 309–11.

[9] This attitude may reflect his own experience: he was initially restrained from joining Christian monks in the desert by the needs of his widowed mother. See Wilken, *John Chrysostom*, p. 9.

himself to sexual dishonor. And the man who doubted the soul's immortality was behaving like his wife. Chrysostom's discussion of mourning, then, equated the religious doubt that led some Christians to turn to paganism or Judaism with female unreasoning passion and with sexual dishonor.

ATHENIAN POLITICS AND THE DISPLAY OF GRIEF

The tendency to think about uncontrolled, dangerous emotions in gendered terms was linked to the ancient Greek association of irrationality with female nature. One starting point is Greek funeral statutes, which emphasized the restraint of women. A number of Greek cities imposed restrictions on mourning and funerals, laws that in many ways parallel the late medieval Italian statutes. Their real nature and purpose have been much debated. The sources that mention them date from the late fifth or even fourth and third centuries B.C.E. Some scholars attribute them to the archaic period and to Solon's efforts to establish democracy in Athens, on the theory that the laws were an effort to control aristocratic display.[10] In the fifth century, the city of Ceos ruled that only the closest female relatives of the dead and up to five cousins or nieces—who are termed in the law "the polluted ones"—could go the house of the dead at the start of the funeral procession. Funeral processions were to be silent, and women were to leave the grave before men.[11] The Athenian law is similar: the ritual in which the corpse was laid out for last greetings was to take place inside the house rather than in a public place and was to be limited in duration. Only women who were elderly or close kin could take part in the procession, and only close kin could join in the beginning of the procession.[12] Scholars

[10] On this attribution, see Nicole Loraux, *Mothers in Mourning*, trans. Corinne Pache (1990; Ithaca: Cornell University Press, 1998), p. 19n. M. Alexiou, *The Ritual Lament in the Greek Tradition* (Cambridge: Cambridge University Press, 1974), pp. 15–16, ascribes the law to Solon. Loraux cites C. Ampolo, "Il lusso funerario e la città arcaica," *Annali dell'Istituto orientale di Napoli* 6 (1984): 92–94.

[11] Loraux, *Mothers*, pp. 21–22. She cites F. Sokolowski, *Lois sacrées des cités grecques* (Paris, 1969), 97. An English translation appears in *Women in Greece and Rome*, ed. Mary R. Lefkowitz and Maureen B. Fant (Toronto: Samuel Stevens, 1977), pp. 18–19, which cites Athenian funeral law, syll. 1218.

[12] See Roger Just, *Women in Athenian Law and Life* (London: Routledge, 1989), p. 198. He cites Demosthenes 43 [Makartatos]: 62; Loeb translation, modified. For a recent "more sanguine view of female status and power" in Athenian death ritual, see Karen Stears, "Death Becomes Her: Gender and Athenian Death Ritual," in *The Sacred and the Feminine in Ancient Greece*, ed. Sue Blundell and Margaret Williamson (London: Routledge, 1998), pp. 113–27.

have suggested that these rules were part of an effort to limit public display. An explicit prohibition of all non-kinswomen except the elderly suggests the idea that female mourning was perceived in sexual terms, since only women past menopause could take part. Women under age sixty were banned from the chamber of the dead and the procession unless they were close kin, and they were not to lacerate themselves or to wail.[13] S. C. Humphreys has argued that these laws targeted not women per se but rather women used as a medium of display. In her view, the laws sought to limit public funerals that could serve as the occasion for an aristocratic show of power.[14] This recalls the argument that the medieval Italian statutes were intended to forestall vendettas. Grieving kinswomen could whip up a family to respond to an attack with disproportionate action. Public mourning by women could be a political threat, a challenge to the fragile authority of the city government. Sophocles articulated this conflict in *Antigone*, in which mourning expresses the values of the aristocratic kin group, fundamentally opposed to the new democratic state. He also unforgettably portrayed it in terms of men and women: it is the young woman Antigone who is outside the democratic community and stands for the values of the kin group. Her mourning is not a rebellion. Rather, it is in obedience to "the gods' unwritten and unfailing laws" that she defies the political laws of the city and buries her brother with honor.[15]

Nicole Loraux has pointed out that Antigone's action was not a rebellion but a customary obligation. She reads the laws somewhat differently, arguing that the creation of what was considered a democratic system, in which a large proportion of people played some role in political life, required the removal of women from public life. Women embodied qualities that threatened order. The political community was to be a community of men.[16] The perception of a need to limit women's mourning derived from the Athenian notion of the irrationality of female nature, "women's endowment with those characteristics inimical to ordered life."[17] The extreme examples of female disorder are the nightmare creatures of Greek myth, all savage, uncontrollable, and feminine: the Harpies, the Furies, Medusa.[18] Laws on female mourning were a response not only to displays of aristocratic power

[13] S. C. Humphreys, *The Family, Women, and Death: Comparative Studies* (London: Routledge & Kegan Paul, 1983), p. 85.

[14] See ibid., pp. 85–86; Alexiou, *Ritual Lament*, pp. 21–22.

[15] Sophocles, *Antigone*, line 455. On feminist analysis of Antigone, see Page duBois, "Antigone and the Feminist Critic," *Genre* 19 (Winter 1986): 371–83.

[16] See Loraux, *Mothers*, pp. 9–28.

[17] See Just, *Women*, esp. chap. 9; the quotation is p. 218.

[18] Just cites John Gould, "Law, Custom, and Myth: Aspects of the Social Position of Women in Classical Athens," *Journal of Hellenic Studies* 100 (1980): 38–59.

but to the "disruption caused by women's lamentations, the threat they pose to the good order—indeed to the very survival—of society by their introduction of the unrestrained, the emotional, the illogical."[19] The rational self-control needed for an orderly political community was equated with male nature, opposed to emotional display, considered to be female.

Philosophers developed these associations. Plato's account of the death of Socrates in the *Phaedo* became for ancient and medieval authors the paradigmatic account of a rational, philosophic death. Plato neatly gendered responses to the death. When Socrates drank the hemlock, "Apollodorus, who even earlier had been continuously in tears, now burst forth in such a storm of weeping and grieving that he made everyone present break down except Socrates himself. But Socrates said: What a way to behave, my strange friends. Why, it was mainly for that reason that I sent the women away, so that they shouldn't make this sort of trouble."[20] It was of course not a woman but the young man Apollodorus who wept and wailed. When they heard his words, they were ashamed and restrained their tears. Tears and loud outcries—and the implied fear of death—were shameful, cowardly, and feminine.

In the *Republic*, Plato argued explicitly for the political value of ascribing lamentation for the dead to women. The discussion is in the context of the need to inculcate bravery in the Guardians, future mathematician rulers of the ideal state. Plato brought together the idea of mourning as a political threat with the suspicion that dramatic mourning makes unacceptable statements about death. He advocated excising from the poetry read by children "the wailings and lamentations of the famous heroes." These were the laments of warriors for fallen friends and comrades, such as the passage in the *Iliad* in which Achilles weeps, wails, and pours ashes on his head at the death of his beloved Patroklos. These actions by heroes, Plato argued, imply to the children who read them that death is a fearful thing. Plato's solution was again to gender mourning: "We shall do well, then, to strike out descriptions of the heroes bewailing the dead, and make over such lamentations to women (and not to women of good standing, either) and to men of low character, so that the Guardians we are training for our country may disdain to imitate them."[21] Lamentation teaches fear of death, an attribute Plato considered undesirable in a ruler. The way to avoid timid Guardians was to make lamentation dishonorable, something done by low-status women and disreputable men.

[19] Just, *Women*, p. 198.

[20] Plato, *Phaedo*, trans. David Gallop (Oxford: Oxford University Press, 1993), 117d, p. 78.

[21] Plato, *Republic*, book II, 383–87. *The Republic of Plato*, trans. F. M. Cornford (Oxford: Oxford University Press, 1945), pp. 76–78.

When the Greek historian Polybius (d. 122 B.C.E.) sought to characterize the Roman Republic, he similarly stressed the rhetorical power of honorable funerals to instill values. The ritual procession to the Rostra, the display of official insignia, and the funeral oration serve to stress not only the accomplishments of the dead man but those of his ancestors. This "constant renewal of the good report of brave men" makes their fame immortal, their renown "a matter of common knowledge and a heritage for posterity. But the most important consequence of the ceremony is that it inspires young men to endure the extremes of suffering for the common good in the hopes of winning the glory that waits upon the brave."[22] This is why Romans place the needs of the state over self and family. They will volunteer for certain death in battle to save their countrymen; they will deliberately sacrifice their own flesh and blood in the interests of their country. His example is Horatius at the bridge; in Polybius' version, Horatius drowned.

Plutarch discussed the Athenian funeral laws in the *Life of Solon*, written between 105 and 115 C.E., centuries after they were enacted. The *Lives* were well known in the ancient world, although not available in the medieval period. Plutarch set the Athenian mourning laws against the background of Solon's efforts to control social disorder and create a stable democracy. His account parallels in striking ways the medieval Orvietan efforts to control disorder through legislation. Plutarch reports that Solon sought to restrain not only female mourning but marriage and the transmission of wealth, intemperate speech, and immigration. This endeavor recalls the efforts by legislators in late medieval Italian towns: the way to create an orderly community is to restrain inappropriate forms of passion. Several laws, according to Plutarch, defined marriage as intended for procreation and not for profit. At marriage, the bride was to eat a quince (apparently an aphrodisiac) and be shut up in a chamber with the bridegroom. There was a ban on dowries and penalties for inappropriate marriages, especially those with large age discrepancies, since the purpose of marrying is not to gain wealth. To this end, Solon allowed heiresses to choose a consort from their husband's kinsmen; Plutarch says this practice was intended to discourage men from marrying for money. A husband was to have sex with his wife three times a month without fail; "leaving aside the issue of procreation, the husband is thereby indicating that he respects his wife for her self-restraint and feels fond of her."[23]

[22] Polybius, *The Rise of the Roman Empire*, trans. Ian Scott-Kilvert (Middlesex, U.K.: Penguin Books, 1979), 6:53.

[23] Plutarch, "Solon," in *Greek Lives*, trans. Robin Waterfield (Oxford: Oxford University Press, 1998), p. 64.

Solon legislated against speaking ill of the dead, who should be regarded with piety, or making an intemperate, angry speech about a living person, in courts of law, temples, or festivals. A law on testamentary bequests facilitated the rational transmission of property. Solon made gifts to friends possible but, Plutarch tells us, not indiscriminate gifts made when a man's reason was weakened, for example, during an illness or as a result of coercion or a woman's coaxing. Another law addressed the problems created because people from all parts of Attica were driven by need to move into Athens and thus "contaminate the city with a mass of foreigners." Dante's Cacciaguida echoed this idea in the *Paradiso* when he blamed the ills of Florence on "la confusione delle persone," the mingling of different peoples and classes. Like the Orvietan consuls, Plutarch understood social disorder in Solon's Athens in terms of intemperance, greediness: venal rather than procreative marriages, angry speech, coerced bequests.

It is in the context of intemperance and social disorder that Plutarch located Solon's controls on women. The law was designed to "impose conditions of neatness and orderliness on women when they were outdoors, and also on the way mourners expressed their grief and on the conduct of festivals."[24] It limited women who were out of the house from wearing elaborate clothing, carrying costly food, or going out at night unless on a cart with a lamp. Then, Plutarch writes, Solon "banned mourners from lacerating themselves and using set dirges, and outsiders from lamenting at others' funerals." He also banned expensive show at funerals, including the sacrifice of a cow and lavish funeral dress.[25] Like Plato, Plutarch neatly distinguished between gendered analysis of behavior and the actual roles of men and women. He commented on Solon's laws from the perspective of his own society, Athens in the first century C.E.: "Most of these practices are also banned in our laws, but ours also state that offenders are to be punished by the Superintendents of Women, on the grounds that they are indulging in unmanly and effeminate feelings and faults."[26] Men do give themselves over to immoderate gestures of grief. When they do so, they are behaving like women and therefore are to be treated as women. This is precisely the logic of the medieval Orvietan lawmakers. We first learn from the law that women grieve in immoderate gestures. Then we learn that in practice men grieve in this way. Therefore, we conclude that men are shamefully behaving like women. I do not know whether this account might have indirectly influenced thirteenth-century authors, but the parallels are both striking and revealing.

[24] Ibid., p. 65.
[25] Ibid., p. 66.
[26] Ibid.; see the discussion in Loraux, *Mothers*, p. 23.

Another thread in Chrysostom's sermon is the tendency to eroticize female grief and to link it with destructive rage. Loraux has written a series of brilliant studies of Athenian understandings of gender, based on the tragedies. She argues that when the Athenians removed grieving women from funerals, they represented them on the stage. Mourning was subversive because it was closely linked to violent rage, typified by a bereaved mother's outburst of destructive fury. Grief can become an explosion of wrath and then horrific revenge. Murder in Greek tragedy, after all, is a woman's crime. Medea, "the ingenue who is also a serial killer," is the exemplar.[27] Medea murders her male relations, literally dismembers her sons. Grief and rage were linked in the medieval visual arts. Images of the Sins used the gestures associated with grief to express Ira, anger. An eleventh-century manuscript depicts Rage tearing her hair as an attendant rends his clothing.[28] A twelfth-century Tree of Vices includes luctus, the lament, as one of the fruits of rage.[29] In the early fourteenth century, Giotto represented Ira, Rage, in his cycle of frescoes in the Arena Chapel in Padua. Anger is portrayed by a woman leaning backward as she tears open her clothing at the breast, mouth twisted open.[30] The same gesture could indicate extreme grief: a woman in the contemporary Massacre of the Innocents scene in the lower church at Assisi rends her clothing in the same way at the death of her child, as does an angel in Giotto's fresco of the Crucifixion in the Arena Chapel.

Grief and female erotic passion were often linked. As Loraux points out, Greek tragedy ascribed the eroticism of grief to women, typified in the disturbing image of a bereaved mother longing for the body of her dead son. When Plutarch wrote to his wife consoling her for the loss of a young child, he emphasized not only that mourning is disorderly but that it is a form of unrestrained erotic passion. He likened the extravagance of female grief to the wild rapacity of the maenads. "It is not only in Bacchic revels," he writes, "that a good woman should avoid corruption; she should also realize that the distress and emotional disturbance of mourning stands in

[27] Ruth Morse, *The Medieval Medea* (Cambridge: Cambridge University Press, 1996), p. 186.

[28] See Adolf Katzenellenbogen, *Allegories of the Virtues and Vices in Medieval Art* (London, 1939; reprint, Toronto: University of Toronto Press, 1989), fig. 12.

[29] Ibid., fig. 66.

[30] See Giuseppe Basile, *Giotto: The Arena Chapel Frescoes* (London: Thames & Hudson, 1994).

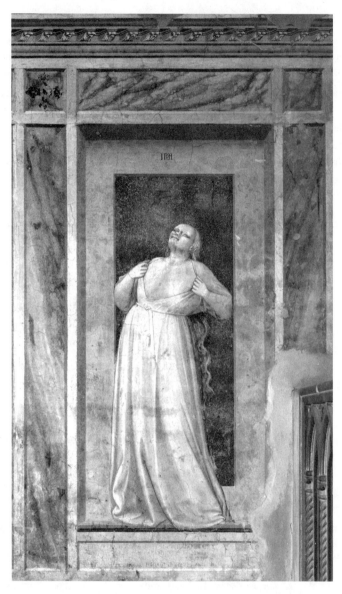

Giotto di Bondone. *Rage*. 1303–6. Arena Chapel, Padua. Photo credit: Alinari/Art Resource, NY.

need of control, not in order to resist feelings of affection, but to resist license." He praises her for restraint: "We freely indulge our affection in desiring, honoring, and remembering the dead; but the insatiable craving for lamentation that leads to wailing and beating the breast is no less undignified than incontinence in pleasure."[31] Lamentation is not an expression of honorable affection but rather shameful excess, close to Bacchic indulgence. As we saw, the Christian preacher Chrysostom developed the association with female sexuality when he preached against the lament. When a woman grieves, she displays her body to men. In some ancient texts, funerals were occasions in which men assessed young women's looks. Another theatrical example is Terence's *Phormio*, in which a male character admires a young girl he spots lamenting the death of her mother. She is lovely, he considers, despite her unkempt appearance, disheveled hair, naked foot, foul dress.[32]

Female grief as erotic display became a standard image in medieval romances. In Chrétien de Troyes' *Yvain*, written between 1169 and 1173, the hero butchers the lord of a town and then peeks through a window at the widow's display of sorrow. Yvain falls in love as he watches her violent gestures of grief: "I grieve for her beautiful hair, which surpasses pure gold as it glistens; it kindles and inflames me with passion when I see her tearing and pulling it out; nor can it ever again dry the tears that flow from her eyes."[33] He goes on to describe his amorous reaction as she mutilates her face, clutches her throat, beats and claws her breast. His sudden passion is a convenient one, since the town is actually hers and when he marries her he gets her lands as well. The widow's grief becomes a display of her desirability. In *Erec and Enide*, composed around 1170 and considered the earliest Arthurian romance, Chrétien used a false death to set up another lament as erotic display. Enide sees her wounded husband, Erec, fall from his horse and concludes that he is dead: "she ran to him, not hiding her sorrow, shrieking, wringing her hands, ripping away her dress and baring her breast, tearing

[31] Plutarch, *Moralia*, 608 F–609 A; see Plutarch, "A Consolation to His Wife," trans. Donald Russell, in *Plutarch's Advice to the Bride and Groom and A Consolation to His Wife*, ed. Sarah Pomeroy (New York: Oxford University Press, 1999), p. 60.

[32] virgo pulchra, et quo magis diceres,
 Nil aderat adiumenti ad pulchritudinem:
 Capillus passus, nudus pes, ipsa horrida,
 Lacrumae, vestitus turpis . . .
 Terence, *Phormio*, lines 104–7.

[33] Chrétien de Troyes, *The Knight with the Lion, or Yvain (Le chevalier au lion)*, ed. and trans. William W. Kibler (New York: Penguin Books, 1985), lines 1466–71.

out her hair, clawing bloody lines along her tender face."[34] Like Charle-magne grieving for Roland, she faints on the corpse, awakens to lament and rail, then faints again. She draws Erec's sword to take her own life but pauses, "remembering her pain and her sorrow." Up gallops a passing noble count to stop her, drawn by the sound of her wails. The count comments that her weeping and wailing make her look like a fool, but he still is so taken with her that he immediately marries her by force. The count is only restrained when Erec revives and splits his head open. These tales were highly popular in thirteenth-century Italy. The contemporary version of the story of Tristan and Isolde preserved in the Riccardiano Library in Florence recounts Tristan's lingering death from King Mark's poisoned spear, with endlessly drawn-out scenes of eroticized grief. Ultimately, Isolde holds Tristan to her breast and dies of grief with him, "arm to arm and mouth to mouth the two suffering lovers die together."[35]

MALE DECORUM: LUCIAN'S SATIRE ON GRIEF

In the second century, Syrian social satirist Lucian of Samosata wrote "On Funerals," a treatise linked to his better-known satire of sacrifice.[36] The comic treatise ridicules undignified funeral customs and again uses gender to score points. Lucian, who wrote in Greek and died c. 190, disdained phi-losophers; the treatise analyzes shows of grief not on philosophic grounds but rather as distasteful, uncultured behavior. The focus is on male deco-rum: how a dignified father should behave. Lucian first describes the silly things people think about the afterlife because they take mythmakers like Homer and Hesiod literally. Then he recounts their foolish practices at death, juxtaposing the calm of death with frenetic grieving. After the body is prepared, "Next come cries of distress, wailing of women, tears on all sides, beaten breasts, torn hair, and bloody cheeks. Perhaps, too, clothing is rent and dust sprinkled on the head, and the living are in a plight more pitiable

[34] Chrétien de Troyes, *Erec and Enide*, trans. Burton Raffel (New Haven, Conn.: Yale University Press, 1997), lines 4582–89.

[35] "Tristano Riccardiano," in *La prosa del Duecento*, ed. Cesare Segre and Mario Marti (Milan: Ricciardi, 1959), pp. 555–661. On the popularity of the Tristan story in Italy, see Marie-José Heijkant, *La tradizione del "Tristan" in prosa in Italia e proposte di studio sul "Tris-tano Riccardiano"* (Sneldruk Enschede: Druk, 1993).

[36] See Christopher P. Jones, *Culture and Society in Lucian* (Cambridge, Mass.: Harvard University Press, 1986). David Marsh, *Lucian and the Latins* (Ann Arbor: University of Michigan Press, 1998), examines the Quattrocento interest in Lucian.

than the dead; for they roll on the ground repeatedly and dash their heads against the floor" while the corpse lies handsome and tranquil, decked with wreaths.[37] The image evokes Priam's agonized grief at the death of Hector. Once again, the account characterizes grieving as a feminine action but one in which everyone participates. The only behavior that is specific to women is wailing: both men and women beat their breasts, tear their hair, bloody their cheeks, roll on the ground.

Lucian played on gender expectations to underscore the idea that a display of grief is undignified. He pictures "the mother, or indeed the father," throwing himself on the corpse and lamenting the death. Again, this evokes heroic male grief, Priam sorrowing for Hector. But Lucian's point is that the father's grief is unheroic, undignified. Then Lucian imagines a dead youth briefly revived in order to reproach his father for his extravagant grief: " 'Unfortunate man, why do you shriek? Why do you trouble me? Stop tearing your hair and marring the skin of your face.' " The dead youth urges his father to mourn "more truthfully" by saying things like " 'Poor child, never again will you be thirsty, never again hungry or cold!' " The sketch of an old father grieving violently and irrationally—in actions the text suggests are expected of mothers—is at the heart of the satire. Lucian also underscored the indignities of old age. Are you grieving, the dead youth asks his father, "since I did not get to be an old man like you, with your head bald, your face wrinkled, your back bent, and your knees trembling . . . who now at the last go out of your mind in the presence of so many witnesses?" Lucian's play on gender is cruel but effective: in this culture, an aging mother grieving violently would not seem so pathetic and undignified.

CONSOLATION, REASON, AND THE RESTRAINT OF GRIEF

Lucian's satire urged rational acceptance of death in a way that resembled contemporary Stoics. Why sorrow because a beloved son has been spared the indignities of old age? The rational analysis of grief was central to philosophic letters of consolation, a ubiquitous genre that became critically important to thirteenth- and fourteenth-century writers.[38] Stoic philosophers

[37] Lucian, "On Funerals (De luctu)," in *The Works of Lucian*, vol. 4, trans. A. M. Harmon (Cambridge, Mass.: Harvard University Press; Palermo: Palombo, 1913), pp. 113–31.

[38] See George McClure, *Sorrow and Consolation in Italian Humanism* (Princeton, N.J.: Princeton University Press, 1991), introduction, and Marsha Colish, *The Stoic Tradition from Antiquity to the Early Middle Ages* (Leiden: Brill, 1985).

developed at length a medical analogy, in which philosophic argument is understood to serve as a cure for a diseased soul. Disease for the Stoics meant attachment to external things, leading to the emotions or passions—fear, love, grief, anger, jealousy, and so forth. The goal of Stoic philosophy was to reshape the self in such a way as to become detached from externals. In this way, a person could extirpate the passions. Detachment is achieved through a "rigorous rational examination." This meant critiquing one's ideas and beliefs in order to discard beliefs that are found to be false and thus move and change the soul. The goal is "a way of life ordered by reasoning" rather than by passionate emotion. Stoic philosophers often taught by means of instructive narratives, with letters of consolation a common example. As Martha Nussbaum argues, these narratives follow a pedagogical order, reflecting the need to bring students gradually to critique their own beliefs.[39] The letters of the Roman philosopher Seneca move with the student back and forth between general principles and telling examples. Gradually, the letter was to wake up the student's soul to take charge of its education.

The most important of the Stoics for the Middle Ages was Seneca. His consolatory letters, including one to a woman named Marcia consoling her on the death of a son, became an influential source of Stoic ideas on grief. The *Ad Marciam* is a prime example of what Nussbaum terms "therapeutic philosophy." The basic view argued in the letter is that grief accomplishes nothing, since we cannot change fortune. As Seneca wrote to Polybius, "If grief tortures us and does not help us, we ought to lay it aside as soon as possible and recall the mind from its empty consolations and a sort of morbid pleasure in grieving." We have no other recourse: "unless reason puts an end to our tears, fortune will not do so."[40] Seneca speaks as a teacher, at times with a humane sympathy for bereavement, recognizing, for example, that consolation is possible only after some lapse of time. He argues that people will prolong and indulge in grief, even deriving a form of pleasure from sorrow. Marcia at the time of his letter had already grieved for her son for three years, and her mourning had become a "morbid pleasure" (prava voluptas).[41] Seneca tells her that the consolations of grief are empty. Tears do no good for the dead: either they don't know about them or if they do they are displeased by them. He endlessly recounts inspiring examples of men and women who showed fortitude in sorrow.

What of gender? The premise of the letter is that Marcia suffers no

[39] Martha Nussbaum, *The Therapy of Desire: Theory and Practice in Hellenistic Ethics* (Princeton, N.J.: Princeton University Press, 1994), esp. pp. 335–41.

[40] Seneca, "De consolatione ad Polybium," in *Moral Essays*, vol. 2, trans. John Basore (Cambridge, Mass.: Harvard University Press, 1932), pp. 365–67.

[41] Seneca, "De consolatione ad Marciam," in *Moral Essays*, vol. 2, p. 8.

"womanish weakness of mind" (infirmitate muliebris animi): she is just as capable as a man of philosophic fortitude. The notion that women despite their weakness are capable of behaving in masculine ways is characteristically Roman, as Loraux points out.[42] The Stoics' commitment to critique ordinary beliefs and assumptions led them to assert that females even have a capacity for philosophy: Musonius Rufus, in "That Women Too Should Do Philosophy," directly argued that women ultimately have the same faculties as men and should be allowed to study, although it is not clear that this view had any practical consequences and that women were actually allowed to become philosophic scholars.[43] Seneca took a similar position, again in the abstract. The passions maintain the same hold on everyone, since all are from Nature, and it is habit and false presumption that make the difference. Nevertheless, sexual and ethnic differences exist: "Though they suffer the same bereavement, women are wounded more deeply than men, savage peoples more deeply than the peaceful and civilized, the uneducated, than the educated."[44] Seneca ranked social groups by their emotional vulnerability, with rational, educated men at the top and uneducated savage women presumably at the bottom. As I will show, Boncompagno echoed these ideas when he attributed the extreme denial of death to Africans.

Seneca repeatedly asserts that women have the capacity to overcome feminine weakness. After many examples of noble Roman men responding to death with fortitude, he rhetorically imagines Marcia's objection: "You forget that you are giving comfort to a woman; the examples you cite are of men." Seneca answers, "But who has asserted that Nature has dealt grudgingly with women's natures and has restricted their virtues? Believe me, they have just as much force, just as much capacity, if they like, for virtuous action; they are just as able to endure suffering and toil."[45] He enumerates noble Roman women who rose above the constraints of gender, a list that was to become standard in the Renaissance, including Lucretia, Cornelia, the mother of the Gracchi, and so forth.

In 41 C.E., Seneca wrote a letter to his mother, Helvia, consoling her not for a death but for his own exile to Corsica, imposed by the emperor Caligula. The letter is a formal treatise, intended for a wider audience, and it may be that he wrote to her privately as well. Seneca made thorough use of the medical analogy, consolatory advice as a physician's treatment of a wound or illness. Of all Helvia's sorrows, including the deaths of her mother, uncle, husband, and three of her grandchildren, "of all the wounds

[42] Loraux, *Mothers*.
[43] Nussbaum, *Therapy of Desire*, pp. 322–24.
[44] Seneca, "Ad Marciam," pp. 22–23.
[45] Ibid., pp. 48–49.

which have ever pierced your body," his exile he admits is the worst. "It has not simply broken the skin but has cut into the breast and vital parts." He enjoins her to "offer herself bravely for treatment. Come, put away wailings and lamentations and all the other usual noisy manifestations of feminine grief."[46] Instead, she is to allow him to treat her wound.

Seneca's medicine includes the exhortation to rise above the limits of female nature. "You must not excuse yourself as being a woman," he writes, "who has been virtually given the right to indulge excessively but not endlessly in tears." More is expected from her, since "the excuse of being a woman does not apply to one from whom all womanly faults have been absent." He enumerates the faults of women: unchastity ("that worst evil of our time"), the influence of jewels and pearls and the glitter of wealth, being ashamed of fertility and hiding a pregnancy or seeking an abortion, the use of cosmetics, revealing clothing. Helvia's "matchless ornament" instead has been modesty (pudicitia). "So you cannot in order to justify your grief claim the name of woman from which your virtues have set you apart: you ought to be as immune to female tears as to female vices."[47] This leads him to the list of exemplary Roman matrons: Cornelia, who lost ten children, including the Gracchi; Rutilia, who followed her son into exile. Helvia should console herself with the company of family members, even with liberal studies.

Seneca included a long passage in praise of Helvia's brave sister, who in his view should be his mother's greatest comfort. The accomplishments of Seneca's aunt were an odd mix. She lacked what Seneca terms the brazenness of modern women, and during the sixteen years her husband governed Egypt, she was never seen in public, received and made no petitions, played no public role. It was when their ship was wrecked and her husband killed that she showed her mettle: "facing shipwreck on a disabled boat, [she] was not deterred by the fear of death from clinging to her dead husband and seeking not the means of her own escape but the means of getting his body off for burial. This is the sort of courage you must match, by withdrawing your mind from grief and resolving that no one shall think you regret having had children."[48] Her effort was for her dead husband and not for herself. Like her brave sister, Helvia should value not her own comfort or emotions but rather the need to honor her husband and children. The implication is a thread important in consolatory letters, including, as we'll see, an influential letter of Jerome's: women are urged not to give way to a grief that could re-

[46] Seneca, "Ad Helviam Matrem de consolatione," in *Four Dialogues*, ed. C. D. N. Costa (Warminster, U.K.: Aris & Phillips, 1994), pp. 134–35.

[47] Ibid., pp. 160–61.

[48] Ibid., pp. 168–69.

flect badly on the letter's male author. If Helvia indicated by her pain and sorrow over Seneca's exile that she regretted that she ever had children, it would shame him. Seneca's letters thus combined the notion that women can rise above their weak natures with gendered understandings of grief. His language repeatedly depicts grief as feminine: "What is so base and so womanish [tam humile ac muliebre] as to give oneself over to be utterly consumed by sorrow?"[49] To grieve is to be not virile but weak and womanly. These Stoic views directly influenced thirteenth- and fourteenth-century analysis of violent emotions and the need for their restraint.

JEROME AND THE LAMENT AS RELIGIOUS DOUBT

A thread important to the Judeo-Christian tradition is the idea that a display of grief denies religious faith. For the Stoics, to grieve for the dead meant a failure to attain rational detachment. For some Christian preachers, it meant a failure to believe in resurrection and the afterlife. As Chrysostom argued, women who lament the dead demonstrate to outsiders that Christians do not truly believe their own teachings. Patristic writers at times characterized funeral laments as a Jewish practice. In fact, the traditions within Judaism are far more complex. The crucial scriptural texts for restraint of laments are prohibitions on self-mutilation and the excessive expression of grief, in Leviticus and Deuteronomy. Depictions of male grief also included the honorable laments of fathers for lost sons, notably Jacob's lament for Joseph and Saul's for Absalom.[50] The Babylonian Talmud includes "injunctions to dissuade women from lamenting for the dead in a violent fashion," but it also depicts Arab laments as "a rite worthy of imitation."[51] Fred Astren has shown that the rabbinic legal texts from Late Antiquity tended to locate concerns about death ritual within the laws of purity. The rabbis also came to limit excessive mourning because of its consequences for the mourner.[52]

Medieval Christians picked up the patristic association of Judaism with

[49] Seneca, "Ad Polybium," pp. 372–73.
[50] See II Samuel 1:17–27. For an example of references to female mourners, see Jeremiah 9:17–20.
[51] Leor Halevi, "Wailing for the Dead: The Role of Women in Early Islamic Funerals," *Past and Present* 183 (May 2004): 3–39.
[52] See Fred Astren, "Depaganizing Death: Aspects of Mourning in Rabbinic Judaism and Early Islam," in *Bible and Qur'an: Essays in Scriptural Intertextuality*, ed. John C. Reeves, Society for Biblical Literature Symposium Series, 24 (Atlanta: Society for Biblical Literature, 2003), pp. 183–99.

lamentation, as I will show. They also explored the idea that grief is a test of faith, based on the Book of Job and Lamentations.[53] Job posed the problem of righteous suffering and righteous rebellion. For Gregory the Great in his *Moralia in Job*, written c. 595, and then for medieval readers, Job became not a rebel but the figure of saintly patience under adversity, a man of perfect faith. The medieval Job is the opposite of the person who gives way to grief, in rage and despair. In the early fifth-century *Psychomachia* of Prudentius, the battle of Virtues and Vices, Job appears as the escort of the personified virtue Patience. Her opponent is Ira, rage, who again was often depicted making gestures of self-injury and lamentation and in the *Psychomachia* ultimately commits suicide in despair.

Some of the Greek Christian Fathers were passionately concerned about mourning and discussed it in letters and sermons in terms of the nature of women. Violent grief posed a somewhat different problem for them than it did for the Stoics. Seneca's concern was to teach the soul to defend against interior passions, to attain philosophic calm. For Christian teachers such as Origen (d. 232) and Cyprian (d. 258), the lament was a pagan practice.[54] Chrysostom in the fourth century preached that extremes of mourning endangered not only the mourner but the Christian community. It was a return to pagan or Jewish practice, a denial of Christian belief in resurrection. Further, if people who were supposed to be Christians grieved in this way, it reflected on their ministers. One response was to stigmatize the display of grief as female and shameful, as Chrysostom preached.

Worries about women and funeral laments are less evident in the writings of the Latin Fathers. Augustine echoed concerns about mourning in the ninth book of the *Confessions*, in his struggle to hold back his tears at the death of his mother, Monica. It is not a woman but rather a child, his son Adeodatus, who wails and then is hushed. Sorrow is not feminine but childish. Weeping would suggest that Monica was unhappy in her death or altogether dead. Augustine does not give way to his childish feelings of sorrow until he is alone. The passage suggests the close connection between the Roman sense of public decorum and the idea that the appropriate Christian response to death is restraint. But here loud sorrowful grief is ascribed not to women but to a boy.

In 384, Jerome wrote a famous letter to the Roman widow Paula to castigate her for excessive lamentation over the death of her young daughter, Blesilla. Jerome was still in Rome in 384, but he was an unpopular figure

[53] For a survey of the biblical and apocryphal traditions of Job and the influence of the story in the Middle Ages, see Lawrence L. Besserman, *The Legend of Job in the Middle Ages* (Cambridge, Mass.: Harvard University Press, 1979).

[54] See Alfred Rush, *Death and Burial in Christian Antiquity* (Washington, D.C.: Catholic University of America, 1941), pp. 174–86.

among the Roman clergy and community, considered a tactless reformer who had dubious relations with a circle of rich, pious women.[55] Paula was one of a number of noble Roman women who under his spiritual direction had turned their palaces on the Aventine hill into virtual convents, communities of women who devoted themselves to austerities: celibacy, fasting, study. Jerome was disliked by many Romans, who found these practices unnatural for women.[56] In fact, he was soon to leave Rome in disgrace and move to Bethlehem.[57]

Jerome's letter on the death of Blesilla begins with a tone of sympathy: "But what are we doing? the tears that we ourselves weep are to be forbidden to the mother. I confess my emotion, this entire book is written with tears."[58] Then he urges Paula to restrain her excessive grief. He echoes many of the topics in Chrysostom's sermons, including the idea that grief implies doubt of the afterlife: "If you believed your daughter to be living, you would not grieve that she is gone to a better place."[59] The association of the lament with Judaism is also present: "Jews up to this very day weep and with their feet bare roll in ash."[60] Paula's demonstrative sorrow will provoke ridicule because it implies Jewish unbelief: "Those standing about will laugh: this is the unbelief of the Jews."[61]

Jerome associates excessive tears with images of unbelief, sacrilege, and killing: "These tears that are full of sacrilege are to be detested, they are yet more full of unbelief, they are without measure and come up to the point of death. You ululate and exclaim, and, as if fired by torches, as much measured restraint as is in you, you continually kill."[62] Paula, rather than seeking to

[55] Eugene F. Rice, *Saint Jerome in the Renaissance* (Baltimore: Johns Hopkins University Press, 1985), pp. 12–14, points out that the death of his protector, Pope Damasus, made his position in Rome more vulnerable.

[56] Rice, *Saint Jerome*, pp. 47 and 217n, demonstrates that the letters were widely available.

[57] See Brown, *Body and Society*, chap. 18.

[58] "Sed quid agimus? matris prohibituri lacrimas ipsi plangimus. Confiteor affectus meos, totus hic liber fletibus scribitur." Jerome, Letter 39 ("Ad Paulam de morte Blessillae"), part 2, lines 4–6. Saint Jérome, *Lettres*, ed. Jérome Labourt (Paris, 1951), 2:73. On the consolatory letters of Jerome, see J. H. D. Scourfield, *Consoling Heliodorus: A Commentary on Jerome, Letter 60* (Oxford: Oxford University Press, 1993). See the discussion of this letter in Kate Cooper, *The Virgin and the Bride: Idealized Womanhood in Late Antiquity* (Cambridge, Mass.: Harvard University Press, 1996), chap. 4.

[59] "Si viventem crederes filiam, numquam plangeres ad meliora migrasse." Letter 39, p. 77, lines 16–17.

[60] "Flent usque hodie Iudaei et nudatis pedibus in cinere volutati sacco incubat." Letter 39, p. 79, lines 15–16.

[61] "Rideant circumstantes: ista infidelitas Iudaeorum est." Letter 39, p. 83, lines 16–17.

[62] "Detestandae sunt istae lacrimae plenae sacrilegio, incredulitate plenissimae, quae non habent modum, quae usque ad vicina mortis accedunt. Ululas et exclamitas, et quasi quibusdam facibus accensa, quantum in te est, tui semper homicida es." Letter 39, p. 83, lines 9–14.

calm and restrain her grief, is whipping herself up to lament more loudly. Jerome exhorts her to imitate Melania the Elder, who reacted to the deaths of her husband and two children not with tears but by first remaining immobile and then throwing herself on the feet of Christ, saying she could serve him more easily now that he had freed her from these burdens. Then she defied expectations by disposing of her remaining son and her goods and embarking for Jerusalem.[63]

Again, Jerome fears that Paula's grief at her daughter's death reflects on his teaching and faith. He was already under attack for directing a group of noble Roman women to repudiate the obligations of family. If Paula's tears indicate that her faith is weak, the Roman community will draw conclusions about his ministry. Paula's tears for her daughter embody popular anger at monks who encourage women to avoid marriage and children in favor of Christian austerities. He writes that when people see her fainting in the funeral cortege, they will murmur: "Is it not true, what we have often said? She grieves for her daughter killed by fasting, and because there are no grandchildren from a second marriage. At what point should these detestable monks be expelled from the city, stoned, thrown in the waves? They seduced a pitiful matron, who as this proves never wished to be a nun: no pagan mother ever grieved so for her children."[64]

For Jerome, Paula's tears evoke public reproach, the town's anger at his encouragement of young elite women to break with the customary obligations of family and turn to Christian chastity and fasting. Jerome's letter then departs from the Stoic tradition of consolation, since the goal is not a form of therapy for Paula but rather decorum. She is to grieve in a restrained way that will vindicate Jerome himself. It is difficult to read his letter without wondering whether he too was troubled by the thought that his religious direction of Blesilla led to her early death. Paula at any rate

[63] "praesentia exempla sectare. Sancta Melanium, nostri temporis inter christianos vera nobilitas, cum qua tibi Dominus mihique concedat in de sua habere partem, calente adhuc mariti corpusculo et necdum humato, duos simul filios perdidit. . . . Quis illam tunc non putaret more lymphatico, sparsis crinibus, veste conscissa lacerum pectus invadere? acrimae gutta non fluxit; stetit inmobilis et ad pedes advoluta Christi, quasi ipsum teneret, adrisit: 'expeditus tibi servitura sum, Domine, quia tanto me liberasti onere.' Sed forsitan superatur in ceteris? Quin immo, qua illos mente contempserit in unico postea filio probat, cum omni quam habebat possessione concessa ingrediente iam hieme Hierosolymam navigavit." Letter 39, p. 81, line 25–p. 82, line 10.

[64] "Cum de media pompa funeris exanimem te refferrent, hoc inter se populus mussitabat: 'nonne illud est, quod saepius dicebamus? dolet filiam ieiuniis interfectam, quod non vel de secundo eius matrimonio tenuerit nepotes. Quousque genus detestabile monachorum non urbe pellitur, non lapidibus obruitur, non praecipitatur in fluctus? matronam miserabilem seduxerunt, quae quam monacha esse noluerit hinc probatur quod nulla gentilium ita suos umquam filios fleuerit." Letter 39, p. 82, lines 20–29.

remained faithful and convinced. When, soon after this letter was written, Jerome abandoned Rome for Bethlehem, Paula left her two young children, followed, and used her resources to build a convent in Bethlehem. When she died there in 404, Jerome mentioned his pleasure that there were no laments and ululations. Instead, monks chanted the psalms.[65]

LAMENTS IN EARLY ISLAM

Early Islamic traditions also represent funeral grief in gendered terms. One common theme in Arabic poetry was a comparison of "the sorrow of a bereft she-camel, weeping her mournful cry over the death of an unweaned camel foal, to the grief of a mother losing her son or a sister losing her brother."[66] In one famed poem, a male author applied the maternal she-camel image to his own grief. Leor Halevi has recently analyzed restrictions on funeral laments in early Islam, based on oral tradition. There are striking similarities with the Christian traditions. Early pietists objected to wailing because they perceived it to be a pre-Islamic, barbaric practice and a rebellion against God's will. A death should be accepted with calm fortitude. However, serious injunctions about funeral laments derived not from Medina but from traditions transmitted by Iraqi Sunnis from eighth-century Kufa. These were represented as oral traditions deriving from funerals in Medina from Mohammed's time. Halevi found that traditions directly transmitted from Medina were mixed and did not justify taking strong measures to prevent women from even attending funerals. It was in Kufa, a booming garrison city in Iraq, that pietists chose to stress traditions that "portrayed zealous actions against women wishing to join funeral processions," even locking them up or throwing dust in their mouths.[67] Halevi argues that the pietists were shaping collective memories in an effort to transform funeral ritual, and for political reasons. Their target may have been proto-Shi'ite rebellions. Kufa was divided into tribal quarters, each with its own cemetery, and groups such as the proto-Shi'ites gathered at their cemeteries to plot rebellion. It may be that the Sunni pietists advanced more severe patriarchal controls "to prevent wailers from igniting rebellion."[68] In sum, Halevi found that the laws were the product of the close as-

[65] Jerome, Letter 108, para. 29. Saint Jérome, *Lettres*, 5:198.

[66] Halevi, "Wailing for the Dead," p. 30. He cites Alan Jones, *Early Arabic Poetry* (Reading, U.K.: Ithaca Press Reading, 1992), 2 vols., 1:119–22, vv. 32–35. Now see Leor Halevi, *Muhammad's Grave: Death Rites and the Making of Islamic Society* (New York: Columbia University Press, 2007), chap. 4.

[67] Halevi, "Wailing for the Dead," p. 24.

[68] Ibid., p. 26.

sociation of funeral grief, gender, and fears of political disorder. I do not know whether these Islamic traditions, perhaps transmitted through Muslim Sicily, could imaginably have influenced Christian lawmakers in north Italian towns in the thirteenth century. As with Plutarch's account of Solon's Athens, the parallels are striking and revealing.

Ancient authors in many ways were more concerned with male honor and decorum than with anything women did. They shared a preoccupation with emotional restraint as the key to control and order. Uncontrolled emotions were dangerous because they could spark actions that would threaten the survival of Christian Antioch, democratic Athens, Jerome's religious communities. And as Plato wrote in the *Republic*, the way to make men disdain emotions like the fear of death was to assign those emotions to women. To understand the lament for the dead in gendered terms thus was a way to encourage the male restraint and decorum that fostered stability and order. The next chapters examine the analysis of grief in the thirteenth century. As we will see, Hellenistic philosophy was a crucial influence, with its distrust of emotion and enthusiasm for rational control.

CHAPTER FIVE

INTERCESSION FOR THE DEAD AND SORROW FOR SIN

The equation of men's emotional self-mastery with social order was a central theme for thirteenth-century Italians. This association was based in part on rich ancient sources, notably Hellenistic philosophy, with its distrust of emotion and emphasis on rational control. Who urged these ideas in the thirteenth century? When I began this project, I assumed that the late thirteenth-century challenge to funeral laments was inspired by Christian clerics preaching moral reform. Laments were disturbing, I thought, because they conveyed a distinctly un-Christian response to death. They express loss and despair, not pious hopes for the afterlife. As I explored understandings of grief in canon law and in thirteenth-century preaching, worship, and religious art, I learned that my assumption that worries about laments came from the clergy was largely wrong. The answer is more complicated and I think more interesting. I realized that thirteenth-century theologians were profoundly ambivalent about the power of grief. On the one hand, they placed a new emphasis on interior emotion, the sorrow for sin that was crucial to penance and salvation. On the other hand, they believed that strong emotions threatened order, within the self and in society, and preached against unrestrained passions, including not only pride and lust but despair.

Clerics, including the mendicant friars, were not the primary driving force behind efforts to curb the laments of the laity in the thirteenth century. It was especially after the definition of Christian life articulated at the Fourth Lateran Council that clerics instead encouraged grief, in controlled forms. Preachers urged a model of the afterlife that allowed the orderly

commemoration of the dead in confraternal rituals. Theologians analyzed grief not in the context of funerals and mourning ritual but rather as part of the sacrament of penance, which required sorrow for sin. This meant a new valuation of forms of sorrow: to accomplish the sacrament, people had to mourn their sins as they mourned their dead. Sermons and painting used powerful imagery to stir up grief and encourage emotional participation in Christ's suffering. Christian art turned from making the supernatural present to making emotion visible. Viewers were invited to share in the grief of the angels, of the Marys at the death of Christ. This theme was popular and widely diffused, performed in vernacular laude, hymns sung by confraternities, notably the flagellants who sang intense Holy Week laude that voiced Mary's grief at the death of her son.

CANONS ON THE LAMENT

As I have suggested, from the early Middle Ages Christian funeral liturgy and lay expressions of grief existed side by side, and death rituals included not only household members but clients, allies, and members of the community. Lay and clerical rituals of course came into conflict. Early medieval church councils periodically condemned displays of grief, and penitential manuals listed fines for them. The Third Council of Toledo in 589 sought to forbid the funeral songs that the laity was accustomed to sing for the dead. The songs were altogether banned from the funerals of clerics, and if a bishop could get away with it, he was not to hesitate to ban them for all dead Christians.[1] Psalms and canticles were to be substituted. Carolingian penitentials and collections of canons all included the same canon on clawing the hair and face, with minor variations. It provided that those who cut their hair because of the death of a child or parent, or

[1] "Religiosorum omnium corpora qui divina vocatione ab hac vita recedunt, cum psalmis tantummodo et psallentium vocibus debere ad sepulcra deferri. Nam funebre carmen quod vulgo defunctis cantare solet, vel pectoribus se, proximos aut familias caedere, omnino prohibemus. Sufficiat autem quod in spe resurrectionis Christianorum corporibus famulatium divinorum impenditur canticorum. Prohibet enim nos Apostolus nostros lugere defunctos dicens: De dormientibus autem nolo vos contristari sicut et ceteri qui spem non habent. Et Dominus non flevit Lazarum mortuum sed ad huius vitae aerumnas ploravit resuscitandum. Si enim potest hoc episcopus omnium Christianorum prohibere, agere non moretur. Religiosis tamen omnino aliter fieri non debere censemus; sic enim Christianorum per omnem mundum humari oportet corpora defunctorum." "Texto crítico," in *Concilio III de Toledo, XIV Centenario, 589–1989*, ed. Felix Rodriguez (Toledo: Gráfica, 1991), pp. 19–38. This prohibition is XXII, p. 32.

mutilated their faces with nails or metal, should do thirty-six days of penance.[2]

The serious effort to restrain lay mourning practices came with the Carolingian reform. However, the reformers were realistic. They sought not to abolish lay forms of commemoration for the dead so much as to channel these forms into practices that were more Christian. Often these were practices that supported religious institutions. The False Capitularies, a collection of canon law created by reforming clergy c. 850, extended the substitution of hymns for lay laments to the laity: "let the faithful be admonished," it provided, "that they should not persist in pagan practices for their dead. Rather let each of them with a devout mind and compunction in the heart beg God's mercy for the soul of the dead. And when they carry the dead to the burial, they should not ululate but rather . . . let those who have not mastered the psalms sing out Kyrie Eleison, Christe Eleison for the soul of the dead, with the men beginning and the women responding."[3]

This injunction was a part of a campaign to Christianize death ritual.[4] The moment of death was crucial because of the belief that the soul is judged as it leaves the body and goes to an immediate reward.[5] The proper response is not to rage or grieve but to seek the most efficacious ways to provide for the salvation of the dying person by means of the sacrament and prayers. After death, one sings the Kyrie Eleison, the praises of God. People with wealth were encouraged to use their resources to support the potent prayers of monasteries whereas more humble Christians had to rely on the efforts of the parish priest, if they had one. In sum, reforming clergy in the Carolingian period sought to redefine funeral customs, a redefinition that

[2] "Si quis comam suam inciderit propter mortem filiorum aut parentum aut faciem suam laniaberit cum ungulas aut ferro, XXXVI dies peniteat." See Cécile Treffort, *L'église carolingienne et la mort: Christianisme, rites funéraires et pratiques commémoratives* (Lyon: Presses universitaires de Lyon, 1996), p. 82. She cites seven collections in which this canon or a close variant appears.

[3] "Admoneantur fideles, ut ad suos mortuos non agant ea, quae de paganorum ritu remanserunt. Sed unusquisque devota mente et cum conpunctione cordis pro eis anima Dei misericordiam imploret. Et quando eos ad sepulturam portaverint, illum ululatum excelsum non faciant; sed sicut superius diximus, devota mente et cum conpunctione cordis, in quantum sensum habuerint, pro eius anima implorare Dei misericordiam faciant. Et illi, qui psalmos non tenent, excelsa voce, Kirie eleison, Christe eleison, viris incoantibus, mulieribusque respondentibus alta voce canere studeant pro eius anima." *Benedicti diaconi capitularium collectio*, book II, c. 197; *PL* 97, 771D. See Treffort, *L'église carolingienne*, p. 84n.

[4] See Frederick S. Paxton, *Christianizing Death: The Creation of a Ritual Process in Early Medieval Europe* (Ithaca: Cornell University Press, 1990).

[5] See Brian E. Daley, *The Hope of the Early Church: A Handbook of Christian Eschatology* (Cambridge: Cambridge University Press, 1991). Thanks to Thomas Tentler for pointing this out to me.

countered lay practices stigmatized as pagan while it built the power and wealth of monasteries and perhaps of parish churches. The clerical attack on lay mourning rituals was thus a part of the long effort to convert Europeans to Christianity and to eradicate lay practices considered pagan.

THIRTEENTH-CENTURY PREACHERS

By the thirteenth century, preachers had different campaigns to wage. During this great age of preaching, Dominican and Franciscan friars as well as secular clergy addressed passionate sermons to the laity.[6] They urged civic and individual morality: to transform society meant to transform the self. They launched vehement attacks on immorality and excoriated people, especially women, for vanity, luxury, greed, even religious doubt. They were less concerned about restraining behaviors that were potentially non-Christian and more worried about moral reform. The battle against pagan practices if not won was no longer a direct concern. Preachers were not embattled in the same way: one does not find in the preaching of the late thirteenth century quite the polemical tone of a John Chrysostom, who had good reason to fear the loss of Christians to Judaism or paganism.

Nevertheless, thirteenth-century preachers evoked the perceived dangers of the people they considered outsiders, notably Muslims and heretics. They preached Crusades, including attacks on Muslims in Europe such as the colony at Lucera established by Frederick II.[7] They were also threatened by the lure of heterodox preaching. Cathar and radical Franciscan preachers challenged the wealth and authority of the Catholic Church. Their genuine poverty and courage in defying the church gave them moral authority, and some gave sermons of great power. The executions of heretics could spark popular outrage: in Bologna in 1299, when two living and one dead Cathar were burned at the stake, the town rioted in protest. These heterodox movements attracted converts, despite the risks. The friars' response to the successes of the Cathars was not the reform of rituals such as funeral lamentation. Rather, they attacked directly by lambasting them as filthy and immoral. The friars also lived within a compulsory Catholic Christian society with powerful tools at hand to pursue religious

[6] Louis-Jacques Bataillon, "La predicazione dei religiosi mendicanti del secolo XIII nell'Italia centrale," in *La prédication au XIIIe siècle en France et Italie* (London: Variorum, 1993), no. 12.
[7] See David D'Avray, "Application of Theology to Current Affairs," in *Modern Questions about Medieval Sermons*, ed. Nicole Bériou and David D'Avray (Spoleto: Centro italiano di studi sull'alto Medioevo, 1994), pp. 217–45.

deviance: people convicted of heresy and their families could be stripped of their property and citizenship. On and off from the 1240s, Inquisitions in the Italian towns chased after heretics, albeit with mixed success. Chrysostom had feared pagan ridicule: funeral laments by Christians implied that his flock did not believe his sermons and doubted the resurrection. Men like the Florentine Dominican preacher Fra Remigio apparently did not fear that the laments of the laity would reflect back on their ministry and give Cathar or Apostolic preachers a laugh at their expense.

To my knowledge non-Christian mourning customs did not become an important focus in sermons, though the point is impossible to prove because it rests on the absence of evidence. During the revival movement of 1233 termed the Great Devotion, some preachers were so successful that they were invited to aid in civic moral reform by writing new town statutes, including in Padua, Verona, Vicenza, Bologna, Parma, and Milan.[8] Friar Gerard Boccadabati's laws for Parma survive; they concerned peace and justice, heresy and moral reform, including laws on adultery and fornication. The friar did not use the opportunity to attack lay lamentation.[9] Similarly, when Fra Remigio preached on mourning in the late thirteenth century, he catalogued lay laments, as we'll see, but did not lambaste them.

The influential Dominican theologian Thomas Aquinas lived and preached in Orvieto in the early 1260s: he was made conventual lector of the Dominican priory there in 1261. Thomas, who after all was an Italian nobleman whose brothers were knights, surely had witnessed lay laments like those penalized in the court sentences of the 1270s and 1280s. While in Orvieto, he lectured on the Book of Job and composed the commentary on the Gospels that has come to be called the *Catena Aurea*, perhaps for Pope Urban IV.[10] This was a Gospel commentary in which Thomas compiled quotations from the earliest ecumenical councils and patristic authors, creating a handy source for preachers and one that became a bestseller. Jacopo da Voragine, for example, drew heavily on it when he composed the *Golden Legend*, a popular collection of stories about the saints. Here was an opportunity to criticize lay funeral laments. Thomas knew the homilies of Chrysostom on

[8] Augustine Thompson, *Revival Preachers and Politics in Thirteenth-Century Italy: The Great Devotion of 1233* (Oxford: Oxford University Press, 1992), esp. p. 183; André Vauchez, "Une campagne de pacificazione en Lombardie autour de 1233: L'action politique des ordres mendiants d'après la réforme des statuts communaux et les accords de paix," *École Française de Rome: Mélanges d'archéologie et d'histoire* 78 (1966): 519–49.

[9] See Thompson, *Revival Preachers*, p. 183.

[10] James A. Weisheipl, *Friar Thomas D'Aquino: His Life, Thought, and Works* (Garden City, N.J.: Doubleday, 1974), pp. 147–63, discusses Thomas's stay in Orvieto. See M. Michèle Mulcahey, *"First the Bow Is Bent in Study": Dominican Education before 1350* (Toronto: PIMS, 1998), pp. 290–91.

Matthew and John from the Latin translation of Burgundio of Pisa and used them extensively. It is telling that although Thomas cited Chrysostom's sermons as he commented on the tale of the grief of Martha and Mary and the raising of Lazarus in John 11, he ignored Chrysostom's severe attacks on female laments in Antioch's forum.[11]

Clerics, secular clergy as well as the friars, sought to influence lay responses to death, but in different ways. First, the new understanding of the mission of the clergy after the Fourth Lateran Council at its best fostered sympathetic efforts to console the bereaved. So, for example, when Federico Visconti, archbishop of Pisa, preached a sermon on behalf of the dead, he urged forms of consolation.[12] We should leave off weeping and grief since the dead cannot return, he preached. Instead, we can find consolation in a number of ways, which Federico went on to enumerate. The greatest consolation was the knowledge that the person had confessed and died contrite.

Second, the thirteenth-century church pressed opportunities for the laity to respond to death and grief by intervening in the afterlife. The full elaboration of Purgatory was the culmination of the long medieval campaign to penitentialize death. At the heart of this effort was the belief that God judges people not collectively but as individuals. After death, most souls that escape damnation undergo a period of purgation. During this period, the prayers of the living can aid the dead in purging their sins.[13] These beliefs meant that funeral rites could not only express sorrow or praise God but seek intercession on behalf of a dead person's soul. The late thirteenth century thus saw the explosion of commemorative masses, in which the living provided for their dead by funding masses on their behalf.[14] Jacques Chiffoleau gave this approach to death the memorable tag "la comptabilité de l'au-delà": the afterlife had become an accountable one.[15] Families demonstrably

[11] Thomas Aquinas, *Catena aurea in quatuor evangelia*, 2 vols., ed. P. Angelici Guarienti (Taurini: Marietti, 1953), 1:482–88. See Louis-Jacques Bataillon, "Jacopo da Varazze e Tommaso d'Aquino," *Sapienza* 32, 1 (Naples, 1979), reprinted in Bataillon, *La prédication*, no. 18; Mulcahey, *"First the Bow,"* p. 505.

[12] "Cessare ergo debemus plorare et tristari pro eis, cum sit impossibile eos posse reverti. Immo debemus habere consolationem de nostris mortuis pro dictis tribus rationibus, maxime si moriuntur bene contriti e confessi." *Les sermons et la visite pastorale de Federico Visconti archevêque de Pise (1253–1277)*, ed. Nicole Bériou and Isabelle le Masne de Chermont (Rome: École Française de Rome, 2001), pp. 902–3.

[13] Jacques LeGoff, *The Birth of Purgatory*, trans. A. Goldhammer (Chicago: University of Chicago Press, 1984).

[14] See Sharon Strocchia, "Remembering the Family: Women, Kin, and Commemorative Masses in Renaissance Florence," *Renaissance Quarterly* 42 (Winter 1989): 635–54.

[15] Jacques Chiffoleau, *La comptabilité de l'au-delà: Les hommes, la mort et la religion dans la région d'Avignon à la fin du Moyen Age (vers 1320–vers 1480)* (Rome: École Française de Rome, 1980).

took the obligation to fund the religious bequests of their dead kinsfolk very seriously. As mentioned in Chapter 2, an account book from a Sienese family in the 1230s and 1240s is a rare and vivid look at the impact of death on a family's finances. This family paid heavy costs not only for funerals but for legacies to religious houses. When an adult brother, Spinello, died, his 1241 funeral cost 7 libra. The following years saw modest charitable gifts on behalf of Spinello's soul. The heaviest expenditures were his legacies to religious houses, including the parish church, hospitals, female convents, the Dominican friars, for a total of 25 libra in 1241 and 17 the following year. They were demonstrably paid. As Pellegrini points out, such payments reveal "the absolute hegemony of suffrages for the dead" in the religious costs of "a good family of the urban bourgeois" in the mid-thirteenth century.[16]

Another popular way for the laity to seek intercession for the dead was in confraternities.[17] These associations had existed in Italian towns from the tenth century, drawing both clerics and laity. They proliferated in the thirteenth.[18] In Orvieto, lay confraternities are documented from the 1250s, though there is little internal evidence for their nature before 1313.[19] The 1325 mourning statute mentions their role in funerals: members attended and carried candles and were exempted from any penalty.[20] The best-documented in Orvieto is a Franciscan confraternity dedicated to Mary that was granted a papal indulgence between 1254 and 1261. The surviving records suggest that it was highly popular. A single extant page from March 1313 contains the beginning of a list of "men and women of the fraternity of the Holy Virgin Mary." It names the rector, who was a friar, the treasurer, and lay rectors for each quarter. A list of forty-eight names follows, identified as "the men" from the parish of San Costanzo, two of them dead.[21] The rest of the

[16] Michele Pellegrini, "Negotia mortis: Pratiche funerarie, economia del suffragio e comunità religiose nella società senese tra due e trecento," *Bulletino senese di storia patria* 110 (2003; published 2004): 19–52.

[17] Philippe Aries, *The Hour of Our Death*, trans. H. Weaver (New York: Knopf, 1982), p. 161. On confraternities, see John Henderson, *Piety and Charity in Late Medieval Florence* (Oxford: Clarendon Press, 1994).

[18] See Treffort, *L'église carolingienne*, p. 115.

[19] On medieval Orvietan confraternities, see Mary Henderson, "Piety and Heresy in Medieval Orvieto: The Religious Life of the Laity, c. 1150–1350" (Ph.D. diss., University of Edinburgh, 1990), part B.

[20] Carta del Popolo, rubric 117, *CD*, pp. 804–5: "Item quod rectores fraternitatis et omnes illi de fraternitate quando vadunt cum candelis post mortuum, non teneatur ad penam aliquam de morando vel stando in ecclesia cum candelis vel sine candelis."

[21] See BNR, Cod. V.E., 528, 4 recto; 5 recto–10 recto is the 1347–50 list; the inventory is 3 recto. The codex has been published, but without the matriculation list and necrology: "Sacre rappresentazioni per le Fraternitate d'Orvieto nel Cod. Vittorio Emanuele 528," *Bollettino della (Regia) Deputazione di Storia Patria per l'Umbria*, appendix 5 (Perugia, 1916).

list is lost, and we do not know whether an equal number of women from the parish also belonged or whether comparable numbers were drawn from the other parishes. Still, it seems clear that the confraternity was quite large.

What did this confraternity actually do? A fifteenth-century inventory gives clues. It lists the confraternity's privilege from Pope Alexander, processional banners with images of the Virgin and the Cross, candleholders, containers for oil to be dispensed as charity, books of laude, an old inventory, containers for collecting money, a notebook with a list of the dead, and four big candles "per portare a morti," to carry to the dead. The members may have listened to short sermons one evening a week, as did the Dominican Marian confraternity in Imola studied by Mulcahey.[22] The group at some point became a laudesi company, which means they enjoyed a paraliturgical role singing vernacular hymns, perhaps reciting the Ave Maria, and taking part in processions. Typically, one Sunday a month, the members of a laudesi company would attend Mass, then after the Gospel assemble in the cloister and walk in procession through church carrying candles and singing hymns. Then they would stand in the choir until the Mass had been celebrated. From the early fourteenth century, companies performed dramatized lauds in some Umbrian towns, including Assisi, Gubbio, and Perugia as well as Orvieto.[23] These might be laments: flagellant confraternities in particular sang hymns that evoked the Passion and the grief of the Virgin.

Confraternity members also put on funeral processions for their members, often providing the pall and bier. A brother carrying a cross or banner would lead a procession that included relatives, confraternity members, perhaps guild associates, and also perhaps paupers hired to swell the crowd. The procession would carry the corpse first to the funeral church and then, after the office of the dead, to the tomb. Thus paid-up membership in a confraternity was a way to be sure of a decent funeral; the group might even buy the offerings of wax if the family was unable to do so.[24] Some sang at the grave, often hymns that stressed the macabre horrors of death and cannot have been particularly consoling.

Confraternities not only buried the dead but—more important—commemorated them. The 1269 statutes of the confraternity of San Bartolomeo in San Sepolcro, a small town near Arezzo, give a clear picture of how this was done. The confraternity numbered over a thousand members in the late thirteenth century. They performed two mourning functions: they remembered the dead, compiling over time a book of their names, and they

[22] Fra Nicola da Milano, *Collationes de Beata Virgine*, ed. Michèle Mulcahey (Toronto: PIMS, 1997), introduction.
[23] See Henderson, *Piety and Charity*, pp. 84–85.
[24] Ibid., pp. 155–63.

acquired merit by acts of charity and then expended that merit in powerful prayers on behalf of those dead souls. This was done in a startlingly literal fashion. Two lay rectors recorded the names of those who wished to join the fraternity, and the charity they promised. Generally, new members agreed to pay a penny every Saturday, a penny every time a member died, and two pennies on All Saints' Day. On Saturdays, the rectors walked about town and collected everyone's pennies. When the confraternity gathered in church the first Sunday of each month, before the service the rectors again walked through the people, stating how many members had died that month and collecting the pennies. Other gifts were made: "even women," the statute reads, "gave bread, eggs, and pennies." Then a cleric chosen as prior formally announced the names of the dead, and the members in each case asked God for aid for the dead person's soul. Finally, the priest conducted the service. The rectors periodically dispensed the substantial charity they had collected from the membership to the deserving poor, again working from lists in a systematic fashion.

These practices were based on the notion that lay prayer and intercession were effective ways to aid the dead. A living person could acquire merit, collected in tidy sums, and then spend it on behalf of the dead individuals he or she had chosen to aid. Members must have been confident that their charity and prayers worked and that after they died their successors in the confraternity would perform the same acts for them. In 1265, the bishop of Arezzo rewarded the rectors of the San Sepolcro confraternity with a plenary indulgence, a kind of free pass out of Purgatory for the repentant. Ordinary members received more limited indulgences, forty days for giving a gift, one hundred days for attending a Sunday meeting.[25] And of course after death they received the benefit of the confraternity's prayers.

Confraternal charity was a lay form of commemoration based on an orderly model of the afterlife and the links between the living and the dead, forms that were literally accountable. A Christian could methodically contribute to ease individual suffering in the afterlife. In effect, the main impetus from the clergy, including secular clerics as well as the friars, was not so much to attack non-Christian funeral rituals but to urge an active, controlled role for the laity in commemorating and aiding the dead. They encouraged a hopeful, accountable contribution under the control of clerical authority. Confraternities sang bitter laments, but they were hymns intended to evoke the Passion and foster sorrow for sin.

[25] The 1269 statutes of the confraternity are printed by James Banker, *Death in the Community: Memorialization and Confraternities in an Italian Commune in the Late Middle Ages* (Athens: University of Georgia Press, 1988), pp. 188–90; see his discussion in chap. 2. There is a very large literature on late medieval Italian confraternities: see Henderson, *Piety and Charity*.

Contemporary funeral sculpture expressed a hopeful view of the afterlife. Tranquil individual death was exquisitely rendered in monumental tomb sculpture in Orvieto under the patronage of the papal curia. The tomb of the French cardinal Guillaume de Braye was carved after his 1282 death by Arnolfo di Cambio and placed in the Dominican church in Orvieto. It was probably modeled on the tomb of Eudes of Châteauroux in the same church, a tomb that was lost, perhaps when half the church was torn down to build a Fascist-era gymnasium. An effigy of the dead cardinal appears on a litter surrounded by curtains, creating a private death chamber. Angels resembling deacons draw back the curtains to allow the viewer a glimpse of the cardinal's image, newly dead.[26] Death seems to have come to him as tranquil repose. There is little hint of the physical decay of the body, a theme that was to become prominent in tomb sculpture and painting a few decades later but was avoided in late thirteenth-century Italy, perhaps because of concerns about the Cathar emphasis on the corruption of the flesh.[27] The cardinal's soul also appears on the tomb, above the effigy. It is represented as a kneeling suppliant, presented to the Virgin by a patron saint. The composition depicts a private, tranquil death. It emphasizes the immortal soul and above all the need for intercession in hopes of individual salvation. The dead soul's gesture is one of quiet submission and supplication.[28] This peaceful, dignified picture epitomizes late thirteenth-century teaching on the need for intercession and the hope of salvation.

SORROW FOR SIN

The scrutiny of grief was central to contemporary moral teaching. If sorrow for the dead was to be muted and focused on intervention to mitigate the pains of Purgatory, sorrow for one's own sin was crucial to the sacrament of penance and the hope of salvation. The Middle Ages inherited from

[26] On funeral effigies, see Carlo Ginzburg, "Représentation: Le mot, l'idée, la chose," *Annales* 46 (November–December 1991): 1219–34.

[27] On "transi tombs," emphasizing images of corruption, see K. Cohen, *Metamorphosis of a Death Symbol: The Transi Tomb in the Late Middle Ages and Renaissance* (Berkeley: University of California Press, 1973); Cohen discusses the tomb of the Cardinal de Braye, p. 32.

[28] The tomb has been beautifully restored and reconstructed. See Paola Refice, "La tomba de Braye e i monumenti funebri con la figura del giacente," in *Arnolfo di Cambio: Una rinascita nell'Umbria medievale*, ed. Vittoria Garbaldi and Bruno Toscano (Milan: Silvana Editoriale, 2005), pp. 157–61. On its place in the tradition of monumental tomb sculpture, see E. Panofsky, *Tomb Sculpture* (New York: Abrams, 1967), pp. 77–78; see also Julian Gardner, *The Tomb and the Tiara: Curial Tomb Sculpture in Rome and Avignon in the Later Middle Ages* (Oxford: Clarendon Press, 1992).

Augustine and Gregory the Great the view that penance was a three-part process: contrition, confession, and satisfaction. There was a complex and gradual shift from public to private penance, with emphasis on the inner sorrow essential for the sacrament.[29] Theologians and canonists long debated when in the process of penance sins are remitted and whether confession is not only desirable but necessary. In 1215, the church under the leadership of Pope Innocent III issued *Omnius utriusque sexus*, the canon that defined the universal requirement for Christians as attendance at Mass once a year at Easter, confession of sin, and the sacrament of penance. From 1215, then, it was quite clear that one of the central obligations of priests was to encourage contrition, hear confession, and administer penance to the laity.

The purpose of the sacrament of penance was to mediate Christ's suffering to the faithful. A priest in the sacrament exercised the power of the keys, the power that enables the priest, as Thomas Tentler notes, to "place us in contact with the suffering of Christ and make justification possible."[30] At the core of penance was the idea of contrition. It was defined in the contemporary *Summa for Confessors* of Raymund of Pennaforte as "sorrow for sins voluntarily assumed, with the intention of confessing and doing satisfaction."[31] Preachers were to urge Christians to search their hearts for grief over their sins, the contrition that was essential to God's forgiveness in the form of penance. The emotional experience of sorrow was thus integral to the sacrament. This raised urgent questions. What constitutes voluntary sorrow for sins? What did a penitent need to feel in order to make a good confession? What emotion was worthwhile, and what emotion was unproductive and even dangerous?

Preachers and confessors had an obligation to explain contrition to the laity and to answer their questions. How could people know that they felt the right emotion, the contrition they needed to fulfill the sacrament? The answer often was that to be contrite meant to be torn apart by sorrow for sin. Some explained that this meant to grieve as one would sorrow over a death. How does one tell? Motivation was crucial: contrition had to come not from the fear of damnation but from love for God. How can one know? One severe response was a sin-or-leprosy test: Jean, Sire de Joinville, biographer of Louis IX, reports that the sainted king once asked him, "Which would you prefer—to be a leper, or to have committed a mortal sin?" Joinville replied that he would rather commit thirty mortal sins than be a leper. This was the wrong answer. Louis explained: "When a man dies he is

[29] See Marcia L. Colish, *Peter Lombard*, 2 vols. (Leiden: E. J. Brill, 1994), 2:583–609.

[30] Thomas N. Tentler, *Sin and Confession on the Eve of the Reformation* (Princeton, N.J.: Princeton University Press, 1977), p. 66.

[31] Raymund of Pennaforte, *Svmma de poenitentia et matrimonio* (Rome, 1603; reprint, Farnborough, U.K.: Gregg Press, 1967), III, 34, 8, p. 443.

Tranquil death and the hope of intercession. Arnolfo di Cambio. Tomb of
Cardinal Guillaume de Braye. San Domenico, Orvieto. Photo credit: Edward
English.

cured of the leprosy of his body; but when a man who has committed a mor-
tal sin is dying he cannot know for certain that in his lifetime his repentance
has been sufficient to win God's pardon."[32] Choose any bodily evil rather
than let mortal sin enter the soul.

The king's answer underscored the anxiety of uncertainty: people cannot
know whether their sorrow and repentance have been enough. As Tentler
has shown, some theologians recognized that to require perfect sorrow for
sin could impose a great psychological burden and foster "a brooding and
anxious search for sin [that] leads only to the suffering of consciences."[33]
Thomas Aquinas in his influential explanation of the sacrament avoided
rigid and severe standards for contrition and warned against examining the
reasons for sorrow "because a man cannot easily measure his own emo-

[32] Jean de Joinville, "Life of St. Louis," in *Chronicles of the Crusades*, trans. M. R. B.
Shaw (Harmondsworth, U.K.: Penguin Books, 1963), chap. 4.
[33] Tentler, *Sin and Confession*, pp. 113–14; on Aquinas, p. 25.

Arnolfo di Cambio. Tomb of Cardinal Guillaume de Braye, detail. San Domenico, Orvieto. Photo credit: Edward English.

tions." He also spoke of the need to moderate sorrow for sin lest it become despair.[34]

If theologians insisted on the need for sorrow, they were also wary of unfettered emotions. At least from the time of Aquinas, they distinguished between concupiscible sorrow and intellectual sorrow.[35] Concerned to understand contrition as an active choice of the will rather than a passive response to an outside object, Aquinas took the view that the soul has two parts, sensitive (movement and sensation) and intellective (thought and volition). The soul has eleven passions, the concupiscible (love and hate, desire and aversion, joy and sorrow) and the irascible (hope, despair, confidence, fear, and anger). They are passive potencies, which means that the soul is moved to that particular state by an outside object. Contrition was not the sorrow of the sensitive soul, which would be concupiscible and reactive, but rather the sorrow of the intellective soul, which is an active choice of the will. This neat distinction provided a way to encourage certain kinds of emotions and not others.

[34] Thomas Aquinas, *Summa theologiae* 3a, 84, 9, in *S. Thomae Aquinatis Opera omnia*, 7 vols., ed. Roberto Busa (Stuttgart: Fromman-Holzboog, 1980), 2:918; *In quattuor libri sententiarum*, book IV, 14, 1, 4, in *Opera omnia*, ed. Busa, 1:498.

[35] See Peter King, "Aquinas on the Passions," in *Aquinas' Moral Theory*, ed. Scott MacDonald and Eleonore Stump (Ithaca: Cornell University Press, 1999), pp. 101–32.

The idea that contrition meant sorrow inspired by love for God and sympathy with his sufferings fostered efforts to evoke those feelings, in sermons and moral treatises and also in painting. As Richard Kieckhefer has pointed out, thirteenth-century preachers urged for the laity not contemplative prayer, which was intuitive and nondiscursive, moving toward mystical illumination, but rather meditative prayer, which meant reflections on images and events, most of them drawn from the life of Christ.[36] To this end, they produced moving sermons that used images to stir up strong emotion. The Franciscan Anthony of Padua (d. 1231) wrote a model sermon for the Thursday of Easter week that is a passionate lament for the suffering and death of Christ. It culminates in a vivid picture of Christ's body dead on the Cross. Anthony tells in evocative visual biblical images the story of the betrayal and the Passion: "And what more? Life died for the dead. O the eyes of our Beloved closed in death! O face, on which the angels hope to gaze, turned pallid. O lips, honeycombs dripping with words of eternal life, become livid! O head that hangs drooping, terrible to the angels. Those hands, at whose touch leprosy was healed, lost vision restored, demons driven out, bread multiplied, those hands alas are transfixed with nails and bathed in blood."[37]

In the early fourteenth century, Fra Giordano of Pisa elaborated on the physical suffering of Jesus in a Good Friday sermon that was recorded in detail by one of his hearers in the vernacular. "We must have compassion and weep [piangere] over his passion." Jesus sustained pain beyond any other, for three reasons, Giordano preached. The first is because his passion was the most general, with suffering in every portion of his body. He even suffered in all his senses. One example Giordano gives is the sense of smell, since Jesus was crucified in a place that reeked of decaying bodies. The second reason is that his suffering was the most bitter. Giordano again enumerated the injuries he sustained in each body part; his face was slapped until it bled red, then sinners spat at him and filled his face with white spit. "You know," Giordano preached, "that hands are full of nerves and bones; his hands suffered terrible pain when the nails, which had no points, were driven in with great force. And as the weight of his body hung from them, the nails gave him the greatest torment." The third reason is that his body was of the greatest purity and delicacy and thus the most sensitive to pain. And in this

[36] Richard Kieckhefer, *Unquiet Souls: Fourteenth-Century Saints and Their Religious Milieu* (Chicago: University of Chicago Press, 1984), p. 90–91.

[37] Anthony of Padua, "In Cena Domini," in *A. Antonii Patavini: Sermones dominicales et festivi*, 3 vols., ed. Beniamino Costa, Leonardo Frasson, and Ioanne Luisetto (Padua: Edizioni Messaggeri, 1979), 3:177. For an Italian translation, see Sant'Antonio di Padova, *I sermoni*, trans. G. Tollardo (Padua: Edizioni Messagero, 1994), pp. 194–95.

way, Giordano concluded, his hearers, by considering the pain that Christ suffered for them and for all sinners, would grieve and repent their sins.[38]

This language is a close description of the painful life-size images of Christ dead on the Cross of the period. Painters turned to images that evoked an emotional response, moving away from an older understanding of an image as making the supernatural present to the viewer. In the Early Middle Ages, an icon of the Virgin served to bring her and her power to a particular place.[39] A believer went to an icon in supplication or to give thanks. In the thirteenth and fourteenth centuries, though people continued to seek miracles from icons, painters also began to use pictures to evoke interior states, drawing in the viewer to participate in religious emotions. To gaze at a picture of the Virgin was to be drawn into her tender compassion and to share her suffering over the death of her son. Painters created wise and gentle Madonnas, regal images that represented God's mercy as the milk of a nursing mother. These Madonnas adore the infant Jesus in the simultaneous awareness of his adult suffering and death. They gaze into the eyes of the viewers, drawing them in to contemplate Christ, the way of salvation.

Paintings of Christ on the Cross changed. Earlier images of Christ emphasized not death but royal triumph. In mid-twelfth-century Crucifixions, Christ is alive, triumphant on the Cross, eyes open, victorious over death. By 1200, artists instead painted the dead Christ. He hangs on the Cross, eyes closed, body sagging with dead weight, as Anthony of Padua and Giordano of Pisa described him. The viewer is moved by horror, grief, and pity. Often the grieving figures of Mary and John appear at either side of the Cross and draw in the viewer to share their sorrow. These changes in the way Christ was painted were particularly influential because most people saw them: life-size Crucifixions were suspended in most Italian churches in the period. They were a part of the shift toward identification with the suffering of Jesus that was central to late medieval piety.

The scene of the lamentation for Christ also evoked grief in the viewer. Its development has been thoroughly studied by art historians seeking the origins of the Renaissance pietà. Early narrative cycles of the death of Christ included no lament but moved straight from the deposition of Christ's body from the Cross to the entombment: the body, wrapped in a burial shroud, is placed in the sepulcher. Psalters from the ninth century portray Christ's shrouded body carried by two men, Nicodemus and Joseph of Arimathea, who shove it into a tomb in a wall. In the tenth century, some Byzantine

[38] Giordano da Pisa, *Prediche sul secondo capitolo del Genesi*, ed. Serena Grattarola (Rome: Istituto storico domenicano, 1999), appendix 2, pp. 180–88.

[39] On icons, see Hans Belting, *Likeness and Presence: A History of the Image before the Era of Art*, trans. Edmund Jephcott (Chicago: University of Chicago Press, 1994).

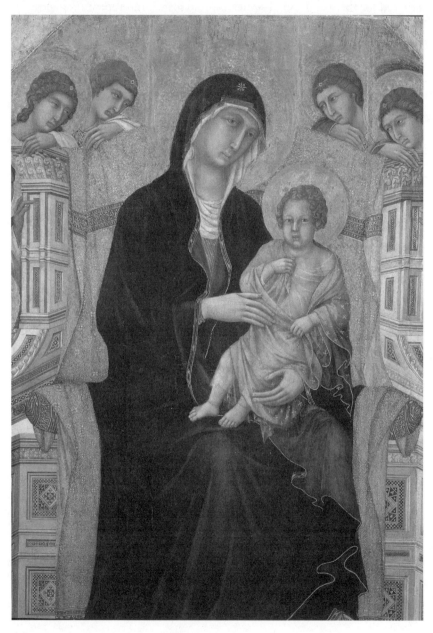

Duccio (di Buoninsegna). *Madonna and Child*. Detail from the Maesta altarpiece. 1308–11. Museo dell'Opera Metropolitana, Siena. Photo credit: Scala/Art Resource, NY.

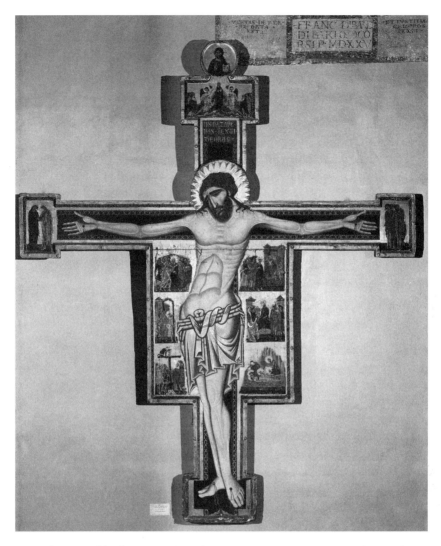

Coppo di Marcovaldo (fl. 1260–80). Crucifix. Museo Civico, San Gimignano. Photo credit: Scala/Art Resource, NY.

artists added a devotional pause: Joseph in one scene leans back to gaze at the dead Christ, in a gesture that invites the viewer to gaze with him.[40] In the mid-eleventh century, artists elaborated on this idea, adding a display of grief in the form of a cluster of women, identified with the women mentioned in Gospel accounts as beholding the sepulcher. A psalter from Constantinople

[40] See Kurt Weitzmann, "The Origins of the Threnos," in *De artibus opuscula XL: Essays in Honor of Erwin Panofsky*, ed. Millard Meiss (New York: New York University Press,

dated 1066 added the grieving Virgin as well.[41] There is an eleventh-century Gospel book in the Laurenziana Library in Florence that illustrates the scene with Mary present, in the third scene at Christ's head.[42]

The Lamentation became a powerful devotional image, a moment in which the viewer is invited to join in mourning Christ's death. It included a cluster of grieving women, two in the Greek tradition and three in the Western. The focus of the scene was the tender sorrow of Christ's mother, embracing the body, kissing his forehead. Christ's body was no longer wrapped in a burial shroud but pitifully exposed as he is in Crucifixion scenes, naked except for a loincloth. With the inclusion of the Virgin, eleventh-century artists began to add John as well, developing the gesture in which he lifts and kisses Christ's left hand. The Byzantine lament, or *threnos*, also includes Joseph and Nicodemus at Christ's feet and the two grieving Marys at a distance. The Virgin and John make gestures of great tenderness, stooping over the body to embrace the dead Christ, kissing the forehead or hand. The mourning women serve as a chorus. They express grief with dramatic stylized gestures, often standing or kneeling with upraised arms, their hair loosened. This Byzantine repertoire of gestures and the scene of lamentation over the dead Christ were taken up by artists in thirteenth-century Italy.

Cimabue drew on these gestures to represent women as icons of lamentation. One example is the Old Testament lament of the parents of Joseph in the mosaic ceiling of the Baptistry in Florence.[43] The work was directed by artists termed "greci," Greeks, probably from Venice. Jacob laments the loss of his son, holding a hand to his eye, the gesture of both Mary and John in contemporary Crucifixions. It is the mother, Rachel, who makes the stylized gesture of grief characteristic of female mourners in Byzantine laments, both arms raised over her head. Cimabue used this gesture to powerful effect in the extraordinary Crucifixion scene he painted in the upper church at Assisi: at the moment of the death of Christ, a woman, probably the Magdalene, extends her arms stiffly upward in a powerful motion of grief and despair. In Cimabue's evocation, winged angels circle the Cross, keening in pain and grief (see p. 4).

1961), pp. 476–90; Weitzmann cites C. R. Morey, "Notes on East Christian Miniatures," *Art Bulletin* 11 (1929): 84 and fig. 100.

[41] Matthew 27:61; Mark 15:47; Luke 23:55. This is the Theodore Psalter, British Museum MS add. 19352. According to Weitzmann, "Origins," it is the first appearance of the grieving Virgin in representational art.

[42] This is Laurenziana Lib. Plut. VI, 23.

[43] See the summary of the literature on the attribution of these mosaics to Cimabue in Enio Sindona, *L'opera completa di Cimabue e il momento figurativo pregiottesco* (Milan: Rizzoli, 1975), pp. 86–87.

By the end of the thirteenth century, Italian painters commonly represented women given over to extremes of grief. Sorrowing women with loosened hair claw at their cheeks with fingernails, rip open their clothing at the breast, raise their arms to wail and lament. These histrionic gestures became conventional. A spectacular early example was recently discovered in an area under the choir of the cathedral in Siena, an atrium that served as part of an eastern entrance but was closed off as the cathedral was expanded in the early decades of the fourteenth century and ultimately was filled in. Probably painted c. 1280, the fresco cycle includes a Deposition from the Cross and a Lamentation of expressive intensity.[44] Christ's arms have been freed but not his feet, and one apostle supports the corpse at the waist as it bends sideways. Another apostle kneels to use tongs to pull the nail from the bleeding feet. The Virgin supports Christ's body at the shoulders and touches her cheek to his face. The Marys also tenderly touch his hands to their cheeks, on either side of the cross. Another beautifully composed example is Giotto's Lamentation from the Arena Chapel in Padua, painted 1305–6. Grieving women huddle around Christ's body, some seated and some standing. Mary holds up his head and gazes into his face; Mary Magdalene holds his left foot in her lap. In an ancient gesture of grief, John bends forward, arms extended backward in sorrow.[45] In the sky, the angels display their grief, even tearing at their hair and cheeks. Similarly, the angels hovering at the Crucifixion tear at their hair; some wail open-mouthed, arms extended, or clasp their hands to their cheeks as they gaze in sorrow at Christ on the Cross.

The scene of the Massacre of the Innocents also became common: the moment of pain and horror as mothers struggle hopelessly to prevent Herod's soldiers from butchering their sons or fall to the ground to grieve over their mangled bodies. Some have open mouths and arms thrown back as they wail in sorrow. The paintings make their inner pain visible through gestures of self-injury: women pull at their hair, tear at their own flesh.[46] These paintings similarly draw in the viewer to participate in the women's shock and horror at the slaughter of their infant sons (see p. 5).

The same gestures could convey not shock but a depth of sorrow. Pietro Lorenzetti's *Entombment of Christ* from the Lower Church of San Francesco at Assisi shows Christ lowered into his tomb. The gestures of

[44] See Alessandro Bagnoli, "Alle origini della pittura senese," in *Sotto il Duomo di Siena: Scoperte archeologiche, architettoniche e figurative*, ed. Roberto Guerrini (Milan: Silvana Editoriale, 2003), pp. 107–47.

[45] On this action, termed the Hippolytus gesture, see Moshe Barasch, *Gestures of Despair in Medieval and Early Renaissance Art* (New York: New York University Press, 1976), pp. 71–72.

[46] See ibid., pp. 64–67.

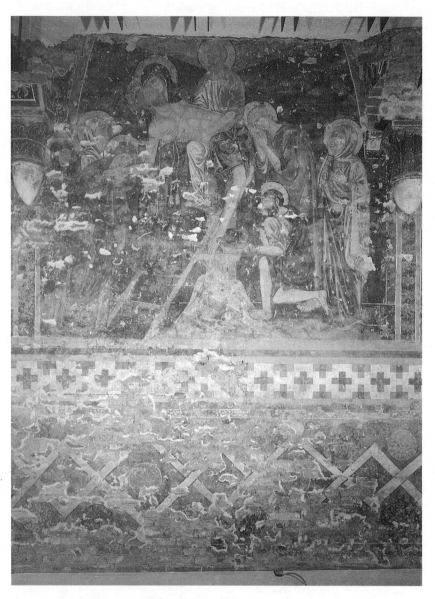

Deposition from the Cross. Chapel beneath the Cathedral of Santa Maria, Siena. c. 1280.
Photo credit: Fabio Lensini.

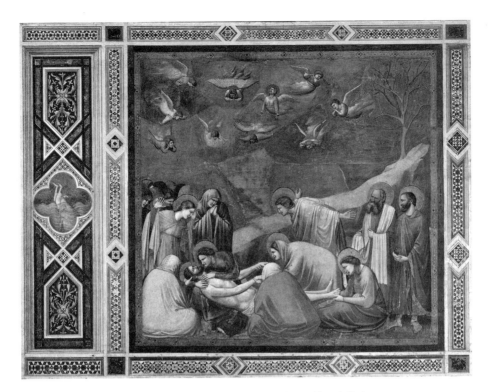

Giotto di Bondone. *The Lamentation for Christ*. 1305–6. Arena Chapel, Padua.
Photo credit: Scala/Art Resource, NY

mourning here are tender rather than histrionic. His mother kisses Christ's
cheek as the Marys pull back their hair, touch their cheeks, or raise their
hands in sorrow.

Dramatic lamentation came to be conventionally female in fourteenth-
century painting, intensifying the tendency to understand the emotion of
grief in gendered terms. One telling example is the portrayal of a story in
which a man lamented an accidental death: in the painted version, the
lamentation is performed by women. The painting, by Francesco Traini,
depicts the miracle of Saint Dominic discussed in Chapter 3. According to a
vita written c. 1290, Dominic was in a chapter house in Rome when "a cer-
tain man, wailing and tearing out his hair, exclaimed, lamenting in a horri-
ble voice, 'Alas, alas.' "[47] An Orsini nephew had just died from a fall from his
horse. Dominic stepped outside and revived the youth. When Francesco

[47] "ecce vir quidam ejulans, & sibi capillos extrahens, voce horribili lamentabiliter ex-
clamavit: Heu! Heu!" Theodoric of Appoldia, "Acta Sancti Dominici," chap. 7, part 89,
AASS (first August volume): 579 B–D.

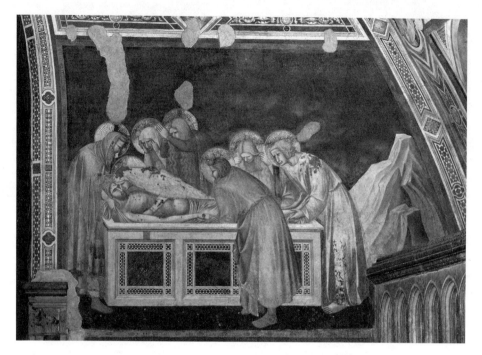

Pietro Lorenzetti. *Entombment of Christ*. c. 1320. Lower Church, S. Francesco, Assisi.
Photo credit: Scala/Art Resource, NY.

Traini painted the scene for an altarpiece of the miracles of Dominic for the
church of Saint Caterina in Pisa, executed before 1344–45, he depicted the
wailing and hair-tearing as done not by a man but by a cluster of women.[48]
As in the Orvietan statutes, loud male grief is ascribed to women.

There is direct evidence that this understanding of sorrow for sin and the
Passion was preached in Orvieto around the time of the funeral sentences,
in the sermons of Eudes of Châteauroux.[49] Eudes was a protégé of the

[48] On the altarpiece, see M. Meiss, "The Problem of Francesco Traini," *Art Bulletin*
15 (1933): 97–173, reprinted in his *Francesco Traini*, ed. Hayden B. J. Maginnis (Washing-
ton, D.C.: Decatur House Press, 1983); and George Kaftal, *St. Dominic in Early Tuscan
Painting* (Oxford: Blackfriars, 1948), pp. 72–74.

[49] See Agostino Paravicini Bagliani, *Cardinali di curia e "familiae" cardinalizie dal 1227
al 1254*, Italia sacra, 18 (Padua: Antenore, 1972), pp. 198–212. Alexis Charansonnet, "L'évo-
lution de la prédication du Cardinal Eudes de Châteauroux (1190?–1273): Une approche
statistique," in *De l'homélie au sermon: Histoire de la prédication médiévale*, ed. Jacqueline
Hamesse and Xavier Hermand (Louvain-la-Neuve: Fédération internationale des instituts
d'études médiévales, 1993), pp. 103–42; Fortunato Iozzelli, *Odo da Châteauroux: Politica e re-
ligione nei sermoni inediti*, Deputazione abruzzese di storia patria, Studi e testi 14 (Padua:
Bottega d'Erasmo, 1994). I would like to thank Kate Jansen for suggesting Eudes' sermons.

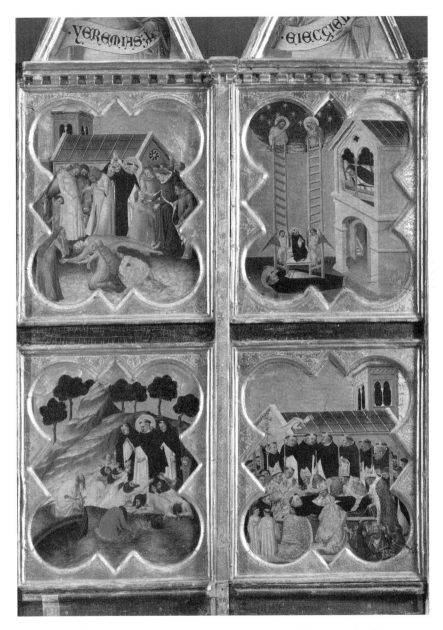

Francesco Traini. *The Resurrection of Nepoleone degli Orsini*. Detail from *Miracles of Saint Dominic*. 1344–45. Museo Civico, Pisa.

French Crown who became master of theology and then chancellor at the University of Paris. In 1244, he was made a cardinal and bishop of Tusculano, becoming a major figure at the papal curia. Eudes went as papal legate on crusade and was present at the disastrous Battle of Mansurah in 1250.

Extraordinarily prolific, Eudes left 1,200 extant sermons.[50] The bulk were written during his long stays with the papal curia in Perugia, Viterbo, and Orvieto. Eudes preached on the major events of his day, such as the Battle of Tagliacozzo. He was deeply concerned with papal politics and often preached against the Mongols and Saracens. One sermon was an effort to launch a Crusade against the colony of Muslims at Lucera in Apulia, people originally deported from Sicily by Frederick II. He at times urged grief, even in these sermons. The second sermon on the dead at Mansurah lists reasons to mourn (luctus) and weep (plangere). These include the *vituperium* of the Christian people, despised by Muslims for the battle; Christian blasphemy of the name of God, who seemed to them unable to save the army; the contempt of the Muslims for the banner of the Holy Cross, which they threw to the ground and trampled; Muslim courage and Christian fear; the fact that some weak Christians gave up their faith when they heard of the disaster; and finally, Christian sin, which in the last analysis was responsible for the defeat. Ultimately, he preached, Christians should grieve not for the noble dead at Mansurah but for themselves, unworthy to suffer what the noble dead had endured.[51]

At the end of his life, Eudes had his sermons *de tempore*—which means they follow the cycle of the liturgical year—copied to serve as models, and gave the four volumes to the Dominican convent in Orvieto, where he died in 1273. The sermons evidently were used: the marginalia include not only corrections of biblical citations but comments and even queries. So, for example, Eudes explained that one reason for the imposition of ashes on Ash Wednesday is that man comes from dust and will return to dust. Why then, he asks, do we impose ashes rather than dust? Someone commented in the margin: "Good question." Ultimately, the volumes ended up in the Dominican archive in Santa Sabina in Rome. These sermons were actually preached, if not by Eudes himself, by the local Dominicans in Orvieto. They would have been understood by the community: the friars recorded their sermons in Latin but normally preached in the vernacular.

When Eudes preached on grief, he did not attack lay lamentation but rather used it as a model for contrition, drawing a parallel between the

[50] *Repertorium der lateinischen Sermones des Mittelalters für die Zeit von 1150–1350*, ed. J. B. Schneyer (Münster, 1972), 4:394–483. The count is from Charansonnet, "L'évolution," p. 104.

[51] D'Avray, "Application of Theology"; this text is quoted on pp. 233–34.

lament of a mother for her son and our need to grieve over the passion of Christ and over sin. The occasion was a Good Friday sermon on the Passion.[52] The theme is Zechariah 12:11, a prophecy of Jerusalem's lamentation for sin: "On that day the mourning in Jerusalem will be as great as the mourning for Haddad-rimmon in the plain of Megiddo." Eudes took the opportunity to preach on our need for lamentation. Just as the sons of Jerusalem made a lament, so should we. He drew on parallel laments, some biblical, some from the experience of his listeners. When the Old Testament patriarch Jacob was shown the bloody tunic of his son Joseph, he lamented and could not be consoled. Now we are shown the blood and passion of Christ and must, like Jacob, mourn inconsolably (lugere inconsolabiliter). Eudes directly urged that we model our sorrow for sin on that of women, grieving wives and mothers. Just as a wife grieves on the anniversary of the death of her husband, or a mother on the anniversary of the death of a son, so must we on these days of the anniversary of the Passion of Our Lord lament and grieve.[53]

Returning to the passage that Chrysostom used to castigate female lamentation, Eudes instead used it suggest that grief is a measure of love. When the Jews saw how Jesus wept at the death of Lazarus, they said, "See how he loved him!" (John 1:36). Of us it can also be said, behold how much they love him. Saul wept over his son Absalom, and his lament showed how much he loved him. Our grief at the Passion is an indication of our love of Christ. In this context, Eudes took his swipe at emotional responses to the death of a hero in epic poetry: "there are many who are more apt to weep if they hear someone speak of the death of Roland than if they hear someone speak of the death of Christ." This echoes Augustine's comment in the first book of the *Confessions* that in his boyhood he wept for the death of Dido but not for his own death, caused by his lack of love for God.[54]

Nothing will soften the hardness of the hearts of sinners like grief and compunction, Eudes continued. A heart softened by memory of the passion of Christ will be able to withstand temptation and not permit the devil to approach. This lament displeases the devil, just as an adulteress is displeased by the lament made for the death of her husband, fearing that people will say of her what was said of the women in Luke 23. The reference is to Luke 23:28–29, in which Jesus tells the people lamenting as he makes his way to the Cross, "Daughters of Jerusalem, do not weep for me, but weep for yourselves

[52] AGOP XIV, 32, #117, 169 verso–171 recto (Schneyer 236).

[53] "Modo enim sit anniversarium passionis dominice unde sicut mulier quando facit anniversarium viri sui vel mater filii luget. Sic et nos hiis diebus deberemus plangere et lugere."

[54] Augustine, *Confessions* I.13.21.

and your children. For behold, the days are coming when they will say 'Blessed are the barren and the wombs that never bore, and the breasts that never gave suck.' " Similarly, the good must grieve, lest they be ungrateful or be said to return evil for good and render Christ's passion useless. Eudes enumerated the five wounds and concluded: "Each of us in his order and fashion and according to the grace given to him must make this lament, laity, clerics, and religious. Let us grieve recalling the memory of the passion of Christ, suffering with him so that we come to reign with him . . . so that for this and the other good that we do we deserve by the aid of our lord Jesus Christ to come to eternal joy."

In effect, Eudes was not concerned about lay laments. In a memorial sermon for Innocent IV, he preached in favor of funeral lamentation: despite the pope's failure to recover all the land of the church, "we must weep [plangere] over the death of such a father."[55] The real threats were the unbelievers, Muslims and Mongols, and the right response was Crusade. Eudes' concern in his sermons de tempore was pastoral: the need to foster sorrow for sin. And so he brought together the laments of two Old Testament patriarchs for lost sons, Jacob's grief for Joseph and Saul's for Absalom, with the sorrow of a bereaved wife or mother, as models for contrition.

HYMNS OF LAMENTATION

Contrition was not only preached to people but sung in dramatic forms. Laude were hymns that at times were sung by confraternities and in the fourteenth century came to be performed as drama. One powerful genre was the *Planctus Mariae*, the lyrical lament of Mary at the death of Jesus.[56] As Sandro Sticca has written, the lament captured the inner sorrow of Mary at her son's torture and death and expressed it lyrically, in her own voice, conveying the immediacy of her agony to listeners. Like images of the pietà, Mary's lament derived from the Greek literary tradition and was taken up in the West in the twelfth century. A fragmentary lament in the vernacular that survives in the archive of the abbey of Montecassino is thought to date from the late twelfth century.[57] Lyrical compositions on the compassion of

[55] Quoted by David D'Avray, "Sermons on the Dead before 1350," in *Modern Questions about Medieval Sermons*, ed. Bériou and D'Avray, p. 181.

[56] See Sandro Sticca, *The Planctus Mariae in the Dramatic Tradition of the Middle Ages*, trans. Joseph R. Berrigan (Athens: University of Georgia Press, 1988); on the immediacy of her emotion, p. 85.

[57] See *Laude dugentesche*, ed. Giorgio Varanini, Vulgares Eloquentes, 8 (Padua: Editrice Antenore, 1972), pp. 3–4.

the Virgin were a related form, also intended to aid Christians in internalizing her sorrow and mourning with her. By the early 1300s, laments were performed as drama. In Gubbio, a confraternity sang the Virgin's lament during the night of Good Friday, and according to a contemporary source it "inspired more tears than words from those present."[58] Through identification with Mary's grief, listeners experience the suffering of Christ.

The tradition of Mary's lament became a cruel and tragic one because her maternal grief came to be linked to reproach of the Jews for provoking her sorrow. Representations of Mary's grief became a focus for late medieval hostility to the Jews; in some regions in the fourteenth century, synagogues were rebuilt as Marian shrines.[59] A group of dramatic laude from Orvieto that were collected in 1405 and perhaps date from the mid-fourteenth century includes an example, a dramatic representation of Mary's joyful assumption into heaven that includes vengeful Jews, one of whom repents.[60]

Some of the most moving of the vernacular laude were composed by Jacopone da Todi in the second half of the thirteenth century.[61] His hymns were extraordinarily popular, so often copied and borrowed that the textual tradition is quite tangled.[62] Most of Jacopone's hymns are personal, individual meditations on death and salvation. Some take the form of dialogues. A macabre example is "Quando t'alegri omo d'altura," a hymn that invites mindfulness of death through meditative prayer contrasting the living and the dead, with an organ-by-organ description of the decomposition of the corpse. Many of the hymns are laments; the extraordinary "Donna de Paradiso" is a dialogue among Mary, the Jews, Jesus, and John during the Passion. Mary is urged to run and see that her son has been taken; "I fear they will kill him, they so flagellate him." She calls to the Magdalene to join her, and begs Pilate, "Don't allow my son to be tormented." The Jews cry out to crucify him. She sees the Cross, sees his clothes taken, sees his wounds and

[58] Sticca, *Planctus Mariae*, p. 134.

[59] See for a recent discussion Hedwig Rockelein, "Marie, l'église et la synagogue: Culte de la Vierge et lutte contre les Juifs en Allemagne à la fin du Moyen Age," in *Marie: La Culte de la Vierge dans la société médiévale*, ed. Dominique Iogna-Prat, Éric Palazzo, and Daniel Russo (Paris: Beauchesne, 1996), pp. 512–32.

[60] *Laude drammatiche e rappresentazioni sacre*, 3 vols., ed. Vincenzo de Bartholomaeis (Florence: Le Monnier, 1943; reprinted 1967), 3:381–97.

[61] Jacopone is thought to have died in 1306; on the meager evidence for his life, see *Le vite antiche di Iacopone da Todi*, ed. Enrico Menestò (Florence: La Nuova Italia, 1977). For a recent bibliographical summary, see Franco Suitner, *Jacopone da Todi: Poesia, mistica, rivolta nell'Italia del Medioevo* (Rome: Donzelli, 1999), pp. 249–71.

[62] See Lino Leonardi, "La tradizione manoscritta e il problema testuale del laudario di Iacopone," in *Iacopone da Todi*, Atti del XXXVII convegno storico internazionale, Todi, 8–11 ottobre 2000 (Spoleto: Centro italiano di studi sull'alto Medioevo, 2001), pp. 177–204.

his hands nailed. As Mary looks at her son on the cross, she begins her lament:

> E io comenzo el corrotto:
> figlio, lo mio deporto,
> figlio, chi me t'ha morto,
> figlio mio dilicato?
> Meglio averiano fatto
> Che l'cor m'avesser tratto,
> Che ne la croce é tratto,
> Stace descïliato!

> [Oh, let me begin to chant the dirge,
> My son has been taken from me.
> O Son, my fair Son,
> Who was it that killed You?
> Oh, that they had ripped out my heart,
> That I might not see your torn flesh
> Hanging from the Cross!]

Jesus replies,

> Mamma, ove si' venuta?
> Mortal me dài feruta,
> ca 'l tuo planger me stuta,
> che 'l veio sì afferrato.[63]

> [Mother, why have you come?
> Your agony and tears crush Me;
> To see you suffer so
> Will be my death.]

He commends her into the hands of his brother John. She speaks of his beauty and sweetness, and grieves,

> Figlio, l'alma t'é uscita,
> -figlio de la smarrita,
> Figlio de la sparita, -figlio attossicato!

[63] *Poeti del Duecento*, 2 vols., ed. Gianfranco Contini (Milan: Ricciardi, 1960), 2:119–24. The translation directly follows Jacopone da Todi, *The Lauds*, trans. Serge Hughes and Elizabeth Hughes, Classics of Western Spirituality (New York: Paulist Press, 1982), pp. 278–80.

[My Son, you have breathed your last;
Son of a mother frightened and dazed,
Son of a mother destroyed by grief]

By the late thirteenth century, vernacular hymns tied to the liturgical calendar were performed by confraternities.[64] The first laudesi company is thought to have been Sienese, founded in 1267. It included men and women, who sang prayers and hymns in the confraternal church. Confraternities of the Raccomandati di Maria also appeared in the 1260s, and again included both men and women who gathered in churches to walk in procession and sing hymns in praise of Mary. Disciplinati confraternities practiced flagellation as penance and also sang, typically in the street before the service and in the oratory afterward, on Sundays and particularly Good Friday. Their hymns were penitential, often laments over the Passion. For example, the 1327 statutes of the confraternity of Santo Stefano in Assisi provided that on Good Friday the members went to the church of Saint Francis and "represented to the populace, reverently, tearful hymns and sad songs and the bitter lament of the widowed Virgin mother deprived of her son, encouraging tears more than words or voices."[65] Two Orvietan laudarios survive. The earlier includes a dialogue between a worshiper and God concerning the suffering, passion, and death of Jesus.[66] The second collection, copied in 1405, includes the representation of the Assumption of the Virgin. Could women join in these public laments, or was it only men who voiced this feminine grief? Scholars have assumed that women could not join flagellant confraternities, which were the groups often charged with the performance of laments over the Passion. But Cinzio Violante has pointed out that the statutes of the flagellant confraternity of the Magdalene of Bergamo allowed women to join, with the permission of their husbands or elders.

In effect, just in the decades when towns imposed statutes banning funeral laments, confraternity members publicly sang hymns that voiced Mary's bitter grief at the death of her son. They even sang at burials, often hymns in the memento mori tradition that urged mindfulness of death in

[64] See Gina Scentoni, "Il laudario iacoponico e i laudari dei disciplinati perugini e assisani," in *Iacopone da Todi*, Atti del XXXVII convegno storico internazionale, Todi, 8–11 ottobre 2000 (Spoleto: Centro italiano di studi sull'alto Medioevo, 2001), pp. 243–97.

[65] "In hora autem prima omnes induti vestibus vadant ad ecclesiam Beati Francisci et Beate Marie Angelorum lacrimosas laudes et cantus dolorosos et amara lamenta Virginis matris viduae proprio orbatae filio cum reverentia populo representent magis ad lacrimas intendentes quam ad verba vel voces." Quoted by Scentoni, "Il laudario iacoponico," p. 248.

[66] Madrid, Biblioteca Nacional, n. 10077; cited by Scentoni, "Il laudario iacoponico," p. 275.

order to inspire contrition.[67] Carolingian reformers had sought to replace the funeral laments of the laity with the Kyrie Eleison, somewhat implausibly. By 1300, some laments were Christianized: lay confraternities sang hymns at burials that urged repentance: one was to grieve not over the person being buried but for one's own sin. Jacopone's "Quando t'alegri omo d'altura" is a powerful example, a dialogue in which a corpse in the tomb speaks of the loss of his rich robes, golden hair, eyes, nose, and so forth. This can be read as an ironic substitute for the corrotto. The dead man is reminded that his *parenti*, his kin, cannot protect him from the worms that devour him. In truth, they were quicker than the worms to strip him and divide his property and clothing. The funeral lament here is transformed: it is not the honorable grief of the living at the loss of their relative or neighbor but rather the bitter regrets of a dead man mourning his own misspent life and misplaced affections. His kin cannot help him now and instead have despoiled him. He cautions the living: "O worldly man, contemplate me!"[68]

[67] See Scentoni, "Il laudario iacoponico," esp. pp. 262–63.
[68] *Poeti del Duecento*, ed. Contini, 2:108–11; there is a translation in *Lauds*, trans. Hughes and Hughes, pp. 114–16.

LAY POLITICAL CULTURE AND CRITIQUES OF THE LAMENT

Ihave suggested that mourning in medieval Italy was the responsibility of the family and the community, and men as well as women loudly lamented the dead. Male nobles in particular were expected to display their sorrow over the loss of a son, kinsman, or ally. At the same time, there were rich precedents from the ancient world for the idea that mourning and lamentation, like passionate emotion and disorder more generally, belonged especially to women. The mourning laws of the thirteenth-century towns returned to this ancient association of women with qualities antithetical to civic life. Townspeople experimented with new social and political forms; they were casting about for new ideas, including ways of thinking about gender, family, and marriage as well as new forms of political association. There were extended discussions of how to live in an urban community: how to foster cooperation, avoid violence, find happiness in this life, and achieve salvation in the next. As Daniela Romagnoli has urged, the thirteenth century saw an explosion of works on social comportment, many of them products of the political needs of the Italian communes and written by preachers or by laymen, judges, notaries, masters.[1] All kinds of ancient and medieval works were read. In the first half of the century, in the absence of a developed political theory justifying the communes, ideas about the self and society were discussed in a variety of genres, notably manuals of advice.

[1] Daniela Romagnoli, "Le buone maniere," in *Ceti, modelli, comportamenti nella società medievale (secoli XIII–metà XIV) (Pistoia, 14–17 maggio 1999)* (Pistoia: Centro italiano di studi di storia e d'arte, 2001), pp. 255–71, drawing in part on the work of Cinzio Violante and Renato Bordone.

Critiques of funeral laments were a part of these discussions. They came not from the convents of the friars or even from bishops and secular clergy but rather from the political culture that arose in the lively intellectual world 'of the early thirteenth-century schools and law courts. These communities interpenetrated, and lawyers and scholars were clearly influenced by contemporary preaching and religious teaching. At the same time, the two cultures were in some ways at odds. Certainly, scholars at times voiced a sharp skepticism about popular preachers and popular beliefs. In the world of the schools, histrionic laments were not solemn social and political statements but the laughable customs of unlettered boors and savages. Dignified lamentation meant a Latin elegy.

The early thirteenth century saw a new emphasis on the production of forms designed for urban politics, including works derived from the ancient rhetorical tradition such as Boncompagno's *Rhetorica*, as well as epistolary and notarial manuals. Works of practical advice in governance were drawn from the Mirror for Princes tradition but were directed at podestà and civic politics. The most influential works came to be those of Brunetto Latini. It was in the second half of the century that discussions based in Aristotelian and Ciceronian political theory appeared. Recently, scholars have explored the relationship between these normative works in political theory and actual laws. One example is Enrico Artifoni's analysis of preambles to the Bolognese *Liber Paradisus*, the legislation freeing serfs in Bologna's contado, and other collections of statutes.[2]

Laymen concerned about stable political order turned to Stoic as well as Augustinian ideas about the restraint of the passions. These were men who wrote civic statutes and adjudicated court cases. One of them discussed funeral laments at length: Albertano of Brescia, a jurist and civic official whose 1246 *Book of Consolation and Advice* applied Augustinian and Stoic ideas to the problem of living in an urban community. How can a nobleman learn to weather adversity and tribulation, in particular a violent attack on his family? Can he with honor hold back from retaliatory violence, deliberate, and choose a wise and peaceful response? Albertano used a lament to pose the problem of emotionality: when a man's wife and daughter are attacked, the man explodes in sorrow and rage and is explicitly likened to a grieving mother. Then Albertano drew on Stoic philosophy to explore ways to console and heal his interior passions and thus enable him to choose wisely among possible courses of action.

[2] On the development of political rhetoric in the early thirteenth century and the place of Boncompagno in that tradition as well as the *Liber Paradisus*, see Enrico Artifoni, "Retorica e organizzazione del linguaggio politico nel Duecento italiano," in *Le forme della propaganda politica nel Due e Trecento*, ed. Paolo Cammarosano, Collection, 201 (Rome: École Française de Rome, 1994), pp. 157–82.

A fascinating and elusive account of regional mourning customs from the early thirteenth century exists in the form of a digression in a manual of rhetorical formulas. The text is Boncompagno da Signa's *Rhetorica antiqua*, a manual of rhetoric that, the author tells us, was read aloud by Bolognese masters in 1215. Boncompagno was a distinguished scholar who wrote a long series of rhetorical and epistolary handbooks, all composed with a certain whiff of arrogance or even, as Ronald Witt suggests, megalomania.[3] His treatise *Amicitia*, on friendship, is famously concerned not with amity but rather with its absence: he doubted that people were capable of living in community. Boncompagno loved to recount the practical jokes he played on jealous rivals.[4] The chronicler Salimbene de Adam called him both a solemn teacher of rhetoric and the *trufator maximus*, chief trickster.[5] The reader never quite knows when to take Boncompagno at face value. For example, he speculated in his epistolary manual, the *Palma*, that letters were invented either by Moses writing notes on bricks for the Israelites captive in Egypt or when someone wrote a note on a laurel leaf to one of the sons of Noah telling him to cover his father's nakedness.[6]

Boncompagno also amused himself by making fun of the grandiose claims of preachers and the gullibility of the laity. When the Dominican John of Vicenza preached in Bologna during the Great Devotion in 1233 and was so popular that he was invited to rewrite the town's statutes, Boncompagno made up a silly rhyme mocking him. After John confessed that he was able to perform miracles, Boncompagno admitted that he could too, and announced to the Bolognese that he planned to fly and that they would be allowed to watch. The word spread, and on the appointed day, Salimbene writes, a great crowd assembled at the base of the mountain. Boncompagno made a pair of wings for himself, appeared on the mountain, and gazed at the crowd. They stared back. After a time, Boncompagno intoned, "Go your way with divine blessings, and let it be enough for you that you have looked upon the face of Boncompagno."[7] At that point, Salimbene tells us, the Bolognese realized that he had made fools of them. The Franciscans did

[3] Ronald Witt, "Brunetto Latini and the Italian Tradition of *Ars Dictaminis*," *Stanford Italian Review* 3 (1983): 19.

[4] See Terence O. Tunberg, "What Is Boncompagno's 'Newest Rhetoric'?" *Traditio* 42 (1986): 303–4n.

[5] Salimbene de Adam, *Cronica*, 2 vols., ed. Giuseppe Scalia, Scrittori d'Italia, 232 (Bari: Laterza, 1966), 1:109–10. See Artifoni, "Retorica," p. 169.

[6] Artifoni, "Retorica," p. 169n.

[7] Salimbene de Adam, *Cronica*, 1:109–10.

not think much of John either, Salimbene tells us, recounting the story of a friar who visited the Dominican house and requested a piece of John's tunic as a relic, then used it to wipe his backside, dropped it in the latrine, and called out to the brothers to come recover the sacred relic.

Boncompagno's survey of the curious funeral customs of the laity is tacked onto a section on rhetorical forms of consolation for death, in which Boncompagno sketches possible ideas and formulas. There is a cynical, humorous edge to the discussion that is typical of Boncompagno. What can one appropriately say at a death? he asks. If a great prelate of the church dies, the orator can say that he was the golden candelabra in the temple of the Lord, the father of orphans, and so forth. At the death of an emperor and king, an orator can speak of triumphal victories, of *facta clarissima*, of ceaseless labors on behalf of the empire or kingdom. If the dead man had offspring, one can say that he is not dead since he lives on through his heirs. Provided it is true, it should always be said that the dead person "had recourse to the laments of penitence and, protected with the shield of the holy body and blood of the Lord, has flown to the celestial kingdom."[8] That is, the person repented and received the sacrament.

Boncompagno follows these useful if pompous oratorical suggestions with a lengthy digression about how different peoples grieve for their dead. He takes the view that no one can know all the customary forms of lamentation (consuetudines plangentium) even if one circled the whole orb of the earth, since diverse customs are observed even in the same land. He then proceeds with a regional survey of mourning practices, some of them very curious. What is the point to the catalog and where did he get his information? It is an odd digression for a manual of rhetorical formulas, and seems to me best explained as a way to entertain his colleagues and students. Boncompagno makes just the kind of cheap regional jibes that can enliven a university lecture on a dull subject, then as now. There is no obvious classical source, though its tone certainly echoes Lucian's satire on funerals. Historians such as Herodotus mention curious burial practices, and Cicero discussed burial customs in the *Tusculan Disputations*. None, to my knowledge, catalogued types of laments. Boncompagno may well have collected his own information: he would after all have encountered students and teachers from many parts of Europe, and perhaps he asked around about how various peoples mourned.[9]

[8] Boncompagno, *Antiqua rhetorica*, in *Briefsteller und Formelbucher des elften biz vierzehnten Jahrhunderts*, 2 vols., ed. Ludwig Rockinger (Munich: Auf Kosten der K. Akademie druck von J. G. Weiss, 1861), 1:141–43.

[9] Edward English suggested to me that Boncompagno's text is best viewed as intended to amuse students and probably draws on information gleaned from the university community.

What influences how different peoples grieve in his account? For authors such as Master John of Orvieto, community displays of mourning measure the character and value of the dead. For Boncompagno, they reveal not the true worth of the dead to the community but rather the sincerity or hypocrisy of the living. If Boncompagno rather than Master John had written the account of the Orvietans' grief at Parenzo's murder, he might well have hinted at insincerity, their show of heartbroken grief at the loss of a heavy-handed judge who had cost people a lot of money in judicial fines. At the same time, he is acutely aware of the relative nature of cultural expectations: in some places, people are not thought to grieve unless they tear out their hair whereas in other places, they can weep quietly and not make a commotion.

Boncompagno begins his survey with the Romans, who he tells us are not thought to sorrow over a death unless they claw their faces with their nails, tear out their hair, and rip their clothing to the navel. It is in this context that he describes *computatrices*, in the passage discussed in chapter 2. These professional female mourners led funeral chants counting the praises of the dead, producing "tears for money not for grief." Sicilians, Apulians, and Campanians follow the same customs, and if they cannot have computatrices they recount the funeral dirges as they know them. This account recalls the practice at early Roman funerals of hiring women, termed *praeficae*, to sing dirges, *neniae*.[10] With computatrices Boncompagno introduces a note of hypocrisy, again attributed to women. They weep for money and not sorrow.

The Greeks in lamentation in part observe the Roman customs and bring in computatrices, Boncompagno tells us. However, he continues, "then when some Greek tears the hair from his beard, sorrow comes from the heart. After that a great clamor is produced and the weeping multiplies." The action that really sets off a Greek lament is not a hired woman chanting and wailing but a man ripping out his beard. It is this male display of sorrow that comes from the heart. Again, the contrast with paid female wailers makes the gesture meaningful.

Boncompagno goes on with a catalog of distant mourning customs, some of them absurd. It is hard to tell when he is kidding, teasing and entertaining the colleagues and students for whom the text after all was written. Most of his audience would not have been locals. Some of his sketches seem ironic and a bit ridiculous; surely some are regional jokes. One is cruel: the wife of a dead Calabrian, he explains, removes her head covering and tears out a fair

[10] See John Bodel, "Death on Display: Looking at Roman Funerals," in *The Art of Ancient Spectacle*, ed. Bettina Bergmann and Christine Kondolen (New Haven, Conn.: Yale University Press, 1999), pp. 259–81.

amount of her hair. Whoever comes to the lament strikes her once with an open hand on her now nearly bald head and says "O captiva!" (literally "evil woman"). This is a painful image, the widow so polluted by her husband's death that she mutilates herself and everyone slaps her. Boncompagno moves immediately to Tuscany, where, he tells us matter-of-factly, there is clawing of the face, tearing of the clothing, and ripping out of hairs. The people of Lombardy and the Romagna, he goes on, bring forth loud noises and few tears. When they hear this commotion they run to the bodies of the dead in a disorderly mass, and many people to give the impression of lamentation rub their eyes with sage so that they appear to cry. And these types, while weeping in this manner, covertly smile: "Et tales taliter plangendo subrident." Boncompagno was describing the hypocrisy of the people of Romagna, where after all he taught and first read his book aloud. Surely this was a scholar's jibe at the expense of the locals.

Boncompagno's cultural map of lamentation measured sincerity and hypocrisy by histrionics. Some peoples come off well. The Gauls, he says, observe diverse forms of lamentation, according to the customs of their provinces. They lament only when they are moved by the deaths of those who are dear to them. The Franks are the same. The Spanish scarcely weep unless the dead genuinely merit their tears. The English, Bohemians, Poles, and Slavs mix drinking with weeping until they are drunk, and so are consoled in a more enjoyable fashion. One can imagine students having a laugh at the expense of the English and their reputation for drunkenness. The Hungarians lament bitterly but are unable to sustain their grief because they are always out in the country hunting. Some provincials mingle songs with tears, since they initially weep and then immediately hymn with drums, singing, and harps. And so, weeping and hymning, they customarily soften their grief. Germans soften the madness of grief, standing or sitting near the bodies of the dead without noise or clamor. They simultaneously weep in subdued voices and sigh, and produce pious tears without a burdensome commotion.

Boncompagno attributed extreme forms of lamentation to non-Christians, who have no hope of salvation. Some are assimilated with animals: Sardis in the fashion of wild animals strike at the air with blows of their voices when they grieve. Barbari ululate like wolves, and their women bark like foxes. The Saracens who live in the east grieve most bitterly over the deaths of those dear to them. But it is in parts of Africa, Boncompagno writes, that the lament is most prolonged: for the space of a certain number of days, the tomb is left open and those bound by affection go to the body of the dead and say "What are you doing? Why do you not rise up? You have delayed a long time. When will you come? Now is the hour of rising. Do

not delay."[11] This takes the idea that lamentation is a denial of death to extremes, and attributes it to Africans. This image is immediately followed with an ironic picture of those who do have hope, clerics and priests singing sweet and joyful songs for the dead: "when others groan they laugh, and when others sigh for grief they rejoice." The image is jarring. The purported meaning is that clerics laughed and rejoiced at immortality and the new life of the soul, but Boncompagno also hints loudly that clergy rejoice because they profit from deaths.

Boncompagno makes a strong case that forms of mourning vary with cultural expectations. Men grieve in a variety of ways that reflect on their characters, or at least their nationalities. A Roman would be obligated to take part in the corrotto whereas a German would grieve more quietly. At the same time, the trufator maximus brings a refreshing cynicism to accounts of the lament: he is happy to exaggerate and poke fun at customs he finds silly. Boncompagno was also quick to underscore hypocrisy, either the joy and laughter of the clergy or the Lombards who smile as they weep false tears brought on by rubbing their eyes with sage. He has something of the tone of an old-fashioned anthropologist recounting the customs of the primitives, with a tendency to attribute restraint to people he considers civilized and the extremes of grief to non-Christians and people he considers exotic. It is Africans who are so incapable of dignified acceptance of death that they keep urging a corpse to wake up. In sum, Boncompagno does not attack histrionic laments so much as mock them. Again, for a scholar, dignified lamentation meant a Latin elegy.

A CRITIQUE OF EXPECTATIONS
FOR NOBLEMEN

Albertano of Brescia by contrast used a description of a funeral lament not to mock the laity but to question the wisdom and dignity of some cultural expectations for noblemen. An educated man who could imaginably have attended Boncompagno's lectures in Bologna, Albertano wrote three short treatises of advice about how to navigate civic politics and the vita civile, linking this topic to the interior life and to religious values. By 1226, he had become a judge and lawyer in the modest town of Brescia, near Lake Garda. His career is representative of early thirteenth-century Italian professional and legal elites. Albertano was a member of the class of urban knights, men who dominated civic

[11] "Set in partibus Affrice magis perseverant in planctu, quoniam per aliquot dierum spacium dimittunt aperta sepulcra, et qui erant dilectione coniuncti accedunt ad corpus defuncti, dicentes: quid facis? quare non surgis? multum stetisti. quando venies? iam est ora surgendi. noli tardare."

offices in these decades, and joined the pool of professionals circulating with podestà, hired city executives.[12] He became a client of local elites, the Maggi of Brescia, a family that included diplomats and a bishop. When Emmanuel de Maggi was made podestà of Genoa in 1243, Albertano accompanied him as legal adviser. Albertano thus belonged to one of the generations of urban elites trained to do active service in the military. He served as a witness at a momentous political occasion, the oath of the rectors of the Second Lombard League, an alliance against the imperial power, and then held an important military command. In 1238, when Emperor Frederick II laid siege to Brescia because of the town's alliance with Milan and the Lombard League, Albertano was given command of the strategic fortress of Gavardo. When Frederick's forces took the fort, he was captured and briefly imprisoned in Cremona.

It was during his stay in prison that Albertano began to write on the problem of how to live in an urban community. He wrote three manuals of advice, each addressed to one of his sons at the moment of the young man's coming of age. The lengthy *De amore et dilectione Dei et proximi et aliarum rerum, et de forma vitae*, written in prison and dedicated to his oldest son, is about how to love God, live in amity with neighbors, choose friends wisely, and care for tangible goods and also for intangibles such as justice.[13] The *Ars loquendi et tacendi* is a careful, highly detailed discussion of when and how to speak in public and when to remain silent.[14] In 1246, Albertano dedicated his *Liber Consolationis et Consilii* (Book of Consolation and Counsel), to his son John, a surgeon. The treatise is a manual on how to weather the storms of urban life. "Many people," Albertano began, "are so afflicted and weighed down by adversity and tribulation that, too disturbed in mind either to console and advise themselves or to seek consolation from others, they become so sorrowful that they fall from bad to worse."[15] Albertano

[12] See *I podestà dell'Italia comunale*, part 1, *Reclutamento e circolazione degli ufficiali forestieri (fine XII sec.–metà XIV sec.)*, ed. Jean-Claude Maire Vigueur (Rome: École Française de Rome, Istituto storico italiano per il Medio Evo, 2000). As Maire Vigueur has pointed out, Albertano belonged to the class of urban knights, not merchants: Maire Vigueur, "L'ufficiale forestiero," in *Ceti, modelli, comportamenti nella società medievale (secoli XIII–metà XIV) (Pistoia, 14–17 maggio 1999)* (Pistoia: Centro italiano di studi di storia e d'arte, 2001), pp. 75–97.

[13] Albertanus of Brescia, *De amore et dilectione Dei et proximi et aliarum rerum, et de forma vite*, ed. Sharon Lynne Hiltz (Ph.D. diss., University of Pennsylvania, 1980).

[14] Albertanus of Brescia, *Liber de doctrina dicendi et tacendi: La parola del cittadino nell'Italia del Duecento/Albertano da Brescia*, ed. Paula Navone, PerVerba: Testi mediolatini con traduzioni, 11 (Florence: SISMEL edizioni del Galluzzo, 1998).

[15] "Quoniam multi sunt, qui in adversitatibus et tribulationibus taliter affliguntur et deprimuntur, quod, cum in se propter animi perturbationem nec consilium nec consolationem habeant neque ab aliis expectent, ita contristantur, ut de malo in peius cadant." Albertani Brixensis, *Liber consolationis et consilii*, ed. Thor Sundby (London: N. Trübner, 1887), p. 1.

proposed to teach his son how to administer this kind of consolation as well as heal people's bodies. In effect, it is a manual about how to handle mental distress and the sorrow it brings. However, it is not really a psychological guide. The real project is self-restraint, eliminating distressing emotions in order to be able to follow a wise course of action. Albertano termed this consolation and counsel: first, how to learn to handle emotion disturbance; then, how to act rationally, get advice from wise allies, evaluate it, and only then after all this reflection take action. Drawing on ancient writers and on his own experience, Albertano sought to teach his son and other readers the first stage: how best to console the emotions, particularly grief and rage.

Albertano's treatise can be read as a careful scrutiny of the wisdom and rationality of expectations for men of his generation and class, mid-thirteenth-century urban nobles. As I will suggest, he at times used gender to critique assumptions underlying those expectations. In other words, Albertano, in Lévi-Strauss's phrase, "used women to think with." The work was immensely popular, quickly translated from the original Latin into French, German, Catalan, and Dutch; it directly influenced the *Menagier de Paris* and the *Livre du Chevalier de la Tour Landry* and was reworked by Chaucer in English as the "Tale of Melibee." At least five versions in Italian dialects appeared in the thirteenth century alone.

How can a man achieve self-restraint in the face of a violent attack? Albertano turned for answers to Stoic ideas about self-control and emotional detachment. He read Seneca closely, and a manuscript copy of some of Seneca's letters that has his marginal notes survives in Brescia.[16] As we have seen, for the Stoics, the soul that is stirred up by emotions is diseased, and the best treatment is philosophic argument.[17] Disease meant attachment to external things, leading to the emotions or passions: fear, love, grief, anger, jealousy. The goal of philosophy was to reshape the self in such a way as to become detached from externals. In this way, a person could extirpate the passions. This meant not inescapable appetites like physical hunger but tendencies in the mind—fears, uncertainties—that ultimately derive from the body's reactions to externals.[18] Detachment is achieved through rigorous rational examination, critiquing those mental tendencies in order to discard beliefs and ideas that are found to be false. As William Harris has suggested,

[16] Claudia Villa, "La tradizione delle 'Ad Lucilium' e la cultura di Brescia dall'età carolingia ad Albertano," *Italia medioevale e umanistica* 12 (1969): 9–51. See Leighton D. Reynolds, *The Medieval Tradition of Seneca's Letters* (Oxford: Oxford University Press, 1965).

[17] See Martha Nussbaum, *The Therapy of Desire: Theory and Practice in Hellenistic Ethics* (Princeton, N.J.: Princeton University Press, 1994), chaps. 10 and 11.

[18] See Peter Brown, *The Body and Society* (New York: Columbia University Press, 1988), pp. 129–30.

the approach in some ways resembled modern cognitive therapy.[19] The recognition that what gives rise to pleasure, anger, or grief is not intrinsically good or evil can move and change the soul. The goal is a serene life ordered by lucid reason. As I will show, Albertano moderated this approach in practice, advocating not the extirpation of grief but its moderation.

For Albertano, then, the way for a man to respond to the violent ups and downs of urban life was first to achieve a rational detachment that would allow him to act wisely. The method he urged to achieve detachment was self-examination. Advocated by Cicero and Seneca, this method meant scrutiny and perhaps rejection of ideas and beliefs behind common expectations for men of his status.[20] This was not an easy course to follow, particularly in a culture that linked noble identity and honor with knighthood and a willingness to pursue violent remedies. How could he persuade his son and readers to adopt this potentially dishonoring approach? The form Albertano chose is a narrative, a tale of violence in which a man is provoked to passionate grief and rage and then calmed and advised by his wife. The narrative form serves to keep the treatise grounded rather than abstract: Melibeus often responds to his wife's advice in ways that seem realistic. A narrative form also allowed Albertano to demonstrate the benefits of listening to prudent advice by giving the story a happy ending. Melibeus ultimately responds to the attack in a well-considered, wise, and merciful way that enhances his status and power.

Gender expectations are a central theme. It is the wife, the appropriately named and at least to this modern reader rather tiresome Prudence, who acts as Stoic counselor. She stands in a long medieval tradition of female personifications of philosophy and the virtues, notably Boethius's *Consolation of Philosophy*. As Prudence urges close examination of Melibeus's assumptions, her role in the dialogue at times codes his possible choices as masculine or feminine in ways that raise questions about cultural values. The use of gender is revealingly inconsistent, with several reversals. Albertano at times juxtaposed female emotionality versus manly reason, but the debate in the dialogue over whether Melibeus should even listen to his wife's advice is framed differently: it is a choice between virile war and feminine prudence. The effect, it seems to me, is a genuine critique of expectations for male nobles: on reflection, is a manly leap to war actually foolish rather than prudent?

The stage for Prudence's advice is quickly set. Three enemies break into Melibeus's house while he is away. They beat Prudence severely and wound

[19] See, for example, his discussion of Cicero's anger therapy, *Restraining Rage: The Ideology of Anger Control in Classical Antiquity* (Cambridge, Mass.: Harvard University Press, 2001), pp. 374–75.

[20] See Harris, *Restraining Rage*, p. 379, on Seneca's ambivalence about this approach.

their daughter in five places, the eyes, ears, mouth, nose, and hands, leaving her almost dead. Rape is not mentioned, although the scenario suggests it and the tale certainly resembles accusations of rape and assault in thirteenth-century court records.[21] Conflict is provoked by an affront to a man's honor defined in terms of an insult to his women. The scenario recalls contemporary explanations of the origins of factional war: the insult that provoked elite Florentine families to form the Guelf and Ghibelline factions. Modern scholars agree that the factions derived from struggles over consular offices and urban turf that went back at least to the civil war of 1177. Thirteenth- and fourteenth-century chroniclers, however, explained factional rivalry in terms of men using women to insult each other. In the earliest version of the story, the division began in 1216 with a minor scuffle between two young nobles at a banquet. Their families and allies sought a reconciliation by arranging a wedding between the two families; when the young groom, Buondelmonte, chose to spurn the peace-offering bride and marry someone else, the affront sparked brutal assassination, vendetta, and factional war.[22] If a noble family is insulted by means of its women, it retaliates, in the Florentine story by a sneak attack on the wedding procession in which young Buondelmonte is pulled off his horse, his veins are cut, and he bleeds to death in the street. The scenario in Albertano's treatise is a somewhat different kind of affront than the one in the Florentine tale, although in both stories women serve as proxies for their men. In the Florentine narrative, the ultimate affront was Buondelmonte's spurning of a peace-offering bride. In Albertano's treatise, Melibeus's enemies insulted him by physically attacking his women and invading his house to do so. They used ladders and then entered the house through the windows. Thirteenth-century judges like Albertano followed Roman law and distinguished between assault or rape in the street and inside the house, penalizing violations of the home far more severely.

When Melibeus returns to his home and discovers the insult and injuries to his wife and daughter, he launches into a lament. In the original Latin, "seeing this, he began a great lament, weeping, tearing his hair to pieces, and ripping up his clothing like a madman."[23] The thirteenth-century Italian

[21] For an example of a register of court inquests containing numerous rape cases, see ASB, Curia del Podestà, Libri Inquisitionum et testium, 5.

[22] Pseudo-Brunetto-Latini, "Cronica Florentina," in *I primi due secoli della storia di Firenze*, 2 vols., ed. Pasquale Villari (Florence: G. C. Sansoni, 1898), 2:233. See Carol Lansing, *The Florentine Magnates: Lineage and Faction in a Medieval Commune* (Princeton, N.J.: Princeton University Press, 1991), pp. 165–68, and Enrico Faini, "Il convito del 1216: La vendetta all'origine del fazionalismo fiorentino," *Annali di storia di Firenze* 1 (2006): 9–36.

[23] "Melibeus vero post modum reversus, hoc videns coepit magno planctu flendo comas sibi dilaniare vestesque suas quasi more furiosi dilacerare." *Liber consolationis*, chap. 1, p. 2.

version of Andrea da Grosseto elaborates on this picture of lamentation: Melibeus began to weep strongly and to pull out his hair and to tear the clothes from his back as if a man out of his senses who entirely tears himself open and destroys himself.[24] Prudence urges Melibeus to calm himself, but he only cries and wails more and more. The vocabulary and gestures are those of thirteenth-century accounts of laments for the dead. It is important to recognize that although this picture of male histrionics seems incongruous to a modern reader, it was surely normal for contemporaries, a display of emotion expected of an outraged nobleman. The image recalls the father who raged and grieved at his son's judicial torture by the Bolognese court in 1286, and as I suggested in Chapter 3, the judges asked to testify in the inquest found his lament expected and appropriate.

Albertano treats lamentation quite differently. Melibeus is directly likened to a woman grieving for a dead child and then counseled as if he were a bereaved mother rather than an insulted husband and father. If the paradigmatic insult to a man's honor is an attack on his women, the paradigmatic uncontrolled emotion is a woman's lament. This switch from insulted father to grieving mother parallels the Orvietan cases, in which laments by men came to be characterized in the statutes as something women do. Prudence treats Melibeus like a bereaved mother. Unable to quiet his grief, she recalls her Ovid to the point that only someone feebleminded would forbid a mother to weep at the funeral of her child. After she satiates her soul with weeping, Ovid wrote, then her sorrow can be moderated with words.[25]

Prudence follows Ovid's advice and waits until her husband has satiated what is termed his weakened or diseased soul (animum aegrum) with weeping. Then she launches into a long lecture, much of it pasted together from biblical texts and the consolatory letters of Seneca.[26] In effect, Albertano depicted Melibeus's emotional reaction as if it were a funeral lament, enabling him to draw on the analysis of grief in Seneca's letters of consolation.[27] Prudence reproves Melibeus for his immoderate grief. Andrea da Grosseto's

[24] "Incominciò fortemente a piangere e a trarsi li capelli e a squarciarsi li drappi di dosso, e quasi secondo che uomo ch'è fuor di senno tutto si squarciava e si distruggea." Andrea da Grosseto, "Volgarizzamento del *Liber consolationis et consilii* di Albertano da Brescia," in *La prosa del Duecento*, ed. Cesare Segre and Mario Marti, La Letteratura Italiana, 3 (Milan: Ricciardi, 1959), p. 206.

[25] The citation is to Ovid, *De remedio amoris*, book I, v. 127–30. Harris suggests that a cathartic approach was Neoplatonist (*Restraining Rage*, pp. 123–24).

[26] See Villa, "La tradizione della 'Ad Lucilium,'" and the discussion in James Powell, *Albertanus of Brescia: The Pursuit of Happiness in the Early Thirteenth Century* (Philadelphia: University of Pennsylvania Press, 1992), chap. 2.

[27] See George McClure, *Sorrow and Consolation in Italian Humanism* (Princeton, N.J.: Princeton University Press, 1991), introduction.

vernacular version put this sharply: "Oh stupid one, why do you make your-self crazy? Why do you totally destroy yourself for such a small thing?"[28] Dry your tears and see what you have done. It is not fitting for a wise man to grieve violently, since the lament does nothing for the one who grieves. God will guard their daughter perfectly if he chooses to do so. Even if the girl were dead, Melibeus should not destroy and lacerate himself for her. Prudence continues with thirteenth-century-style therapy as she examines and rejects ideas that justify grief. She quotes Seneca to the effect that a wise man does not grieve for the death of a son or a friend, since otherwise he suffers their deaths as he waits for his own.

Melibeus responds with a defense of the lament: people need to grieve. With so much sorrow, no one could hold back from weeping and crying out. The emotion is too strong. Further, he points out, grieving is not wrong. Jesus himself grieved and wept at the death of his friend Lazarus. Prudence replies that tempered grief and weeping is not forbidden and is even allowed, citing Paul's Epistle to the Romans and then Cicero. But Melibeus's display of grief is excessive. Seneca explains how one should grieve, with moderation. Your eyes should neither be dry at the loss of a friend nor pour forth like a river. Weep, she says, but do not cry out. The term Albertano used is *plorare*, the verb Fra Remigio used to indicate weeping and crying out. Andrea da Grosseto translated it as *piangere gridando*, again verbs used to describe noisy laments in contemporary records. Prudence continues with a mix of texts from Seneca and the Old Testament Book of Proverbs on the dangers of grief. Better to guard a friend than to grieve for his loss. Seneca writes in his epistles that nothing is more stupid than to have the reputation of a man who sorrows a great deal, since nothing can happen to the wise man that will make him grieve because he will remain upright under any burden. Job is an example of this, she adds and illustrates at some length. Accept misfortune like Job. Better to rejoice in things we have than to grieve for what we have lost. For this reason, we console a neighbor for the loss of a son by suggesting that he should not weep because he has lost a good son but rather rejoice because he did have a good son.

In effect, Melibeus's lament is not the appropriate response of a noble knight to an intolerable insult but rather the emotional overreaction of a woman or a madman. A wise man is rational and calm. Again, the use of gender is very much in the consolatory tradition. Seneca depicted grief and lamentation as womanish weakness. He wrote to Polybius, "What is so base

[28] "O stolto, perché ti fai tener matto? Perché ti distruggi tutto per così piccola cosa?" Sundby (Albertani Brixensis, *Liber consolationis et consilii*) cites the *De amore* of Pamphilus.

and so womanish as to give oneself over to be utterly consumed by sorrow?"[29] Grief is not virile but weak and womanly.[30] However, Albertano was not writing a treatise about women or how men should instruct their wives and daughters. The concern in the treatise is with male emotionality. This is the reason for the reversal of gender roles, in which the woman calms and advises her husband. Albertano did not write a dialogue in which a husband urged restraint on his wife because women's cries and tears in themselves were not of much interest.

But why critique a man's justifiable lament? It will lead to trouble. Prudence points out that there is a close link between sorrow and rage. Nothing, she quotes Seneca, turns more quickly to hatred than sorrow. The insight that anger is very much a part of grief is important to modern discussions of bereavement.[31] Further, Prudence suggests, sorrow that is new can be consoled and comforted, but sorrow about something that happened long ago is scorned and not without reason, since it is either hypocritical or foolish. Andrea strengthened this point in his translation, emphasizing that longstanding grief either is hypocritical and faked or is the result of madness.[32] Prudence turns to Saint Paul on the need to seek instead to have the sorrow that leads to penitence. In effect, Melibeus's sorrow may harden into bitter anger and even madness, further clouding his rational judgment. This passage is the most explicit thirteenth-century explanation I have seen of why funeral laments might pose a danger such that the state has good reason to restrain them.

Melibeus agrees that all this is true and useful, but, he admits, his soul is so disturbed by sorrow that he does not know what he should do. Prudence responds with a suggestion: consult proven friends and family for advice. He concurs and calls on a large number of men. There is an element of realism in the account of the war council, evoking contemporary networks of social and political alliance and the tensions within them; its recent analysts include Jean-Claude Maire Vigueur, Andrea Zorzi, and James Powell.[33] Melibeus's

[29] "Quid autem tam humile ac muliebre est quam consumendum se dolori committere?" Seneca, "De consolatione ad Polybium," in *Moral Essays*, 3 vols., trans. John Basore (Cambridge, Mass.: Harvard University Press, 1932), 2:372.

[30] "molliter et effeminate." Seneca, "Ad Polybium," p. 407.

[31] See the classic study by Beverly Raphael, *The Anatomy of Bereavement* (New York: Basic Books, 1983), pp. 43–44.

[32] "E 'l dolore ch'è novello vuole esser raconsolato e dégli esser dato conforto; ma'l dolor ch'è d'antica cosa dé esser schernito e aviliato, perciò ch'egli è fatto per epocresia e apparenzia; anco per enfi[n]gimento; o egli è fatto per pazzia e matezza." Andrea da Grosseto, "Volgarizzamento del *Liber consolationis et consilii*," pp. 207–8.

[33] Maire Vigueur, "L'ufficiale forestiero"; Andrea Zorzi, "La cultura della vendetta nel conflitto politico in età comunale," in *Le storie e la memoria: In onore di Arnold Esch*, ed. Roberto Delle Donne and Andrea Zorzi (Florence, 2002), http://www.storia.unifi.it/_rm/e-book; Powell, *Albertanus of Brescia*.

neighbors are called, including men who fear rather than love him, former enemies with whom he had made peace, and some flatterers and yes-men (assentitori lusinghieri). They praise Melibeus for his power, wealth, and connections, disparage his enemies, grieve and rage at his misfortune, and advise vendetta and war to avenge the offense. A wise judge disagrees and counsels caution and deliberation. The tension here is not between male and female but between impetuous youth and wise old age. It is the young men, confident in their strength, prowess, and numbers, who cry out for immediate vendetta and war. Strike while the iron is hot. An old man speaks words of caution. They do not understand what they are urging. Vendetta and the war born from it once begun can be almost impossible to end. He describes the cruel realities of war but is insulted and interrupted by the others until he sits down in confusion. When Melibeus puts the question to a vote, his council chooses "vendetta and war."[34]

At this moment of crisis, Albertano launches into a stock debate about female nature. The digression seems odd but neatly employs gender to scrutinize cultural expectations. The choice of immediate war is coded as masculine: Albertano explains that the majority party was on the side of "immediately making vendetta and in a manly fashion conducting war."[35] Caution and restraint by contrast are now voiced not by an old man but by a woman. It is Prudence who steps in and asks, "My Lord, do you not even wish to have my counsel?" He denies her request, for five reasons. Again, these are best read as assumptions underlying cultural expectations. First, his reputation: people would think him stupid if, on her advice, he doubted what all the men have already voted. Second, women have no good in them. Third, if he agreed and followed her advice, he would give her lordship and power over him. Fourth, if he took her advice, then when it was important to keep something secret she would give it away because women cannot keep secrets. And fifth, as Seneca writes, women give bad advice.

Albertano thus addressed assumptions behind the view that to listen to advice is to give in to weakness, in particular the notion that it damages a man's reputation if he wavers and reconsiders a decision rather than stands firm. What are the implications if Melibeus chooses prudence over a rush to war? Is this a sacrifice of his reputation, his authority, his manliness? Implicit in the text is a recognition that it was in part a willingness to resort to violence that maintained elite male authority. Albertano has Prudence critique these assumptions. It is not stupid to change your mind for good reasons, and as

[34] Zorzi, "La cultura della vendetta," argues that the treatise indicates that vendetta was normal social practice.

[35] "de partita vindictae in continenti faciendae atque guerrae viriliter pertractandae." *Liber consolationis*, chap. 2, p. 11.

Seneca tells us, the truth and utility of things are always found in consultation with a few wise men, not a clamorous multitude. Not all women are evil, and he who despises all displeases everyone. Many women are good, or after the resurrection Jesus would not have shown himself first to Mary Magdalene. To listen to her advice is not to give her rule over him, since he has free choice. Although some women are wicked and talk too much, she is not one of them. This is not a sacrifice of his authority. If women give bad advice to men who are seeking good counsel, and the men take it, then the blame falls on the men since they have dominion and the power to choose. Prudence concludes with five points in praise of women, drawn from Seneca and Cato, as well as examples from the Old Testament of women of good counsel. When God gave Eve to Adam as a helpmeet, that meant that men are supposed to consult women. Nothing is better than a good wife or more evil than a bad one.

Melibeus is convinced, comments that she lives up to her name and asks her to explain prudence to him, what it is and how to acquire it, which she does at length. In effect, he chooses the seemingly feminine course of prudent deliberation rather than the manly leap to war. The bulk of the treatise is a detailed discussion of counsel and courses of action. It is a practical manual. Prudence makes points, endlessly citing Seneca, Cicero, biblical texts, Publius Syrus; Melibeus states objections that often have the ring of something a contemporary noble might have said. Prudence gives lots of concrete advice, detailing how to consult others (avoiding anger, greediness, and haste), when to keep things secret, what kinds of advisers to consult (avoid the stupid, flatterers, former enemies, neighbors who fear rather than love you, drunks, evil men, youths). She examines how to analyze advice and decide what should be taken up and retained, what revised, what rejected as error. Then she goes through the advice given him by his war council, enumerating all his errors. Error number seven, for example, was that he followed not the advice of his wise friends but rather that of the stupid, erring multitude.

Prudence then develops a close analysis of the wise advice he received from the judges and old men: "that he should above all guard his person, diligently fortifying his house, and that he act in these things not hastily or in a rush, but with diligent provision, preparation, and deliberation, taking the greatest care and solicitude with everything."[36] This turns out to be interior, a matter of fortifying the soul that is the house of his body rather than literally arming his urban tower. She examines the advice of the others—neighbors who fear him, flatterers, youths—who counseled him to "immediately make vendetta and pursue manly war with a powerful hand."[37] Prudence explores the levels of

[36] *Liber consolationis*, chap. 31, pp. 68–69.
[37] "qui tibi consuluerunt, vindictam in continenti faciendam et guerram viriliter et potenti manu peragendam." *Liber consolationis*, chap. 35, p. 76.

meaning of the term *consentaneus*, agreeing or consenting. In this context she points out that he is outnumbered by his enemies, since he has no sons, brothers, or other blood kinsmen. His enemies have many sons and kinsmen, so that even if Melibeus kills two or three, others will remain who will quickly destroy him. Is it really within his power and ability to consent to this advice? Would it mean consenting to reason? What would follow? She analyzes the multiple causes of the offense itself, including divine punishment. Punishment (vindicta) belongs only to God and to a secular judge, and not to an individual. If you seek it, go to a judge, who will either impose a corporal punishment or denounce them as infames and take their property, condemning them to live in poverty with dishonor and blame. Albertano, a judge himself, urged the view that his profession should have a monopoly on secular punishment. Melibeus thinks this is not enough: he prefers to pursue vendetta himself and trust to fortune. Prudence outlines the valid reasons for war, why this is not one of them, and ultimately persuades him to seek reconciliation and concord.

The treatise has a happy if contrived ending. There is a realistic discussion of the fears of the consequences of making peace. With her husband's permission, Prudence meets in secret with their enemies and "spells out to them the good of peace and evils of conflict and war, and exhorts them to grieve over their injury to Melibeus and his daughter, and to accept his judgment." They rejoice, "very much moved by the sweetness of words and touched within the heart with sorrow, weeping."[38] Calling her "wisest of ladies," they say they are willing to agree but fear that Melibeus will be angry and his judgment for them will be iniquitous. She persuades them that Melibeus is a benevolent and generous man, not greedy, but contemptuous of iniquity and money. They agree to follow his judgment. He finally summons his council, "faithful friends and agnates and cognates, found to be proven and faithful."[39] The implication is that not all kin—agnatic or cognatic—prove themselves faithful! After discussion, the council approves the choice to seek reconciliation and make peace. The council invites his adversaries, who show up at his court with their oath takers and a few others. Melibeus seems a changed character, behaving not like a bereaved mother but like a man of dignity. He rises to his feet and states that it is true that they have done great injury to him, his wife, and daughter without just cause, and deserve death. He wants to hear from them whether they are willing to submit to his judgment. They respond that they are not worthy to

[38] "valdeque dulcedine verborum moti ac dolore cordis intrinsecus tacti cum fletu responderunt dicentes, Domina sapientissima." *Liber consolationis*, chap. 49, p. 113.
[39] *Liber consolationis*, chap. 49, p. 116.

come to his court, and deserve death; they have come to confide in his clemency and mildness; they prostrate themselves at his feet and ask his indulgence. Melibeus takes them up and makes a pact that they are to return for his pronouncement in eight days, after he has had time to check with the doctors about his daughter's convalescence and to deliberate.

Melibeus learns that his daughter is recovering and "remunerates the doctors copiously," a gesture sure to appeal to Albertano's physician son. Then, just as his enemies feared, he makes an injurious plan. He will have them despoiled of all their goods and sent across the sea, never to return. After all, this punishment is lighter than the death they lawfully deserve. Prudence sensibly points out that this will leave the men no incentive not to return and revive the war. This brief exchange encapsulates a major source of political instability in the period: harsh confiscations and exiles fostered not peace but civil war. Finally, Melibeus chooses clemency. At the appointed day, his enemies with their oath takers show up at his court and, with bent knees and effusive tears, prostrate themselves at the feet of the lord and lady and say: Behold, we have come to obey your precepts in all things and for all things. "Truly, though unworthy, we entreat and honor your lordship, since you are not exercising vendetta toward us, but rather your rule is placable, merciful, and compassionate, and we honor your indulgence toward those placed beneath you. For you will be the stronger: as it is written, by forgiving many things the strong become stronger."[40] Melibeus replies that their sweet words and gentle response mitigate his wrath and indignation; and their devotion, contrition, penance, and confession of sin have induced him to be appeased, clement, and compassionate. He takes them up by the hand and receives them with the kiss of peace. "And so both parties departed with inward and outward joy."[41] Not only does Melibeus survive and avoid the risk of reprisals, he ends up with his lordly authority enhanced: even his enemies acknowledge that he is the stronger man. He is transformed from a figure of histrionic grief, likened to a woman or a madman, to a wise and generous lord, strengthened by his clemency.

In sum, Albertano used a narrative form to address the problem of how a nobleman can best live in urban society.[42] He perceived some cultural expectations for nobles to be foolish and risky. A man should not act in sorrow

[40] "Verumtamen, licet indigni, vestram exoramus dominationem, quatenus, erga nos non exercentes vindictam, sed potium placabilitatem, clementiam et pietatem, nos subditis vestris dignemini indulgentiam. Eritis namque potentiores; scriptum est "Multa ignoscendo potens fit potentior." *Liber consolationis*, chap. 51, p. 125.

[41] *Liber consolationis*, chap. 51, p. 127.

[42] See Charles Trinkaus, "Petrarch's Critique of Self and Society," reprinted in his *The Poet as Philosopher* (New Haven, Conn.: Yale University Press, 1979), pp. 52–89.

or in anger, should not be quick to have recourse to violence even in the face of an affront to his honor. Instead, a man must learn to console himself, attain calm, avoid giving way to passions, seek instead to have the sorrow that leads to penitence. Otherwise, sorrow can harden into bitter anger and madness, clouding his rational judgment. Albertano similarly urged the need to restrain passions in his *Ars loquendi et tacendi*. He insisted that before a man can judge when to speak, he needs self-knowledge, commenting: "Be certain that your spirit is not troubled with passions inimical to it: wrath, hatred, and envy. If your soul is troubled, keep it in check and do not speak. As Cicero says: Virtue restrains the violent emotions and forces the passions to obey reason."[43]

Passions in check, a man can choose a course of action with rational detachment, in Melibeus's case avoiding a hasty and violent reaction that would spark further retaliation and probably result in his death. To persuade his readers to follow this approach and break with expectations for men of their status, Albertano depicted a lament and then used Stoic imagery to characterize it not as a virile show of honor but as womanish weakness. Male honor required decorum and restraint. What had seemed womanish weakness—prudent evaluation of courses of action and the choice of mercy and forgiveness—becomes the acceptable response. This neatly parallels the funeral statutes that punished men for grief that was coded as feminine. It is restraint that is manly.

I cannot show that Albertano's treatise directly influenced the men who wrote the laws that sought to restrict laments, although it was highly popular, with five Italian-language versions available in the thirteenth century alone. More important, Albertano articulated precisely the ideas that seem to me to have driven the laws. Passionate grief is close kin to rage and can encourage disastrous conflicts. It is through the restraint of the passions—particularly those of noblemen—that peace and civic order are possible. Petrarch a century later also critiqued lamentation and turned to Stoicism to find consolation and rational calm. But for Petrarch, as I suggest in Chapter 8, the grief and anger expressed in the lament were a subjective danger, a threat to the self.

[43] See Carla Casagrande and Silvana Vecchio, *I peccati della lingua: Disciplina e etica della parola nella cultura medievale* (Rome: Istituto della Enciclopedia Italiana, 1987), pp. 73–74.

EMOTIONAL ORDER AND JUST ORDER

I have suggested that thirteenth-century writers were ambivalent about the power of grief. On the one hand, preachers placed a new emphasis on interior emotion, the sorrow for sin that was crucial to penance and salvation. On the other hand, lay intellectuals such as Albertano feared that unchecked sorrow could literally drive men from bad to worse, precipitating actions that could put them and the peace of their community at risk. Self-examination was needed to attain rational calm and then choose a wise and honorable course of action. Following images from Seneca and Cicero, Albertano used gender to examine assumptions about social expectations and the interior faculties: is prudent restraint a mark of feminine weakness or manly reason?

In the second half of the century, as scholastic philosophers developed theories of the state, they also drew on ideas about male and female nature. Often this endeavor was based on an Augustinian view of the consequences of original sin. Theologians and preachers linked the interior life, emotional or psychological disorder, with political and social disorder. The link was based on analysis of sin in terms of concupiscence, understood in gendered terms: the rational faculty was male, the passions female. For Anthony of Padua, the temptation to sin was like having a man and woman arguing inside one's head. By the late thirteenth century, these ideas were very much present in theories of the state. To sustain an orderly society required control of the concupiscible passions, including grief and lust. State authority is a badly needed remedy for the consequences of sin. Gendered understandings

of the passions were central: the coercive power of the state is needed to quell impulses that were often coded as feminine.

FEMALE NATURE

The use of images of women to evoke grief was part of a broader thirteenth-century preoccupation with the analysis of female nature. Preachers addressed countless sermons to women and urged models for pious female behavior for their three status categories: married, widowed, and religious.[1] They also preached about women. The Franciscan preacher Anthony of Padua, who was educated in theology at Bologna, was an important source for the transmission of these ideas. Anthony became provincial minister for much of northern Italy from 1227 to 1230, which meant that he was responsible for instructing the friars on how to preach and teach sacred doctrine to the laity. He composed a cycle of model sermons intended as a manual, designed to aid other friars who preached to a lay audience. Anthony discussed female nature in a sermon on the Annunciation, one of his cycle of Marian sermons. His text was "You are blessed among women." We read in Aristotle, he said, " 'that women feel compassion more intensely than men, are quicker to tears, and have more tenacious memories.' In these three qualities are indicated compassion toward one's neighbor, devotional tears, and the memory of the Passion of the Lord."[2] If women are more emotional than men, their weakness also makes them more prone to sin. Anthony preached: "We learn from a discussion of the whore of Babylon that the Latin *mulier*, or woman, derives from *mollitie*, effeminateness or weakness, and signifies the feminine weaknesses of Eve, who initiated sin."[3] Women were especially associated with concupiscence, or lust. Jacopo da Voragine preached that there are three things that are insatiable: hell, the *os vulvae*, and the earth.[4] This offered a way to think about male behavior. Jacopo

[1] See Carla Casagrande, ed. *Prediche alle donne: Testi di Umberto di Romans, Gilberto di Tournai, Stefano di Borbone* (Milan: Bompiani, 1978); Letizia Pelligrini, *Specchio di donna: L'immagine femminile nel XIII secolo: Gli "exempla" di Stefano di Borbone* (Rome: Studium, 1989).

[2] Anthony of Padua, *Sermones dominicales et festivi*, 3 vols., ed. Beniamino Costa, Leonardo Frasson, and Ioanne Luisetto (Padua: Edizioni Messaggeri, 1979), 3:160–61. The citation is Aristotle, "Historia animalium," IX, 608b 8–13.

[3] Anthony found this derivation in Isidore of Seville, 22, 12–13; *Glossa ordinaria*, Apocalypse 17, 3. Anthony of Padua, sermon on the third Sunday after Easter, *Sermones*, 1:285. See Anthony of Padua, *I sermoni*, trans. G. Tollardo (Padua: Edizioni Messagero, 1994), p. 269.

[4] Joan Cadden pointed out to me that this is a reference to Proverbs 30:16.

measured men by their susceptibility to lust: in a Palm Sunday sermon, for example, he described a man of reason (homo rationalis) as one who "has a wife as if he did not have one," which means that he has sexual relations with her not for physical pleasure but only for the procreation of children.[5]

These ideas were at times directly applied to civic politics. Brunetto Latini in his Aristotelian political and moral encyclopedia *Li livres dou tresor*, like Jacopo, distinguished between "the life of concupiscence" and the life of sense and honor. There are three types of lives, he wrote: first, the life in which people "live according to their animal natures: their life is the life of concupiscence"; second, "the civic life, that is, one of sense, prowess and honor"; third, the life of contemplation.[6] It is not animal lust but the life of sense, prowess, and honor that fosters urban community. The view that the sensual appetites, greed and concupiscence, are feminine at times translated into the idea that one way to control political disorder is to restrain women's indulgence. Political reform programs could combine diplomacy with moral reform, including restraints on women. The Dominican cardinal Latino Malabranca was a legate sent by Nicholas III to Lombardy and Tuscany in the late 1270s to make peace in the cities. The cardinal accomplished a dramatic public reconciliation of warring factions and in Florence in 1280 presided over the creation of a new bipartisan regime. To my knowledge, his sermons do not survive, but there is a description of his program of pacification in the chronicle of the gossipy Franciscan friar Salimbene. Fra Salimbene reports that Latino in this campaign to restrain factional violence urged a tough ordinance on female dress, banning long trains and requiring all women to veil their faces when they went out. This was serious: the ordinance forbade priests to give absolution to women who did not comply.[7] Why fuss over women's dresses and insist that they veil their faces in public in a campaign to stop factional wars and make peace? Female influence and male violence were linked: if only women kept their faces covered, men could show more restraint. Concupiscence, the sensual appetite that is a source of violent conflict, was feminine. When the Seven in Orvieto legis-

[5] Stefania Bertini Guidetti, ed., *I "Sermones" di Iacopo da Varazze* (Florence: Edizioni del Galluzzo, 1998), p. 97n.

[6] Brunetto Latini, *The Book of the Treasure (Li livres dou tresor)*, trans. Paul Barrette and Spurgeon Baldwin (New York: Garland, 1993), book 2, part 4, p. 147. See Julia Bolton Holloway, *Brunetto Latini: An Analytic Bibliography* (London: Grant & Cutler, 1986).

[7] *The Chronicle of Salimbene de Adam*, trans. Joseph L. Baird, Giuseppe Baglivi, and John Robert Kane (Binghamton, N.Y.: Medieval and Renaissance Texts and Studies, 1986), pp. 160–61, 443. On efforts to curb female dress, see Susan Stuard, *Gilding the Market: Luxury and Fashion in Fourteenth-Century Italy* (Philadelphia: University of Pennsylvania Press, 2006), esp. chap. 4.

lated to control women's dress and keep them out of the town hall, they were looking for ways to exclude irrational concupiscence from public life.

ORIGINAL SIN

In part, this approach derived from understandings of original sin. One way in which late medieval people explained psychological and social conflicts was to look back to their origins in the biblical story of the Creation. Lust and its pernicious effects in society were best explained as the consequence of the original sin of Adam and Eve. This view was formulated by the fourth-century bishop and theologian Augustine of Hippo. Augustine understood original sin in terms of concupiscence, best revealed by the excitation of the sexual organs, a movement that is disobedient to the will.[8] The result of the fall of Adam is that humans have lost rational control of their bodies, including but not exclusively the loss of perfect control of the genitals. For Augustine, this was "a revolt of the senses and of the body generally."[9] He analyzed this revolt against reason in terms of the psychological difference between men and women. Adam because his nature was rational would not have listened to the serpent alone. It was Eve who was moved by concupiscence and acted as intermediary.[10] As Pierre Payer neatly explains, in Augustine's *On Genesis against the Manichees*, "Eve represents the desire for pleasure and Adam represents rational consent."[11]

This reading of Creation and original sin was available to scholars in the standard theology textbooks, including the *Glossa Ordinaria* and the *Sentences* of Peter Lombard, and was conveyed to the laity in sermons.[12] Preachers taught people to think about their inner lives and temptations in ways that derived from Augustine's view. One approach was an emphasis on

[8] See J. Van Oort, "Augustine on Sexual Concupiscence and Original Sin," *Studia Patristica* 22 (1989): 382–86.

[9] See John Rist, *Augustine: Ancient Thought Baptised* (Cambridge: Cambridge University Press, 1994), pp. 321–27.

[10] See P. Agaesse and A. Solignac, notes to *La Genèse au sens littéral en douze livres*, in *Oeuvres de Saint Augustin*, Bibliothèque augustinienne, 49 (Paris: Declée de Brouwer, 1972), pp. 555–59.

[11] See Pierre Payer, *The Bridling of Desire* (Toronto: University of Toronto Press, 1993), p. 43. On the history of Christian understandings of sexual desire, see Eric Fuchs, *Sexual Desire and Love* (Cambridge: Cambridge University Press, 1983). See also R. Howard Bloch, *Medieval Misogyny and the Invention of Western Romantic Love* (Chicago: University of Chicago Press, 1991), chap. 1.

[12] See *Petri Lombardi Libri IV Sententiarum* (Claras Aquas: Collegii S. Bonaventurae, 1916), 2.24.12.5 (1:459–60).

sin as intention, the choice to sin rather than the action. This approach encouraged people to think about their psychological faculties and interior lives in gendered terms. Anthony of Padua included a discussion of original sin among his Sunday sermons. He drew heavily on the standard theology textbooks to give an Augustinian explanation of the choice to sin in terms of the original sin of Adam and Eve. The sermon explains how to analyze temptation in terms of a reenactment of the fall within the soul. Anthony quoted Augustine's analysis of Eve as desire for pleasure and Adam as rational consent. When any of us falls into sin, Anthony preached, what takes place is just like what occurred among the first three protagonists, the serpent, the woman, and the man. First, there is the suggestion, perhaps from the bodily senses. This presumably he identified with the snake. If our concupiscence is not taught to sin, the serpent is overcome. But if it is taught to sin, then it is convinced, like the woman. This means that lust has been stimulated, identified with Eve and her temptation of Adam. Next, it may be that reason, or Adam, can restrain lust. Anthony follows Augustine in speaking of reason as using its "virile energy" to control lust. When reason succeeds in restraining lust, we emerge the victors and do not fall into sin. But if our reason consents to carry out what concupiscence urges, then we are expelled from the life of the blessed, as the man and woman were from the terrestrial paradise.

Further, Anthony spells out, it is the consent that is the sin, so that we are judged guilty if we consent even if we do not carry out the action. Anthony quoted the *Sentences* of Peter Lombard to explain the difference within the soul between venial and mortal sin in terms of these male and female faculties. If the sin is not thought out in advance but is a sensual impulse that strikes the woman (that is, the lower part of reason), escaping the authority of the man (that is, reason), it is venial sin. If, however, we have the opportunity to reflect and then choose to sin, it is mortal.[13] Anthony thus urged preachers to invite their listeners to think about their own psychological and moral conflicts in terms of mental faculties that are coded male and female: again, the temptation to sin is like having a man and woman argue inside your head. The rational self is male, the passionate urges that lead to sin are female. When you act on a sensual impulse and commit a venial sin, it means that the lustful woman has escaped the man's authority. When you reflect and then choose to sin, the rational male has made the decision and the sin is mortal.

The Florentine chronicler Giovanni Villani (c. 1277–1348) mentioned these ideas about female nature in a way that suggests that this theological discourse transmitted in sermons truly did influence how the laity thought

[13] Anthony of Padua, Sermon on Luke 7, 11–12, for the sixteenth Sunday after Pentecost, in *Sermones dominicales et festivi*, ed. Costa et al., 2:252. For an Italian translation, see Anthony of Padua, *I sermoni*, trans. Tollardo, p. 717.

about women. Villani discussed women who dressed in defiance of the sumptuary laws, with the consent of their husbands. If women's clothes are shamefully embellished (disonesto ornamento), he writes, it is because of women's disordered appetite (disordinato appetito). "And in this way the disordered appetite of women conquers male reason and good sense."[14] The notion that the female disordered appetite conquers male reason echoes the approach in Anthony's sermon: these ideas were influential.

In the first decade of the fourteenth century, a group of laypeople wrote down the vernacular sermons of the Dominican Fra Giordano da Pisa. Fra Giordano preached in Pisa and in Florence between 1303 and 1307. His preaching to members of Dominican confraternities included a cycle of evening collations on Genesis.[15] Most extant thirteenth-century sermons are actually the Latin frameworks on which preachers elaborated. Giordano's recorded sermons allow a glimpse of what laypeople heard when a friar actually explained these ideas to them in the vernacular.[16] When Giordano analyzed the temptation story in his sermons on the third chapter of Genesis, he also encouraged listeners to think about temptation to sin in terms of masculine and feminine qualities.[17] He opened up the theme of what he terms the demon speaking to the woman in three ways. First, to the fragile mind (ad mentem fragilem), since women are humanity's fragile *mens*. "The poison that the demon puts in human flesh is concupiscence. By the woman is intended lower reason [la ragione di sotto], by the man is higher reason [la ragione di sopra]. The lower reason, which is in the woman, is the reason which considers earthly and worldly things, and thus the fragile reason. The other is the higher reason, which considers higher things, and this is very strong."[18] The demon tempts the woman, the fragile lower reason.

In sermon 13, Giordano asks why the sin of Adam was greater, so that it was through the man's bite of the apple that all of human nature was corrupted. One answer is the ratione cognitionis: the man was wiser than the woman, so his sin was greater. Then the ratione dominationis, ragione signoria: he did

[14] "[E] così il disordinato apetito delle donne vince la ragione e il senno degli uomini." Giovanni Villani, *Nuova cronica*, 3 vols., ed. Giuseppe Porta (Parma: Ugo Guanda Editore, 1991), book 11, chap. 11, 2:537. See the discussion in Stuard, *Gilding the Market*, p. 91.

[15] Carlo Delcorno, *Giordano da Pisa e l'antica predicazione volgare*, Biblioteca di Lettere italiane, 14 (Florence: L. S. Olschki, 1975), believes they were preached in Pisa in 1307–9; see Giordano da Pisa, *Prediche sul secondo capitolo del Genesi*, ed. Serena Grattarola (Rome: Istituto storico domenicano, 1999), pp. 32–33.

[16] See Delcorno, *Giordano da Pisa*, esp. 70–80, on Giordano's audience. For a recent study, see Cecilia Iannella, *Giordano da Pisa: Etica urbana e forme della società* (Pisa: Edizioni ETS, 1999).

[17] Giordano da Pisa, *Sul terzo capitolo del Genesi*, ed. Cristina Marchioni (Florence: L. S. Olschki, 1992).

[18] Ibid., sermon 3.

not have to obey her, since he was her lord, signore. Prudence made the same point to Melibeus in Albertano's dialogue when she told him that when a man takes a woman's bad advice, he is culpable because it is he who has dominion. In this context, Giordano explains the doctrine of intentionality: it is the sinner's intent that can aggravate the evil, not the actual result. If the effect is more disastrous than you intended, the evil is not worse. If you want to burn a whole city but light only a shed and only it burns, whereas someone else wants to burn a house and lights it and burns an entire city by mistake, who sins more? The one who lit the shed, because of his evil intention. Another answer is the source, the ragione per la origine. The husband ate the apple only to console the wife and not because he was tempted. To sin without temptation is a more grave sin.

JUST ORDER AND THEORIES OF THE STATE

Preachers associated original sin with the loss of just order in society, drawing on thirteenth-century theology that connected the control of interior passions with politics and the social order. This approach linked Augustine's emphasis on original sin as concupiscence with the ideas of Anselm of Canterbury (d. 1109), who perceived sin in terms of the loss of an original justice. Anselm had emphasized the idea that a harmonious just order existed in Paradise. When Adam and Eve sinned and betrayed their rational natures, they lost that harmony, the human capacity to serve justice.[19] Starting with Alexander of Hales, a number of theologians drew on this idea and formulated explanations of original sin that closely associated sexual impulses and the uncontrollable movements of the genitals with disobedience to authority and the absence of just order.[20] The Dominican friar Thomas Aquinas thus explained original sin as a loss of original justice, which meant the harmony of the human will with God's plan.[21] The result of the loss of that

[19] Anselm of Canterbury, "De Conceptu Virginali et de Originali Peccato," in vol. 2 of his *Opera omnia*, ed. F. S. Schmitt (Edinburgh, 1946), chaps. 1–3, pp. 140–43. See Odon Lottin, "Les théories sur le péché originel de Saint Anselme à Saint Thomas D'Aquin," in *Psychologie et morale aux XIIe et XIIIe siècles*, vol. 4 (Louvain: Abbaye du Mont César, 1954). See Payer, *Bridling of Desire*, chap. 2. A useful analysis of pre-Scholastic understandings of concupiscence is John W. Baldwin, *The Language of Sex: Five Voices from Northern France around 1200* (Chicago: University of Chicago Press, 1994), chap. 4.

[20] See Alexander of Hales, *Summa theologica* (Quaracchi: Ex typographia Collegii s. Bonaventurae, 1930), book 2, part 2, question 2, treatise 3, question 2 (pp. 220–26).

[21] See M. Michèle Mulcahey, *"First the Bow Is Bent in Study": Dominican Education before 1350* (Toronto: PIMS, 1998), pp. 294–96, 301–4, for an analysis of when Aquinas completed these sections of the *Summa* and *De malo* and a summary of the literature. Mulcahey argues that they were written just after his return to Paris, after a stint of teaching in Rome.

harmonious justice is original sin, the individual's disposition to disorder, to make choices that are not in agreement with the divine plan.[22] Concupiscence is the effect of original sin, or in Thomas's formulation the material cause. It is disordered desire, the body's pursuit of natural appetites in disregard of reason. Sensuality is a rebellion against reason. This is true in society as in the body. Orderly justice requires the imposition of rational control, the restraint of disordered desire. This analysis directly connected disorder in human nature with social disorder. Before the fall, there was no need for external restraints since humans enjoyed an interior justice, which meant that they made choices in harmony with God's plan. With original sin, humans have lost their rational control of the body and its appetites. It is thus original sin that creates social disorder; without it, there would be no conflict in society. Orderly justice requires rational control, in society as within the body.

The idea that human nature is perverted by sin was thus a foundation of theories of the state. State authority is required and justified by human weakness. For Augustine, humans before the fall had a natural disposition to associate together in society. One result of the corruption of original sin was the loss of that associative nature. The human race has become unsocial by its corruption. For Augustine, then, the state is necessary not as an extension of a natural human tendency to associate but as a remedy for sin, a mechanism to compel humans to suppress antisocial passionate behaviors. The implications of gendered understandings of the passions are important here: the coercive power of the state is needed to quell impulses that were at times coded as feminine. Ptolemy of Lucca, who studied with Aquinas, in his "On the Government of Rulers" struggled to reconcile an Augustinian understanding of the need for state authority as the consequence of sin with the Aristotelian idea of the natural propensity of humans to live together in society.[23] Another variant of this view that became influential in the thirteenth century was the notion that people retain their natural tendency to associate but in consequence of original sin need to be persuaded to do so. This is a Ciceronian emphasis on reason and persuasion: because of sin, rhetoric is crucial. People must be made to see the need to live together in society.[24] Albertano's insight was that unless a man's passions are checked by rational analysis, they

[22] Thomas Aquinas, *Quaestiones disputatae de malo*, in *Opera omnia*, vol. 22 (Rome: Commissio Leonina, 1982), question 4, article 2. On Thomas's analysis of concupiscence as the material rather than the formal cause of sin, see Conan Gallagher, "Concupiscence," *The Thomist* 30, 3 (1966): 228–59.

[23] Ptolemy of Lucca, "De regimine principium," trans. James A. Blythe as *On the Government of Rulers* (Philadelphia: University of Pennsylvania Press, 1997); see book 3.

[24] Cary J. Nederman, "Nature, Sin, and the Origins of Society: The Ciceronian Tradition in Medieval Political Thought," *Journal of the History of Ideas* 49, 1 (1988): 3–26.

can lead to a destructive course of action. Here this approach is formulated as a theory of the state: people need rational persuasion to learn to live together.

Fra Remigio de'Girolami, a famed Dominican preacher in Florence at the end of the thirteenth century, addressed the problem of just order in society and the interior passions in influential sermons. Educated in theology at the University of Paris, Fra Remigio became the first master of theology at Santa Maria Novella and ultimately a sort of official orator of the Florentine Republic. He preached five sermons to the town's guild executives, the Priors, the Florentine equivalent of Orvieto's Seven, and developed a political analysis in terms of the common good that has been considered an example of Aristotelian influence on early Renaissance statecraft.[25] Fra Remigio spoke far more extensively about the consequences of sin. In a sermon from a collection de Sanctis, he preached on the text from the Sermon on the Mount, "Blessed are those who mourn, since they shall be consoled." Fra Remigio first divided this theme into three parts, the blessed, those who mourn, and the promise of consolation. In his discussion of those who mourn, he first categorized them, distinguishing as I discussed in chapter 2 between the verbs to sorrow, groan, weep, cry, lament, and mourn. Second, he asked what we should mourn. In this context, Fra Remigio turned to original sin discussed in Augustinian terms, describing its effects in terms of concupiscence and the loss of perfect control of the genitals and then in terms of political disobedience, the intellect as king disobeyed by the members of the body.[26] Disorder in society is directly understood to be the effect of concupiscence. We are divided into contradictory appetites. We can love a person according to concupiscible appetite because of the beauty of her body, yet abhor her according to the irascible appetite because of enmity. The eye can delight to see a shining burning flame that the hand would be horrified to touch; the nose can enjoy the scent of a flower that the tongue and mouth would hate to eat. The image evokes the cruel situations of women married into enemy families to anchor peace pacts.

It is striking that the term *passion*, with its complex meanings in philosophical traditions stretching from the Stoics to the Scholastics, came to be used in the Italian vernacular to indicate strong factional allegiance. A man might have to set aside his passions to act for the good of his whole city. To give an early example, when the chronicler Giovanni Villani spoke of the Florentines preparing to defend their city in 1328, he portrayed them as "free men" who

[25] On his career in Florence, see Mulcahey, *"First the Bow,"* pp. 388–96, 436–38.

[26] BNF, Conventi Soppressi, D.1.937 (Schneyer #927), 341 verso–343 recto. On the manuscript, see Letizia Pellegrini, *I manoscritti dei predicatori* (Rome: Istituto storico domenicano, 1999), pp. 321–24.

"were disposed to bear every passion and constraint in order to maintain their city with God's help."[27] Passion, then, could mean the strong emotional attachment that might prevent a man from acting for the common good.

POLITICAL FRESCO

The themes of order and disorder were also conveyed in political fresco. A rich vocabulary existed in fresco that is now largely lost, as most of these paintings have long since disappeared. Towns painted images of people convicted of infamous crimes in the Palazzo Pubblico; as I suggested in Chapter 1, we know that these images were painted rapidly, could serve as surrogate punishments, and genuinely disturbed people, judging from the case of a young man who confessed under torture that he had scratched out the picture of his father in the Palazzo Pubblico in Bologna.

Towns also used fresco to set out political ideas. The few pictures that survive suggest ways in which gendered imagery could be deployed. Perhaps the most baffling and potentially revealing is an extraordinary fresco recently discovered on the wall behind a public fountain in Massa Marittima.[28] It is just a block from the cathedral. The structure dates from the mid-thirteenth century; the date of the fresco is uncertain but thought to be mid to late thirteenth or early fourteenth century. Massa is a modest town in southwestern Tuscany that was under Sienese rule, in a period when Siena was Ghibelline, closely allied with the faction that backed the imperial party. The painting can be interpreted in a number of ways; as George Ferzoco suggests, one is political and anti-imperial. It depicts imperial influence in terms of sexual disorder, in quite an explicit way. A group of four women are painted twice, standing on either side of a tree lavishly hung with phalluses. The women on the right are decorous, restrained. An imperial eagle flies in overhead, headed to the left. On the left, the same women appear, with four eagles hovering just over them. The imperial reference is unmistakable: the birds closely resemble contemporary drawings of the imperial insignia. Underneath them, on the left side of the tree, two women engage in a hair-pulling fight over a bag of phalluses, and a third arranges more phalluses in the tree with a pole.[29] A fourth woman is penetrated from the rear as one of the eagles perches on her head.

[27] "Come franchi uomini erano disposti a sostenere ogni passione e distretta per mantenere coll'aiuto di Dio la cittade." Villani, *Nuova cronica*, book 11, chap. 97, 2:642.
[28] George Ferzoco, *The Massa Marittima Mural* (Leicester, U.K.: Troubador, 2004).
[29] Ferzoco, *Mural*, argues that she is placing them in nests and is therefore a witch, like the fifteenth-century depictions in the *Malleus Maleficarum*.

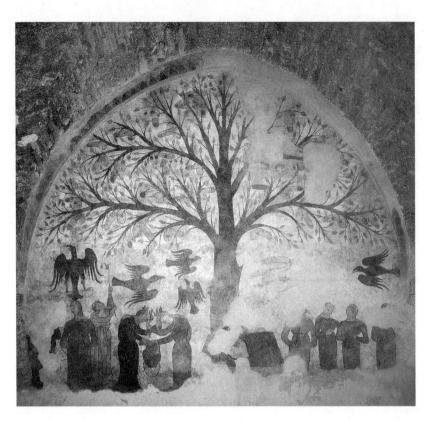

Fresco. Fontana dell'Abbondanza, Massa Marittima. Photo credit: Fabio Lensini.

In my view the fresco echoes the idea in contemporary political theory that the state is needed to restrain concupiscence. A failed or illegitimate state therefore can be pictured as one that fosters sexual disorder. The fresco vividly depicts imperial misrule in images of women and the concupiscence they embody left unrestrained by men or manly reason. Under the sign of the imperial eagle, women are left free to fight over men's organs and to indulge their greedy sexual appetites, including sodomy, a sexual act that is not procreative and violates the natural order. And further, men do not control penises, women do. These are the disordered appetites of women, freed from rational male control.

The fresco was surely intended to be a comic and deeply insulting anti-imperial statement. One bit of evidence for the culture of Massa's Ghibellines survives, from the period after the Angevin victory at Benevento decisively weakened the imperial cause. In 1273, a group of Ghibellines from Massa made peace with their Guelf neighbors and placed themselves under the lordship of

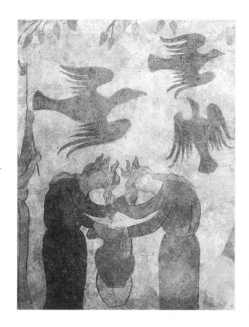

Women fighting over phalluses. Fresco detail. Fontana dell'Abbondanza, Massa Marittima. Photo credit: Fabio Lensini.

a local count. They also formed a company with the count: when they launched another *cavallata*, an armed raid on horseback, the count would aid them in exchange for a share of the booty, in goods and persons.[30] They had evidently become brigands. Perhaps, then, the fresco expressed hostility to Sienese Ghibelline rule, perhaps to the predatory local Ghibelline nobles; it could also date from 1310–13 and the threat posed by the Italian campaign of the Holy Roman Emperor Henry VII. My hope is that further research will reveal more about who had it painted and what local clerics thought of these sexual images so close to the cathedral. One larger question is whether this fresco was anomalous or a glimpse of a common vocabulary of sexual imagery—perhaps derived from the ancient world—now largely erased. Sadly, the fresco itself, once cleaned and exposed to light, has faded badly.

The best-known example of gendered political imagery is of quite another kind: Ambrogio Lorenzetti's highly sophisticated *Good and Bad Government* in the Sienese Palazzo Pubblico. In the early fourteenth century, a number of towns commissioned painters to set out political ideology on the walls of the town hall. The best-preserved is the great allegory painted by Ambrogio Lorenzetti in the room where Siena's executives, the Nine, met. The fresco of good government was painted on the wall directly behind them, so that anyone who did business with the town's Nine—say, a rebellious noble or a

[30] ASS, Diplomatico Pannochieschi d'Elci, 7 aprile 1273, perg. #14.

Tree of Phalluses. Fresco detail. Fontana dell'Abbondanza, Massa Marittima. Photo credit: Fabio Lensini.

Florentine ambassador—would be confronted not only with the men them-selves but with this powerful evocation of the nature and justification of their rule.[31] Unlike the Massa Marittima fresco, in this case the symbols are neatly labeled and explained. The paintings have been extensively studied as evi-dence of contemporary political ideology, by such scholars as Nicolai Rubin-stein, Chiara Frugoni, Quentin Skinner, and Randolph Starn.[32] A figure representing Tyranny presides over the court of bad government, which

[31] Thanks to Edward English for this interpretation of the impact of the fresco.

[32] Chiara Frugoni, *Pietro and Ambrogio Lorenzetti* (Florence: Scala, 1988), pp. 63–66. See Randolph Starn and Loren Partridge, *Arts of Power: Three Halls of State in Italy, 1300–1600* (Berkeley: University of California Press, 1992), which cites the extensive bib-liography on the frescoes.

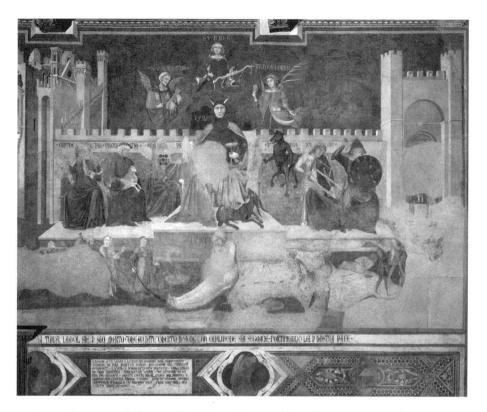

Ambrogio Lorenzetti. *Tyrannia*. Detail from *Allegoria del Buon Governo*. 1337–40. Palazzo Pubblico, Siena. Photo credit: Scala/Art Resource, NY.

includes a trinity of avarice, pride, and vainglory as well as cruelty, treachery, fraud, rage, division, and war.

The point I would like to underscore is that the psychological qualities that are the source of bad government are depicted in gendered terms: again, the disordered appetites of women. Tyranny, at the center, is the Whore of Babylon of the Book of Revelation, holding in her hand the gold wine cup brimming with her fornications and under her foot a goat representing lust. The personification of the gratification of self at the expense of the community, of the forces that lead to bad government, is a lustful woman. A tyrant's greed for power is a whore's lust for sex. The lack of just order in the state is understood in terms of unrestrained sensual appetite, portrayed as a woman. Again, the way to govern well is to restrain appetites coded as feminine.

In sum, the equation of sensual appetites with female nature and rational authority with male was familiar to thirteenth-century Italians from a range

of sources, including sermons on original sin and political fresco. It is not surprising that Giovanni Villani echoed this idea when he explained violations of the dress code in terms of women's disordered appetites conquering men's reason. Men have been given lordship and are obliged to control sensual appetites, in the self as in the state. Misrule fosters disorder, rule by lust rather than reason.

CHAPTER EIGHT
THE SEDUCTIVE DANGERS OF GRIEF

I have suggested that the laws on funeral laments addressed a problem that was cognitive rather than functional. Men weeping and crying out in the streets and ripping at their beards posed no real threat to public order. The clusters of men fined for grieving at funerals in Orvieto were not mustering their allies to launch an attack on their enemies. Their noisy sorrow posed an intangible threat, displaying an aspect of human nature—intense grief—that people believed could provoke actions that might shatter the town's fragile order. Stability required male emotional restraint and decorum. This concern over the display of strong emotion was a real change. Fifty years earlier, men as well as women were expected to make a show of their feelings at funerals. It would, I believe, have been shocking for a man to hold back his grief at the death of a friend or ally, let alone his own son. As I suggest in Chapter 9, by the late fourteenth century even soldiers mourning their war captain kept their grief in check.

The mourning laws also reflected contemporary interest in the interior life, a cultural preoccupation with the emotions. Writers and painters were fascinated to find ways to represent and understand inner feelings. There was a new movement in painting toward images designed to draw in the viewer to participate in religious emotions. These pictures conveyed strong emotions, often maternal ones: tender compassion, sorrow at the cruel death of a child. A mother's affection was the best metaphor for God's mercy. The poets of what Dante termed the *dolce stil novo* wrote verses of extraordinary beauty about grief and love. Theologians and preachers grappled with the problem of the emotions and urged some forms of sorrow as crucial for salvation while they castigated other, closely related emotions as disorderly sensual appetites

that were the consequence of original sin. With sin, our reason has lost control of these bodily appetites. State authority is needed as a remedy for human weakness: we must be persuaded and even required to bridle our feelings. The laws on the lament thus restrained displays of grief and rage that the lawmakers believed could shatter political order.

Often these concerns were expressed in terms of gender. The conceptual vocabulary available in the thirteenth century to understand the powerful emotions surrounding death was limited. One approach was a return to the ancient tendency to think about and represent psychological faculties in terms of male and female nature. The pattern that is implied in the statutes and in sermons is evident in painting: a turn to gender difference to understand and control disturbing emotions. If reason is male and sensual impulses are female, then one way to think about the interior struggle over the temptation to sin is to imagine a man and woman arguing inside your head. As this implies, the primary concern behind the laws and their enforcement was the restraint not of women but rather of men. The emotions were coded as feminine, but the perceived threat was male grief. The laws nevertheless had real consequences for women: restrictions on the ways they were allowed to grieve in public were part of a general narrowing of social roles available to women in the late medieval towns.

Did men and women understand their own interior lives in these categories? None of the medieval texts I have discussed are people's accounts of their own experience. All are abstract analysis of sorrow or descriptions of the actions and feelings of others, real or fictional. Further, none are female voices. From this perspective, this book is a study of how men talked about women. I know of no discussion of mourning or the experience of sorrow written by a woman from this period. There are a few hagiographical accounts. The most vivid is a slender anecdote from a mid-thirteenth-century saint's life, written by a contemporary friar who was the woman's confessor. It can be read as a repudiation of the obligations of mourning. Umiliana dei Cerchi, daughter of a major Florentine banking house, pursued a spiritual vocation in part through the active rejection of the customary roles of daughter and wife. In one of her visions, a demon tempted her to break a Lenten vow of silence by showing her the bodies first of her slain kinsmen, then her young children newly dead, and urging her to speak to them. Umiliana withstood the temptation to give way to emotion and remained silent.[1] Her refusal to grieve was part of her rejection of family expectations and patrilineal

[1] Vito of Cortona, "Vita de B. Aemiliana seu Umiliana," *AASS* 27 (19 May): 385–402; the vision is 389F–390A. Diane Owen Hughes originally suggested this interpretation of the episode to me. On Umiliana, see Anna Benvenuti Papi, "Umiliana dei Cerchi: Nascita di un culto nella Firenze del Dugento," *Studi francescani* 77 (1980): 87–117, and my discussion in

honor. This account was, of course, written not by Umiliana but by her confessor, Vito da Cortona.

There is an extraordinary source for the subjective experience of grief in the mid-fourteenth century: the writings of Petrarch. Petrarch struggled with grief and mourning throughout his long career, and he discussed his feelings at length, particularly in his letters. Unable to find a way to defend himself from the ravages of grief, he scavenged the writings of the ancients for advice about how to fend off overwhelming emotions. This effort was a part of the very conscious effort to shape the self that scholars have come to term Renaissance self-fashioning. He articulated many of the themes I have explored, including gendered ideas about reason and emotion, the seductive pleasures of grief, and fear of the destructive effects of sorrow and despair. He also linked the restraint of grief with civic order.

REMEDIES FOR GRIEF

In a passage in the *Secretum*, Petrarch counsels interior moral reform achieved by meditation on the physical horrors of death. The *Secretum* is a dialogue between a figure representing Petrarch and a spiritual guide who is identified as Augustine, though he espouses Stoic views that the saint would have firmly rejected.[2] The dialogue is an examination of Petrarch's inner conflicts, undertaken in hope of spiritual and moral reform. Petrarch in the dialogue voices his struggle to escape attachment to worldly things. Augustine advises him to meditate on death. Visualizing the physical decay of the flesh is a way to reshape the self, turn the mind away from trivialities and the quotidian to focus on one's final end.

The *Remedies for Fortune Fair and Foul*, Petrarch's manual of therapeutic advice that became a Renaissance best seller, includes among remedies for adversity many chapters on grief. The work was completed in 1366, late in Petrarch's career. A series of dialogues teach how one can counteract sorrow over various kinds of deaths, including that of a wife, a son, an infant, and a brother, as well as one's own death, one's own early death, death far from home, death without proper burial, and so forth. The voices in the dialogues are personifications of Sorrow and Reason: Sorrow sets out a troubling experience, and then Reason argues the emotional reaction away. This work draws

The Florentine Magnates: Lineage and Faction in a Medieval Commune (Princeton, N.J.: Princeton University Press, 1991), pp. 111–20.

[2] Francesco Petrarca, "Secretum (De secreto conflictu mearum curarum) libri tres," in *Prose*, ed. G. Martellotti and P. G. Ricci (Milan: Ricciardi, 1955), pp. 21–215.

heavily on the Stoic therapeutic approach. George McClure terms it a psychological encyclopedia. There is also a cookbook quality to the remedies that makes them somewhat inaccessible to modern readers. Petrarch separated the emotion from rational analysis of the circumstance. When Sorrow sets out a painful emotion ("I lament the deadly fall of my infant son"), Reason offers rational comfort in the form of an abstract argument that dismisses the emotion ("A sudden death is to be desired for the innocent, to be feared for the guilty").[3] This view can seem cold-blooded, at least to modern readers, especially since Petrarch in this chapter was probably thinking of the death in infancy of his own grandson. However, Petrarch did not believe that a more personal, emotional consolation was possible. What real comfort could there at the accidental death of a beloved child? The dialogues were not intended to be sympathetic; they gave readers not comfort but Stoic therapy in the form of distance: rational perspectives on death.

The remedies often echo the Stoic tendency to code reason and emotion as male and female. For example, chapter 48 treats the loss of a son.[4] The dialogue relies heavily on Cicero and Seneca. When Sorrow states, "I am consumed with longing for the son I lost," Reason replies, "You should be comforted because you will soon join him," and argues that for men, nothing of short duration is difficult. Reason goes on with examples of fathers who reacted appropriately when sons died, including as an honorary male "that nameless Spartan woman" who reacted to the news of her son's death by saying that she raised him to be unafraid of death for his country.

MANLY AND WOMANISH GRIEF

Petrarch also wrote at length about his own experience of grief in his extraordinary letters. In many letters, he broke with an older tradition of structured artificial formulas derived from Ciceronian rhetoric and instead wrote more directly about his feelings and experience.[5] The letters must be read with care: at times they are fictitious, and Petrarch constantly revised them and often split them into several letters. Ultimately, he assembled them in two collections for posterity, purging the problematic ones.[6] The

[3] *Petrarch's Remedies for Fortune Fair and Foul*, 5 vols., trans. and ed. Conrad H. Rawski (Bloomington: Indiana University Press, 1991), book II, dialogue 49, 3:117–18.

[4] Ibid., 3:115–17. For a thorough analysis of Petrarch's sources, see pp. 176–81.

[5] See Ronald G. Witt, "Brunetto Latini and the Italian Tradition of *Ars Dictaminis*," *Stanford Italian Review* 3 (1983): 23–24.

[6] Francesco Petrarca, *Le familiari*, ed. Ugo Dotti (Urbino: Argalia Editore, 1970). The purged and miscellaneous letters are collected in Francesco Petrarca, *Lettere disperse*, ed.

letter collections are thus a Petrarchan exercise in self-representation, or perhaps an early example of Renaissance posturing. It is important to recognize that the letters are not a direct glimpse of Petrarch's psychology so much as his representation of self. Horrified grief at a particularly cruel death will elicit pages of classical erudition in elegant Latin prose. When he writes of the untimely death of a friend, he speaks of his "painful grief that cannot be contained within the boundaries of a letter." Then he strikes a humanist posture, speaking of his plan "to console myself with my letters and with an appropriate volume," in the manner of Cicero and Ambrose.[7] The letters thus are not accounts of Petrarch's immediate emotions or experience but rather reveal how he chose to portray his reactions to death over time. Nevertheless, the self-portrait he sketched is extraordinary. He used his poetic gifts to create powerful images of his own ambivalent understanding of grief and struggle for interior stability.

Petrarch's letters about death and grief more or less follow the formula of ancient letters of consolation: praises of the dead, examples of brave mourners, "philosophical topoi of the futility of grief, the inevitability of death, the miseries of life, the hope of immortality."[8] They are full of gendered imagery, familiar from the ancient consolatory tradition: one should grieve "viriliter" not "muliebriter," in a manly and philosophical rather than womanly and emotional fashion. The distinction between gender categories and actual men and women is very much present: following Seneca's model in the letter to Marcia, Petrarch often lists examples of Spartan women or noble Roman matrons who proved themselves capable of virile mourning.

A letter consoling an anonymous and perhaps fictional person over a friend whose corpse was tossed into the sea is a vivid example. Petrarch begins, "I grieve for you that a good friend has perished, but more importantly I am indignant that right judgment has perished in you. You console yourself in a way that I say is neither manly enough nor philosophical."[9] The complaint that the body was not properly buried seems an old woman's quibble (querimoniam anilam). Petrarch illustrates the point with the inspirational story of Lamba Doria leading the Genoese fleet in battle against Venice. When Lamba early in the fight saw his only son killed by an arrow

Alessandro Pancheri (Parma: Fondazione Pietro Bembo, 1994); see pp. xxxii–xxxvi for their numeration in earlier collections. See also *Petrarch's Correspondence*, ed. E. H. Wilkins (Padua: Antenore, 1960), and Giuseppe Billanovitch, *Petrarca letterato* (Rome: Edizione de storia e letteratura, 1947), 3–55.

[7] Petrarca, *Le familiari*, ed. Dotti, IV, 10.

[8] Goerge McClure, *Sorrow and Consolation in Italian Humanism* (Princeton, N.J.: Princeton University Press, 1991), p. 32.

[9] Familiari II, 2. The letter is undated. See Petrarca, *Le familiari*, ed. Dotti, I, 1, pp. 133–41.

in the flower of his youth, and a group gathered around his corpse to lament, Lamba called out, "This is not the time for wailing but for fighting," and tossed the still-warm body into the sea. His courageous action inspired the Genoese to victory. Petrarch argues that the father "was not less pious than if he had thrown himself on the body wailing like a woman [muliebriter]" and had become incapable of action at this moment of military crisis for his republic.[10] You, he adds, addressing his grieving friend, would have torn your cheeks with your fingernails, not at the death but at the burial. Then Petrarch draws heavily on a passage on burial customs from Cicero's *Tusculan Disputations*. You should rely on reason, he counsels, and recognize that burial customs have varied; for example, Artemisia, queen of Caria, out of conjugal love ate the ashes of her husband and became his living grave. Manly reason can restrain feminine passion. A brave, pious soldier does not give way to grief but controls his feelings and does battle for his city.

And yet Petrarch saw with clarity the limits of Stoic manliness. People cannot always benefit from this advice. He even comments refreshingly in his last letter that common people tend to find these philosophic strictures "unthinkable and strange." At his most sympathetic, Petrarch articulates the opposition between reason and passion as an interior struggle: being torn between conflicting reactions to death. Sometimes he opposes being controlled and manly not to being womanish but to being human. Familiari II, 1, is an early letter, sent between 1338 and 1340 to a friend, Philip, bishop of Cavaillon, whose brother had died prematurely.[11] Petrarch praises Philip for his calm, dignified grief. Philip's face, Petrarch writes, reveals him caught between brotherly compassion and manly courage.[12] The two attitudes reflect his gentleness and his wisdom, for "it is human at the death of one's dear ones to shed tears as evidence of one's devotion; it is manly to place a limit upon them and to control them." The opposition is an interior tension not between manly control and feminine indulgence but rather between compassionate humanity and philosophic restraint.

Arguing in the letter to Philip that death can free us from worse things, Petrarch embroiders on the tale of Socrates' philosophic death. Socrates takes on the stance of a Stoic suicide, indifferent to Fortune and "happy to

[10] See Petrarca, *Le familiari*, ed. Dotti, pp. 136–37n, for a discussion of the sources of the story. The discussion of burial customs follows Cicero, *Tusculan Disputations* I, 43–45.

[11] Petrarca, *Le familiari*, ed. Dotti, I, 1, pp. 117–31; the English translations are from Francesco Petrarca, *Rerum familiarum libri I–VIII*, trans. Aldo S. Bernardo (Albany: State University of New York Press, 1975), pp. 57–64, with minor emendations.

[12] Petrarca, *Le familiari*, ed. Dotti, p. 119.

leave behind by dying the threats of tyrants whom he had disdained during his lifetime. He serenely brought to his lips the cup of poison" but was distracted by the laments of his wife.[13] It is the wife who bursts out in grief because she cannot accept the death of an innocent and just man. Her lamentation momentarily distracts Socrates from serene philosophic acceptance. He chides her: "Would you have preferred that I should die a guilty wrongdoer?" Petrarch draws the moral: we should rejoice when good people die because they have been snatched from this valley of affliction and transferred to more joyful things. Worrying about where people die and are buried is indulgence in womanish feelings. A man who does this is "wallowing in the errors of his wet nurse or of gossipy women."[14] And as with the unnamed Spartan mother, a woman is produced as an example of manly behavior. Saint Augustine's mother, Monica, was disdainful of the site of her death and burial, pointing out that nothing is far from God. "This was a woman and Catholic. We who are Catholic and profess to be men, shall we indulge in any more womanish feelings?"[15]

How, then, should we respond to death? Petrarch writes to Philip: "To pray for the dead is a devout kind of service. But tears are the armament of women and are not fitting for men unless perhaps they are very few and fully controlled. Otherwise they are harmful to those who weep, and they are of no help to those for whose love they are shed."[16] Petrarch was fully aware of how difficult it was to adopt this philosophic stance. He depicts grief in terms of passionate desire for the dead. "If you still feel the torments of desire," he continues, remember that you too will be dead soon.[17] He places in the mouth of "aliquis" (someone): " 'What shall I do in the meantime? I am torn by a desire, I am overcome by love, and I am tortured by an eagerness to see my brother again.' "[18]

In other words, Petrarch often did not follow his own advice. He recites

[13] "cuius inter cetera feminei ululatus commiseratio viri erat, quod is iustus atque innocens moreretur." Translation based on Petrarca, *Rerum familiarum libri I–VIII*, trans. Bernardo.

[14] "et si cui contrarium videtur, adhuc se nutricis et muliercularum, erroribus imbutum norit."

[15] "Hec mulier illa catholica. Nos qui et catholici sumus et viros pollicemur, nunquid muliebrius sentiemus?"

[16] "Pium obsequii genus est pro defunctis orare. Lacrime autem sunt arma mulierum, viros non decent, nisi moderatissime forsan atque rarissime; alioquin et fundentibus eas officiunt et illis non proficiunt quorum amore funduntur." Translation emended from Petrarca, *Rerum familiarum libri I–VIII*, trans. Bernardo.

[17] "Si quibus etiam nunc desiderii stimulis urgeris."

[18] " 'Sed quid interim faciam?' dixerit aliquis, 'desiderio torqueor, amore langueo, aviditate crucior fratrem meum revidendi.' "

the cold examples of people who maintained Stoic dispassion at the death of loved ones: "Anaxagoras at the announcement of the death of his son said, 'I hear nothing new or unexpected; for I, being mortal, knew that I had begotten a mortal.'" Petrarch's own voice is closer to that of Socrates' wife, bursting out in grief at an unfair death, or to the anonymous "someone" overwhelmed by passionate longing for a beloved brother who has died. This complicates the gendered opposition of male reason and female passion in a revealing way. Petrarch as he represents himself identifies not with manly philosophy but with the qualities he codes as feminine, and sometimes as human.

FEAR OF GRIEF

Why this identification with the feminine? Petrarch portrayed himself as afraid of grief. Some of his letters contain intense outpourings of sorrow, sorrow he says he cannot control. The early letters are striking. Some were written in 1348–49, when the first wave of the plague decimated populations across Europe. Familiari VIII, 7, is a famous letter about his emotional response to the deaths of so many friends in the plague. He writes in Familiari VIII, 9, a letter to Ludwig von Kempen, the friend he termed his Socrates, about his distress when two mutual friends turned aside from a journey to visit him and were ambushed by bandits, one of them killed and the other lost. Characteristically, in the middle of his discussion of the fate of his friends, his attention shifts from their experience to his own feelings. Petrarch comments at length on his ambivalence:

> I seem to contradict myself in its words, nor can I restrain myself. But meanwhile, I know not how, I am seized by something I do not wish, if indeed I can wish unwillingly, and I am undergoing something miserable and deadly and yet pleasing to my mind. Weeping also has a kind of sweetness with which I have unhappily nourished myself in these days, and tormented myself, and in which I have taken pleasure. For unless I do find delight in it, who compels me to deal with these sorrowful things? But it is a delight more painful than any punishment, for while memory wrenches the mind, my grief diminishes.[19]

Grief is a thing that seizes him. There is a parallel with contemporary understandings of sexual desire as the loss of rational control of the body, the

[19] Familiari VIII, 9; Petrarca, *Le familiari*, ed. Dotti I, 2, p. 891; it was originally written in 1349. On Petrarch's revision of this letter, which was originally part of a longer text, see McClure, *Sorrow and Consolation*, pp. 32–33 and 196n.

consequence of original sin. Grief too is a loss of ability to restrain the self, an indulgence that is sweet and pleasurable as well as deadly.

Petrarch's Latin with its passive verbs elegantly conveys a sense of being pulled between conflicting emotions. He evokes a whole contradictory complex of feelings, a sense of being taken over by emotion unwillingly and yet an admission of the sweet pleasures of sorrow, feelings of guilt at being the indirect cause of the death, and so forth. The letter suggests extreme vulnerability. He does not know whether the second man is dead and is "distracted and torn to pieces in an extraordinary and wretched manner by raging and contradictory anxieties and messengers." He is now tormented by three passions: hope, fear, and grief. He knows what he should do, he writes: "Shutting my door to all consolers, I ought to devote myself alone to my grief, and either lighten my mind with tears or oppress it, either lessen my desire for mourning or satisfy it." He likens his state of uncertainty to a ship tossed on the sea: "I dislike intensely having my mind overwhelmed with countless waves tossing about the swift skiff of hope hither and yon on the changeable sea of rumors."[20] And, he tells his reader, he is aware that this is not honorable. He apologizes for indulging in his indecorous sorrows (dolori meo indulgens non decori). The discussion is a measure of his weakness, but he needed to unburden himself lest he break under the weight of evils.

Petrarch sketches himself as preoccupied with his own emotional state, as if he were more worried about being upset than about the fate of his friend. A letter written in a similar circumstance, Familiari VII, 12, catches this same self-absorption. Petrarch wrote of his distress when, waiting for a visit from a friend, he received instead news of the man's death. He had decided from painful experience to disdain Fortune but "after such a manly decision here I am again falling prey like a woman and a silly man. Or should I perhaps have said ridiculously or even tearfully. To others perhaps I appear ridiculous; to myself I appear deeply miserable and wretched." He is troubled by his own emotional weakness. "Almost never have I examined anything as I now have myself, and I must confess not without shame that I find more feeling in me and less strength than I thought; for I used to think (and it was proper because of my wide reading and long experience in life) that I had hardened myself against all blows and injustices of fortune. Unhappily I was wrong. . . . Now my torn mind grieves the more out of control, the more it perceives that it has lost more than it thought." He vacillates between giving way to grief and his usual remedies.

[20] "pessime michi esse, alternantibus animi fluctibus et facilem spei cimbam huc illuc, rumorem estu vario ac reciprocante, lactantibus."

Most ancient and medieval discussions we have seen separate the emotions of grief from concerns about their expression in mourning. Preachers such as Chrysostom addressed the social and political consequences of violent displays of mourning. Jerome, like Chrysostom, was worried about what on-lookers would think of a display of grief rather than what it meant for the spiritual state and religious faith of the mourner. Petrarch was more attuned to the interior life or perhaps more willing to admit its validity. He was in-tensely aware that grief and mourning are very much entwined and worried about the psychological effects both of outward displays of mourning and of the restraint of grief. He wrote to Cardinal Giovanni Colonna of the dan-gers of allowing "a disturbed mind to hide behind a calm exterior. This was most dangerous to many, for while they disguised their upsets and behaved in public as though they were happy, they were dejected in their private rooms and wasted away in concealed grief. Such artifice is appropriate for an insane mind and labors only for one's own destruction. It is much safer to confess one's grief and to weep openly."[21] Petrarch perceived what in mod-ern vocabulary would be termed the repressed emotion as harmful, and urged catharsis through tears.

Petrarch sometimes thought that grief was best purged through tears. Implicit in this approach is a different idea, the sense that the emotions of grief are somehow alien to the self but can capture one. They also can liter-ally be drained away through tears. In September 1348, he wrote a letter to Stefano Colonna il Vecchio, the father of his patron, Cardinal Giovanni, who had just died. At least to this modern reader, it is a staggeringly callous letter. Stefano had buried five brothers, his wife, all seven sons, and many grandchildren, and now in extreme old age—Petrarch calls him one hun-dred years old—he was left alone and without heirs. Petrarch's letter is a di-rect statement of just how cruel Stefano's experience had been and how little was left to him. "Alas, pitiable old man," it begins, "what crime did you commit against heaven . . . to be punished with so long a life?"[22] Petrarch rehearses all the old man's losses and even recalls an occasion in which Ste-fano himself had unknowingly predicted Giovanni's death. Fortune has

[21] Petrarca, *Le familiari*, ed. Dotti, VII, 13.

[22] The letter is Familiari VIII, 1. McClure, *Sorrow and Consolation*, p. 37, calls this the saddest of his letters of consolation. As McClure points out, Petrarch returned to com-ment on the letter in 1363 in Variae 58, calling it an effort to cure Stefano's grief by purg-ing it.

changed the elderly man "from a most happy father to a spectacle of pitiable bereavement." Stefano has nothing left to hope for—however, Petrarch underscores, this means that Fortune can no longer injure him. Petrarch enjoins him to rational acceptance. "The public calls you bereft of children, an old man, a wretched man. You must believe that the multitude is mad as usual and that you are happy." In fact, Petrarch argues, Stefano has learned by experience that Fortune is nothing, happiness but a myth. Nothing further can be taken from him: "You entered this life naked, you shall exit naked." This seems cold comfort indeed.

Five years later, Petrarch justified the harshness of the letter in another missive.[23] He was afraid of being criticized for it: the person who delivered the letter watched Stefano weep and sigh as he read it and feared the letter would harm him, provoking the old man's friends to charge Petrarch "with bringing on some harmful and fatal condition."[24] Instead, Stefano wept to satiety and exhausted the source of tears in his heart. This reaction convinced Petrarch of the efficacy of a cathartic remedy: purging grief through tears. He adopts this approach at times to relieve his own mind of grief, but with ambivalence. Venting his sorrow in a letter is effective, but the expressions in the letter are "pitiable and unmanly." "I found pleasure in what men find the contrary of pleasure; in some way I was softened and caressed by my own troubles. Nothing did me more good than my weeping; a torrent of tears extinguished the flames of my heart."[25]

It may be that Petrarch gradually decided that venting grief was not a good idea. McClure argues that he changed his view to urge Stoic indifference rather than admit to emotional vulnerability: "The vulnerable mourner of 1348–49 [becomes] the Stoic opponent of Fortuna." Petrarch writes during the cruel 1361 recurrence of the plague: "I would hope not again to be forced to laments unsuitable to this age, to these studies and to myself. I then permitted myself many freedoms which I now deny myself . . . I shall stand upright if I can: if not, fortune will lay me low dry-eyed and silent. Lamentation is more shameful than destruction."[26] And yet, as McClure points out, he at times continues to indulge in expressions of grief. Why this fear of the lament?

[23] Variae 58, written in 1353, now edited by Alessandro Pancheri as Dispersa 56; see Petrarca, *Lettere disperse*, ed. Pancheri, p. 390.

[24] Familiari et Variae 3: 466; quoted by McClure, *Sorrow and Consolation*, pp. 37–38.

[25] The translation is from *Letters from Petrarch*, trans. Morris Bishop (Bloomington: Indiana University Press, 1966), p. 220. Again, the letter is Variae 58, Dispersa 56.

[26] See McClure, *Sorrow and Consolation*, p. 32; translation, *Letters from Petrarch*, trans. Bishop, p. 223.

Petrarch was convinced that grief was dangerous to the self, as his letter to Philip suggests. His 1355 letter on the death of Paolo Annibaldeschi is about the power of grief.[27] Paolo was one of Petrarch's friends, a Roman nobleman whose surname in the poet's view was probably a reward for an ancestor's heroic service with Scipio Africanus against Hannibal and the Carthaginians. Paolo fell dead of grief at the sight of the body of his son, killed in battle and mutilated by the enemy. Petrarch in answer to a letter from Neri Morando about the death described his shock at Neri's news, terming it an attack on his body: the bitterest of sorrows, like a poisoned barb, an assault on his ears and soul. He thought that he had armed himself, he writes, that he had habituated his eyes to sad sights, his ears to bitter tales, his breast to all the wounds of Fortune, that his soul was hardened and armed against blows of Fortune by his awareness of all the terrible things that could happen to him and to his friends. However, he was in no way armed against this spear, and it has transfixed him. His friend by dying in this way "brought deadly sorrow to him" (mihi mortiferum dolorem attulit). The images of piercing weapons evoke the young man's lacerated corpse: Petrarch is stabbed and pierced by sorrow just as the youth was hacked by the weapons of his enemy.

At the same time, the expression of grief is a pleasure, a savage sweetness. What could seem better to the sorrowful soul than to engage itself in sorrow? Grief is a voluptuous pleasure, as Horace wrote.[28] Petrarch launches into a discussion of the pleasures of lamentation, then breaks off when he recalls that by his lament he does nothing for the dead but only harms himself and injures Neri's eyes and ears.[29] Sorrow is a physical assault on the interior self, lamentation a voluptuous pleasure but one that is harmful and even deadly. Again, there is a parallel with sexual pleasure understood as original sin: allowing oneself to give way, to be captured by an urge that is both a sweet pleasure and a deadly one.

But why is grief so dangerous? What makes it so deadly? The answer is not a single reason but a complex of ideas and fears. Petrarch explores them in his letter by writing much of it as an imagined dialogue, addressed as a

[27] Variae 32, edited by Pancheri (Petrarca, *Lettere disperse*) as Dispersa 28. The date of the letter has been debated: see *Letters from Petrarch*, trans. Bishop, p. 93n.

[28] Pancheri (Petrarca, *Lettere disperse*) identifies the text in Horace, *Ars poetica*, 105–6, and also cites Ovid, *Tristia*, IV, 3, 37: "est quaedam flere voluptas."

[29] "Sed quo pergo? Ut illi nihil prosim, mihi noceam, forte aures atque oculos tuos laedam?"

long reproach to Paolo. Petrarch was not surprised, he wrote, by the news of the young man's death in battle, the mutilation of his body, or the grief of his father. It is the immoderacy of Paolo's lament that is entirely new to Petrarch and an inconsolable sorrow to him: that the noblest and he had once thought the strongest of men could so bend his back to Fortune, so unbridle grief that it cast him down to death.[30]

Petrarch spoke repeatedly of the temptations of grief, its bitter pleasures. Paolo, he writes, I do not know by what deadly sweetness you were ravished in despairing death ("desperatam in mortem nescio qua ferali dulcedine raptus es"). He angrily excoriates Paolo for dying in this way. Paolo's grief is destructive of others, in particular of Petrarch's tranquility. He thought he had exhausted his tears in grieving for the Colonna family, but now he produces tears in the form of words from the furthest depths of his soul. Then he reproaches Paolo for the harm his death has done to Petrarch's interior state: what, alas, have you done to me? Paolo's death is almost antisocial, as if he had given himself over to the enemy.

By dying, Paolo set a bad example. He had better options: he could have produced more sons or procured prayers and suffrages for the salvation of the young man, who after all died an unprepared death. Or he could have pursued vengeance, the ultimate solace of a father and a strong man. Why did he not make one of these choices? Incredibly, Petrarch excoriates Paolo for not responding to the sight of his son's hacked-up corpse by using the examples of illustrious men to recall himself to life and hope. He recounts them for pages: Anaxagoras, Xenophon, Pericles, Marcus Cato the Elder, and so forth, then like Seneca in his letter to Marcia turns to "clarae mulieres," famous women.

Petrarch also offers the idea that Paolo's grief was a dementia, the idea that he has dishonored his son's memory, and the idea that Paolo's lament has offended Christ. "How much thought did you give that you might perish by your lament and offend Christ?" he writes, "Christ, the spectator and judge of our actions, who is undoubtedly and rightly troubled by mortal complaints about his eternal judgments." Paolo's sudden, deadly lament (luctum repentinum mortiferum) is unmanly. It is more honorable in a man to die of wounds than to die of tears. Even grieving women do better. Petrarch turns to a catalog of female laments, many of them familiar from Seneca's letter to Marcia. Petrarch can enumerate a long list of those to whom sorrow gave a reason to die, but none who took it up. The legendary death of Homer is a possibility, but he discards it as unworthy of the poet's greatness.

[30] "sic Fortunae tergum praebuit sic laxavit fraena moestitiae, ut illa eum praecipitaret in mortem."

Finally, Petrarch speaks of despair. He addresses his reader directly, counseling a form of self-deception. "All who live under the rule of Fortune have to conduct themselves like those who are oppressed by a cruel tyrant. Patiently developing a thick skin, they must instruct their eyes and ears and form their souls in such a way that they do not see what they could see, do not hear what they could hear, and do not know what they could know: dissimulating many things in order to bear everything." This is a powerful and disturbing image of Renaissance dissimulation as interior life: to live in such a way as to pretend to yourself that the things you experience are not there, "tempering bitterness with a mild smile." This is very far from the Senecan notion of detachment from the passions: Petrarch here counsels training the self not to avoid reliance on external goods but rather to engage in willful self-deception: don't look at it, hear it, or think about it, even though you know it is there.

He goes on to voice the "horrible thought" that there might be an unbearable evil, an evil that we who are passing through life dread so much that it would be better to end life.[31] Paolo's death from grief opens up the possibility of despair, of the threat of an evil so intolerable that the terrible sin of death by suicide is preferable. "A wise man arms himself against anything that can happen to him. I was not prepared for this and did not know it was possible—I had seen swords, illness, poisons, attack by wild beasts, shipwreck, fire, but I had not seen a sudden deadly lament." Petrarch purged this disturbing letter from his collections.

MOURNING PRACTICE AND CIVIC ORDER

Petrarch's last long letter places mourning at the center of the need for moral reform in a city-state. He makes exactly the move that I have argued is implicit in the attribution of lamentation to women, the projection of concerns about controlling the interior self onto the larger community. Renaissance self-fashioning becomes the job of the state. Interior disorder results from passion, and disorder in society similarly results from violent passions identified with women.

In 1373, at the end of his life, Petrarch wrote a long letter on the duties of a ruler to his patron, Francesco il Vecchio da Carrara, the lord of Padua. The political context is important. Francesco's rule had been plagued by the ravages of mercenary companies as well as plots by his younger half-brothers to

[31] "Horribile cogitatu est, quam nihil est mali quod non impendeat hanc vitam agentibus, cui, nisi fallor, optandus finis esset quem tantopere formidamus."

overthrow him. In 1373, longstanding tensions over the border with Venice led to war. After an initial victory, the Paduans in July suffered a disastrous defeat at a battle at Buonconforto, and Francesco il Vecchio agreed to costly and humiliating terms in order to make peace.[32] He struggled to find the funds to pay his mercenaries. The elderly Petrarch accompanied Francesco's son on a mission to Venice to acknowledge his father's guilt for the war; Petrarch made a speech to the doge and greater council praising the peace. That winter, Francesco's half-brothers made another failed attempt at assassination and were imprisoned for life. As Ben Kohl writes, Francesco "complained to Petrarch of the existence of such evil in the world." Petrarch in response "mused on the ironies of life, including evil in a universe ruled by a benevolent God."[33]

Petrarch's letter on the duties of a ruler thus was written at a time when his patron had suffered bitter defeat and treason and also had wisely made peace. It can certainly be read as a letter of consolation. Petrarch examines first the ideal character and duties of a ruler, drawing on examples from Roman history of good rulers beloved by their subjects and bad rulers, who tend to be murdered by them. Then Petrarch turns to how to rule Padua and offers concrete advice: repair the streets, drain the swamps, don't raise taxes, extend hospitality and patronage to scholars and artists, and so forth. There is a scattered quality to the letter, and Petrarch admits at one point that he is writing down whatever comes into his head. Still, as Ronald Witt and Benjamin Kohl note, "the entire tract stresses decorum, measure, prudence and dignity."[34] Toward the end of the letter, Petrarch recalls that he had intended at this point to exhort Francesco "to correct the morals of your subjects." But he has now concluded that the project, with one exception, is impossible, since "it is always difficult to change what has evolved out of custom." The exception is a "public evil": noisy funerals.[35]

Petrarch ends, then, with an attack on funeral lamentation. He evokes the debate between nature and culture, saying that he is not sure why people lament: "whether it is because of human nature or from some long-standing custom that at the death of our close friends and relatives we can scarcely contain our grief and tears, and that our funeral services are often attended

[32] See Benjamin Kohl, *Padua under the Carrara, 1318–1405* (Baltimore: Johns Hopkins University Press, 1998), pp. 118–31.

[33] Ibid., p. 129.

[34] *The Earthly Republic: Italian Humanists on Government and Society*, ed. Benjamin G. Kohl and Ronald G. Witt with Elizabeth B. Welles (Philadelphia: University of Pennsylvania Press, 1978), introduction to Francesco Petrarca, "How a Ruler Ought to Govern His State," p. 31.

[35] The letter is Petrarch, *Rerum senilium liber XIV: Ad magnificum Franciscum de Carraria Padue dominum: Epistola 1*, "*Qualis esse debeat qui rem publicam regit,*" ed. V. Ussani (Padua, 1922).

by wailings and lamentations." He knows that public displays of grief are especially deep-rooted in Padua and ascribes them to commoners. Commoners "are more apt to show their emotions and less likely to be moved by what is proper," and as soon as someone dies, "a great howling and torrent of tears begins."

What is wrong with a display of grief? Petrarch offers Cicero's familiar quotation from Euripides, to the effect that present existence is so evil that we should lament at birth. However, "the common people would find these [philosophic opinions] unthinkable and strange, and are not apt to be persuaded to rejoice at death." All Petrarch really asks, he says, is that loud displays of grief be curbed: "there ought to be hymns to Christ or devoted prayers for the soul of the deceased in a subdued voice or even silence," not wailing and lamentation. "This custom is contrary to any decent and honorable behavior and unworthy of any city under your rule." Petrarch suggests a number of familiar ideas about noisy mourning. The behavior is not decent or honorable and can be equated with other forms of disorder: fear of an enemy attack or a madman. And he hints that it denies Christian teaching.

The letter ends with a vivid sketch of a noisy funeral, with a suggestion that the display of grief is inappropriate because the dead person was insignificant: "Some old dowager dies, and they carry her body into the streets and through the public squares accompanied by loud and indecent wailing so that someone who did not know what was happening could easily think that here was a madman on the loose or that the city was under enemy attack. Now, when the funeral cortege finally gets to the church, the horrible keening redoubles, . . . the walls resound with the lamentations of the mourners and the holy altars shake with the wailing of women." Petrarch's rhetorical strategy is gradually to distance grief from the self. First, he understands displays of grief as custom or perhaps human nature. It is something "we" do and is perhaps intrinsic to our very nature: we struggle to contain grief and tears at the deaths of friends and relatives. Then he begins to distance these emotional displays, ascribing "a great howling and torrent of tears" to commoners rather than nobles. They grieve not for close friends but for "some old dowager." Finally, he separates grief entirely from the self by calling lamentation something that women do. Petrarch begs Francesco to "order that wailing women should not be permitted to step outside their homes; and if some lamentation is necessary to the grieved, let them do it at home and do not let them disturb the public thoroughfares." The way to promote moral reform and govern a city-state well is to restrain women from wailing in the street at funerals. Ironically, by 1373 it may well have been only commoner women who lamented the dead in the streets in cities such as Padua, where funeral grief had been given over to women not just rhetorically but in practice.

WARS AND FUNERALS IN FOURTEENTH-CENTURY ORVIETO

P etrarch's letter to Francesco il Vecchio was written against the background of the chaotic military conflicts of the mid-fourteenth century. The practice of war had changed with a growing reliance on mercenaries, professional soldiers rather than citizen militia. The move of the papal curia to southern France had destabilized the region, as the popes and their allies battled to recover the papal states. More generally, economic and demographic decline undermined the communes. The fates of the city-republics diverged sharply. Most towns gave up republican government and like Padua submitted to signorial rule, often domination by a larger territorial power. A few cities, notably Florence and Venice, survived as republics and became territorial states themselves. Funeral laws proliferated.

This chapter is not a narrative of these complex changes, but instead a sketch of some of the implications for how people thought about grief and funerals. I turn first to Orvieto after 1313. As the political climate changed and civil wars broke out, the town council repeatedly responded with legislation on grief. Contemporary chroniclers vividly recounted these events, including funerals. These accounts take us into the streets of Orvieto during the disastrous civil war of 1313 and then the endless battling as local nobles and their followers competed to hold the town as signori. They offer another kind of glimpse of the contemporary perception that noble displays of funeral grief fostered battles for power. One chronicler in particular connected noble ambitions for lordship and the resultant killings with the funeral grief and revenge that reinforced loyalty, affection, and obligation among nobles and their clients. Then I turn briefly to broader changes in

funerals by the late fourteenth century. They came to emphasize chivalric pomp, ostentatious expense, and hired mourners. My example is richly documented Florence, which was becoming a territorial power. Like neighboring cities, Florence put on elaborate state funerals for its mercenary war captains, funerals that epitomize these changes.

CIVIL WAR AND FUNERAL LAWS

Orvieto, like many Italian city-states, was at a pivotal moment in 1300. The town was engaged in an ambitious building campaign, including its physical fabric as well as stable fiscal and political institutions. It was threatened not only by outside military powers but by internal division and the ambitions of the powerful. The wealthiest of the noble families threatened to muster their allies and clients, expel their opponents, and establish a signoria, lordship. Popular regimes could maintain only a delicate balance, based not on coercion so much as commitment to the vita civile. After 1313, all the legislative efforts of the Seven could not protect Orvieto from a slide into factional war. During the first decade of the century, the popular regime maintained its precarious political balance. Factional opponents demonstrably participated together from 1294, as Ghibellines returned to service in the town's councils alongside their Guelf opponents. The Seven perceived the nobles as a threat to popular rule, and particularly from 1306 to 1309 imposed measures intended to restrict the magnates and protect popular interests. This was in imitation of other towns, but the Seven copied their measures with a relatively light hand. They knew well that the commune needed the nobles in order to govern and lacked the military force to coerce them. The council minutes occasionally show explicit efforts to incorporate nobles, albeit warily. In 1303, the popular regime launched an ambitious military campaign to take over the rich, long-disputed Aldobrandeschi lands. Council minutes describe first the decision and then the difficult struggle to raise and fund an adequate military force. On September 12, the town council voted to create a commission of twelve men "chosen from the town's best and better men," to ride with the podestà and Capitano in order to advise on military operations. They needed noble military expertise. The council also recognized the need for bipartisan support for the venture and explicitly required that the commission of nobles be balanced, with six members from each party.[1]

After 1313, the town's tenuous social and political balance broke down repeatedly. The general economic and demographic decline of these decades

[1] For these council debates, see *CD*, no. 602, pp. 388–96; this text is p. 389.

was exacerbated in Orvieto by the 1303 move of the papal curia to Avignon, which put an end to the periodic visits of the lavish courts of the popes and cardinals and their royal visitors. Orvietan prosperity was based in its wealthy contado and thriving artisanate. The departure of the popes both weakened the urban economy and meant the end of the stabilizing effect of the papal presence in the region. The gradual result was the town's loss of control over the rich lands in the contado and district. In the thirteenth century, the commune had struggled with the papacy over control of lands in the contado and suffered repeated interdicts; in the fourteenth, local nobles, emboldened by the relative lack of effective outside authority, claimed them. The town was unable to maintain order, and the contado came to be plagued with revolts and noble depredations. A minor raid of 1323 was typical: Count Romano Orsini's men killed or kidnapped a handful of men and stole five thousand sheep.[2] Gradually, not only sheep but the land itself was taken over.

The Seven's fears of division and factional violence were amply realized. Conflict broke out when the German emperor Henry VII's Italian venture stirred up the Ghibellines' hopes.[3] A partisan Guelf chronicler vividly blamed them for the terrible destruction in Orvieto. In August 1313, he wrote, the local Ghibellines promised to give the emperor entry into Orvieto. The Guelfs, fearing the advent of the emperor, humbly begged the Ghibellines to take over governance and agreed to comply with their rule provided only that the emperor was denied entry. When the Ghibellines refused, the result was war. The chronicler described the back-and-forth of the fighting, with masses of troops crowded into the narrow streets and squares of the town high up on its plateau. The Guelfs fought strongly, and many Ghibellines began to flee out the Porta Vivaria when Bindo de Vaschis appeared with reinforcements, eight hundred knights and three thousand foot soldiers from Todi, Spoleto, and nearby towns. They rode back in the same gate with great joy, trumpets and other instruments sounding. Some Guelfs became convinced that they should leave the city or face death. As Bindo's allies raised his banner on high, many of the Guelf party, "plorantes et clamantes," weeping and crying out, fled out the Santa Maria and Postierla gates.

Then the balance shifted when twelve hundred knights and as many foot soldiers from Perugia arrived to support the Guelfs, who marched back in through the Porta Maggiore, again to the sound of trumpets. They caught

[2] Daniel Waley, *Mediaeval Orvieto: The Political History of an Italian City-State, 1157–1334* (Cambridge: Cambridge University Press, 1952), p. 124.

[3] The classic account is William Bowsky, *Henry VII in Italy: The Conflict of Empire and City-State* (Lincoln: University of Nebraska Press, 1960).

up with Bindo in the Postierla. When he was thrown down from his horse, the Guelfs killed him with knives, swords, and lances. After chopping off both his hands, they carried the body to the Franciscan church, moved, the author explained, by mercy. After two more of their leaders were killed, the Ghibellines with their wives and children were driven from the city. Ultimately, the chronicler wrote, more than four thousand men died in the fighting and more than three hundred houses in the city burned.[4] The fifteenth-century chronicler Luca Manenti wrote of fighting in so many parts of the city that Orvieto seemed "un mongibello de arme, pianto et occisione": a veritable mountain of weapons, lamentation, and killing.[5] Many destroyed houses were never rebuilt.[6]

Like the people of other towns, the Orvietans sought to resolve factional conflicts by imposing destructive exiles on the leaders of the losers and confiscating their property, a policy that fostered instability by creating a class of bitter exiles who had little to lose. With Henry VII's sudden death from disease on August 24, 1313, and the Ghibelline defeat, the Orvietan Guelfs exiled their opponents and took their properties.[7] This move left them with little incentive to obey the law and every reason to attack. Albertano of Brescia had warned sixty years earlier of the disastrous consequences of heavy factional punishments. Events certainly proved him right. The new Guelf regime replaced the Seven with the Five, dominated by the Guelf nobility, particularly the Monaldeschi. Foreign policy disasters and the threat of popular rebellion led in 1315 to reinstitution of the Seven, with Poncello Orsini serving as captain in 1315–17 and 1321–22. This last popular regime imposed new measures intended to strengthen the popolo and ordered a new compilation of the popular constitution, or Carta del Popolo, completed and issued in 1323.

One aspect of the regime's response to factional violence was continued efforts to curb funeral grief. At some point between 1307 and 1323, the regime revised and elaborated the statute. The law in 1307 had simply limited funeral banquets and lamentation, with an emphasis on women. "No woman or any other person may go outside the house wailing and crying out [plorando], nor may they wail outside the house; those breaking the law must pay a 10-libra fine for each occasion. A woman who breaks the law

[4] "Annales Urbevetani," in *Ephemerides Urbevetane*, ed. Luigi Fumi, *RIS* XV, V, vol. 1 (Città di Castello, 1920), pp. 187–88.

[5] Cronaca di Luca di Domenico Manenti, in *Ephemerides Urbevetane*, ed. Fumi, p. 351.

[6] Waley, *Mediaeval Orvieto*, p. 141.

[7] The fragmentary extant list of the confiscated lands is ASO, Catasto 401, "Bona comunis olim rebellium."

[8] ASO, Statuti 26a, 10 recto–verso, dated 25 August 1307 at 13 recto.

must pay the fine from her dowry and not from her husband's goods. . . . Wailing and crying out inside the house of the dead are allowed, and not outside."[8] By 1323, new, more complex provisions also sought to keep funerals small and limited to close kin, as well as to restrain noisy and dramatic gestures. There was further attention to gender divisions. A burial could be attended only by the men who carried the body, and no one could linger at the church after the requiem or return to the tomb to grieve.[9] Women could not join in the funeral cortege carrying the body to church for burial "unless the body is that of a woman, which should fittingly be buried by women, and then only twelve women may go."[10] No one could plorare (weep and cry out) or beat their hands together outside the home or cloister.[11] This was the statute that specifically banned the corrotto, ascribing it to women, with a penalty of 100 soldi from the offender's dowry or, in the absence of a dowry, a beating. The house in which a woman "counted" a corrotto was to pay the same fine. Funeral meals and mourning dress were limited, along with gesticulations of grief. Bared heads and disheveled hair were forbidden to both men and women: "No one after the death may go outside the house pulling or tearing their hair, or remove the bands or hood from their heads."[12] Women were not to go back and forth to the house of the dead with their hair unbound or leave off their cloaks more than two days after the burial unless they were within three grades of kinship. Men could not wear black clothes for the dead or grow beards for more than eight days. Some displays of grief were allowed: members of the death confraternity could attend and stand in the church holding candles without penalty. There was a sense that honor was due to nobles: a knight's corpse could be carried to the church accompanied by a draped horse, banner, and shield, though if the funeral of anyone who was not a knight broke this rule, his lord or the house where the funeral procession began was to be fined 25 libra and the podestà was obligated on oath to confiscate the banner, shield, and drape.[13]

[9] "Cum vero corpus ad sepeliendum portatur, aliqui masculi ad sepolturam non accedant, nisi qui portaverint illud, et predicatione facta apud ecclesiam, statim homines ab ecclesia redeant . . . et corpore sepulto, nulla persona alio die redeat ad plorandum occasione mortui." The text is Carta del Popolo, rubric 117, CD, pp. 804–5.

[10] "Nulla mulier vadat ad ecclesiam cum corpore, quando portatur ad sepelliendum, nisi esset corpus mulieris, quod opporteretur mulieribus sepelliri; et tunc XII mulieres tantum vadant."

[11] "Nullus ploret ad mortuum, vel debattendo manus extra domum vel claustrum."

[12] Nullus etiam post mortuum vadat extra domum se pelando vel decapillando, vel extrahat sibi insulam seu capputeum de capite."

[13] I have emended Fumi's edition of this phrase, which reads "Dominus illa seu dominus, inde exiret talis defunctus." The Albornoz version of the 1350s reads "domus seu dominus unde exiret talis defunctus." ASO, Comune 29, 15 verso.

We lack court records that could reveal how strenuously the statute was enforced. Probably, as civil war and mass exiles tore the social fabric, funerals became factionalized. The sense of community that had brought political opponents together at funerals in the 1280s was lost. It is clear that whatever had restrained noble factions from fighting over the city had failed and that lawmakers linked this factionalism to the show of grief at funerals. After 1322, when Poncello Orsini was driven from office, the revived popular regime struggled against contending local nobles with varying success. The regime again turned its attention to funerals, in October 1331 legislating to restrict the use of wax. Two days later, the council discussed new measures to enforce the law, essentially adopting the system used at Bologna. They voted to ask the Seven to appoint a foreign notary, who would enjoy a salaried six-month term and servants and would be obligated to oversee the bridges, fountains, and streets as well as betrothals, weddings, and funerals. The council discussion focused on enforcement of the funeral laws: the official was obligated to visit the houses of everyone who died to investigate infractions or pay a 10-libra fine, which was two-thirds his monthly salary. Neighborhood representatives were to be appointed and charged with reporting deaths.[14]

Ermanno Monaldeschi's coup d'état of 1334 established a signoria. Ermanno was the son of the wealthy landowner Corrado di Ermanno, discussed in chapter 1, now further enriched by the confiscated properties of his family's defeated enemies. Another long version of the statute on weddings, funerals, and female dress was written during his tenure. It included careful limits on banquets, controlling not just the guest list but the menu. Restrictions on female dress were elaborated, as were the rules on "funerals and laments."[15] Ermanno's short tenure set the precedent for signorial rule, and his death in 1337 precipitated a long struggle as competing branches of his Monaldeschi heirs fought to replace him. All contenders turned to outside allies, notably the Counts of Montemarte, who had been effectively restrained by the commune in the early thirteenth century but now attempted to regain power.

From 1341 to 1345, Benedetto di Bonconte and his ally Matteo Orsini effectively ran the town as signori, holding off their competitors, Ermanno's sons. A contemporary account written by a chronicler who was probably an Orvietan and certainly had his ear to the ground described how this signoria fell. He vividly explained it in terms of the interplay of noble vendetta—attack and

[14] T. Petrocelli, L. Riccetti, and M. Rossi Caponeri, eds., "Orvieto," in *La legislazione suntuaria, secoli XIII–XVI: Umbria*, ed. M. Grazia Nico Ottaviani, Pubblicazioni degli Archivi di stato, 43 (Rome: Ministero per i beni e le attività culturali, 2005), pp. 1003–4.

[15] Ibid., pp. 1004–10.

retaliation—and faction. Grief and laments were central. The chronicler's explanation really begins with a funeral lament for a young noble whom the Orvietans believed the signori had ordered killed. "In 1343 on Feb. 14 they made the corrotto of Guido di messer Simone, who was killed in the Marches. Count Nicola the kinsman of messer Matteo Orsini killed him, and according to what was said by common people in Orvieto, messer Matteo ordered it: messer Matteo had been at that time in Rieti in the Marches and Guido was in Rieti to speak of his affairs to messer Matteo, in hopes that it would please Matteo to let him return to Orvieto."[16] After Guido left Rieti, he encountered Matteo's Orsini kinsman Nicola, who killed him.

Retribution came a year and a half later and in the chronicler's view was part of a conspiracy by the sons of Ermanno to regain power. First, a ruse: one of their allies gave false information that lured one signore, Benedetto, from the city with his troops, leaving Matteo exposed. "In 1345 on August 5 mastro Scarlatto was taken into prison. He was a dear friend and familiar of the sons of messer Ermanno and was imprisoned in the house of Benedetto di messer Bonconte. . . . And this mastro Scarlatto confessed to Benedetto that the sons of Ermanno were about to seize Pian Castagnaio with the aid of Count Guido and Count Jacomo [of Soana]. So Benedetto di Bonconte rode out with all the knights and foot soldiers in Orvieto and took them to Pian Castagnaio."[17]

This meant that "messer Matteo remained in Orvieto without knights," and the brothers and friends of the murdered youth could move against him. "The same day, that is, Saturday evening, Gulino di Petruccio Count of Montemarte came to Orvieto and according to what people say in Orvieto, he was sent by the sons of messer Simone, since they had made a deal together to oppose messer Matteo and messer Benedetto di messer Bonconte because of the death of Guido di messer Simone, whom messer Matteo had had killed, and because they held [Gulino's father] Petruccio di Pietro, Count of Montemarte, in prison." Matteo suspected a plot and tried to protect himself by summoning his supporters.

The next day, Sunday, at the hour of Vespers, messer Matteo sent out a whispered message to certain of his friends in Orvieto: "Arm yourselves, because I know that Gulino di Petruccio has made a deal to pull us down from the signoria." Many of his allies did arm themselves and accompanied him as he rode in the piazza, where he was joined by Gulino with his

[16] "Discorso historico con molti accidenti occorsi in Orvieto et in altre parti," in *Ephemerides Urbevetane*, ed. Fumi, p. 5.
[17] Ibid., pp. 6–7.

followers. When they were in front of the Porta de Sette, Matteo's friends began to wound Gulino, saying, "Traitor, you will not escape from this moment." And if it had not been for the quality of Gulino's armor, he would have been killed; as it was, he was injured in many places and his followers were wounded as well. . . . Many people went with a great clamor to the house of Count Petruccio to loot his neighbors.[18]

The account of Matteo's subsequent death powerfully evokes the clamor of armed men on horseback putting on a show of force in the town's small squares. After Gulino was stopped,

> messer Matteo many times rode around the piazza with many people, crying out "Viva Benedetto, viva il signore e viva messer Matteo." While messer Matteo was circling the piazza, armed and on horseback, Leonardo di messer Simone and Neri di madonna Gianotta [brothers of the youth killed a year and a half before], armed, entered the piazza with about twenty-five armed men, crying out, "Viva il Signore, viva Benedetto," showing themselves as if allied with messer Matteo. But then they turned on Matteo and came up close against him, now saying "Viva il Popolo." They killed messer Matteo and left the piazza. No defense was made for messer Matteo, and the house of Benedetto di Bonconte was pillaged and burned. Messer Matteo was taken dead to San Francesco of the friars.[19]

The Palazzo del Popolo was sacked and civic records destroyed, although the chronicler did not mention it.

The Orvietans were now faced with a dangerous opportunity: with one signore dead and the other lured out of town with his troops, who would rule? On Monday, the town council met and according to the chronicler revoked all the signorial authority that had been given to Matteo. The Seven were once again to have all their past offices and authority. Despite the constitutional form, this was not a return to popular rule. The council named as Capitano del Popolo a Sienese, who was to bring fifty knights and one hundred foot soldiers. This was a factional choice, a turn to Ghibelline Siena. The regime then struggled to hold the city until he arrived with his troops, challenged by the threat of popular revolt as well as noble contenders for the signoria. They called to all the men of the community to arm themselves and assemble by *gonfalone*, neighborhood, in the piazza. The Seven summoned Leonardo di Simone, Matteo's killer, who refused out of fear for his person. A popular re-

18 Ibid., p. 7.
19 Ibid., pp. 7–8.

bellion threatened, and there was a scuffle in the Piazza del Popolo. When Leonardo appeared, riding out into the piazza with his armed allies and banner, there was popular opposition and the scuffle became a battle.

Meanwhile, two alliances of nobles contending for lordship of the town brought military forces to the base of the plateau: Matteo's fellow signore Benedetto di Bonconte appeared with two hundred knights and one hundred fifty foot soldiers at San Gregorio, facing the southern wall of the city. The Seven ordered him to Ficulle. A few days later, he and his troops ravaged the countryside, burning the houses in valley of San Marco and the Rocca of Ripesena and, disastrously, the wheat and other crops in the Paglia valley. His enemies, the sons of Ermanno Monaldeschi, arrived on the same day with three hundred soldiers and eighty knights, camped for a day at San Bernardo, just under the aqueduct, and then were told by a messenger from the Seven that they needed to leave and not menace Orvieto's contado. In this tense moment, the chronicler reported, Matteo's funeral cortege was held, apparently delayed five days after his death, despite the season. "Friday 12 August during the hour of terza the Franciscan friars carried the body of messer Matteo out of Orvieto in a coffin covered with black, with a silk banner on it, and men carried it . . . they took it according to what was said at the time to the castle at Mugnano held by his son."[20]

The council managed to hold out and imposed a brief period of Ghibelline rule under Sienese auspices. It lasted only until Benedetto with help from Guelf Perugia retook the city in February of the following year, 1346. Then, in May, the sons of Ermanno expelled him and took over. War ensued between Benedetto, in alliance with papal forces, and Orvieto, allied with the Prefetti di Vico and Viterbo. In the midst of these conflicts, in July 31, 1347, the council voted yet another revision of the funeral statute, this time directly addressing the restraint of male laments. "No man can or should lament the dead [corroctare] or bare his head for any dead person, nor enter the house of the dead, with the corpse present."[21] The exceptions were those who provided wax and so forth and those who were to carry the body to the church for burial, who were allowed to enter and leave the house as needed, "provided they did not lament or cry out or bare their heads." It is clear that enforcement was problematic: the law provided that anyone who made an accusation or denunciation to the court was to be believed, and the court could proceed against violators by holding an inquest, regardless of any contrary statute or law. The measure passed on a split vote, twelve to six. It was preceded on the same day by a provision that may help explain it

[20] Ibid., p. 9.
[21] ASO, Riformagioni 134, 54 verso. See "Orvieto," ed. Petrocelli et al., p. 1010.

and certainly evokes the climate of personal rule. The town's rector and his officials were banned from carrying out executions themselves. The death penalty was to be enforced in the accustomed manner and locations, at the scaffold in Alsina or outside the Porta Maggiore, below the church of Saint George. The two measures together suggest that the council again associated male laments with unrestrained personal power in defiance of long-standing legal order, and also, not surprisingly, that enforcement was a struggle.

In 1348, the plague arrived, shocking the Orvietans.

> On the kalends of May 1348 there began in Orvieto a great mortality, which every day increased through June and July, until a day came when five hundred Christians died, great and small, male and female. The mortality was so great and the people so stunned that they died quickly: one morning healthy and the next morning dead. All the artisans' shops remained closed. This mortality lasted finally until the kalends of September, and from it many families and houses remain empty and they say that nine out of ten died. Those who remain are shocked and ill, and with great terror have left the houses that remained to them from their dead.[22]

On July 5, the town council passed a different kind of funeral law: noting that the plague "shot its arrows everywhere" and that so much wax had already been used for funeral candles that it was difficult for people to conduct them with this customary honor, the law restricted the consumption of wax for nobles and members of the popolo alike.[23] A short necrology from the Franciscan confraternity dedicated to the Virgin Mary dates from 1347–50, including the worst plague months, late summer 1348. It evokes the sad experience of that period; ninety-one died in 1348, most of them in July and August.[24] The confraternity must have struggled to commemorate them all.

With the loss of much of the contado, famine, depopulation, and endemic warfare, the town was left struggling to maintain a grain supply and raise funds to pay mercenary troops. Orvietans in this crisis like many towns turned away from popular institutions and relied instead on *balie*, commissions with extraordinary powers that overrode the constitutional system.[25] Then, in 1354, the Spanish cardinal Albornoz led a papal reconquest of the

[22] "Discorso historico," in *Ephemerides Urbevetane*, ed. Fumi, pp. 25–26. See the discussion in Elisabeth Carpentier, *Une ville devant la peste: Orvieto et la peste noire de 1348* (Paris, S.E.V.P.E.N., 1962), part 2, chap. 2.

[23] ASO, Riformagioni 135, 21 verso.

[24] Biblioteca Nazionale di Roma, V.E. 528, 5 recto–10 recto.

[25] *CD*, no. 680, pp. 537–39.

Patrimony. Orvieto briefly joined in the Prefetti di Vico's resistance and then submitted. David Foote has argued that Orvietan submission originally was not so much a collapse of popular rule but rather a failed effort to stabilize without the loss of autonomy. When Albornoz initially refused to recognize Orvietan institutions, the town's ambassadors walked away and military conflict revived. When the town submitted, it was explicitly to Albornoz and the pope as individuals, with the understanding that the arrangement would end at the deaths of the two men.[26] During the council debate, according to a contemporary source, a Ser Cecchino spoke of the devastation and depopulation of town and countryside. Since the city of Orvieto and its region, he argued, "have been so cruelly injured and almost totally desolated" by war, "for the good of peace and concord and the peaceful and tranquil state of the city, so that the city and countryside can improve and be filled again with people and men," the council should vote Albornoz and the pope governors for life.[27] Submission to Albornoz led to a short-lived revival of the popular constitution, including yet another edition of the funeral statute.[28] The papal vicar was made responsible for enforcement. The first decades of papal rule were relatively peaceful, but Orvieto suffered cruelly during the intermittent wars of the Great Schism, when the town repeatedly became a battleground, passed back and forth between the contending papal forces. In 1380, the town was sacked and burned by Breton mercenaries; more than three thousand Orvietans were killed and hundreds of houses burned. In 1390, Roman forces took the town after a dire siege. According to a chronicler, the town's population dropped to five hundred and ate mice to survive. The town had included close to three thousand hearths in 1292; the number dropped to one thousand by 1397.

POMP, HIERARCHY, AND HIRED WEEPERS

The fourteenth century more generally saw broad changes in funerals: a growing elaboration and control, not only of suffrages for the dead but of

[26] David Foote, "In Search of the Quiet City: Civic Identity and Papal Statebuilding in Fourteenth-Century Orvieto," in *Beyond Florence: The Contours of Medieval and Early Modern Italy*, ed. Paula Findlen, Michelle Fontaine, and Duane Osheim (Palo Alto, Calif.: Stanford University Press, 2003), pp. 190–204.

[27] "Quod cum Civitas Wetana cum suo comitatu et districtu, hoste humani generis operante et propter guerram discrimina, fuerit diutius lacessita ac quasi totaliter desolata, pro bono pacis et concordie status pacifici et tranquilli dicte civitatis etc ut dicta civitas et comitatus et districtus de bono in melius augeatur et personis et hominibus repleature." *CD*, no. 680.

[28] ASO, Comune 29, 15 recto–16 recto.

the burial procession itself. Elite funerals displayed wealth and status, with processions a carefully controlled show of hierarchy, and emotional lamentation given over to the deserving poor and to women. Chiffoleau has documented a growing preoccupation with funeral pomp, beginning in 1310 and accelerating after 1350. The pattern began with the very wealthy and spread downward. Testators detailed plans for their funeral processions in their wills, specifying not only costly objects such as drapes for the bier but people to walk in the cortege. They required priests, fellow guildsmen, confraternity members, and mendicants as well as the honest poor, who were recompensed for their role in the procession. Men tended to specify *boni homines pauperes*, good poor men, whereas women were more apt to call for poor widows or girls. Many testators requested a number with religious significance: twelve poor weepers, evoking the apostles, or four, the number of cardinal virtues. A noble or prelate who could afford a crowd might well require twenty-five, fifty, or one hundred of the honest poor, paid to mourn in the procession that carried his corpse to the funeral and burial.[29]

For Florence, Strocchia has documented a parallel turn toward pomp, with funerals "increasingly marked by theatricality and ostentation."[30] The town's sumptuary laws effectively served not so much to limit as to tax expensive display, a function that was made explicit after 1384, when Florentines could simply buy exemptions from the funeral laws, allowing them flamboyant funerals. Between 1384 and 1392, at least 233 expensive permits were sold. The money was spent on wax, palls, burial garb, and mourning dress. The accounts do not mention laments.

The chronicler Matteo Villani wrote a vivid account of the 1359 funeral of Biordo degli Ubertini, from a family of rural nobles who were on the list of proscribed magnates. The funeral was in fact a civic gesture of political rehabilitation, honoring a nobleman for his show of loyalty to Florence. When a military force led by Currado di Lando had threatened the Florentine army, Biordo, "who was a great master of war," and his kinsman Farinata saw an opportunity. Banned as rebels by the Florentine commune, they demonstrated their loyalty to Florence by offering to fight and then bringing along thirty well-equipped knights. Biordo became ill because of the battle and was moved to the Portinari house in Florence, where the commune sent him many physicians to medicate him, in gratitude for his loyalty. When Biordo died nonetheless, the commune put on a rich burial, which

[29] Jacques Chiffoleau, *La comptabilité de l'au-delà: Les hommes, la mort et la religion dans la région d'Avignon à la fin du Moyen Age (vers 1320–vers 1480)* (Rome: École Française de Rome, 1980), pp. 129–38.

[30] Sharon Strocchia, *Death and Ritual in Renaissance Florence* (Baltimore: Johns Hopkins University Press, 1992), p. 64.

Villani recounted at length. The bier was initially placed at the loggia of the Pazzi family to await the arrival of Biordo's kinsman, the bishop of Arezzo, and others of his house. At the bier were soldiers, dressed in black, and horses and banners, one after the other, all along the streets to the Palace of the Priors and the cathedral. This scene was so rich and moving, Villani writes, that the whole populace, the small and the powerful, came to watch. The image is striking: fifty years earlier, the funeral of an Ubertini noble versed in war, with his kinsmen and large numbers of horses and troops in the center of Florence, would have been not a touching parade but a serious threat. Villani goes on to list the commune's expensive contributions, including a display of wax and rich drapes at the burial church, the Franciscan Santa Croce. The bier was covered in cloth of gold, with banners of the arms of the commune, the Guelf party, and the Ubertini lineage, trimmed with squirrel fur. Six horses had banners with Biordo's arms, one pennon of the popolo, and another of the Guelf party. At the service, Villani tells us, there were "many *fanti* and *donzelli* dressed in black." Grieving soldiers are mentioned in the same breath as adolescent girls. At the obsequies were his kinsmen the bishop of Arezzo, Farinata, and all the others, dressed in black, the priors and the other rectors and officials of the commune, and all the clerks, good citizens, clergy, and religious of Florence.[31]

A division in expectations for elite men was reflected in funeral practice. Whereas nobles like Biordo degli Ubertini pursued the military vocation, many urban elites did not. Men who in the thirteenth century would have been trained and equipped to fight in the militia gave up that role to mercenaries. Urban knighthood shifted in meaning, and men who were knighted by the commune for political reasons might lack military training: the title could be purely honorary. Still, even men whose knighthoods entailed no military service had a show of knightly trappings at their funerals. Niccolò di Jacopo Alberti, an important political leader and ambassador, was buried in August 1377. His heirs brought sixty torches, and the Guelf party honored him with twelve more. Eight horses carried chivalric or corporate symbols. Alberti's request to be buried in a Franciscan habit was ignored: he was dressed in red samite and cloth of gold, at a cost of 3,000 florins. Five hundred poor mourners wept over his bier.[32]

Perhaps the most revealing of late fourteenth-century funerals were those of the mercenary war captains, professional soldiers. Towns made great heroes of their victorious captains and put on state funerals at their deaths. One example is the 1363 funeral of the Florentine war captain Piero Farnese, who

[31] Matteo Villani, *Cronica*, 2 vols., ed. Giuseppe Porta (Parma: Ugo Guanda Editore, 1995), vol. 2, book 9, chap. 43. His service to the commune is detailed in chap. 30.
[32] Strocchia, *Death and Ritual*, p. 77.

died of illness in San Miniato del Tedesco. His body was transported to Florence and after a funeral with *amirabile pompa d'asequio*—detailed by the chronicler in a line that the modern editor deemed unreadable—was buried in the cathedral, all at the commune's expense.[33] William Caferro has argued that towns came to use state funerals for their mercenary captains as an opportunity for competition and posturing. Siena, perennial enemy of Florence, buried the war captain Giovanni d'Azzi degli Ubaldini at the enormous cost of 462 florins. He was in fact an exiled Florentine nobleman who worked for Siena. His procession included four horses provided by the commune with banners of the arms of the popolo, another twenty horses with banners with his arms, helmet, sword, and spurs, as well as an armed man on a horse carrying a naked sword.[34] The Florentines responded a few years later with the elaborate and expensive funeral for their own mercenary captain, John Hawkwood, in 1394. Siena soon replied with its rich burial of another mercenary leader, Giovanni "Tedesco" da Pietramola.

Hawkwood's funeral became famous, even celebrated in popular verse decades later.[35] There was a great show of chivalric pomp, banners, pennants, gold drapes, and a helmet with a golden lion holding a Florentine lily in relief, as well as funeral pomp such as massive candles. Four horses bore the arms of the commune, two more those of the Guelf party. Hawkwood's men sent eight warhorses and grooms, six with banners with his arms, two with war helmets. His son, then his wife and daughters, all dressed in black, followed the bier, followed by his entire household. The funeral cortege walked from the Piazza Signoria to the Baptistry, where, in a ritual innovation, the corpse was placed on a bier set over the gold-draped baptismal font. There, the chronicler reports, Hawkwood "was lamented by the women, in the presence of the whole population of Florence."[36] A century earlier, it would have been deeply dishonoring for a war captain to be lamented by women and not friends and allies, one's own men. By 1394, the display of grief had been given over to women and the deserving poor.

[33] Villani, *Cronica*, vol. 2, book 11, chap. 59.

[34] See Maria Corsi, "La rappresentazione del rito funebre e della sepoltura nella pittura senese del Medioevo," *Bullettino senese di storia patria* 110 (2003; published 2004): 341–70; this discussion is on p. 358.

[35] A. Medin, "La morte di Giovanni Acuto," *Archivio storico italiano*, ser. 4, 17 (1886): 161–77. William Caferro, *John Hawkwood: An English Mercenary in Fourteenth-Century Italy* (Baltimore: Johns Hopkins University Press, 2006), pp. 314–17. See Strocchia, *Death and Ritual*, p. 81.

[36] *Cronica volgare di anonimo fiorentino*, ed. Elina Bellondi (Città di Castello, 1915), *RIS* 26:2, fasc. 2, chap. 28. A *zibaldone*, a sort of memoir and literary scrapbook, includes an account that apparently was copied from the chronicle and says the same thing: "e quivi fu pianto dalle donne in presenza di tutto il popolo di Firenze." ASF, Carte Bardi, 3rd series, 59, unpaginated.

EPILOGUE
THE POLITICS OF GRIEF

I have used a rare moment of change in funeral ritual at the end of the thirteenth century to explore the intersection of changing gender expectations with state formation. The association is familiar to historians of Italy because of the long-standing explicit link between state and patriarchal authority. Cosimo de Medici, after all, styled himself Pater Patriae. However, despite calls in the 1980s for research analyzing the links between gender and high politics and the state, few studies of medieval and early modern Italian state formation have done so. Scholars of late medieval Italian gender—myself included—instead have often debated how the state victimized, restricted, or protected women, or how women evaded the state's efforts.[1] At the same time, although considerable attention has been paid to what used to be regarded as private life, notably clientelism, this has rarely meant analysis of the role of gender categories in the changing construction of "public" and "private."[2]

The possibilities remain rich. One particularly lucid statement is the work of Linzi Manicom on modern South Africa. She pointed out in a 1992 historiographical essay that "the very fundamental categories of state and politics—like citizen, worker, the modern state itself—are shot through with gender; they were in fact historically constructed and reproduced as

[1] See for one study among very many Samuel Kline Cohn, *Women in the Streets: Essays on Sex and Power in Renaissance Italy* (Baltimore: Johns Hopkins University Press, 1996).

[2] See the magisterial survey by Giorgio Chittolini, "The 'Private,' the 'Public,' the State," in *The Origins of the State in Italy, 1300–1600*, ed. Julius Kirshner (Chicago: University of Chicago Press, 1996), pp. 34–61.

masculine categories, predicated on the subordination of women."[3] Manicom argued for a turn from looking at what the state actually does to women toward understanding state formation itself as a gendered and gendering process. "In trying to understand 'the state' as gendered, what is important is the way in which, historically, pre-existing forms of power and gender relations are appropriated and transformed by the institutions of rule (as in the making of customary law). At the same time the jurisdictional boundaries of 'state' and 'non-state' areas of life are ordered and re-ordered along gender lines, such as the shifting public/private divide."[4] The question becomes not who rules and who is victimized, but rather how rule is achieved. Developing a point from Joan Scott, Manicom argues that specific historical regimes use gender meanings "as metaphors of governance and of domination and subordination," and then make them concrete through specific enactments.[5]

I have suggested that the change in funeral ritual in late medieval Italy offers a glimpse of this association. Lawmakers evidently believed that peaceful rule required that they control how men were expected to act at funerals: in effect, that they govern their own grief. In the thirteenth century, men—particularly nobles—expressed sorrow with tears and loud laments, even gestures of self-mutilation, and did so in the streets. Was this behavior anomalous? It reflected a literary tradition depicting grief as an aspect of male honor: epics going back to Homer portray a male warrior's duty to lament the loss of his sons, friends, and allies. Heroic epics were popular in late medieval Italy: as Eudes of Châteauroux preached, people grieved more for the death of Roland than the death of Christ. Given the fragmentary nature of the records, I cannot prove the point conclusively, but male laments were evidently normal practice in north Italian towns. Many sources describe mourning as a community obligation, but there are also scattered mentions of *homines plorantes*, men weeping and crying out or taking part in large numbers in a corrotto, a funeral lament. When a distraught Bolognese father assaulted the judge responsible for his son's judicial torture, witnesses deemed his emotional lament appropriate, what was expected of a man who had lost his son.

Dramatic grief served social and political as well as psychological needs.

[3] Linzi Manicom, "Ruling Relations: Rethinking State and Gender in South African History," *Journal of African History* 33 (1992): 441–65; the quotation is on p. 444. Thanks to Stephan Miescher for pointing out this article.

[4] Ibid., p. 457.

[5] Ibid., p. 458. See Joan Scott, "Gender: A Useful Category of Historical Analysis," in *Gender and the Politics of History* (New York: Columbia University Press, 1988), pp. 28–50, esp. p. 45.

Grief can be deployed rhetorically, then as now, as televised images of Palestinian funerals powerfully demonstrate. In Orvieto in the 1280s, the show of grief measured not oppression but community, the honor and loyalty of the living as well as the depth of their loss. When the adult son of an Orvietan nobleman died, more than one hundred men joined with the father to express their grief, weeping, crying out, even tearing at their hair or beards. Their laments served to reconstitute the community as they responded to a loss by gathering together in a display of respect, friendship, loyalty. The men fined for shows of grief included kinsmen, friends, neighbors, even—in this period of delicate political balance—factional opponents.

Italian city-republics from the mid-thirteenth century wrote laws that sought to restrict these displays of grief at funerals. The laws reveal a larger turning point, an effort to shift conventions for acceptable emotional display which was tied both to politics and to gender expectations. Men, especially ruling elites, were to act with decorum and give emotional grief over to women. To use Manicom's terminology, lawmakers enacted a gendered metaphor of governance and subordination. The effort drew on a complex of ideas about gender, emotionality, and political order. I found that to explore the sources of those ideas required a somewhat nontraditional study that moves from analysis of the social and political milieu of the laws to evidence such as testimony in court cases, epic poetry, sermons, painting, and liturgical drama as well as intellectual history materials: theology, political and moral treatises and letters.

In part, lawmakers seeking to maintain stable political order looked back to the ancient association of women with disruptive passions. The idea that the state should intervene in funerals derives at least from the ancient Greek mourning laws. Grief was often ascribed to women and associated with unrestrained and irrational sexuality that threatened order. Patristic writers took up these ideas and linked grieving women to religious doubt and despair. In the thirteenth century, it was not clerics so much as lay intellectuals who perceived sorrow and disorder in this way. Preachers and theologians understood grief somewhat differently. The real effort by clerics to curb lay funeral laments had been centuries earlier, part of the Carolingian attempt to end practices considered pagan. In the thirteenth century, preachers and confessors sought instead to foster grief but to channel it into contrition, the sorrow for sin that was essential to salvation. There was a cultural turn toward images and practices that lamented sin, including a new emphasis on images of Christ on the Cross not triumphant but dead, mourned by his mother and friends. Laypeople were encouraged to join confraternities, groups that commemorated the dead with prayers; some sang hymns at funerals, voicing Mary's grief for her son. Ironically, then, the decades when

towns imposed laws to curb funeral laments also saw a proliferation of images of women weeping, clawing their cheeks, and tearing their hair at the deaths of their children. Christians were urged to interiorize that grief, lamenting with Mary the death of Christ and with it their own sin.

The drive to restrain male emotionality came instead from the world of the schools and lay intellectuals. The master of rhetoric Boncompagno da Signa mocked the histrionic funeral customs of laypeople, just as he mocked the spiritual pretensions of the friars. A dignified lament was a Latin elegy for the dead. Albertano of Brescia, an urban noble and civic judge, wrote dialogues intended to teach his sons and other townsmen how to live together in community. In his *Book of Consolation and Advice*, a critique of expectations for noblemen, Albertano depicted the grief and rage of a nobleman distraught over an insult not as a display of outraged honor but rather as the lament of a bereaved mother, then drew on Seneca and Cicero to urge the idea that the wise and manly response is not necessarily a violent reprisal. A man should act with prudence and restraint. Wisdom and decorum are masculine virtues that can enhance his authority.

In the second half of the century, as scholars developed political theories justifying the communes, they articulated new understandings of gender, passion, and order. In part, this new outlook was based on an Augustinian view of the consequences of original sin in terms of disordered appetites. Concupiscence, or lust, was understood in gendered terms: the sensitive appetites are female, and the rational faculty that can consent or resist them is male. This discourse was not confined to schoolmen: the chronicler Giovanni Villani echoed this idea when he explained women's illegally ornamental clothing in terms of the disordered appetite of women conquering male reason. Further, the Augustinian view linked the interior life, emotional or psychological disorder, with political and social disorder. The state is needed to restrain passionate emotion, now coded not as a show of male honor but as disruptive female irrationality. Hence the need for laws restricting luxury dress. Preachers took up this understanding. When Fra Remigio de'Girolami preached in Florence on grief, he linked interior, emotional restraint with exterior, political order. It became the job of elite men to restrain the passions, equated with feminine emotionality. Petrarch decades later expressed the same idea: one way to govern Padua well is to get noisy grieving women out of the streets. Male behavior at funerals did change, surely not because of the laws so much as the broader discourse on gender and decorum: by the late fourteenth century, even at the Florentine state funeral for a war captain, the lament was given over to women.

In sum, medieval lawmakers refashioned gendered ideas about grief and public order because they understood governance in a way that linked the

inner, emotional self and the state. This new understanding gave heightened significance to decorum, in particular the need for elite men to demonstrate their masculine honor by the conscious restraint of grief. This was a change in ideas about male subjectivity.

What are the implications? Feelings such as grief and anger are both a part of human psychology and socially conditioned, cultural artifacts.[6] It is important to recognize that powerful, even overwhelming feelings of grief are a part of human psychological experience and also that how individuals understand and wrestle with that emotion is very much conditioned by culture. As Barbara Rosenwein has recently pointed out, acceptable conventions for shows of emotion do change. She articulates this idea in terms of emotional communities, groups that shared a set of conventions.[7] I very much agree. Conventions for grief are particularly sensitive to cultural and political influences, so that it is a mistake to imagine that mourning was a static, traditional female role. My interest is in understanding why conventions change and when ideas about subjective experience and gender became linked to politics.

A venerable sociological tradition connects perceptions of the emotions and decorum with politics, most notably the work of Norbert Elias.[8] I am hardly arguing for a return to the grand narratives that saw Western civilization in terms of gradual restraint, a civilizing process in which state formation drove a change away from childish or primitive emotional display toward self-control.[9] According to this approach, to be civilized means to behave with the manners and decorum expected of modern Western elites. Understanding this as a civilizing process makes little sense: as Daniel Smail points out, subalterns always have to conceal their emotions, so that Elias's civilizing process can be read as elites learning to behave more like their servants![10] Further, one attraction of the study of grief is that it makes it difficult to sustain the idea that restraint is more civilized. It is not at all clear that it is somehow better to hold back tears at a tragic death rather than join

[6] For a review of research, see Batja Mesquita, "Culture and Emotion: Different Approaches to the Question," in *Emotions: Current Issues and Future Directions*, ed. Tracy J. Mayne and George A. Bonanno (New York: Guilford Press, 2001), pp. 214–50.

[7] Barbara Rosenwein, "Worrying about Emotions in History," *American Historical Review* 107 (June 2002): 821–45.

[8] Norbert Elias, *The Civilizing Process: Sociogenetic and Psychogenetic Investigations*, trans. Edmund Jephcott, ed. Eric Dunning, Johan Goudsblom, and Stephen Mennell (Oxford: Blackwell, 2000).

[9] It was Johan Huizinga who described medieval emotions as passionate and childlike. Huizinga, *The Autumn of the Middle Ages*, trans. Rodney J. Payton and Ulrich Mammitzsch (Chicago: University of Chicago Press, 1996).

[10] Daniel Lord Smail, *The Consumption of Justice: Emotions, Publicity, and Legal Culture in Marseille, 1264–1423* (Ithaca: Cornell University Press, 2003), p. 245.

together to lament. As Freud famously argued in 1917, the result of restraining grief can be melancholia, long-standing depression as mourners turn the rage that is a part of grief against themselves.[11] Displays of grief also surely do reconstruct social order after a loss, as a community gathers together to lament. Histrionic mourning thus can seem not primitive or childlike but wise, from the perspectives of the individual and the community.

It is also worth pointing out that a link between understandings of interior experience, gender expectations, and the state is hardly unique to Western culture or even to premodern states. In medieval Italy, these ideas derived from the ancient world and Christian theology. Halevi has recently shown us another instance, laws restricting women's funeral laments in early Islam that were linked to the threat of proto-Shi'ite rebellion. The delicate Balinese association of order within the self and external cosmic order is another example.[12]

I hope this book instead adds nuance to another venerable historical debate: the problem of civil society. In recent decades, scholars have returned to this problem to emphasize social discipline as an aspect of early modern state formation, in Italy in particular as part of the Catholic Reform.[13] Edward Muir has explored collaborative solutions to the threats of familial and factional violence which included civic religion, judicial practice, and the influence of models of comportment. By the sixteenth century, Muir argues, civil society was internalized through self-control rather than social control.[14] I have asked not precisely how people solved the problem of civil society so much as how they envisioned it. What did they believe was needed to maintain a stable, peaceful urban community? What did they consider to be the sources of disorder? The late medieval Italian efforts to impose implausible rules on the display of grief at funerals reveal real change in these attitudes, an important turning point. The efforts also suggest another way in which changing gender expectations intersected with state formation. I

[11] Sigmund Freud, "Mourning and Melancholia," in *The Standard Edition of the Complete Psychological Works*, ed. and trans. James Strachey, vol. 14 (London: Hogarth Press, 1957).

[12] Leor Halevi, "Wailing for the Dead: The Role of Women in Early Islamic Funerals," *Past and Present* 183 (May 2004): 3–39; J. Stephen Lansing, *Perfect Order: Recognizing Complexity in Bali* (Princeton, N.J.: Princeton University Press, 2006).

[13] See William V. Hudon, "Religion and Society in Early Modern Italy—Old Questions, New Insights," *American Historical Review* 101, 3 (1996): 783–804. See, for example, the articles collected in *Disciplina dell'anima, disciplina del corpo e disciplina della società tra Medioevo ed Età moderna*, ed. Paolo Prodi with Carla Penuti, Annali dell'Istituto storico italo-germanico, 40 (Bologna: il Mulino, 1994).

[14] Edward Muir, "The Sources of Civil Society in Italy," *Journal of Interdisciplinary History* 29 (Winter 1999).

have attempted to show that gendered metaphors were used to describe and justify governance and then were enacted in laws that pictured order. This is how understandings of interior experience and social and political order were linked. In effect, for the Orvietan lawmakers as for Albertano of Brescia, social control and self-restraint were two sides of the same coin.

BIBLIOGRAPHY

Manuscript Sources

Bologna
Archivio di Stato
Capitano del Popolo
Giudiziario
Corone ed armi
Libri Inquisitionum et testium
Riformagioni del Consiglio del Popolo

Florence
Archivio di Stato
Carte Bardi
Biblioteca Nazionale di Firenze
Conventi Soppressi

Orvieto
Archivio di Stato, Comune di Orvieto
Catasto
Guidiziario
Riformagioni
Statuti
Titolario

Perugia
Archivio di Stato
Podestà

Rome
Archivum Generale Ordinis Praedicatorum
Manuscript XIV
Biblioteca Nazionale di Roma
Codice Vittorio Emanuele

Siena
Archivio di Stato
Diplomatico

Published Primary Sources

Agaesse, P., and A. Solignac, eds. *La Genèse au sens littéral en douze livres: Oeuvres de Saint Augustin*. Bibliothèque augustinienne, 49. Paris: Declée de Brouwer, 1972.

Albertanus of Brescia. *De amore et dilectione Dei et proximi et aliarum rerum, et de forma vite*. Ed. Sharon Lynne Hiltz. Ph.D. diss., University of Pennsylvania, 1980.

——. *Liber consolationis et consilii*. Ed. Thor Sundby. London: N. Trübner, 1887.

——. *Liber de doctrina dicendi et tacendi: La parola del cittadino nell'Italia del Duecento/Albertano da Brescia*. Ed. Paula Navone. PerVerba: Testi mediolatini con traduzioni, 11. Florence: SISMEL, Edizioni del Galluzzo, 1998.

Alexander of Hales. *Summa theologica*. Quaracchi: Ex typographia Collegii s. Bonaventurae, 1930.

Andrea da Grosseto. "Volgarizzamento del *Liber consolationis et consilii* di Albertano da Brescia." In *La prosa del Duecento*, ed. Cesare Segre and Mario Marti. La Letteratura Italiana, 3. Milan: Ricciardi, 1959.

Anselm of Canterbury. "De Conceptu Virginali et de Originali Peccato." In *Opera omnia*, ed. F. S. Schmitt. Edinburgh, 1946.

Anthony of Padua. *A. Antonii Patavini: Sermones dominicales et festivi*. 3 vols. Ed. Beniamino Costa, Leonardo Frasson, and Ioanne Luisetto. Padua: Edizioni Messaggero, 1979.

——. *I sermoni*. Trans. G. Tollardo. Padua: Edizioni Messaggero, 1994.

Bellondi, Elina, ed. *Cronica volgare di anonimo fiorentino*. RIS 26, 2, 2. Città di Castello, 1915.

Benedicti diaconi capitularium collectio. Book II, c. 197; *PL* 97.

Boncompagno. *Antiqua rhetorica*. In *Briefsteller und Formelbucher des elften biz vierzehnten Jahrhunderts*, 2 vols., ed. Ludwig Rockinger. Munich: Auf Kosten der K. Akademie druck von J. G. Weiss, 1861.

Brault, Gerard J., ed. and trans. *The Song of Roland*. University Park: Pennsylvania State University Press, 1978.

Brunetto Latini. *The Book of the Treasure (Li livres dou tresor)*. Trans. Paul Barrette and Spurgeon Baldwin. New York: Garland, 1993.

Caesarius of Arles. *Sermons*. 3 vols. Trans. Mary Magdaleine Mueller. Washington, D.C.: Catholic University of America Press, 1956.

Caggese, Romolo, ed. *Statuti della Repubblica Fiorentina*, vol. 2, *Statuto del Podestà dell'anno 1325*. Florence: E. Ariani, 1921.

Caprioli, Severino, ed. *Statuto del comune di Perugia del 1279*. Fonti per la storia dell'Umbria, 21. Perugia: Deputazione di storia patria per l'Umbria, 1996.

Castellani, Arrigo, ed. *La prosa italiana delle origini I: Testi toscani di carattere pratico*, vol. 1, *Trascrizioni*. Bologna: Pàtron, 1982.

Chrétien de Troyes. *Cligès*. Trans. Burton Raffel. New Haven, Conn.: Yale University Press, 1997.

——. *Erec and Enide*. Trans. Burton Raffel. New Haven, Conn.: Yale University Press, 1997.

——. *The Knight with the Lion, or Yvain (Le chevalier au lion)*. Ed. and trans. William W. Kibler. New York: Penguin Books, 1985.

Cognasso, Francesco, ed. *Statuti civili del comune di Chieri*. Pinerolo: Rossetti, 1913.

Contini, Gianfranco, ed. *Poeti del Duecento*. 2 vols. Milan: Ricciardi, 1960.

Dino Compagni. *Cronica delle cose occorrenti ne' tempi suoi*. Ed. Fabio Pittorru. Milan: Rizzoli, 1965.

Donizo. "Vita Mathildis Carmine scripta a Donizone presbytero." *RIS* 5, part 1. Città di Castello, 1900.

Elsheikh, Mahmoud Salem, ed. *Statuto del comune e del popolo di Perugia del 1342 in volgare.* Fonti per la storia dell'Umbria, 26. Perugia: Deputazione di storia patria per l'Umbria, 2000.

Fasoli, Gina, and Pietro Sella, eds. *Statuti di Bologna dell'anno 1288.* Rome: Edizione Anastatica, 1973.

Federico Visconti. *Les sermons et la visite pastorale de Federico Visconti, archevêque de Pise (1253–1277).* Ed. Nicole Bériou and Isabelle le Masne de Chermont. Rome: École Française de Rome, 2001.

Fornasari, M. ed. *Collectio canonum in V libris.* Vol. 6 of *Corpus Christianorum, continuatio mediaevalis.* Turnhout, Belgium: Brepols, 1970.

Fumi, Luigi, ed. *Codice diplomatico della città d'Orvieto.* Documenti di storia italiana, 8. Florence: Vieusseux, 1884.

——, ed. *Ephemerides Urbevetane.* *RIS* XV, V, 2 vols. Città di Castello, 1920.

Giordano da Pisa. *Prediche sul secondo capitolo del Genesi.* Ed. Serena Grattarola. Rome: Istituto storico domenicano, 1999.

——. *Sul terzo capitolo del Genesi.* Ed. Cristina Marchioni. Florence: Olschki, 1992.

Gregory of Tours. *Libri historiarum X.* Ed. Bruno Krusch and Wilhelmus Levison. Monumenta Germaniae Historica, Scriptorum rerum Merovingicarum, vol. 1, part 1, fasc. 3. Hanover, 1951.

Guidetti, Stefania Bertini, ed. *I "Sermones" di Iacopo da Varazze.* Florence: Edizioni del Galluzzo, 1998.

Homer. *The Iliad.* Trans. Robert Fagles. New York: Penguin Books, 1991.

——. *The Odyssey.* Trans. Robert Fagles. New York: Penguin Books, 1996.

Jacopone da Todi. *The Lauds.* Trans. Serge Hughes and Elizabeth Hughes. New York: Paulist Press, 1982.

Jérome. *Lettres.* Ed. Jérome Labourt. Paris: Les Belles Lettres, 1951.

John Chrysostom. *Sermons.* In *Patrologiae cursus completus. Series Graeca,* vols. 59, 63, ed. Jacques-Paul Migne. Paris, 1857–66. Electronic rpt., Cambridge: Chadwyck-Healey, 1996–2005.

Joinville, Jean de. "Life of St. Louis." In *Chronicles of the Crusades,* trans. M. R. B. Shaw. Baltimore: Penguin Books, 1963.

Jordanes. *Gethica.* Ed. Theodor Mommsen. *Monumenta Germaniae historica . . . Scriptores auctores antiquissimi,* 5, 1. Berlin: Weidman, 1882.

Kohl, Benjamin, and Ronald G. Witt with Elizabeth B. Welles, eds. *The Earthly Republic: Italian Humanists on Government and Society.* Philadelphia: University of Pennsylvania Press, 1978.

Laude drammatiche e rappresentazioni sacre. 3 vols. Ed. Vincenzo de Bartholomaeis. Florence: Le Monnier, 1943; reprint, 1967.

Laude dugentesche. Ed. Giorgio Varanini. Vulgares Eloquentes, 8. Padua: Editrice Antenore, 1972.

Laurentius monachus Casinensis Archipiscopus Amalfitanus. "Vita Sancti Zenobii Episcopi." In *Opera.* Monumenta Germaniae Historica, 7. Weimar: H. Böhlaus Nachf., 1973.

Lucian. "On Funerals (De luctu)." In *The Works of Lucian,* vol. 4, trans. A. M. Harmon, pp. 113–31. Cambridge, Mass.: Harvard University Press; Palermo: Palombo, 1913.

Menestò, Enrico, ed. *Gli statuti comunali Umbri.* Spoleto: Centro italiano di studi sull'alto Medioevo, 1997.

——, ed. *Le vite antiche di Iacopone da Todi.* Florence: La Nuova Italia, 1977.

Meyer, Paul, ed. *L'histoire de Guillaume le Maréchal.* 3 vols. Paris: Librairie Renouard, 1891.

Monacchia, Paola, and Maria Grazia Nico Ottaviani, eds. "Perugia." In *La legislazione suntuaria, secoli XIII–XVI: Umbria,* ed. M. Grazia Nico Ottaviani. Pubblicazioni degli Archivi di stato, 43. Rome: Ministero per i beni e le attività culturali, 2005.

Muzzarelli, Maria Giuseppina, ed. *La legislazione suntuaria, secoli XIII–XIV: Emilia-Romagna*. Pubblicazioni degli Archivi di stato, 41. Rome: Ministero per i beni e le attività culturali, 2002.

Natalini, Vincenzo, ed. *San Pietro Parenzo: La Leggenda scritta dal maestro Giovanni canonico di Orvieto*. Rome: Facultas Theologica Pontifici Atheniae Seminarii Romani, 1936.

Nicola da Milano. *Collationes de Beata Virgine*. Ed. Michèle Mulcahey. Toronto: PIMS, 1997.

Petrarca, Francesco. *Le familiari*. Ed. Ugo Dotti. Urbino: Argalla, 1970.

——. *Lettere disperse*. Ed. Alessandro Pancheri. Parma: Fondazione Pietro Bembo, 1994.

——. *Letters from Petrarch*. Trans. Morris Bishop. Bloomington: Indiana University Press, 1966.

——. *Petrarch's Correspondence*. Trans. E. H. Wilkins. Padua: Antenore, 1960.

——. *Petrarch's Remedies for Fortune Fair and Foul*. 5 vols. Trans. and ed. Conrad H. Rawski. Bloomington: Indiana University Press, 1991.

——. *Rerum familiarum libri I–VIII*. 3 vols. Trans. Aldo S. Bernardo. Albany: State University of New York Press, 1975.

——. *Rerum senilium liber XIV: Ad magnificum Franciscum de Carraria Padue dominum, Epistola 1, "Qualis esse debeat qui rem publicam regit."* Ed. V. Ussani. Padua, 1922.

——. "Secretum (De secreto conflictu mearum curarum) libri tres." In *Prose*, ed. G. Martellotti and P. G. Ricci, pp. 21–215. La letteratura italiana, storia e testi, 7. Milan: Ricciardi, 1955.

Petrocelli, T., L. Riccetti, and M. Rossi Caponeri, eds. "Orvieto." In *La legislazione suntuaria, secoli XIII–XVI: Umbria*, ed. M. Grazia Nico Ottaviani. Pubblicazioni degli Archivi di stato, 43. Rome: Ministero per i beni e le attività culturali, 2005.

Plato. *Phaedo*. Trans. David Gallop. Oxford: Oxford University Press, 1993.

——. *The Republic of Plato*. Trans. F. M. Cornford. Oxford: Oxford University Press, 1945.

Plutarch. "A Consolation to His Wife." Trans. Donald Russell. In *Plutarch's Advice to the Bride and Groom and A Consolation to His Wife*, ed. Sarah Pomeroy. New York: Oxford University Press, 1999.

——. *Greek Lives*. Trans. Robin Waterfield. Oxford: Oxford University Press, 1998.

Polybius. *The Rise of the Roman Empire*. Trans. Ian Scott-Kilvert. Middlesex, U.K.: Penguin Books, 1979.

Pontal, O., ed. and trans. *Les statuts synodaux français du XIIIe siècle*, vol. 1, *Les statuts de Paris et le synodal de l'Ouest*. Paris, 1971.

"Processus canonizationis B. Ambrosii Massani." *AASS* 66 (10 November).

Pseudo-Brunetto-Latini. "Cronica Florentina." In *I primi due secoli della storia di Firenze*, vol. 2, ed. Pasquale Villari. Florence: G. C. Sansoni, 1898.

Ptolemy of Lucca. *De regimine principium*. Trans. James A. Blythe as *On the Government of Rulers*. Philadelphia: University of Pennsylvania Press, 1997.

Raymund of Pennaforte. *Svmma de poenitentia et matrimonio*. Rome, 1603; reprint, Farnborough, U.K.: Gregg Press, 1967.

"Ricordi di una famiglia senese del secolo decimoterzo." *Archivio storico italiano* s. I, V (1847): appendix.

Rodriguez, Felix, ed. *Concilio III de Toledo, XIV Centenario, 589–1989*. Toledo: Gráfica, 1991.

Sachetti, Franco. *Il Trecentonovelle*. Ed. Vincenzo Pernicone. Florence: Sansoni, 1946.

"Sacre rappresentazioni per le Fraternitate d'Orvieto nel Cod. Vittorio Emanuele 528." *Bollettino della (Regia) Deputazione di storia patria per l'Umbria*, appendix 5. Perugia, 1916.

Salimbene de Adam. *The Chronicle of Salimbene de Adam*. Trans. Joseph L. Baird, Giuseppe Baglivi, and John Robert Kane. Binghamton, N.Y.: Medieval and Renaissance Texts and Studies, 1986.

——. *Cronica*. 2 vols. Ed. Giuseppe Scalia. Scrittori d'Italia, 232. Bari: Laterza, 1966.

Seneca. *Four Dialogues*. Ed. C. D. N. Costa. Warminster, U.K.: Aris & Phillips, 1994.

——. *Moral Essays*. 3 vols. Trans. John Basore. Cambridge, Mass.: Harvard University Press, 1932.

Statius. *Thebaid*. Trans. J. H. Mozley. Cambridge, Mass.: Harvard University Press, 1957.

Terence. *Phormio*. Ed. R. H. Martin. London: Bristol Classical Press, 2000.

Theodoric of Appoldia. "Acta Sancti Dominici." *AASS* (first August volume).

Thomas, Antoine, ed. *L'Entrée d'Espagne*. 2 vols. Paris: Firmin-Didot, 1913.

Thomas Aquinas. *Catena aurea in quatuor evangelia*. Ed. P. Angelici Guarienti. Taurini: Marietti, 1953.

——. *Quaestiones disputatae de malo*. In *Opera omnia*, vol. 22. Rome: Commissio Leonina, 1982.

——. *S. Thomae Aquinatis Opera omnia*. 7 vols. Ed. Roberto Busa. Stuttgart: Fromman-Holzboog, 1980.

"Tristano Riccardiano." In *La prosa del Duecento*, ed. Cesare Segre and Mario Marti, pp. 555–661. Milan: Ricciardi, 1959.

Villani, Giovanni. *Nuova cronica*. Ed. Giuseppe Porta. 3 vols. Parma: Ugo Guanda Editore, 1991.

Villani, Matteo. *Cronica*. 2 vols. Ed. Giuseppe Porta. Parma: Ugo Guanda Editore, 1995.

Vito of Cortona. "Vita de B. Aemiliana seu Umiliana." *AASS* 27 (19 May): 385–402.

SECONDARY STUDIES

Alexandre-Bidon, Danièle. "Gestes et expressions du deuil." In *A réveiller les morts: La mort au quotidien dans l'Occident médiéval*, ed. Danièle Alexandre-Bidon and Cécile Treffort, pp. 121–33. Lyon: Presses Universitaires de Lyon, 1993.

——. *La mort au Moyen Age, XIIIe–XIVe siècle*. Paris: Hachette, 1998.

Alexiou, Margaret. *The Ritual Lament in the Greek Tradition*. Cambridge: Cambridge University Press, 1974.

Antonelli, Armando, and Riccardo Pedrini. "Appunti sulla formazione socio-culturale del ceto funzionariale del tempo di Dante: Sondaggi su documenti e tracce." *Il Carobbio* 27 (2001): 15–37.

Arce, Javier. "Imperial Funerals in the Later Roman Empire: Change and Continuity." In *Rituals of Power from Late Antiquity to the Early Middle Ages*, ed. Frans Theuws and Janet Nelson, pp. 115–29. Leiden: Brill, 2000.

Aries, Philippe. *The Hour of Our Death*. Trans. H. Weaver. New York: Knopf, 1982.

Arrighi, Vanna, ed. *Ordinamenti di giustizia fiorentini*. Florence: Archivio di Stato, 1995.

Artifoni, Enrico. "Retorica e organizzazione del linguaggio politico nel Duecento italiano." In *Le forme della propaganda politica nel Due e nel Trecento*, ed. Paolo Cammarosano, pp. 157–82. Collection, 201. Rome: École Française de Rome, 1994.

Ascheri, Mario. "La pena di morte a Siena (sec. XIII–XIV): Tra normativa e prassi." *Bullettino senese di storia patria* 110 (2003; published 2004): 489–505.

——. "Tra storia giuridica e storia 'costituzionale': Funzioni della legislazione suntuaria." In *Disciplinare il lusso: La legislazione suntuaria in Italia e in Europa tra Medioevo ed Età moderna*, ed. Maria Giuseppina Muzzarelli and Antonella Campanini, pp. 199–211. Rome: Carocci, 2003.

Astren, Fred. "Depaganizing Death: Aspects of Mourning in Rabbinic Judaism and Early Islam." In *Bible and Qur'an: Essays in Scriptural Intertextuality*, ed. John C. Reeves, pp. 183–99. Society for Biblical Literature Symposium Series, 24. Atlanta: Society for Biblical Literature, 2003.

Avril, Joseph. "Mort et sépulture dans les statuts synodaux du Midi de la France." In *La mort et l'au-delà en France méridionale (XIIe–Xve siècle)*, pp. 343–64. Cahiers de Fanjeaux, 33. Toulouse: Privat, 1998.

Bagnoli, Alessandro. "Alle origini della pittura senese." In *Sotto il Duomo di Siena: Scoperte archeologiche, architettoniche e figurative*, ed. Roberto Guerrini, pp. 107–47. Milan: Silvana Editoriale, 2003.

———. *Simone Martini e "chompagni."* Florence: Centro Di, 1985.

Baldwin, John W. *The Language of Sex: Five Voices from Northern France around 1200.* Chicago: University of Chicago Press, 1994.

Banker, James. *Death in the Community: Memorialization and Confraternities in an Italian Commune in the Late Middle Ages.* Athens: University of Georgia Press, 1988.

Barasch, Moshe. *Gestures of Despair in Medieval and Early Renaissance Art.* New York: New York University Press, 1976.

Basile, Giuseppe. *Giotto: The Arena Chapel Frescoes.* London: Thames & Hudson, 1994.

Bataillon, Louis-Jacques. *La prédication au XIIIe siècle en France et Italie.* London: Variorum, 1993.

Belting, Hans. *Likeness and Presence: A History of the Image before the Era of Art.* Trans. Edmund Jephcott. Chicago: University of Chicago Press, 1994.

Benvenuti Papi, Anna. *Pastori del popolo: Storie e leggende di vescovi e di città nell'Italia medievale.* Florence: Arnaud, 1988.

———. "Umiliana dei Cerchi: Nascita di un culto nella Firenze del Dugento." *Studi Francescani* 77 (1980): 87–117.

Besserman, Lawrence L. *The Legend of Job in the Middle Ages.* Cambridge, Mass.: Harvard University Press, 1979.

Billanovitch, Giuseppe. *Petrarca letterato.* Rome: Edizioni di storia e letteratura, 1947.

Binski, Paul. *Medieval Death: Ritual and Representation.* Ithaca: Cornell University Press, 1996.

Blanshei, Sarah. "Criminal Law and Politics in Medieval Bologna." *Criminal Justice History* 2 (1981): 1–30.

Bloch, R. Howard. *Medieval Misogyny and the Invention of Western Romantic Love.* Chicago: University of Chicago Press, 1991.

Bodel, John. "Death on Display: Looking at Roman Funerals." In *The Art of Ancient Spectacle*, ed. Bettina Bergmann and Christine Kondolen, pp. 259–81. New Haven, Conn.: Yale University Press, 1999.

Boglioni, Pierre. "La scéne de la mort dans les premières hagiographies latines." In *Le sentiment de la mort au Moyen Age*, ed. Claude Sutto. Québec: Les Éditions Univers, 1979.

Bonardi, A. "Il lusso di altri tempi in Padova: Studio storico con documenti inediti." *Miscellanea di storia veneta*, ser. 3, 2 (1910).

Boswell, John. *Christianity, Social Tolerance, and Homosexuality.* Chicago: Chicago University Press, 1980.

Boucheron, Patrick. "À qui appartient la cathédrale? La fabrique et la cité dans l'Italie médiévale." In *Religion et société urbaine au Moyen Age*, ed. Patrick Boucheron and Jacques Chiffoleau, pp. 95–117. Paris: Publications de la Sorbonne, 2000.

Bouillot, Carine. "La chevelure: La tirer ou arracher, étude d'un motif pathétique dans l'épique médiévale." In *La Chevelure dans la littérature et l'art du Moyen Age (Actes du 28e colloque du CUERMA, 20, 21, 22 février 2003)*, ed. Chantal Connoche-Bourgne, pp. 35–45. Aix-en-Provence: CUERMA, 2004.

Bowsky, William. *Henry VII in Italy: The Conflict of Empire and City-State.* Lincoln: University of Nebraska Press, 1960.

———. "The Medieval Commune and Internal Violence: Police Power and Public Safety in Siena, 1287–1355." *American Historical Review* 73 (1967): 1–17.

Brandenburg, Alain-Erlande. *Le roi est mort: Étude sur les funérailles, les sepultures et les tombeaux des rois jusqu'à la fin du XIIIe siècle.* Geneva: Droz, 1975.

Brown, Peter. *The Body and Society.* New York: Columbia University Press, 1988.

Brumble, H. David. *Classical Myths and Legends in the Middle Ages and Renaissance: A Dictionary of Allegorical Meanings.* Westport, Conn.: Greenwood Press, 1998.

Caferro, William. *John Hawkwood: An English Mercenary in Fourteenth-Century Italy.* Baltimore: Johns Hopkins University Press, 2006.

Carocci, Sandro. "Le comunalie di Orvieto fra la fine del XII e la metà del XV secolo." *Mélanges de l'École Française de Rome* 99, 2 (1987): 701–28.

——, ed. *Itineranza pontificia: La mobilità della curia papale nel Lazio (secoli XII–XIII)*. Nuovi Studi Storici, 61. Rome, 2003.

Carpentier, Elisabeth. *Orvieto à la fin du XIIIe siècle: Ville et campagne dans le cadastre de 1292*. Paris: CNRS, 1986.

——. *Une ville devant la peste: Orvieto et la peste noire de 1348*. Paris: S.E.V.P.E.N., 1962.

Casagrande, Carla, ed. *Prediche alle donne: Testi di Umberto di Romans, Gilberto di Tournai, Stefano di Borbone*. Milan: Bompiani, 1978.

Casagrande, Carla, and Silvana Vecchio. *I peccati della lingua: Disciplina e etica della parola nella cultura medievale*. Rome: Istituto della Enciclopedia Italiana, 1987.

Casagrande, Giovanna. "Fama e diffamazione nella letteratura teologica e pastorale del sec. XIII." *Ricerche storiche* 26 (1996): 7–24.

Ceppari Ridolfi, Maria A., and Patrizia Turrini. *Il mulino delle vanità*. Siena: Il Leccio, 1993.

Charansonnet, Alexis. "L'évolution de la prédication du Cardinal Eudes de Châteauroux (1190?–1273): Une approche statistique." In *De l'homélie au sermon: Histoire de la prédication médiévale*, ed. Jacqueline Hamesse and Xavier Hermand. Louvain-la-Neuve: Fédération internationale des instituts d'études médiévales, 1993.

Chiffoleau, Jacques. *La comptabilité de l'au-delà: Les hommes, la mort et la religion dans la région d'Avignon à la fin du Moyen Age (vers 1320–vers 1480)*. Rome: École Française de Rome, 1980.

Chittolini, Giorgio. "The 'Private,' the 'Public,' the State." In *The Origins of the State in Italy, 1300–1600*, ed. Julius Kirshner, pp. S34–61. Chicago: University of Chicago Press, 1996.

Ciampoli, Donatella. "La legislazione sui funerali secondo gli statuti delle comunità dello 'stato' di Siena." *Bullettino senese di storia patria* 110 (2003; published 2004): 103–119.

Clogan, Paul M. *The Medieval Achilleid of Statius*. Leiden: Brill, 1968.

Cohen, Kathleen. *Metamorphosis of a Death Symbol: The Transi Tomb in the Late Middle Ages and Renaissance*. Berkeley: University of California Press, 1973.

Cohn, Samuel Kline. *The Cult of Remembrance and the Black Death: Six Renaissance Cities in Central Italy*. Baltimore: Johns Hopkins University Press, 1992.

——. *Death and Property in Siena, 1205–1800: Strategies for the Afterlife*. Baltimore: Johns Hopkins University Press, 1988.

——. *Women in the Streets: Essays on Sex and Power in Renaissance Italy*. Baltimore: Johns Hopkins University Press, 1996.

Colish, Marcia L. *Peter Lombard*. 2 vols. Leiden: E. J. Brill, 1994.

——. *The Stoic Tradition from Antiquity to the Early Middle Ages*. Leiden: E. J. Brill, 1985.

Connell, R. W. *Masculinities*. Berkeley: University of California Press, 1995.

Cooper, Kate. *The Virgin and the Bride: Idealized Womanhood in Late Antiquity*. Cambridge, Mass.: Harvard University Press, 1996.

Corsi, Maria. "La rappresentazione del rito funebre e della sepoltura nella pittura senese del Medioevo." *Bullettino senese di storia patria* 110 (2003; published 2004): 341–70.

Cutini, Clara. "Giudici e giustizia a Perugia nel secolo XIII." *Bollettino della Deputazione di storia patria per l'Umbria* 83 (1987): 67–110.

Daley, Brian E. *The Hope of the Early Church: A Handbook of Christian Eschatology*. Cambridge: Cambridge University Press, 1991.

Dameron, George. "Revisiting the Italian Magnates: Church Property, Social Conflict, and Political Legitimization in the Thirteenth-Century Commune." *Viator* 23 (1992): 167–87.

Davidsohn, Robert. *Firenze ai tempi di Dante*. Trans. Eugenio Duprè Theseider. Florence: R. Bemporad & Figlio, 1929.

——. *Storia di Firenze*. 8 vols. Trans. G. B. Klein. Florence: Sansoni, 1965.

D'Avray, David. "Application of Theology to Current Affairs." In *Modern Questions about Medieval Sermons*, ed. Nicole Bériou and David D'Avray, pp. 217–45. Spoleto: Centro italiano di studi sull'alto Medioevo, 1994.

Dean, Trevor. "Gender and Insult in an Italian City: Bologna in the Later Middle Ages." *Social History* 29 (May 2004): 217–31.

Dean, Trevor, and K. J. P. Lowe, "Writing the History of Crime in the Italian Renaissance." In *Crime, Society, and the Law in Renaissance Italy*, ed. Trevor Dean and K. J. P. Lowe, pp. 1–15. Cambridge: Cambridge University Press, 1994.

Delcorno, Carlo. *Giordano da Pisa e l'antica predicazione volgare*. Biblioteca di Lettere italiane, 14. Florence: L. S. Olschki, 1975.

Dizionario biografico degli italiani. Rome: Società Grafica Romana, 1997.

DuBois, Page. "Antigone and the Feminist Critic." *Genre* 19 (Winter 1986): 371–83.

Durkheim, Emile. *The Elementary Forms of Religious Life*. 1915. Trans. Joseph Swain. London: Allen & Unwin, 1964.

Edgerton, Samuel. *Pictures and Punishment: Art and Criminal Prosecution during the Florentine Renaissance*. Ithaca: Cornell University Press, 1984.

Elias, Norbert. *The Civilizing Process: Sociogenetic and Psychogenetic Investigations*. Rev. ed. Trans. Edmund Jephcott. Ed. Eric Dunning, Johan Goudsblom, and Stephen Mennell. Oxford: Blackwell, 2000.

Faini, Enrico. "Il convito del 1216: La vendetta all'origine del fazionalismo fiorentino." *Annali di storia di Firenze* 1 (2006): 9–36.

Ferzoco, George. *The Massa Marittima Mural*. Leicester, U.K.: Troubador, 2004.

Filgueira Valverde, J. " 'El planto' en la historia y en la literatura gallega." *Cuadernos de Estudios Gallegos* 4 (1945): 518.

Foote, David. "In Search of the Quiet City: Civic Identity and Papal Statebuilding in Fourteenth-Century Orvieto." In *Beyond Florence: The Contours of Medieval and Early Modern Italy*, ed. Paula Findlen, Michelle Fontaine, and Duane Osheim, pp. 190–204. Palo Alto, Calif.: Stanford University Press, 2003.

——. *Lordship, Reform, and the Development of Civil Society in Medieval Italy: The Bishopric of Orvieto, 1100–1250*. Notre Dame, Ind.: University of Notre Dame Press, 2004.

Frati, Lodovico. *La vita privata di Bologna dal secolo XIII al XVII*. 1900; reprint, Rome: Sala Bolognese, 1986.

Freud, Sigmund. "Mourning and Melancholia." 1917. In *The Standard Edition of the Complete Psychological Works*, ed. and trans. James Strachey, vol. 14. London: Hogarth Press, 1957.

Frugoni, Chiara. *Pietro and Ambrogio Lorenzetti*. Trans. Lisa Pelleti. Florence: Scala, 1988.

Fuchs, Eric. *Sexual Desire and Love*. Cambridge: Cambridge University Press, 1983.

Gallagher, Conan. "Concupiscence." *The Thomist* 30, 3 (1966): 228–59.

Gardner, Julian. *The Tomb and the Tiara: Curial Tomb Sculpture in Rome and Avignon in the Later Middle Ages*. Oxford: Clarendon Press, 1992.

Geary, Patrick. *Phantoms of Remembrance: Memory and Oblivion at the End of the First Millennium*. Princeton, N.J.: Princeton University Press, 1994.

Ginzburg, Carlo. "Représentation: Le mot, l'idée, la chose." *Annales: E.S.C.* 46 (November–December 1991): 1219–34.

Giorgetti, Vittorio. *Podestà, Capitani del Popolo e loro ufficiali a Perugia (1195–1500)*. Spoleto: Centro italiano di studi sull'alto Medioevo, 1993.

Giovenale, G. B. *La Basilica di Santa Maria in Cosmedin*. Rome: P. Sansaini, 1927.

Given, James. *State and Society in Medieval Europe*. Ithaca: Cornell University Press, 1990.

Gordon, Robert W. "Critical Legal Histories." *Stanford Law Review* 36 (January 1984): 57–125.

Guiance, Ariel. "Douleur, deuil et sociabilité dans l'Espagne médiévale (XIVe–XVe siècles)." In *Savoir mourir*, ed. Christiane Montandon-Binet and Alain Montandon, pp. 15–28. Paris: L'Harmattan, 1993.

Halevi, Leor. "Wailing for the Dead: The Role of Women in Early Islamic Funerals." *Past and Present* 183 (May 2004): 3–39.

Harris, William. *Restraining Rage: The Ideology of Anger Control in Classical Antiquity*. Cambridge, Mass.: Harvard University Press, 2001.

Heers, Jacques. *Le clan familial au Moyen Age*. Paris: Presses Universitaires de France, 1974.

Heijkant, Marie-José. *La tradizione del "Tristan" in prosa in Italia e proposte di studio sul "Tristano Riccardiano."* Sneldruk Enschede: Druk, 1993.

Henderson, John. *Piety and Charity in Late Medieval Florence*. Oxford: Clarendon Press, 1994.

Henderson, Mary. "Piety and Heresy in Medieval Orvieto: The Religious Life of the Laity, c. 1150–1350." Ph.D. diss., University of Edinburgh, 1990.

Hertz, Robert. "Contribution à une étude sur la représentation collective de la mort." *Année sociologique* 10 (1907): 48–137. Reprinted in *Death and the Right Hand*, trans. Rodney and Claudia Needham, pp. 27–86. Glencoe, Ill.: Free Press, 1960.

Holloway, Julia Bolton. *Brunetto Latini: An Analytic Bibliography*. London: Grant & Cutler, 1986.

Holst-Warhaft, Gail. *The Cue for Passion: Grief and Its Political Uses*. Cambridge, Mass.: Harvard University Press, 2000.

Hudon, William V. "Religion and Society in Early Modern Italy—Old Questions, New Insights." *American Historical Review* 101, 3 (1996): 783–804.

Hughes, Diane. "Mourning Rites, Memory, and Civilization in Premodern Italy." In *Riti e rituali nelle società medievali*, ed. Jacques Chiffoleau, Lauro Martines, and Agostino Paravicini Bagliani, pp. 23–39. Spoleto: Centro italiano di studi sull'alto Medioevo, 1994.

——. "Sumptuary Legislation and Social Relations in Renaissance Italy." In *Disputes and Settlements: Law and Human Relations in the West*, ed. John Bossy. Cambridge: Cambridge University Press, 1983.

Huizinga, Johan. *The Autumn of the Middle Ages*. Trans. Rodney J. Payton and Ulrich Mammitzsch. Chicago: University of Chicago Press, 1996.

Humphreys, S. C. *The Family, Women, and Death: Comparative Studies*. London: Routledge & Kegan Paul, 1983.

Humphreys, S. C., and Helen King, eds. *Mortality and Immortality: The Anthropology and Archaeology of Death*. London: Academic Press, 1981.

Huntington, Richard, and Peter Metcalf. *Celebrations of Death: The Anthropology of Mourning Ritual*. Cambridge: Cambridge University Press, 1979.

Iannella, Cecilia. *Giordano da Pisa: Etica urbana e forme della società*. Pisa: Edizioni ETS, 1999.

Iozzelli, Fortunato. *Odo da Châteauroux: Politica e religione nei sermoni inediti*. Deputazione abruzzese di storia patria, Studi e testi 14. Padua: Bottega d'Erasmo, 1994.

Jones, Christopher P. *Culture and Society in Lucian*. Cambridge, Mass.: Harvard University Press, 1986.

Jones, Philip. *The Italian City-State: From Commune to Signoria*. Oxford: Clarendon Press, 1997.

Just, Roger. *Women in Athenian Law and Life*. London: Routledge, 1989.

Kaftal, George. *St. Dominic in Early Tuscan Painting*. Oxford: Blackfriars, 1948.

Katzenellenbogen, Adolf. *Allegories of the Virtues and Vices in Medieval Art*. London, 1939. Reprint, Toronto: University of Toronto Press, 1989.

Kieckhefer, Richard. *Unquiet Souls: Fourteenth-Century Saints and Their Religious Milieu*. Chicago: University of Chicago Press, 1984.

Killerby, Catherine Kovesi. "Practical Problems in the Enforcement of Italian Sumptuary Law." In *Crime, Society, and the Law in Renaissance Italy*, ed. Trevor Dean and K. J. P. Lowe, pp. 99–120. Cambridge: Cambridge University Press, 1994.

——. *Sumptuary Law in Italy, 1200–1500*. Oxford: Clarendon Press, 2002.

King, Margaret. *The Death of the Child Valerio Marcello*. Chicago: University of Chicago Press, 1994.

King, Peter. "Aquinas on the Passions." In *Aquinas' Moral Theory*, ed. Scott MacDonald and Eleonore Stump. Ithaca: Cornell University Press, 1999.

Kohl, Benjamin. *Padua under the Carrara, 1318–1405*. Baltimore: Johns Hopkins University Press, 1998.

Krauss, Henning. *Epica feudale e pubblico borghese*. Trans. A. Fassò. Padua: Liviana Editrice, 1980.

Lansing, Carol. "Concubines, Lovers, Prostitutes: Infamy and Female Identity in Medieval Bologna." In *Beyond Florence: The Contours of Medieval and Early Modern Italy*, ed. Paula Findlen, Michelle Fontaine, and Duane Osheim, pp. 85–100. Palo Alto, Calif.: Stanford University Press, 2003.

——. *The Florentine Magnates: Lineage and Faction in a Medieval Commune*. Princeton, N.J.: Princeton University Press, 1991.

——. *Power and Purity: Cathar Heresy in Medieval Italy*. New York: Oxford University Press, 1998.

Lansing, J. Stephen. *Perfect Order: Recognizing Complexity in Bali*. Princeton, N.J.: Princeton University Press, 2006.

Lauwers, Michel. *La mémoire des ancêtres, le souci des morts: Morts, rites et société au Moyen Age (Diocèse de Liège, XIe–XIIIe siècle)*. Paris: Beauchesne, 1997.

——. "La mort et le corps des saints: La scène de la mort dans les *Vitae* du haut Moyen Age." *Le Moyen Age* 94 (1988): 21–50.

Lefkowitz, Mary R., and Maureen B. Fant, eds. *Women in Greece and Rome*. Toronto: Samuel Stevens, 1977.

LeGoff, Jacques. *The Birth of Purgatory*. Trans. A. Goldhammer. Chicago: University of Chicago Press, 1984.

Lejeune, Rita, and Jacques Stiennon. *La Légende de Roland dans l'art du Moyen Age*. Brussels: Arcade, 1966. Translated by Christine Trollope as *The Legend of Roland in the Middle Ages*. New York: Phaidon, 1971.

Leonardi, Lino. "La tradizione manoscritta e il problema testuale del laudario di Iacopone." In *Iacopone da Todi*, pp. 177–204. Atti del XXXVII convegno storico internazionale, Todi, 8–11 ottobre 2000. Spoleto: Centro italiano di studi sull'alto Medioevo, 2001.

Lesnick, Daniel. "Insults and Threats in Medieval Todi." *Journal of Medieval History* 17 (1991): 71–89.

Levy, Allison. "Augustine's Concessions and Other Failures: Mourning and Masculinity in Fifteenth-Century Tuscany." In *Grief and Gender, 700–1700*, ed. Jennifer C. Vaught with Lynne Dickson Bruckner, pp. 81–94. New York: Palgrave Macmillan, 2003.

Limentani, Alberto. *"L'Entrée d'Espagne" e i signori d'Italia*. Medioevo e Umanesimo, 80. Padua: Editrice Antenore, 1992.

Loraux, Nicole. *Mothers in Mourning*. 1990. Trans. Corinne Pache. Ithaca: Cornell University Press, 1998.

Lottin, Odon. "Les théories sur le péché originel de saint Anselme à Saint Thomas D'Aquin." In *Psychologie et morale aux XIIe et XIIIe siècles*, vol. 4. Louvain: Abbaye du Mont César, 1954.

Maffei, Elena. *Dal reato alla sentenza: Il processo criminale in età comunale*. Rome: Edizioni di storia e letteratura, 2005.

Maginnis, Hayden. *Painting in the Age of Giotto: A Historical Reevaluation*. University Park: Pennsylvania State University Press, 1997.

Maire Vigueur, Jean-Claude. *Cavaliers et citoyens: Guerre, conflits et société dans l'Italie communale, XIIe–XIIIe siècles*. Paris: EHESS, 2003.

——. *Comuni e signorie in Umbria, Marche e Lazio*. Turin: UTET, 1987.

——. "Giudici e testimoni a confronto." In *La parola all'accusato*, ed. Jean-Claude Maire Vigueur and Agostino Paravicini Bagliani, pp. 105–23. Palermo: Sellerio, 1991.

——, ed. *I podestà dell'Italia comunale*. Rome: École Française de Rome, Istituto storico italiano per il Medio Evo, 2000.

——. "L'ufficiale forestiero." In *Ceti, modelli, comportamenti nella società medievale (secoli XIII–metà XIV) (Pistoia, 14–17 maggio 1999)*, pp. 75–97. Pistoia: Centro italiano di studi di storia e d'arte, 2001.

Manicom, Linzi. "Ruling Relations: Rethinking State and Gender in South African History." *Journal of African History* 33 (1992): 441–65.

Marsh, David. *Lucian and the Latins*. Ann Arbor: University of Michigan Press, 1998.

Martinez, Ronald, and Robert Durling. Introduction to *The Divine Comedy of Dante Alighieri*. Ed. and trans. Robert Durling. Vol. 1, *Inferno*. Oxford: Oxford University Press, 1996.

Martino. Ernesto da. *Morte e pianto rituale*. Turin: Einaudi, 1958.

Mazzi, Maria Serena. *Prostitute e lenoni nella Firenze del Quattrocento*. Milan: Il Saggiatore, 1991.

McClure, George. *Sorrow and Consolation in Italian Humanism*. Princeton, N.J.: Princeton University Press, 1991.

Medin, A. "La morte di Giovanni Acuto." *Archivio storico italiano*, ser. 4, 17 (1886): 161–77.

Meersseman, Gerard Giles. *Ordo Fraternitatis: Confraternite e pietà dei laici nel Medioevo*. Rome: Herder, 1977.

Meiss, Millard. "The Problem of Francesco Traini." *Art Bulletin* 15 (1933): 97–173. Reprinted in *Francesco Traini*, ed. Hayden B. J. Maginnis. Washington, D.C.: Decatur House, 1983.

Mesquita, Batja. "Culture and Emotion: Different Approaches to the Question." In *Emotions: Current Issues and Future Directions*, ed. Tracy J. Mayne and George A. Bonanno, pp. 214–50. New York: Guilford Press, 2001.

Migliorino, Francesco. *Fama e infamia: Problemi della società medievale nel pensiero giuridico nei secoli XII e XIII*. Catania: Gianotta, 1985.

Milner, Stephen J. "The Government of Faction in the Florentine State, 1380–1512." Ph.D. diss., Warburg Institute, University of London, 1996.

Mineo, E. Igor. *Nobiltà di stato: Famiglie e identità aristocratiche nel tardo Medioevo; La Sicilia*. Rome: Donizelli, 2001.

Montandon-Binet, Christiane, and Alain Montandon, eds. *Savoir mourir*. Paris: L'Harmattan, 1993.

Morse, Ruth. *The Medieval Medea*. Cambridge: Cambridge University Press, 1996.

Muir, Edward. "The Sources of Civil Society in Italy." *Journal of Interdisciplinary History* 29 (Winter 1999): 374–406.

Mulcahey, M. Michèle. *"First the Bow Is Bent in Study": Dominican Education before 1350*. Toronto: PIMS, 1998.

Muzzarelli, Maria Giuseppina. *Gli inganni delle apparenze: Disciplina di vesti e ornamenti alla fine del Medioevo*. Turin: Scriptorium, 1996.

Muzzarelli, Maria Giuseppina, and Antonella Campanini, eds. *Disciplinare il lusso: La legislazione suntuaria in Italia e in Europa tra Medioevo ed Età moderna*. Rome: Carocci, 2003.

Nederman, Cary J. "Nature, Sin, and the Origins of Society: The Ciceronian Tradition in Medieval Political Thought." *Journal of the History of Ideas* 49, 1 (1988): 3–26.

Nussbaum, Martha. *The Therapy of Desire: Theory and Practice in Hellenistic Ethics*. Princeton, N.J.: Princeton University Press, 1994.

Oberhansli-Widmer, Gabrielle. *La complainte funèbre du haut Moyen Age français et occitan*. Romanica helvetica, 106. Bern: Editions Francke, 1989.

Olberding, Amy. "Mourning, Memory, and Identity: A Comparative Study of the Constitution of the Self in Grief." *International Philosophical Quarterly* 37 (March 1997): 29–44.

Ortalli, Gherardo. *La pittura infamante nei secoli XIII–XVI*. Rome: Jouvence, 1979.

Panofsky, Erwin. *Tomb Sculpture*. New York: Abrams, 1967.

Paravicini Bagliani, Agostino. *Cardinali di curia e "familiae" cardinalizie dal 1227 al 1254*. Italia sacra, 18. Padua: Antenore, 1972.

——. "La mobilità della curia romana nel secolo XIII: Riflessi locali." In *Società e istituzioni dell'Italia comunale: L'esempio di Perugia (secoli XII–XIII)*, pp. 155–278. Perugia, 1989.

Pardi, Giuseppe. *Comune e signoria a Orvieto*. Città di Castello, 1916. Reprint, Rome: Multigrafica, 1974.

——. "Serie dei supremi magistrati e reggitori di Orvieto." *Bollettino della R. Deputazione di storia patria per l'Umbria* 1 (1895): 337–415.

Paxton, Frederick S. *Christianizing Death: The Creation of a Ritual Process in Early Medieval Europe*. Ithaca: Cornell University Press, 1990.

Payer, Pierre. *The Bridling of Desire*. Toronto: University of Toronto Press, 1993.

Pellegrini, Letizia. *I manoscritti dei predicatori*. Rome: Istituto storico domenicano, 1999.

——. *Specchio di donna: L'immagine femminile nel XIII secolo; Gli "exempla" di Stefano di Borbone*. Rome: Studium, 1989.

Pellegrini, Michele. "Negotia mortis: Pratiche funerarie, economia del suffragio e comunità religiose nella società senese tra Due e Trecento." *Bulletino senese di storia patria* 110 (2003; published 2004): 19–52.

Peters, Edward. *Torture*. 2nd ed. Philadelphia: University of Pennsylvania Press, 1996.

Petersen, Nils Holger. "A Mutual Lamenting: Mother and Son in *Filius Getronis*." *Roma ETC* 2: 687–701.

Piccolomini-Adams, T. *Guida storico-artistica della città di Orvieto e suoi contorni*. Siena, 1883.

Porter, Arthur Kingsley. *Spanish Romanesque Sculpture*. 2 vols. New York: Hacker Art Books, 1969.

Powell, James. *Albertanus of Brescia: The Pursuit of Happiness in the Early Thirteenth Century*. Philadelphia: University of Pennsylvania Press, 1992.

Prodi, Paolo, ed., with Carla Penuti. *Disciplina dell'anima, disciplina del corpo e disciplina della società tra Medioevo ed Età moderna*. Annali dell'Istituto storico italo-germanico, 40. Bologna: Il Mulino, 1994.

Putnam, Robert D. *Making Democracy Work: Civic Traditions in Modern Italy*. Princeton, N.J.: Princeton University Press, 1993.

Rainey, Ronald E. "Sumptuary Legislation in Renaissance Florence." Ph.D. diss., Columbia University, 1985.

Raphael, Beverly. *The Anatomy of Bereavement*. New York: Basic Books, 1983.

Refice, Paola. "La tomba de Braye e I monumenti funebri con la figura del giacente." In *Arnolfo di Cambio: Una rinascita nell'Umbria medievale*, ed. Vittoria Garbaldi and Bruno Toscano, pp. 157–61. Milan: Silvana Editoriale, 2005.

Reynolds, Leighton D. *The Medieval Tradition of Seneca's Letters*. Oxford: Oxford University Press, 1965.

Reynolds, Susan. *Fiefs and Vassals*. Oxford: Oxford University Press, 1994.

Riccetti, Lucio. *La città costruita: Lavori pubblici e immagine in Orvieto medievale*. Florence: Le Lettere, 1992.

——, ed. *Il Duomo di Orvieto*. Rome: Laterza, 1988.

——. "Monaldeschi, Filippeschi, comune ad Orvieto nel Medioevo." In *I Monaldeschi nella storia della Tuscia*, ed. Antonio Quattrani, pp. 5–17. Bolsena, 1995.

——. "*Per havere dell'acqua buona per bevere*: Orvieto; Città e cantiere del Duomo, secoli XIV–XV." *Nuova rivista storica* 78 (1994): 243–92.

Rice, Eugene F. *Saint Jerome in the Renaissance*. Baltimore: Johns Hopkins University Press, 1985.

Rinaldi, Rosella. "*Mulieres publicae*: Testimonianze e note sulla prostituzione tra pieno e tardo Medioevo." In *Donna e lavoro nell'Italia medievale*, ed. Maria Giuseppina Muzzarelli, Paola Galetti, and Bruno Andreolli. Turin: Rosenberg & Sellier, 1991.

Rist, John. *Augustine: Ancient Thought Baptised*. Cambridge: Cambridge University Press, 1994.

Rocke, Michael. *Forbidden Friendships: Homosexuality and Male Culture in Renaissance Florence*. Oxford: Oxford University Press, 1996.

——. "Sodomites in Fifteenth-Century Tuscany: The Views of Bernardino of Siena." In *The Pursuit of Sodomy: Male Homosexuality in Renaissance and Enlightenment Europe*, ed. Kent Gerard and Gert Hekma. New York: Harrington Park Press, 1989.

Rockelein, Hedwig. "Marie, l'église et la synagogue: Culte de la Vierge et lutte contre les Juifs en Allemagne à la fin du Moyen Age." In *Marie: La culte de la Vièrge dans la société médiévale*, ed. Dominique Iogna-Prat, Éric Palazzo, and Daniel Russo, pp. 512–32. Paris: Beauchesne, 1996.

Romagnoli, Daniela. "Le buone maniere." In *Ceti, modelli, comportamenti nella società medievale (secoli XIII–metà XIV) (Pistoia, 14–17 maggio 1999)*, pp. 255–71. Pistoia: Centro italiano di studi di storia e d'arte, 2001.

Rosaldo, Renato. "Grief and a Headhunter's Rage: On the Cultural Force of the Emotions." In *Text, Play, and Story: The Construction and Reconstruction of Self and Society*, ed. E. Bruner, pp. 178–95. Washington, D.C.: American Ethnological Society, 1986.

Rosenwein, Barbara. "Worrying about Emotions in History." *American Historical Review* 107 (June 2002): 821–45.

Rossi, Marilena Caponeri. "Il Duomo di Orvieto e l'attività edilizia dei Signori Sette (1295–1313)." In *Il Duomo di Orvieto*, ed. Lucio Riccetti, pp. 29–80. Rome: Laterza, 1988.

——. "Nota sulle fonti giudiziarie medioevali conservate presso la sezione di Archivio di Stato di Orvieto." *Bollettino dell'istituto storico-artistico orvietano* 38 (1982): 3–7.

Ruggiero, Guido. *The Boundaries of Eros*. Oxford: Oxford University Press, 1985.

Rush, Alfred. *Death and Burial in Christian Antiquity*. Washington, D.C.: Catholic University of America, 1941.

Scentoni, Gina. "Il laudario iacoponico e i laudari dei disciplinati perugini e assisiani." In *Iacopone da Todi*, pp. 243–97. Atti del XXXVII convegno storico internazionale, Todi, 8–11 ottobre 2000. Spoleto: Centro italiano di studi sull'alto Medioevo, 2001.

Schmitt, Jean-Claude. *La raison des gestes*. Paris: Gallimard, 1990.

Schneyer, J. B., ed. *Repertorium der lateinischen Sermones des Mittelalters für die Zeit von 1150–1350*. Münster, 1972.

Scott, Joan. *Gender and the Politics of History*. New York: Columbia University Press, 1988.

Scourfield, J. H. D. *Consoling Heliodorus: A Commentary on Jerome, Letter 60*. Oxford: Oxford University Press, 1993.

Sindona, Enio. *L'opera completa di Cimabue e il momento figurativo pregiottesco*. Milan: Rizzoli, 1975.

Smail, Daniel Lord. *The Consumption of Justice: Emotions, Publicity, and Legal Culture in Marseille, 1264–1423*. Ithaca: Cornell University Press, 2003.

Starn, Randolph, and Loren Partridge. *Arts of Power: Three Halls of State in Italy, 1300–1600*. Berkeley: University of California Press, 1992.

Stears, Karen. "Death Becomes Her: Gender and Athenian Death Ritual." In *The Sacred and the Feminine in Ancient Greece*, ed. Sue Blundell and Margaret Williamson, pp. 113–27. London: Routledge, 1998.

Sticca, Sandro. *The Planctus Mariae in the Dramatic Tradition of the Middle Ages*. Trans. Joseph R. Berrigan. Athens: University of Georgia Press, 1988.

Strocchia, Sharon. *Death and Ritual in Renaissance Florence*. Baltimore: Johns Hopkins University Press, 1992.

——. "Death Rites and the Ritual Family in Renaissance Florence." In *Life and Death in Fifteenth-Century Florence*, ed. M. Tetel, R. G. Witt, and R. Goffen. Durham, N.C.: Duke University Press, 1989.

——. "Remembering the Family: Women, Kin, and Commemorative Masses in Renaissance Florence." *Renaissance Quarterly* 42 (Winter 1989): 635–54.

Stuard, Susan. *Gilding the Market: Luxury and Fashion in Fourteenth-Century Italy.* Philadelphia: University of Pennsylvania Press, 2006.

Suitner, Franco. *Jacopone da Todi: Poesia, mistica, rivolta nell'Italia del Medioevo.* Rome: Donzelli, 1999.

Tamba, Giorgio. "L'archivio della società dei notai." In *Notariato medievale bolognese, II (Atti di un convegno)*, pp. 191–283. Studi storici sul notariato italiano, 3. Rome: Consiglio Nazionale del notariato, 1977.

——. *La società dei notai di Bologna.* Ministero per i beni culturali e ambientali. Pubblicazioni degli Archivi di stato, Strumenti 103. Rome: Libreria dello Stato, 1988.

Tarlow, Sarah. *Bereavement and Commemoration: An Archaeology of Mortality.* Oxford: Blackwell, 1999.

Tentler, Thomas N. *Sin and Confession on the Eve of the Reformation.* Princeton, N.J.: Princeton University Press, 1977.

Thiry, Claude. *La plainte funèbre.* Typologie des sources du Moyen Age occidental, vol. 30. Turnhout, Belgium: Brepols, 1978.

Thompson, Augustine. *Cities of God: The Religion of the Italian Communes, 1125–1325.* University Park: Pennsylvania State University Press, 2005.

——. *Revival Preachers and Politics in Thirteenth-Century Italy: The Great Devotion of 1233.* Oxford: Oxford University Press, 1992.

Trachtenberg, Marvin. *Dominion of the Eye: Urbanism, Art, and Power in Early Modern Florence.* Cambridge: Cambridge University Press, 1997.

Treffort, Cécile. *L'église carolingienne et la mort: Christianisme, rites funéraires et pratiques commémoratives.* Lyon: Presses universitaires de Lyon, 1996.

Trinkaus, Charles. *The Poet as Philosopher.* New Haven, Conn.: Yale University Press, 1979.

Tunberg, Terence O. "What Is Boncompagno's 'Newest Rhetoric'?" *Traditio* 42 (1986).

Turrini, Patrizia. "Le cerimonie funebri a Siena nel basso Medio Evo: Norme e rituale." *Bullettino senese di storia patria* 110 (2003; published 2004): 53–101.

Valdez del Alamo, Elizabeth. "Lament for a Lost Queen: The Sarcophagus of Doña Blanca in Nájera." In *Memory and the Medieval Tomb*, ed. Elizabeth Valdez del Alamo with Carol Stamatis Pendergast, pp. 43–79. Aldershot, U.K.: Ashgate, 2000.

Vallerani, Massimo. "L'amministrazione della giustizia a Bologna in età podestarile." *Atti e memorie delle Deputazione di storia patria per le provincie di Romagna*, n.s. 43 (1993): 291–316.

——. "Modelli processuali e riti sociali nelle città comunali." In *Riti e rituali nelle società medievali*, ed. Jacques Chiffoleau, Lauro Martines, and Agostino Paravicini Bagliani, pp. 115–40. Spoleto: Centro italiano di studi sull'alto Medioevo, 1994.

——. "Il potere inquisitorio del podestà: Limiti e definizioni nella prassi bolognese di fine Duecento." In *Studi sul Medioevo per Girolamo Arnoldi*, ed. Giulia Barone, Lidia Capo, and Stefano Gasparri, pp. 379–415. Rome: Viella: 2000.

——. "I processi accusatori a Bologna fra Due e Trecento." *Società e storia* 78 (1997): 741–88.

——. *Il sistema giudiziario del comune di Perugia: Conflitti, reati e processi nella seconda metà del XIII secolo.* Perugia: Deputazione di storia patria per l'Umbria, 1991.

Van Gennep, Arnold. *Rites of Passage.* Paris: 1909.

Van Oort, J. "Augustine on Sexual Concupiscence and Original Sin." *Studia Patristica* 22 (1989).

Vauchez, André. "Une campagne de pacificazione en Lombardie autour de 1233: L'action politique des ordres mendiants d'après la réforme des statuts communaux et les accords de paix." *École Française de Rome: Mélanges d'archéologie et d'histoire* 78 (1966): 519–49.

Villa, Claudia. "La tradizione delle 'Ad Lucilium' e la cultura di Brescia dall'età carolingia ad Albertano." *Italia medioevale e umanistica* 12 (1969): 9–51.

Vovelle, Michelle. "Encore la mort: Un peu plus qu'une mode?" *Annales: E.S.C.* (1982): 276–87.

———. *Mourir autrefois: Attitudes collectives devant la mort aux XVIIe et XVIIIe siècles*. Paris: Éditions Gallimard/Julliard, 1974.

Waley, Daniel. "The Army of the Florentine Republic from the Twelfth to the Fourteenth Century." In *Florentine Studies*, ed. Nicolai Rubinstein. Evanston, Ill.: Northwestern University Press, 1968.

———. *Mediaeval Orvieto: The Political History of an Italian City-State, 1157–1334*. Cambridge: Cambridge University Press, 1952.

Weisheipl, James A. *Friar Thomas D'Aquino: His Life, Thought, and Works*. Garden City, N.J.: Doubleday, 1974.

Weitzmann, Kurt. "The Origins of the Threnos." In *De artibus opuscula XL: Essays in Honor of Erwin Panofsky*, ed. Millard Meiss. New York: New York University Press, 1961.

White, Stephen D. "Comment." *Past and Present* 152 (August 1996): 205–23.

Wickham, Chris. *Legge, pratiche e conflitti: Tribunali e risoluzione delle dispute nella Toscana del XII secolo*. Rome: Viella, 2000. Translated as *Courts and Conflict in Twelfth-Century Tuscany*. Oxford: Oxford University Press, 2003.

Wilken, Robert. *John Chrysostom and the Jews: Rhetoric and Reality in the Late Fourth Century*. Berkeley: University of California Press, 1983.

Witt, Ronald G. "Brunetto Latini and the Italian Tradition of *Ars Dictaminis*." *Stanford Italian Review* 3 (1983): 6–24.

Zorzi, Andrea. "Controle social, ordre public et répression judiciare à Florence à l'époque communale: Eléments et problèmes." *Annales: E.S.C.* 45 (1990): 1169–88.

———. "La cultura della vendetta nel conflitto politico in età comunale." In *Le storie e la memoria: In onore di Arnold Esch*, ed. Roberto Delle Donne and Andrea Zorzi. Florence, 2002. http://www.storia.unifi.it/_rm/e-book.

———. "Politica e giustizia a Firenze al tempo degli ordinamenti antimagnatizi." In *Ordinamenti di giustizia fiorentini*, ed. Vanna Arrighi, pp. 105–47. Florence: Archivio di Stato, 1995.

Zumthor, Paul. "Étude typologique des planctus contenus dans la *Chanson de Roland*." In *La technique littéraire des chansons de geste*, pp. 228–29. Actes du Colloque de Liège (September 1957). Paris: Société d'édition "Les Belles Lettres," 1959.

———. "Les planctus épiques." *Romania* 84 (1963): 61–69.

INDEX